ART OF THE INCAS

HENRI STIERLIN

ART OF THE INCAS
AND ITS ORIGINS

RIZZOLI NEW YORK

Translation from the French,
L'Art Inca et ses origines
de Valdivia à Machu Picchu
by Betty and Peter Ross.
French language edition:
© 1983 by Office du Livre, Fribourg
English translation © 1984 by Office du Livre

First published in 1984 in the United States of America by:
Rizzoli INTERNATIONAL PUBLICATIONS, INC.
712 Fifth Avenue/New York 10019

Library of Congress Catalog Card Number: 83-24693
ISBN: 0-8478-0529-8

Printed in Switzerland

Table of Contents

Introduction 7

The Scope of this Book 7
The Study of Art 8
Arrangement of the Work 9
Unity of Theme 11
An Attempt at Synthesis 13
The Running Sore of Andean Archaeology 14

I. Background, Population and Technological Achievements 17

Geography of the Andean Countries 17
Population of the Americas 19
The Growth of Agriculture 24
Resources and Deficiencies of the Andean Peoples 27

II. The Emergence of Civilization: from Valdivia to Chorrera 31

The Case for Ecuador 31
Appearance of Ceramics 34
The Ceremonial Centre at Real Alto 40
The Machalilla Phase: Retrogression and Innovation 42
The Diversity of Chorrera Pottery 45

III. Chavín: The Birth of Classicism in Peru 50

Phases of Pre-ceramic Agriculture 50
Gourd Decoration and the Art of Weaving 51
Beginnings of Architecture 52
The Chavín Sanctuary 62
Sculpture and Iconography 68
The Dawn of Peruvian Ceramics 78

IV. Ceramics and Gold-work: the Heyday of the Mochica Culture 79

Chavín Pottery 79
The Discovery of Vicús Pottery 84
Mochica Society 89
Architecture and Town Planning 92
Pañamarca and Pampa Grande 97
From Portrait Vessels to Polychrome Pottery 98
Ceramics and Art 102
Art and Archetypes 104
The Emergence of Metallurgy 106
La Tolita and Jama Coaque 107

V.	Artists and Craftsmen of Paracas–Nazca	111
	Four Thousand Years of Evolution	111
	From Paracas Pottery...	114
	...to the Art of the Nazca Potters	114
	The Development of Textiles	117
	Mysterious Drawings in the Desert	122

VI.	Art and Architecture of Tiahuanaco	131
	Mythical City	134
	Architecture of Tiahuanaco	135
	Town Planning and Chronology	138
	Sculpture and Iconography	139
	Diffusion of Tiahuanacoid Forms	141
	Recuay Pottery and the Wilcawaín Tombs	146

VII.	Mass Art in the Chimú Empire	149
	Building of the Chimú Empire	151
	Chanchán: A Study in Urban Planning	156
	The Role of the 'Citadels' or 'Palaces'	159
	Sequence and Duration	161
	Architectural Decoration	164
	Ceramics and Gold-work	167
	Chancay and Ica Regions	169

VIII.	The Inca Empire	172
	Organization and Social Welfare	172
	A Proliferation of Witnesses	172
	Historical Perspective	175
	Social Structure	180
	Public Works	183
	The Intellectual Aspect	188
	A Socialist Culture	190

IX.	The Incas and Art	195
	The Legacy of the Builders	197
	Planning and the Monuments of Cuzco	199
	The City of Pisac: Eagle's Nest	208
	The Lost City: Machu Picchu	209
	Other Types of Building	215
	Inca Arts and Crafts	222
	The Decline of the Pre-Columbians	224

Conclusion	228
Chronological Table I	230
Chronological Table II	231
Acknowledgements	232
Select Bibliography	233
Index	236
List of Plates	240
List of Figures, Maps and Plans	240

Introduction

This volume, devoted to pre-Columbian art from the Valdivia period to that of Machu Picchu, is the third in a series dealing with the creations of the Indian peoples of America prior to the Spanish Conquest. Entitled *Art of the Incas and its Origins*, it constitutes an attempt to synthesize the present state of knowledge in a field in which information continues to accumulate with great rapidity.

Hence few ancient cultures have called for such extensive re-evaluation during the past few decades as have the pre-Columbian societies of the Andes, a fact attributable to the relatively sluggish pace at which archaeology has proceeded here by comparison with Mesoamerica and, in particular, the Old World.

The Scope of this Book

The forms of expression of the societies which inhabited South America are at once varied and homogeneous and, indeed, constitute so vast a field of study as to exceed the bounds set by this book. Thus we shall leave out of account, not only the Central American and Caribbean zone including Colombia, but also the whole eastern part of the continent lying within the Amazon basin. Nor shall we concern ourselves with the cultures of the vast area now covered by Argentina and Chile.

In the territory under consideration, namely the Andean massif flanking the west coast of the South American continent, we shall find a number of societies which constitute a coherent whole. The area in which were grouped the principal Andean cultures of pre-Columbian times extended from Ecuador in the north to Bolivia in the south (a distance of some 2,500 km) and, by way of the *sierra* and the *puna,* from the forested foot-hills of the Cordillera in the east to the oases of the Pacific littoral in the west.

In order to underline the connections, whether geographical or cultural, between these three countries, Peru, Ecuador and Bolivia, we propose to disregard the compartmentalization imposed by national frontiers. Accordingly, in our discussion of the great civilizations of South America, the word Peru is used in the widest sense of the term, the sense, that is, that prevailed at the time of the Spanish Conquest. But our subject also covers the great Inca empire at it was in its heyday, omitting only the latter's borrowings from Chile and from western Argentina, the aesthetic influence of which was of little consequence. Nor have we considered the

contributions made by Colombia, since that country forms part of a distinct cultural entity, sometimes described as the intermediate zone (Willey), which also embraces Central America, that is to say Panama, Costa Rica and Nicaragua. This region, linking the Maya world in the north to the Inca empire in the south, thus constitutes a domain in its own right which is of especial interest due to recent discoveries and will perhaps be the subject of a future volume.

In terms of history, the scope of this work will not extend beyond the sphere of art. For the sake of simplicity we have therefore chosen for our point of departure the first appearance of pottery which occurred a little before 3000 B.C., notably in the neighbourhood of Valdivia in present-day Ecuador. Our study concludes with the Spanish Conquest in 1533 which brought about the collapse of the pre-Columbian cultures of South America. Hence this field of investigation spans four and a half millennia, a period characterized by astonishing multiformity, and one during which a succession of peoples and societies attained different levels of development and evolved forms of expression of very uneven quality.

If we have chosen to begin our book with the appearance of pottery, this is not to say that we are unaware of the existence of earlier manifestations of art, such as the decoration of gourds or the textile motifs of the pre-ceramic era. Important though they may be, these witnesses belong primarily to the sphere of archaeology, since their state of preservation is often too poor to permit of their being reproduced as examples. However, the same does not apply to terracotta pieces, the properties of which enable them to sustain the passage of as much as three or four millennia. Hence our choice has been dictated by the very subject of this study.

The Study of Art

As indicated by the title of this book, that subject, whose geographico-historic limits we have just defined, is art. Accordingly we do not intend to write either an archaeological treatise—though repeatedly drawing on archaeology as a source of raw material—or a detailed historical account of social developments and the events of the Conquest.

We are, therefore, concerned with aesthetic creativity in all its various guises, the main objects of discussion being pottery, metal-work (especially gold-work), textiles and feather-work, as well as architecture and urban planning; the latter are considered as a framework in which a society may evolve and as a clear illustration of the plastic tendencies it has chosen to adopt.

However, the very amplitude of the chronological framework is enough to show that our subject-matter extends far beyond the confines of Inca art as such. For it comprises all the forms of expression anterior to those of the great people who, in the fifteenth century, effected the unity of the pre-Columbian world in the region under discussion. Moreover, the second part of our title, *and its Origins,* plainly indicates that Inca art derived, whether directly or indirectly, from every one of its predecessors in the area comprising present-day Peru, Bolivia and Ecuador. Even though, in certain spheres such as pottery, its creations may not rival those of its predecessors, notably the Mochicas, Inca art represents the culmination of a series of empirical exercises begun 4,500 years earlier in Valdivia.

Again, irrespective of the number of works that have come down to us, the aesthetic approach inevitably entails a measure of subjectivity in the choice of themes to be developed. Amongst those we have selected are some that are still relatively unfamiliar, or which have not been adequately published, for instance the pottery of Chorrera and Vicús, while others, such as Mochica and Nazca pottery, are much more widely known. In so far as these products have been given pride of place, it is on account of the quality they display and the light which they shed on the men who created them.

In addition to ceramics, special mention will be made of gold-work, in particular that of the Chimú–Lambayeque period. This will be compared with the products of Moche, Vicús, Guayas and La Tolita, all of which give evidence of a more or less uniform level of development.

Lastly, the Incas will be considered at some length, largely by reason of the continued survival of what is left of their architecture. Theirs, moreover, is the chief pre-Columbian culture of South America in respect of which we possess accurate eyewitness accounts, made by the chroniclers of the Conquest. Such texts are not available in the case of most of the earlier civilizations so that archaeological evidence remains our only source of information on the modes of thought, mental outlook and the social, economic and political structures of which works of art are, as it were, the outward and visible signs.

The aesthetic approach, then, will mean that we shall concentrate on certain important groups of works at the expense of others which seem to us to be of lesser interest, even though an entire period or culture may have to be omitted. Such omissions are, therefore, the result of a decision that has been deliberately arrived at.

Arrangement of the Work

The scheme adopted in *Art of the Aztecs and its Origins* has been followed in this book, the third volume of our conspectus of pre-Columbian art. For our study is concerned, not only with the great Inca civilization and its imperialist expansionism, but also with the numerous societies that preceded it. Inca architecture, which represents the apogee of Andean building technology, is unquestionably spectacular. Yet the proficiency attained by earlier cultures in the field of urban planning, ceramics, gold-work and textiles equalled, if it did not exceed, the skills of the master craftsmen of Cuzco.

While our title may highlight the achievements of the Incas, this is not to suggest that the other prehistoric cultures of the region have been underrated. In so far as is possible, the book has been subdivided in accordance with chronological and geographical criteria.

Chapter I sets the scene with a description of the topography of the continent and of the manner in which it was peopled. Also discussed are the emergence of agriculture and the resources available to man and what is lacking in the Andean world.

Chapter II considers the birth of artistic forms at the time of the Valdivia culture (about 3500 B.C.), when pottery first appeared. It then passes on to the Machalilla era (about 1600 B.C.) and, finally, to the flowering of Chorrera art (about 1200–500 B.C.). Until some thirty years ago, archaeologists were unaware of these Ecuadorean cultures. It is thus

a comparatively new field in which the latter's contributions have not always been assessed at their true value. Here we may discover a new aesthetic language in the making, a language that was to exert an influence on pre-Columbians throughout the Andean region.

Chapter III, which is devoted to the first manifestations of Peruvian art, opens with an examination of the buildings erected on the coast in about 2000 B.C.; major monumental architecture, however, does not appear until much later, between 1400 and 1200 B.C., when important structures of stone were erected at Sechín Alto and Las Haldas. They served a religious purpose and, at Cerro Sechín, display vigorously executed bas-reliefs. In the second half of the chapter we shall analyse the great civilization of Chavín, once regarded in Peru as being the 'mother' of all the South American civilizations, and occupying a position similar to that of the Olmec culture in Mesoamerica. Yet the most recent radio-carbon datings indicate that it did not reach its heyday until the period between 850 and 200 B.C. From its birthplace in a valley on the eastern slopes of the Andes the art of Chavín was to extend its influence over most of the Peruvian littoral, imprinting upon the region, not only the forms and themes that inspired it, but also a symbolical and structured mode of expression. We shall conclude our chapter by briefly reverting to the Vicús culture in the extreme north of the region, which came to light about 1960. While the value of Vicús art has yet to be fully assessed it would seem to represent the 'missing link' between Chorrera art on one side of the Ecuadorean frontier and Mochica art on the other, thus providing indisputable evidence of the influence exerted by Ecuador on the masterpieces of Peruvian classicism.

In Chapter IV we shall trace the development of the pottery which, from its beginnings at Chavín, subsequently spread to Vicús and finally experienced its classic flowering in the Mochica culture. Also characteristic of the latter are vast pyramids, built of adobe (dried brick) and comparable in size to the ziggurats of Babylon and the pyramids of China and Egypt. Gold-work, which had made its appearance at the time of the Chavín and Vicús cultures, more notably the latter, reached among the Mochicas a degree of perfection that not even the Chimú craftsmen would surpass.

The second part of this chapter is devoted to the societies which grew up in Ecuador during the same period—those, for instance, at Jama Coaque and La Tolita. Here, alongside the work of the seal-maker and the potter, we find clear evidence of a flourishing technology in the field of gold-work, an art enriched by borrowings from Colombia.

In Chapter V we shall leave the northern part of the Andean region and turn to the sites at Paracas, Nazca and Ica on the south coast. Here in the desert, in the oases and on the banks of the very few permanent rivers, societies existed in which the art of weaving and ceramics had already attained a high level of proficiency as far back as the first millennium B.C. Their architecture, however, was not particularly advanced. It was they who drew vast figures of birds, insects and mammals on the surface of the desert, as also what are known as the lines, long straight 'pathways' varying in length between 100 yards and several miles. The purpose of these works has remained a mystery, although a great many hypotheses have been put forward during the past quarter of a century.

Chapter VI takes in a period during which an original culture, characterized by imposing stone architecture and heavily stylized sculpture,

established itself on the high plateaux surrounding the shores of Lake Titicaca. Its art, centred on Tiahuanaco in Bolivia and Huari in Peru and born of the first unification of the Andean region which took place between A.D. 550 and 900, was to extend its influence over a large part of the last-named territory. In many places on the coast it superseded Nazca forms, while adopting the latter's techniques in the manufacture of textiles, including tapestry, as well as of polychrome pottery. In some other respects the products of Tiahuanaco recall the geometric designs of Chavín, even though a millennium separates the two cultures.

In Chapter VII we shall discuss Chimor or the Chimú kingdom on the north coast of Peru, the art of which succeeded that of the Mochicas. This civilization built vast cities such as Chanchán and Pacatnamú and, in the thirteenth and fourteenth centuries of our era, controlled a domain consisting of a number of valleys between Piura and Paramonga and extending along some 700 kilometres of coast-line. While the kingdom has bequeathed a rich store of gold-work, the quality of its pottery, mass-produced in moulds to meet the increased demands of the towns and of a growing population, is poor compared to the masterpieces of the Mochica craftsmen.

Our last two chapters, VIII and IX, are both devoted to the creations of the Incas, whose efflorescence may be said to have begun in about 1430. Chapter VIII contains a general discussion of the last of the great pre-Columbian civilizations, while the illustrations are restricted to the works produced in the central or 'metropolitan' region situated in the Andean highlands. Besides Cuzco, the capital city, the region also comprised other towns situated in the high valleys which nurtured Inca expansionism. Chapter IX is concerned with the arts as such, including architecture, sculpture and pottery, while the illustrations show how the successive conquests of the imperial era imposed the Inca style not only upon the territories around Lake Titicaca and along the coast, from Pachacámac to Paramonga, but also upon the lands of distant Ecuador where, in the mountainous country round Cuenca, stands the temple-fortress of Ingapirca. The chapter ends with a discussion of the unforgettable site of Machu Picchu, rescued from oblivion in 1911 when the American explorer, Hiram Bingham, began his work of retrieving from the encircling jungle what had been an Inca outpost above the Urubamba river up whose course the redoubtable Amazonian tribes had made their way to the high plateaux.

In conclusion, we take stock of the works of art produced by the pre-Columbian peoples of the Andean region, while at the same time making no bones about the considerable gaps that still exist in our knowledge.

This work, then, with its 220 colour plates and some 40 plans, drawings and maps, all of them specially commissioned, is intended to provide a conspectus of South America's artistic heritage and, in particular, of the Andean countries which, during the century preceding the arrival of the Conquistadors, were briefly united under the Incas.

Unity of Theme

Although the foregoing résumé of the contents might seem to suggest a mosaic of heterogeneous cultures without any apparent link between

them, all these societies were nevertheless beneficiaries of a common fund such as we have discussed elsewhere in connection with the Mesoamerican world. All are based on a cultural unity which has helped to form the principal traits of the Andean heritage.

Recent excavations have clearly revealed the existence of a formal continuity in the cultures of South America extending from Ecuador—in particular the littoral north of the Río Guayas—to southern Peru, and including the great centres of the Moche region. Indeed, the discovery of cultures such as the Chorrera in Ecuador and the Vicús in northern Peru has proved that this development, involving reciprocal influences, proceeded mainly in a north-south direction throughout a zone comprising the tropical regions of Ecuador and the scattered oases in the coastal desert of Peru, roughly on the latitude of the Chicama valley and of what is now Trujillo.

In this way, recent evidence in favour of cultural continuity has closed the gap that once existed between the earliest creations of Valdivia and those of the classic Andean civilizations. From the former we may now pass on without interruption to Chorrera and Machalilla and thence, by way of Vicús and Moche to the first phase of Peruvian unification under the Tiahuanaco–Huari empire which in certain respects was the forerunner of the Incanato, or Inca empire, governed by the lords of Cuzco.

A better appreciation of Valdivia's period of inception has enabled us to detect the interrelations between the different regional styles which sprang from those early sources and to apprehend more clearly the development, from its Ecuadorean origins, of the pottery which antedated Peruvian production by almost two millennia. Thus, the flowering of Valdivia no longer represents an isolated phenomenon—an island in a cultural limbo—but rather the point of departure for a number of pre-Columbian societies which, in a gradual process of evolution, transmitted from one to the other the torch of progress, the seminal discoveries made by each. Moreover, we now know that the Valdivia was not the only culture in existence at that early date, for excavations have already brought to light other sites with evidence of pottery dating from the third millennium, notably in the coastal desert country of Talara and Piura, on the Peruvian shore of the vast Gulf of Guayaquil.

In this connection it should be said at the outset that modern frontiers and current political problems have all too often militated against a reasonable assessment of historical events. For archaeological debate, which should be governed solely by scientific criteria, has been tainted with aggressive chauvinism. While northern Peru has long been neglected, excavations have been going ahead in Ecuador. Moreover the all too infrequent contacts between the specialists of the two countries might seem to suggest a similar lack of co-operation between neighbouring cultures during the prehistoric era.

Once the arrears in the archaeological investigation of certain regions have been made good, it will be found that there is no single artistic 'hearth', rather, individual cultures tended to progress simultaneously. In short, there were no inventors of 'civilization', whether in pre-Columbian America or in the Old World. We find, it is true, regions more favoured by nature where the establishment of agrarian societies was helped by climatic conditions. One example is the area adjoining the Gulf of Guayaquil, but here there are no differences of any significance between the northern (Ecuadorean) coast and the southern (Peruvian) coast.

An Attempt at Synthesis

We have already indicated that the object of our study is, as the title implies, art rather than archaeology. Consequently the reader will not find among the plates those early rudiments of pottery, products of an initial phase, which are often, in fact, no more than crudely decorated sherds of little aesthetic interest save perhaps to a narrow circle of specialists. Instead we have chosen to confine our illustrations to works of undoubted artistic merit.

Nor is it the aim of this book to provide an exhaustive account of the pre-Columbian products of the Andes. We have not hesitated to omit less representative styles in favour of an extensive selection of fine pieces exemplifying artistically gifted cultures such as the Vicús, the Mochica and the Nazca.

Bearing this in mind, we have sought to synthesize as much as is possible the whole body of information currently available without, however, entering into a discussion of those nuances or stylistic distinctions which bedevil the approach to a subject whose complexity is compounded by the very multiplicity of cultures it embraces. Thus, in our endeavour to retain an uncluttered canvas, even though this may involve sundry omissions, we shall pass over most of the categories prescribed by the specialists and pay little heed to the controversies that divide the various schools. In this way we hope to present a straightforward schema, a coherent clue to the labyrinth of societies, cultures and epochs which characterize the prehistory of the Andean civilizations.

Simplification does not necessarily imply distortion and, though we may keep to our brief and fight shy of the proliferation of archaeological categories, this does not mean that we shall omit all mention of more recent discoveries. Unlike an archaeological text-book, this work lays no claim to comprehensiveness and thus the reader will look in vain for an account of every individual phase within each individual period. Had we decided to provide examples of all such phases, region by region, we should have been compelled to discard works of the highest merit in order to accommodate less important pieces. Moreover, specialists are not always agreed—notably in the case of ceramics—as to what is or is not a distinguishing characteristic.

An excessive concern for typological and stylistic classification has often led archaeologists to adopt distinctions so fine as to be virtually useless. Thus in the case of the Paracas–Ica period, dubbed Ocucaje (after the name of a much excavated site), the single phase, known as Paracas–Cavernas, has been divided by Rowe, Menzel and Dawson, into ten subphases. These same authors have also subdivided the Nazca period, which occurred in the same archaeological area, into nine phases. Such subdivisions are, for the most part, based on subtle stylistic distinctions rather than on accepted chronological criteria.

Every specialist feels impelled to establish his own pet system of classification. For example the collector R. Larco Hoyle has divided the production of the great Mochica potters into five distinct phases, although the grounds on which he has done so are controversial, to say the least.

Any attempt in the present work to take account of these innumerable phases would be as otiose as would the endeavour to fill what are often substantial chronological gaps by imposing new criteria. Recourse to such classifications would, indeed, unduly encumber the text, for the nomen-

clature of the intermediate phases constitutes a jargon in its own right—
'Cerillos, Cerro de La Cruz, Animas, Teojate, Callango, Tajahuana, Cerro
Uhle' (to denote the Paracas styles), or again 'Proto–Nazca, Nazca–
Monumental, Nazca–Prolifero', or 'Vicús/Vicús, Vicús–Yecala, Vicús–
Negativo, Vicús–Anaranjado' and so forth and so on. None of these
terms are proper to a work which claims to be a synthesis.

The Running Sore of Andean Archaeology

In this volume we confront what is virtually an unknown world, for our
knowledge of the cultures concerned is even more exiguous than in the
case of the Mayas and Aztecs discussed in the two earlier volumes of our
trilogy. Indeed with the exception of the Inca civilization, which may be
described as proto-historic in that we possess eyewitness accounts written
by the Conquistadors and the Renaissance chroniclers, all the other
prehistoric societies of South America remain veiled in mysterious ano-
nymity. We know little or nothing of their language, their social systems,
their philosophico-religious concepts, their pantheons or their beliefs.
Nor do we know their provenance or by what means they succeeded in
supplanting and/or exterminating their predecessors.

Indeed our ignorance is complete save for what we may glean from the
archaeological discoveries made in this region. For since these peoples had
no writing, what little information we possess derives solely from material
witnesses.

An even graver disability is that archaeology itself should still be in its
infancy in a country like Peru, a country ravaged—and this right into our
own times—by generations of tomb robbers in search of gold and other
valuables for disposal on the profitable antique market. Since the time of
the Conquistadors the finest sites have been completely rummaged and
ransacked by innumerable *huaqueros,* or clandestine diggers. Even in the
twentieth century, self-styled archaeologists such as millionaire Peruvian
collectors do not hesitate to level entire burial-grounds with the aid of
bull-dozers. In this way they entirely destroy the stratigraphic evidence,
simply in order to fill their own store-rooms or private museums with a
multitude of objects which, deprived of all scientific context, become
impossible to date and illegible to scholars. While aware of these depreda-
tions, the government is, alas, too preoccupied with other matters to find
time for the preservation of the national heritage, with the result that
dozens of burial-grounds, including those at Moche and Paracas, have
been destroyed. Even at Vicús—discovered only sixty years ago—2,000
tombs have been pillaged yielding, it is true, some outstanding pieces, but
rendering scientific excavation well-nigh impossible. Only six or seven
samples taken *in situ* have given radiocarbon dates which, however, should
be treated with some scepticism. Nor are they representative of all the
phases of a culture which once existed on the borders of Ecuador and
Peru.

Four hundred and fifty years ago the greed for gold led to the excesses,
extortions and violence of the Conquest, to genocide and the annihilation
of an entire Indian culture. That greed is patently still at work, spurring
on the looters as they proceed to obliterate all trace of age-old civiliza-
tions.

The work of the art historian is not made any easier by this critical state of affairs. Moreover, the present sharp rise in the population, the rapid expansion of the coastal cities and the spontaneous growth of shanty-towns, many covering tens of square kilometres on sites previously occupied by prehistoric peoples, are gradually eliminating everything of archaeological interest. Again, lawlessness has actually penetrated to the very heart of the National Museum at Lima where, over the past few years, no less than 5,000 gold objects have been stolen, among them some of the finest and most celebrated pieces of this internationally renowned collection.

The fate of the region's pre-Columbian past is precarious in the extreme, threatened as it is, on the one hand, by the rich *hacienderos* who plunder the subsoil of their vast estates as though it was theirs by right and, on the other, by petty thieves who operate all over the country. Of the latter, some live in the hope of unearthing a piece they can sell in exchange for a mouthful of bread, others act on behalf of the big traffickers responsible for supplying the international art market with archaeological objects.

A handful of responsible archaeological expeditions can do little towards elucidating five millennia of an art that embraces thousands of sites and many different cultures scattered over a territory with a coast-line 2,500 kilometres long and with valleys lying at an altitude of 4,000 metres.

The catastrophic state of affairs obtaining in Peru does not necessarily extend to all the other countries of the Andes. Bolivia, however, is in the hands of a single archaeologist who has monopolized research, has for years refused to open the museum at La Paz, and has virtually excluded foreign expeditions. Moreover, he has also been responsible for a number of grandiose restorations, more in the Hollywood style of Arthur Evans than of a faithful 'copyist'. Ecuador, on the other hand, would seem to have escaped from the ills that beset archaeology elsewhere in South America. The museums are efficiently run and the excavations responsibly conducted, while national and foreign teams of archaeologists are actively engaged in uncovering a past of the utmost importance in what now proves to have been the very hearth of the artistic activity of the New World.

The Amazon basin, on the other hand, that immense and intractable stretch of country, has only just begun to emerge from the shadows. During the past fifteen years attempts have been made to accord it its due, not only as the reservoir of the peoples who colonized, first the high Andean plateaux and then the coastal desert, but also as the birthplace of agriculture which, with the domestication of plants, revolutionized the early existence of Neolithic man. Yet these vast green spaces, permanently steeped in humidity, do not readily lend themselves to archaeological investigation. Here, organic remains cannot survive as they do in the deserts of the Pacific littoral, while traces of human habitation are quickly obliterated by the untamed exuberance of nature.

Today, however, students are posing the question as to whether the 'green hell', as the virgin forest of the Amazon is sometimes known, was not, after all, a 'green paradise' whence a succession of tribes, yielding to demographic pressure, set off to colonize, first the highlands and, later, the Pacific sea-board where they laid the foundations of what was to become the pre-Columbian culture.

Now these regions, though of prime interest, have received little or no attention from archaeologists to whom they are largely unknown territory. Only a few specialists such as G. Reichel-Dolmatoff and Donald Lathrap have ventured to stress the urgency of the problem.

The gaps are clearly considerable and there is every likelihood that more than one question will long remain unanswered. Moreover, we should never lose sight of the flimsiness of the theories now finding acceptance and which seek to explain the peoples and societies responsible for the objects we shall presently discuss. Again, the advances in our knowledge, albeit fragmentary, of the pre-Columbian world, have been so rapid that, with a few rare exceptions, works on the subject are being superseded at an alarming rate. Virtually everything published before 1960 is now out of date. True, we must still take account of the discoveries of some of the great pioneers—Uhle, Tello, and Bennett, for instance—but their interpretations, often cited almost parrot-fashion, are now so old as to run the risk of invalidation by more recent discoveries which may well throw an entirely new light upon previously accepted tenets.

Thus, to an extent unparalleled elsewhere in archaeology and the history of art, the pre-Columbian world of South America is in a state of flux, of full-scale evolution, and hence subject to agonizing reappraisal. Stimulating though this may be to the study of the subject, they also remind us that such knowledge as we possess is only just beginning to take shape and that several decades will have to go by before sufficient progress has been made to provide a reasonably reliable body of information.

It is in this context alone that any meaning can attach to what is a purely provisional assessment of the works handed down to us by the pre-Columbian artists of the Andes.

I. Background, Population and Technological Achievements

If we are to understand the appearance in South America of the first cultures to command a means of artistic expression, a brief account must be given of the background, environment and resources of those prehistoric societies and, more particularly, of the stages by which the continent came to be populated.

Geography of the Andean Countries

In few parts of the world does the physical environment present such violent, abrupt and extreme contrasts as in the Andes. The reliefs betray, geologically speaking, a new country whose exeptional climatic conditions were to exert a profound influence on the lives of its inhabitants. The emergence of civilization was largely dependent on that environment, the peculiar structure of which engendered a strongly differentiated landscape. While not the sole determinant of human evolution, geography does in fact go a long way towards explaining history, for it conditions not only the resources but the very forms of life.

The Andes range, rising in places to almost 7,000 metres, extends for more than 8,000 kilometres along the western side of the continent, from Central America to Tierra del Fuego. Between Ecuador and Chile the coast is almost entirely arid owing to the virtual absence of rain. This vast desert is separated by valleys of no great length, almost all of them now dry. Only a very few can boast permanent rivers which bring life-giving water from the eternal snows above.

Much of the Cordillera is divided into two or three chains separated by valleys, many of them deep-cut, and by high plateaux. In the tropical zone the eastern slopes are bounded by the great Amazon forest. Further to the south, on the Bolivian-Argentine borders, lie the vast grassy plains of the pampas. Between the various chains (Cordillera Oriental and Occidental, Cordillera Negra and Cordillera Blanca, etc.) the valleys yield, in the south of Peru and in Bolivia, to the vast expanse of the *puna,* some 4,000 metres above sea-level. The only vegetation on these high plateaux is a wiry grass known as *ichu* (*Stipa ichu*). As it descends towards Chile, the *puna* gradually gives way to arid land of which the Atacamá Desert forms a part.

Between the Pacific Coast and the Amazon forest this formidable system of mountains is never more than 750 kilometres wide. Towering over the western sea-board of the continent, this narrow barrier several thousand kilometres long commands an ocean with deeps going down to several thousand metres. As pointed out in our introduction, this con-

torted terrain was the home of most of the high civilizations of South America. Situated in the southern hemisphere between Colombia and Chile it straddles some 22° of latitude, representing a distance of about 2,500 kilometres from north to south.

The territory covered by this zone is roughly the same as that occupied in its heyday by the Inca empire which, however, also comprised a narrow tract of country, some 1,500 kilometres long, between Arica and Santiago in present-day Chile. However, the contributions made by this latter region in terms of art are scarcely worthy of mention.

As we have already seen, the arid coastal strip is virtually deprived of rainfall, a circumstance attributable to two constant factors which determine the climate peculiar to the region. The first is the barrier presented by the Andes to the prevailing ocean winds which sweep across the continent from east to west. The clouds gathered by these winds while over the Atlantic are forced upwards by the Cordilleras, so that the moisture they carry precipitates in the form of rain, most of which falls on the eastern slopes of the range.

The second factor is the Humboldt current. Flowing from the Antarctic in a north-easterly direction, it bathes the whole of the coast from Chile to Ecuador with its cold waters whose temperature, exceptionally low for these tropical latitudes, fluctuates between 13°C and 16°C.

The Humboldt is responsible for a number of curious climatic phenomena, affecting the whole of the Peruvian littoral. For it lowers what, in such latitudes, would otherwise be a very high air temperature. In its turn this cold air encourages the formation of mist which causes an even greater drop in temperature and deprives the land of sunlight for days or weeks on end, according to season. Temperatures in the region rarely exceed 18°C. The moisture in the air (humidity may be as high as 90 per cent) is not precipitated in the form of rain, for the air, instead of cooling as it rises, is reheated by the sun at about 1,000 metres, where it is no longer subject to the action of the sea, a process known to meteorologists as an inversion. Nothing, save a fine drizzle, the *garua*, falls upon the coast which is wholly arid save when irrigated by the few rivers flowing down from the Andean peaks. Indeed, nearly all the rain that falls on the Andes is carried back to the Atlantic along the courses of great rivers such as the Orinoco, the Marañón and the Amazon. Such little rainfall as reaches the western slopes makes its way down the all too infrequent watercourses to create habitable oases on the Pacific coast. The full extent of the difference between the eastern and western slopes of the Andes becomes evident if we compare the Amazon, with a course of 7,000 kilometres and a greater volume of water than any other in the world, to the Río Santa in Peru, the country's largest watercourse, which is 200 kilometres long with a volume of water no greater than that of the average European river.

The only exception is the Gulf of Guayaquil in Ecuador, into which large amounts of water are discharged by the Río Guayas, fed in its turn by the tropical rainfall in the wide plain beween the Pacific Ocean and the Cordillera. The region owes its warmth and humidity to the fact that the Humboldt current is deflected from the coast by a warm equatorial current flowing in a southerly direction. Thus, the closer one gets to the Colombian border, the higher the rainfall and the more favourable the ecological conditions to the emergence of societies which, indeed, developed earlier here than elsewhere on the Pacific coast. For the barren

nature of most of that region meant that high cultures could not flourish without the aid of advanced hydrological techniques and forms of artificial irrigation which in turn posited the existence of a centralized political authority.

In fact, very few of the Peruvian rivers are worthy of the name, no more than nine out of fifty-six valleys being watered by permanent streams. Between these circumscribed localities capable of supporting agriculture, the barriers presented by the vast deserts of the Peruvian coast long served to hamper intercourse between neighbouring valleys. The rivers, on the other hand, fostered the growth of cultural entities along their banks, in highlands and lowlands alike. It was not until later that confederations came into being which incorporated several such societies into larger territorial units, thereby imposing some degree of homogeneity on the various regional styles.

Each of the little rivers of the Peruvian coastal strip (from north to south they include the Chira, Piura, Lambayeque, Jequetepeque, Chicama, Moche, Viru, Nepeña, Casma, Pativilca, Supe, Chancay, Rimac, Lurín, Cañete and Pisco) runs roughly at right angles to the coast. Thus on their way to the irrigated areas of the plain they flow briefly through the highlands where communities, living in symbiosis with the inhabitants of the coastal cities, first put down their roots. But the Andean valleys most congenial to the pre-Columbian societies were those which run parallel to the Cordillera, for example, the Santa which forms the Callejón de Huaylas, the upper Marañón, the Apurimac and Urubamba. Deep-cut though many of these valleys are, an extensive system of terraces and embankments enabled them to give birth to cultures of great richness, one of the most notable being that of Chavín (between Santa and Marañón).

Turning now to the southern highlands we find, 4,000 metres above sea-level, the immense basin of the freshwater Lake Titicaca, a different and very specific kind of ecological entity, without any outlet to the sea. Here, too, there arose an original culture, that of Tiahuanaco, which, well before the end of the first millennium A.D., may have achieved the remarkable feat of unifying the pre-Columbian Andean world.

Such, then, is the nature of the geographical region which saw the development of the pre-Colombian societies of the Andean world—a world which comprises within itself elements of the most disparate kind: not only the Amazonian jungle, but coastal deserts of rock and sand bathed by waters reputed to be the richest fishing-grounds in the world and dotted with islands inhabited by eared seals, sea-lions and cormorants; not only the *puna* with its vast horizons, but also deep-cut valleys dominated by the awesome peaks of the Cordillera; not only the lakes of the altiplano, but rivers, alltoo infrequent, whose short if fertile lower reaches support palm-trees and tropical fruits. A region, then, of extreme contrasts and one of the most original chapters in the history of mankind.

Population of the Americas

Various answers have been given to the question of how the American continent came to be peopled, yet fresh hypotheses are continually being put forward in response to new developments. It is therefore a question to which we must again revert. In *Art of the Aztecs* we assigned a date of about 25,000 B.C. to the arrival in America of tribes who made their way

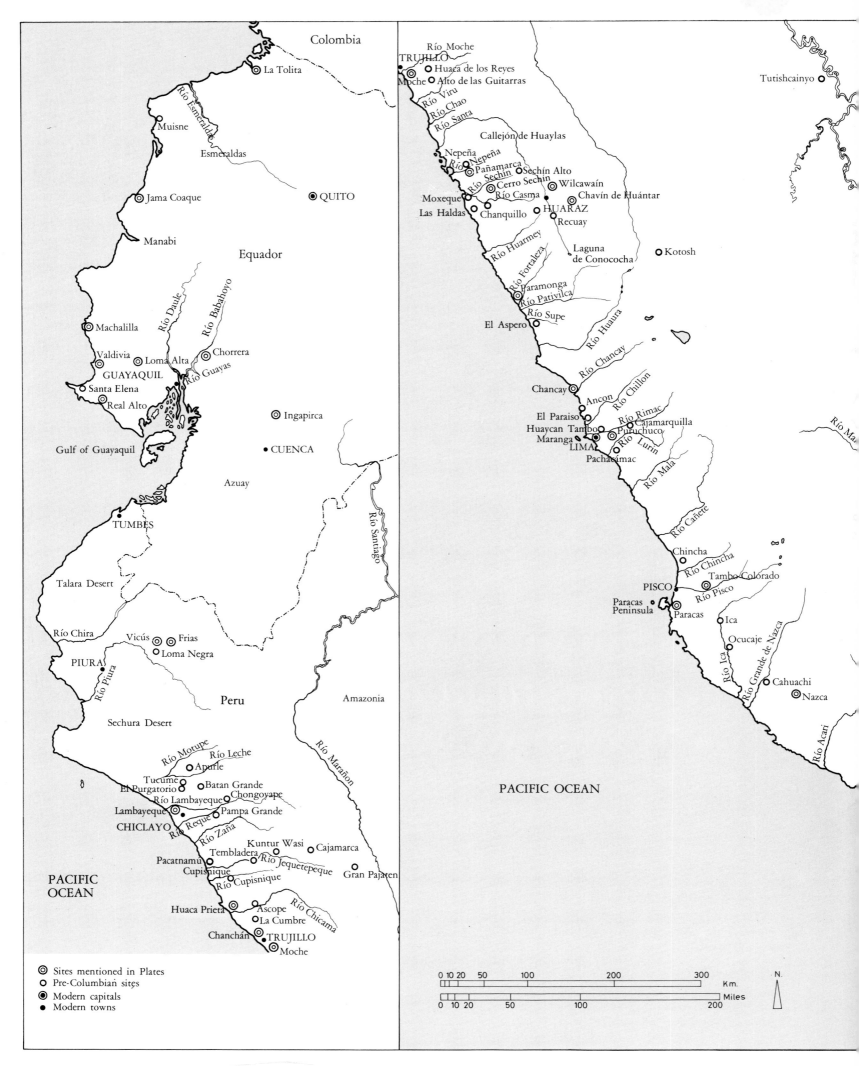

Colombia

La Tolita

Muisne

Esmeraldas

QUITO

Jama Coaque

Manabi

Equador

Río Daule

Río Babahoyo

Machalilla

Valdivia Loma Alta Chorrera

GUAYAQUIL Río Guayas

Santa Elena

Real Alto

Ingapirca

Gulf of Guayaquil

Azuay

• CUENCA

TUMBES

Río Santiago

Talara Desert

Río Chira

Peru

Amazonia

Vicús Frias

Loma Negra

PIURA

Río Piura

Sechura Desert

Río Marañon

Río Motupe Río Leche

Apurle

Tucume Batan Grande

El Purgatorio Chongoyape

Río Lambayeque Pampa Grande

Lambayeque

CHICLAYO Reque

Río Zaña

Kuntur Wasi Cajamarca

Tembladera

Pacatnamú Río Jequetepeque

Cupisnique Gran Pajaten

Río Cupisnique

Huaca Prieta Ascope

La Cumbre Río Chicama

Chanchán TRUJILLO

Moche

PACIFIC
OCEAN

Río Moche

TRUJILLO Huaca de los Reyes

Moche Alto de las Guitarras

Río Virú

Río Chao

Río Santa

Callejón de Huaylas

Nepeña Nepeña

Río Pañamarca

Sechín Sechín Alto

Cerro Sechín

Moxeque Río Casma Wilcawaín

Las Haldas Chanquillo Chavín de Huántar

HUARAZ

Recuay

Río Huarmey

Laguna
de Conococha Kotosh

Río Fortaleza

Paramonga

Río Pativilca

Río Supe

El Aspero

Río Huaura

Río Chancay

Chancay

Ancon Río Chillon

El Paraiso Río Rimac

Huaycan Tambo Cajamarquilla

Maranga Puruchuco

LIMA Río Lurin

Pachacámac

Río Mala

Río Cañete

Chincha

Río Chincha

Tambo Colorado

PISCO Río Pisco

Paracas
Peninsula Paracas

Ica

Ocucaje

Cahuachi

Nazca

Tutishcaínyo

Río Ma

Río Ica

Río Grande de Nazca

Río Acari

PACIFIC OCEAN

◎ Sites mentioned in Plates
○ Pre-Columbian sites
◉ Modern capitals
● Modern towns

0 10 20 50 100 200 300
 Km.
0 10 20 50 100 200
 Miles

N.

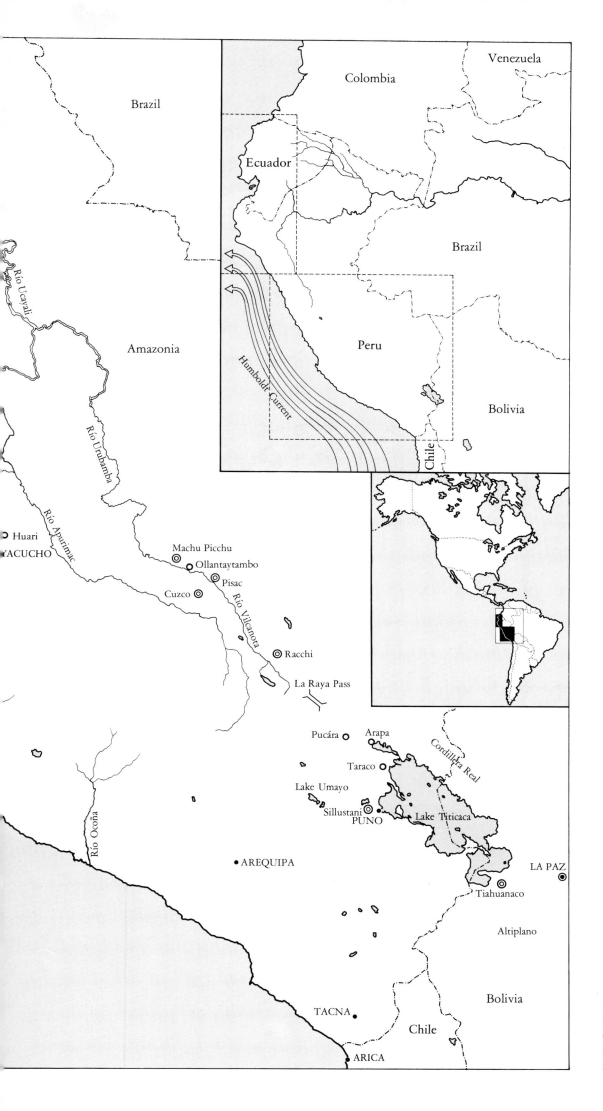

Map of Ancient Peru, including Ecuador, present-day Peru and western Bolivia, with the principal sites mentioned in the text.

21

from Asia by way of the Bering Strait during the last Glacial epoch (the Greater Wisconsin). Now, however, it is possible to be rather more specific.

Though sea-borne migrations at an early period have often been posited, the population of the American continent is still believed to have been effected by successive waves of Asiatic tribes entering by way of the Bering Strait. Today, however, some writers envisage even earlier movements, as much as 30,000 or 33,000 years ago (during the cold Konoshelskoye oscillation). Furthermore, it is postulated that if migration took place almost insensibly, as the nomadic hunters crossed the Great Ice Barrier between eastern Siberia and Alaska in pursuit of seals, the same phenomenon may have occurred during the later glaciations, when the two continents were not yet separated by water.

Here it might be pertinent to summarize the views held by J. Kozlowski and H. G. Bandi on the basis of recent research. During the great glacial periods vast masses of water built up at the Poles in the form of ice, the result being that the level of the world's oceans fell by 80 to 100 metres. Today the depth of the Bering Strait is nowhere greater than the last-named figure, which means that at one time a land bridge existed between the two continents. However, at the end of the cold periods the peripheral ice was the first to retreat, transforming the land into tundra where nomadic hunters pursued their prey, probably reindeer, while passing from one continent to the other. According to the authors this movement took place in several waves during the cold (or pleniglacial) phases of the European Würm period, which, in America, are known as the Wisconsin and the Woodford (between 22,000 and 10,000 B.C.).

From existing indications it may, therefore, safely be concluded that the first wave of migrants arrived some 22,000 years ago during the Early Woodford. They were followed by a second wave some 9,000 years later and, within the next three millennia, by a third. The climate then grew milder, so that the isthmus between the two continents became submerged. And by the time agriculture first made its appearance, all migration had ceased.

However, in his book *Valdivia,* Peter Baumann discusses another theory, first put forward by R. Fester, to the effect that, even before the migrations of Asiatic tribes had come to an end, a 'Caucasian' people had crossed the ice barrier from the Kola Peninsula in northern Europe to make their way, via Spitsbergen and Greenland, to Alaska. Such a migration would, it seems, alone provide an answer to certain questions of palaeolinguistics and human biology (the blood properties of some Amazonian tribes have a positive 'Diego factor').

But the arrival in Alaska of prehistoric tribes, whether from eastern Asia or from northern Europe, does not necessarily imply their penetration of South America. However, the populations of the two Americas, North and South, were of common origin. Thus some of the tribes must have undertaken a long and arduous march through widely differing climates and regions before arriving at the southern tip of the continent.

In 1930 J. Bird discovered human remains in caves near the Strait of Magellan. These bones, together with those of the American horse (much smaller than the European or Asian horse, it became extinct in 5500 B.C.), have been assigned by radiocarbon datings to 6600 B.C. and hence are no more than 8,700 years old. In Chile the burnt skeletal remains of mastodons found along with shaped stones may be assigned to about 9400 B.C.,

1 Terracotta figurine from Manabi province, Ecuador. Valdivia style, Phase 6, about 1800 B.C. Probably a fertility goddess. That no attempt has been made at realism is evident from the stylized features, the schematic appearance of the hair and arms, the summary treatment of the eyes and the massive yet severe contours. The combination of hollow head and solid body is indicative of an already advanced technique. Height 12 cm. Museo del Banco Central, Guayaquil.

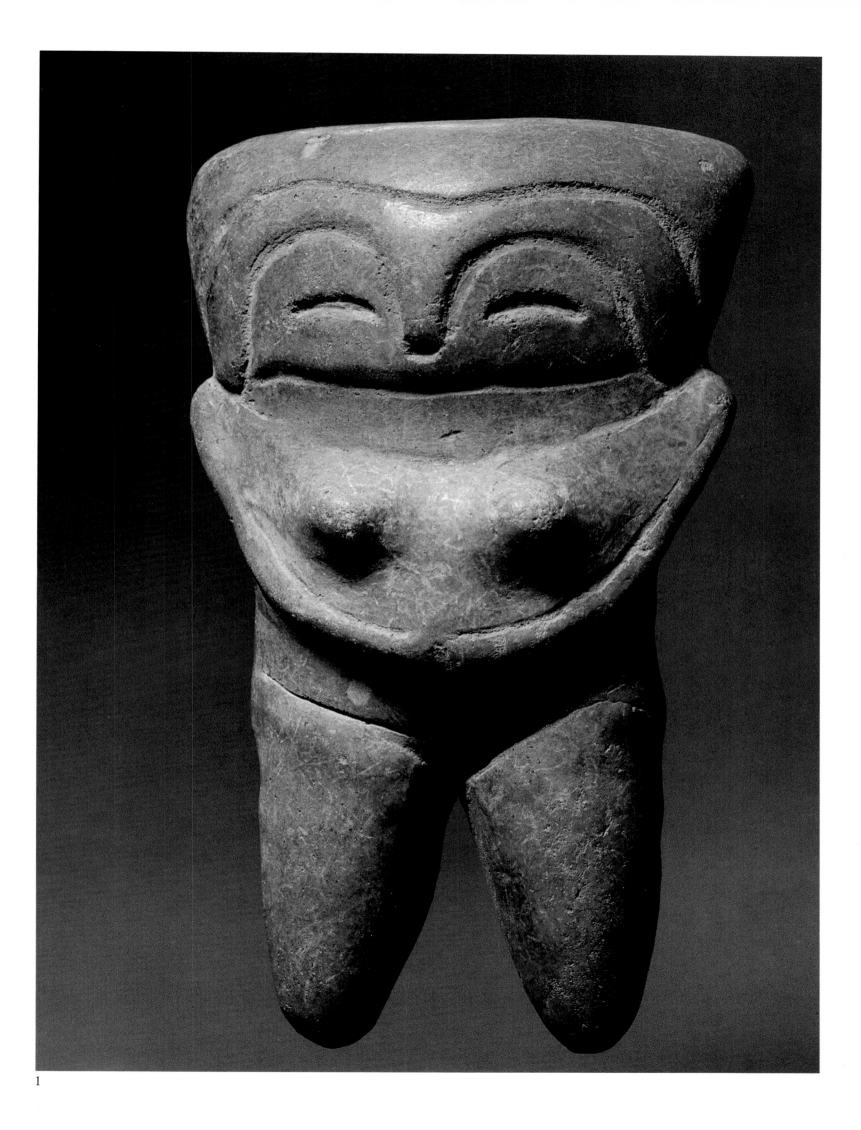

1

while similar discoveries in Venezuela may go back as far as 12700 or even 14900 B.C. Thus, according to existing scientific evidence, man's presence in South America cannot be posited before 15000 B.C.

For many millennia, therefore, the life of the early inhabitants of the New World corresponded to that of Upper Palaeolithic man; like their fellows in Europe and Asia they engaged in hunting, fishing and food-gathering. During the glacial or warmer phases, the tribes followed the migrations of the wild herds upon which they largely depended for their subsistence. However, the extinction of some of these creatures (such as the American horse, the mastodon, the early bison and the megatherium) forced these people to change their mode of existence and adapt themselves to the new conditions. Those in the vicinity of rivers or the sea became adept in the art of catching fish and crustacea, while the inhabitants of the great alluvial plains of the tropics gradually progressed from food-gathering to a rudimentary form of horticulture by learning from patient observation how to adapt and domesticate food plants. Thus, by a process of hybridization and selection they succeeded in so modifying wild species of plants as to render them capable of cultivation.

This process, which must have extended over millennia after its inception 7,000 years ago, has its Old World parallel in the Neolithic revolution, a phase Americanists prefer to describe as Formative by reason of the virtual absence of polished stone implements in the New World. We have yet to discover where this profound change had its beginnings and what brought about the radical transformation that enabled man to pass from a nomadic existence to that of a sedentary cultivator. Of one thing, however, we may be sure: the revolution took place in America independently of any external influence, for after about 10000 B.C. the movement of populations from one continent to another came to an end.

The Growth of Agriculture

While there is no consensus as to the type of locality in which agriculture first appeared on the South American continent, many specialists have come down in a favour of the arid or semi-arid regions, an opinion based on the large number of remains uncovered there, especially on the Peruvian littoral. It might be argued that such proof is dependent not so much on the priority of those remains as on their state of preservation.

Donald W. Lathrap, on the other hand, has shown that the damp and humid areas of the tropics must have been favourable to the growth of agriculture. The experience gained by prehistoric man on this highly fertile land would, in time, have been transmitted to the semi-arid, and then, with the coming of artificial irrigation, to the arid regions.

Those who have looked to the humid tropical zones in their search for the antecedents of agriculture have adopted a rigorously scientific approach. The findings of O. Sauer, P. Mangelsdorf and D. H. Harris reveal a large measure of agreement and have been confirmed by excavations carried out in South-East Asia and in America. G. Reichel-Dolmatoff in the Amazon region of Colombia and Michael Coe in the Olmec country have both succeeded in demonstrating that this theory is archaeologically correct.

According to these specialists, and in particular Betty Meggers, the Holocene phase (7000 B.C. to the beginning of our era) comprised dry, cool periods, not only in the north, but also in the temperate and tropical

regions. The droughts that occurred in the tropical latitudes towards the end of the fifth millennium and again in about 3000 B.C. profoundly modified the plant life of these zones, notably that of the Amazon basin.

This region, now covered with virgin forest, then consisted of immense savannahs where man could settle without fear of being overrun by a luxuriant vegetation. It was therefore in the savannah country at the heart of Amazonia that societies in process of becoming sedentary sought a refuge. And it was here too that the domestication of plants began which, by the fourth and third millennia B.C., gave rise to an intensive form of agriculture in plains subject to seasonal inundation.

In due course, increasing rainfall, coinciding with a warmer phase, led to a progressive contraction of the areas capable of cultivation. According to Lathrap, Amazonia then became the scene of incessant struggles between Indian tribes who, faced with the inexorable advance of the jungle, left their ever-dwindling habitat and set off in search of other lands more hospitable to their primitive agriculture. Scaling the Cordilleran massif by way of river-banks, they eventually reached the Pacific coast where they proceeded to disseminate the knowledge of agriculture they had acquired. These, then, were the peoples who helped to bring into being the prehistoric cultures, witnesses of which we encounter at Valdivia. Here, in the alluvial plain irrigated by the Río Guayas, the tribesmen found in Ecuador an environment not unlike that of their place of origin. Again, it was they who subsequently created religious centres such as Kotosh and Chavín in the valleys of Peru.

As we have seen, this thesis, which sees agriculture as originating in a humid, tropical environment, also postulates radical changes in the nature of the Amazonian vegetation, changes which accord with the argument put forward in our book *Art of the Maya* in connection with the canals dug in the Petén basin to drain off surplus rain-water. There, too, the virgin forest was not as extensive as it is today, much of the room it now occupies being taken up by savannah or grassland in which agriculture was first introduced by the Mayas some 3,000 or 4,000 years ago.

Thus it will be seen that, wherever virgin forest now covers the lowlands, there must once have existed, during a dry phase, regions in which man did not have to contend with the surrounding vegetation. With the advent of a more humid phase the Mayas sought to preserve their fertile ground by building a remarkable system of drainage canals.

In Amazonia, on the other hand, where climatic changes must have occurred at a somewhat earlier date, the agrarian societies were not yet sufficiently organized to be able to contend in this way with the encroachment of the forest. As we have seen, their only recourse was to abandon their homes and go in search of more favourable territories.

If, then, we assume that Amazonia was the cradle of South American agriculture, it follows that the whole course of pre-Columbian civilization in the north, as in the south, must have been affected by this circumstance. For it seems highly probable that the movement of peoples in search of fresh territory was directed, not only towards the Cordillera, the Ecuadorean plain and the Pacific coast, but also towards the Isthmus of Panama and Mesoamerica.

Again, most of the plants cultivated by the pre-Columbians of the Andean region were of tropical origin, as were the myths and principal deities—cayman (alligator), jaguar, monkey and serpent—which would later make their appearance among the cultures of the high valleys.

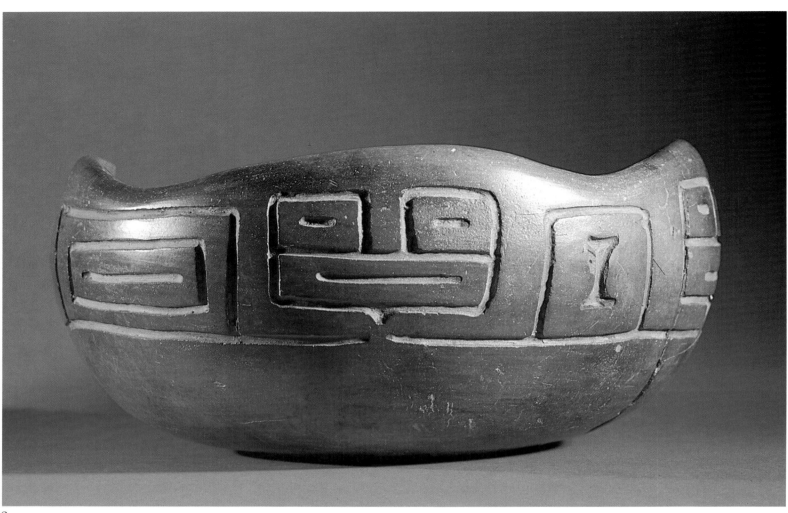

2

3

While on the subject of agriculture we might add that, implicit in the domestication of plants was the domestication of man himself. By increasing their yield he achieved a greater measure of self-sufficiency than he could when his only recourse was to the expedients of hunting and gathering. The resulting demographic growth bound the cultivator more closely to his holding. For in order to feed these extra mouths, more land must be brought under cultivation and its yield increased by incessant labour in the shape of irrigation or drainage, fertilization, the husbanding of reserves of seed, and so forth.

Man, then, having domesticated the plant, became a slave to the service he must render it if he was to survive. It was a symbiosis without which neither would be able to exist. He had become a cultivator in the full sense of the term, dependent as he was on the food plants he had brought into being by selection. Thereafter most of his sustenance was to come from what he produced in the fields, while activities such as hunting and fishing were relegated to second place. Though still valuable sources of protein, they were no longer necessary to the survival of the group.

The prime concern of the cultivator was to watch over his fields and to protect the crops which alone enabled him to make provision against a poor season. Thenceforward he was immobilized, unable to wander for fear of being despoiled of the fruits of his labours. Thus he had become sedentary, with all that that implied. For he now proceeded to accumulate equipment, improve his surroundings and increase his store of material goods—in short, to create circumstances propitious to the emergence of the decorative arts and of architecture.

Resources and Deficiencies of the Andean Peoples

The societies of South America present something of a problem when we come to study the history of their art. Before tracing the stages of their development, therefore, it would seem pertinent to consider what these peoples possessed in the matter of resources and what they lacked.

Among the useful plants they cultivated we might cite several species of tuber—sweet potato, achira, manioc and ground-nut—as well as cereals and pulses such as maize, beans, amaranthus and quinoa. Fruits included the tomato, pineapple, guava, pomegranate, papaya, avocado and gourd, while the pimento or *aji* was everywhere used for seasoning. Cotton fibres were known even before the discovery of ceramics, as was bast made from reeds and cacti, though this is no longer in use today. Finally, mention might be made of medicinal plants, both cultivated and wild, such as coca and tobacco, in addition to a multitude of herbs in the employment of which empiricism was admixed with magic.

By comparison with the Old World, the Andean peoples had very few domestic animals. However, they were better-off than their Mesoamerican contemporaries in that, as early as the third millennium B.C., they possessed two species of *Camelidae,* the llama and the alpaca, which provided them with a source of wool, leather and much-coveted meat. In addition, the llama could serve as a beast of burden, though unable to carry loads very much in excess of 30 kilograms. Both of these natives of the high plateaux gradually adapted themselves to the climate of the lowlands.

Other household or farmyard animals possessed by the pre-Columbians of South America were the dog and the guinea-pig which they reared for

2 Bowl with undulating rim. Valdivia style, Phase 4, about 2100 B.C. Shaped like a section of a gourd, it is decorated with motifs in the form of highly stylized human heads. At Huaca Prieta, Peru, gourds have been found with similar pyrograved motifs. This fragment displays a truly remarkable confidence of line, as well as technical expertise in the treatment of burnished terracotta. Diameter 18.5 cm. Museo del Banco del Pacifico, Guayaquil.

3 Vessel from the Guayas Coast. Late Valdivia style, Phase 7–8, about 1650 B.C. Kaolin has been used to accentuate the incised geometric decoration of this concave-sided piece. Diameter 26.5 cm. Museo del Banco Central, Guayaquil.

their meat; also the duck, but not the turkey—so familiar among the Mexican peoples.

The wild animals they hunted included the puma, the jaguar, the peccary, several species of monkey, the sloth, the bear, the roebuck, the stag and two undomesticated *Camelidae*, the vicuña and the guanaco, as well as birds such as the quail, partridge, pigeon, duck and parrot.

Those who settled on the Pacific coast relied from the outset on fish, shell-fish and crustacea for their main source of nourishment. They also caught turtles, eared seals, sea-lions, cachalots and grampuses. Much favoured were the eggs of the countless sea-birds which nested on the cliffs and offshore islands, and whose excrement formed deposits of the natural fertilizer known as guano, a substance that has been used to manure the land since prehistoric times.

Among the mineral resources we should cite native gold, in the form of nuggets or dust, obtained by washing river sand. Metal-work first made its appearance between 500 and 300 B.C. in northern Peru and Ecuador, where both gold and silver were used in the manufacture of ornamental and ritual objects. Copper served the same purpose, and was also used in the manufacture of weapons and implements. In Ecuador, native platinum was worked by hammering but whether or not they were able to fuse it is not yet known, since a very high temperature (1755°C) is required by comparison with silver (960°C), gold (1064°C) and copper (1084°C). We should also mention that in South America these metals were in use long before Mesoamerica had mastered the same technology.

So rich are the geological resources of the Andean region that it would be difficult to enumerate the many varieties of stone employed in sculpture, tool-making and building. In the coastal areas adobe, or beaten earth, of which the Peruvians made sun-dried bricks or moulded elements, was soon supplemented by stone. Later the Incas, following in the footsteps of the Chavín and Tiahuanaco builders, were to prove especially adept in the use of hard stone, notably granite and quartzite, in masonry work.

We must close this brief survey of the resources of the Andean cultures by considering the deficiencies which they never succeeded in making good, even when at the height of their power. While in many cases such deficiencies lay in the actual absence from the South American continent of certain species of flora and fauna, they are attributable in others to surprising gaps in technological knowledge. Since deficiencies of this kind were in part responsible for the collapse of the pre-Columbian peoples when confronted by the invaders from the West, it would be pertinent to consider them in some details. They also show how diverse are the paths that man may follow in the course of his evolution, exerting, as they do, an influence on the spheres both of nature and of technology.

While the Andean peoples grew species of food plants unfamiliar to the Mediterranean and Asiatic civilizations, they had no knowledge of cereals such as rye, oats and barley. Similarly, the rice grown in South-East Asia was unknown here, which goes to show that immigration and external contacts had ceased by the time of the agrarian phase.

Their lack of animals such as the horse, ox, sheep and goat, was only partially compensated by the presence of domesticated *Camelidae*. In fact, the latter were suitable for use neither as mounts nor as beasts of burden and, since these creatures could not be milked, the population was denied the lactic products available to the pastoral communities of the Old World.

4 Terracotta statuette. Early Valdivia style, Phase 3, about 2300 B.C. This curious figure of a two-headed woman is probably symbolic of the dualist principle in nature. The coiffure is typical of this style. Height about 9.5 cm. Museo del Banco Central, Quito.

5 Terracotta statuette. Valdivia, about 2300 B.C. Rigidly frontal and symmetrical, this female figure, with her hands joined as if in prayer, displays a characteristic coiffure reminiscent of a wig. The treatment of the face is summary in the extreme. Height 9.2 cm. Museo del Banco Central, Quito.

6 Statuette. Valdivia, Phase 5, about 2000 B.C. The treatment of both face and coiffure is considerably more stylized than in the above piece, while the eyebrows assume as much importance as the eyes. The figure is coated with red slip. Height 9.8 cm. Museo del Banco del Pacífico, Guayaquil.

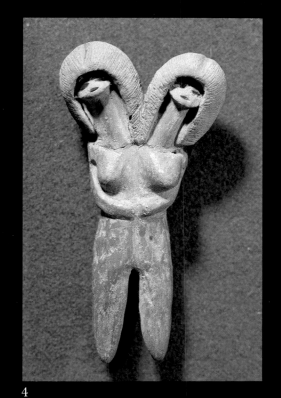

4

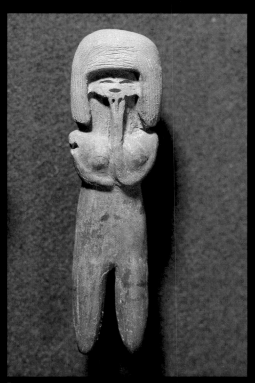

5

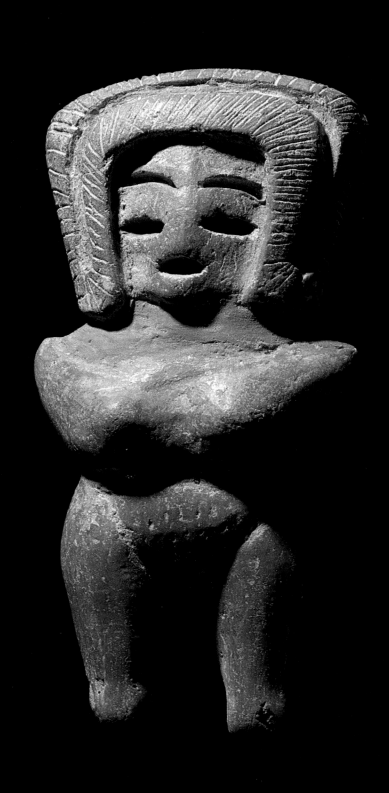

6

The deficiencies from which the Andean cultures suffered in the technological sphere were common to the pre-Columbians of Middle America. The absence of the wheel meant that Indians could not proceed faster than their legs could carry them. They possessed neither the potter's wheel, nor the ploughshare, nor any form of lifting gear, whether cranes, jacks, derricks or hoists; neither did they have aids to irrigation such as the Archimedes' screw nor the shadoof with its weighted beam. Moreover, iron was not used either for tools or for weapons, with the rare exception of meteorites which were worked by hammering.

The absence of vehicles, draught animals and mounts meant that transport by land remained at a primitive stage, being confined to litters (for persons), to portage and traction (for goods and materials) and to runners or *chasquis* (for messages). Transport by sea, though still rudimentary, was somewhat more efficient. The Pacific fishermen used a fragile craft consisting of bundles of reeds with tapering ends and dubbed *caballito de mar* or little sea-horse by the Conquistadors. Produce and manufactured goods were conveyed along the coast on rafts, some of which, at the time of the Incas, were as much as 20 metres long. Built of balsa trunks, they were remarkably buoyant and carried a sail, probably square. It would seem that they were unable to beat to windward and could only make progress when the wind was astern or on the quarter. These were the rafts which made possible the exchanges with Central and Mesoamerica and it was by these means that metallurgical techniques reached the coasts of what is now Mexico in about the ninth or tenth century A.D.

Finally, on the intellectual plane, the pre-Columbians of the Andes never progressed beyond one mnemonic system, a primitive means of calculation known as a *quipu* which enabled them to establish, by means of knots spaced at intervals along pieces of differently coloured string, the state of their stocks and stores or the results of a particular census. Their scientific and technological development was handicapped by the absence of writing, which also influenced their forms of expression. Unlike the Mayas, the Incas were never able to record in writing their myths, their dynastic history nor the knowledge they had acquired.

In short, the Andean societies, in spite of a few incursions into metalwork of a primarily religious or ornamental nature, barely passed beyond what would be described in the Old World as the Neolithic stage. Despite their spectacular achievements in the spheres of irrigation and road building, their impressive urban architecture and their elaborate social organization, the pre-Columbians belong essentially to prehistory. These men, whose often remarkable works of art elicit our admiration, lacked the natural endowments that would have enabled them to achieve a degree of technological development comparable to that attained by the ancient civilizations of Greece, Rome, Egypt, Babylon, China and India.

While the many deficiencies we have noted above may have been partly responsible for that shortcoming, it might equally be attributed to a different conception of progress, or indeed simply to a different rate of evolution. For, like the Inca empire on the eve of its collapse, the kingdoms whose heyday began in about A.D. 1000 were in the throes of change when the violent irruption of the Conquistadors put an end to all hope of future development.

In short, we shall discuss these general propositions which should help us to appreciate the originality of the pre-Columbian peoples of South America, and to understand their artistic achievements.

II. The Emergence of Civilization: from Valdivia to Chorrera

The studies, published in 1956 by the Ecuadorean archaeologist Emilio Estrada and in 1957 by the Americans Clifford Evans and Betty Meggers, disclosed the sensational information that the oldest pre-Columbian culture hitherto discovered lay concealed beneath the soil of Ecuador. For the pottery found on the Valdivia site antedated by two millennia the earliest terracotta objects ever discovered in Peru.

Surprised by this confrontation with a mysterious culture, specialists were forced drastically to reassess their previous findings in pre-Columbian archaeology. For the discovery of these artefacts dating back to the third, if not the fourth millennium B.C., revealed that, at a very early epoch corresponding to Sumer and pharaonic Egypt, considerable advances had already been made in America. Pieces more than 5,000 years old came to light in the early levels of coastal agglomerations and of riparian settlements in the Guayas basin, the hearth of the oldest American civilization.

Most of the information which emerged twenty years ago and so astonished the specialists, still remains valid today. But a number of fresh discoveries have now shown that the Ecuadorean sites are not the only ones to date back as far as 3000 or 3500 B.C. The archaeologist Reichel-Dolmatoff has brought to light quantities of pottery of equal antiquity, notably at Puerto Hormiga on the Caribbean shore of northern Colombia. He has thus shown that throughout the north-west of Amazonia there arose during the fourth millennium the earliest societies of cultivators and potters yet discovered in the New World.

The Case for Ecuador

Ecuador's past has opened a new chapter in archaeology. True, the geologist Geoffrey Bushnell had already found prehistoric remains in that country before World War II but, as we have already indicated, it is to the Ecuadorean specialist, Emilio Estrada, that credit is due for first drawing attention to the antiquity of the Valdivia site. Soon afterwards and in conjunction with his compatriots Carlos Z. Menendez and Presley Norton, he invited the American archaeologists Betty Meggers and Clifford Evans to examine his discoveries. Their article published in *American Antiquity* in 1957 set the seal of scientific approval on Valdivia. Subsequently these studies were taken even further by Henning Bishof, Olaf Holm and Donald W. Lathrap who succeeded in showing that this prehistoric society produced the earliest pre-Columbian pottery in the

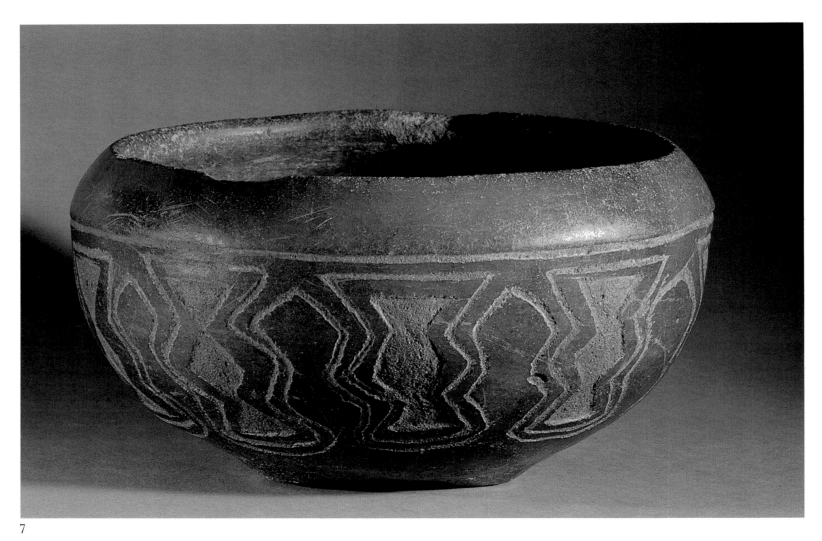

7

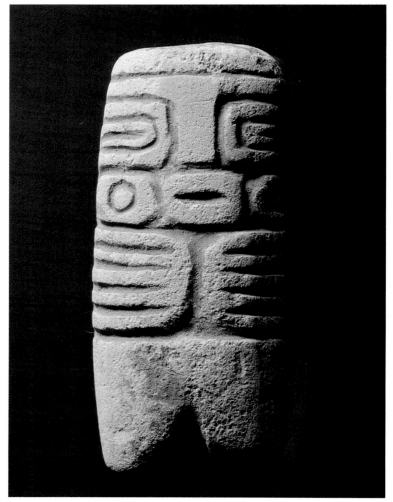

8

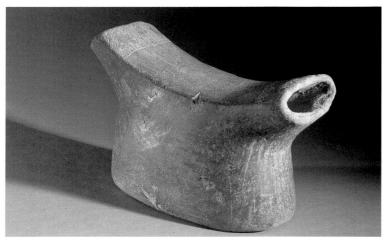

9

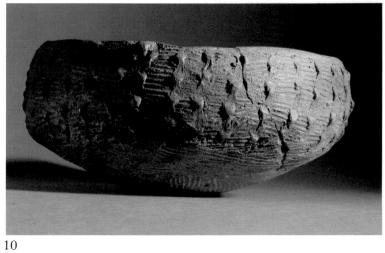

10

Andean region, and possessed a sophisticated urban organization in which religions, rites and sacrifices existed. Indeed Loma Alta, discovered in 1970 by Presley Norton, and Real Alto, excavated four years later by Lathrap, are two of the earliest ceremonial centres yet to have come to light in the New World.

As we have already pointed out, agriculture first appeared in the basin of the upper and middle Amazon whence a succession of early agrarian peoples were compelled to retreat before the encroaching tropical forest, its exuberant growth promoted by a new humid phase following the dry, cold one which probably occurred early in the fourth millennium. A glance at the map will show that the nearest coastal region capable of receiving these tribes was the Gulf of Guayaquil, a region which is, in fact, situated on exactly the same latitude as a vast expanse of savannah to the east of the Cordillera—one of the 'places of refuge' postulated by Betty Meggers. The fact that the primaeval forest grew excessively and the tribes fled from it was due to a new damp phase which came after a cold and dry period, probably about 4300 B.C. The tribes who made their way over the mountains must have found a congenial home in the Guayas Lowland with its alluvial plain irrigated by the seasonal inundation of its rivers. The conditions were much the same as those they had previously experienced in Amazonia, for the mountain barrier delayed the arrival of the heavy rains. Here the new-comers were not faced with the problems of altitude that would have assailed them in the high valleys of the Amazonian tributaries where they would also have had to adapt themselves to a climate and to types of cultivation to which they were not accustomed. Nor did they have to endure the terrible droughts that afflicted the Peruvian littoral, causing all but the permanent rivers to run dry. Thus, freed from the necessity of artificial irrigation with all that that implies in the way of canals and aqueducts as also of social organization, they were forced neither to contend with encroaching sand dunes, nor to adapt the methods of an embryonic agriculture to the *lomas,* a complex technique whereby sweet water was obtained from beneath the surface of the coastal strip. In short, the Ecuadorean plain presented an ideal environment for cultural expansion.

It is therefore in this region, lying between the pluvial fringes of Colombia and the coastal deserts of Peru, that the hearth of the Andean civilizations must have been located. Here, blessed by an ideal climate and favoured by the seasonal flooding of the rivers whose deposits fertilized the land, the Valdivia culture took root. And, as we shall see, it was to make its presence felt in the more southerly regions upon whose art it exerted a not inconsiderable influence.

Moreover, the tropical agrarian régime of the Guayas basin was compatible with a maritime economy which had probably been previously developed by riverine peoples during the pre-agrarian, pre-ceramic period. Indeed, when first discovered, the Valdivia site, which lies on the shores of the Pacific, was thought to be the creation of a society composed mainly of fishermen and shell-fish gatherers who engaged in horticulture simply as a side-line. For at the edge of the village, excavations have revealed huge middens consisting largely of the shells and skeletons of marine animals.

The uncovering of other sites similar to, and in many cases earlier than, Valdivia has revealed that the populations inhabiting the Guayas basin were primarily agrarian. That maize was cultivated there more than 6,000

7 Bowl from Clementina, Valdivia style, Phase 5, about 2000 B.C. The decoration is incised. Diameter 16 cm. Museo del Banco del Pacifico, Guayaquil.

8 Tiny archaic statuette from the Guayas coast. Early Valdivia style, Phase 2, 2400 B.C. Carved from grey volcanic rock, the sculpture is a remarkable example of geometric schematization. The two rings beneath the disproportionately large eyes and on either side of the fleshy mouth represent ear plugs. At waist-level, the five digits of each hand complete a composition based on horizontals and verticals and probably derived from weaving. Museo del Banco Central, Guayaquil.

9 A curious example of Valdivia (Phase 4) pottery, about 2100 B.C. This head-rest testifies to the early origins of an article commonly used by a number of pre-Columbian peoples and also found in ancient Egypt and South-East Asia. Width 17.5 cm. Museo del Banco del Pacifico, Guayaquil.

10 Bowl. Valdivia, Phase 6, about 1800 B.C. The exterior is so decorated as to resemble the skin of a fruit called *chirimoya.* Diameter 15.5 cm. Museo del Banco del Pacifico, Guayaquil.

years ago is apparent from the discovery on archaic sites of nether mill-stones or *metates*. Such finds are not, of course, conclusive, for it is perfectly possible that men of the pre-agrarian period used stones to grind the wild grain or bulbs they had gathered. But the *metates* dating from the early Valdivia period are so numerous that there is no longer any room for doubt.

Again, with the first appearance of ceramics we find pots bearing a series of decorative impressions effected with the aid of cobs from exceptionally large-grained maize. These impressions provide unmistakable proof of the progress already made in the development of food crops. Remains of the cobs embedded in the still malleable surface have enabled botanists to determine the variety successfully produced by the people of Valdivia. Indeed, the grains are appreciably larger than those of the plants grown by the Mexicans several hundred years later. In Real Alto these gigantic grains, the selection of which must have required centuries if not millennia, may be seen on pottery dating back to about 2300 B.C. The maize discovered on this site originated from early varieties grown in Amazonia.

Thus the Valdivia people, who were once thought to have been dependent on the gathering of shell-fish for their sustenance, are now known to have belonged to an agrarian society settled in the Guayas basin and delta. These cultivators did, however, complement their normal diet with seafood, thus obtaining the required amount of protein.

Appearance of Ceramics

The pottery mentioned above whose decoration provides evidence of the cultivation of maize, also represents one of the earliest manifestations of pre-Columbian art. Moreover, these artefacts supply us with our first key to the aesthetic aspirations of the Andean peoples. For in America there would appear to be no trace of any Paleolithic remains—cave paintings, bone carvings, ivories and the like—which, in the West, have enabled us to assign the emergence of art to some time around 25000 B.C. Hence we can only regard pre-Columbian art as having begun with the earliest examples of decorated pottery found by archaeologists, and Valdivia as the most ancient and active artistic centre of the Andean region. Indeed, the Valdivia potters were the first representatives of an uninterrupted succession of creative artists whose works mark the course of South America's aesthetic evolution.

The pottery of Valdivia has been subdivided by the American Betsy Hill into eight phases, running from 2600 to 1500 B.C. These in turn were preceded by the discoveries made at Loma Alta, which go back to 3100 B.C. Even more recent excavations at Real Alto suggest that the Valdivia culture began in about 3550 B.C.

From the expertise displayed in the earliest pieces, it is plain that they are very far from being the first halting manifestations of the potter's art. Not only must their origins go back very much further, they also belong elsewhere. Whatever the case, these dates reveal that, in Ecuador, the 'Formative' era (agriculture and ceramics) antedates a comparable stage in Peru and Mesoamerica by some 2,000 years.

Worthy of closer consideration are the forms, decoration and materials employed by the Valdivia potters. The paste is monochrome, its tone

11 Figurine from Barcelona, Ecuador. Machalilla period, between 1500 and 1100 B.C. In this summarily stylized piece, the nose and eyelids are in relief and no longer incised, as in Valdivia pottery. Height 12.9 cm. Museo del Banco del Pacifico, Guayaquil.

12 Vessel from San Isidro, Manabi. Machalilla, about 1300 B.C. The importance of this piece to the history of pre-Columbian Andean art lies in the fact that it is one of the earliest examples of a stirrup spout. Anthropomorphic motifs round the neck anticipate the Peruvian portrait vessel. Height 18 cm. Museo del Banco Central, Guayaquil.

13 Hollow figurine from Muisne, Esmeraldas. Machalilla style. The body of this grotesque seated man is adorned with red paint, while the edges of his ears and his lower lip display perforations. On his head he wears a hat. Height 12 cm. Museo del Banco del Pacifico, Guayaquil.

14 Hollow Machalilla style figurine from Muisne, Esmeraldas. Here, too, we find perforations similar to those of other anthropomorphic effigies. Height 20 cm. Museo del Banco del Pacifico, Guayaquil.

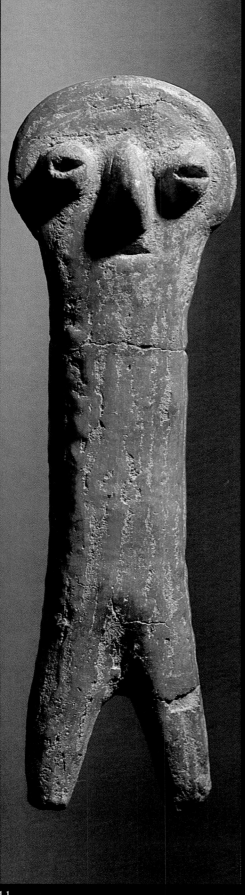

11

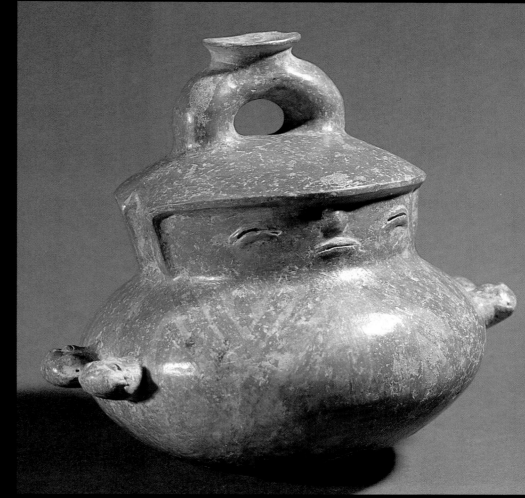

12

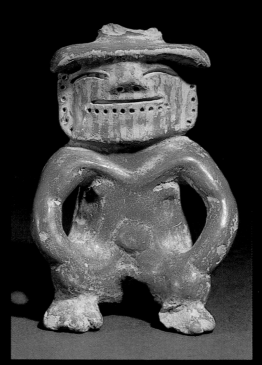

13

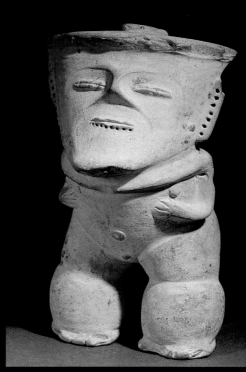

14

ranging from greyish-buff to dark chocolate. Since the pots are somewhat thick and not always thoroughly fired they tend to be friable. In fact this is a primitive form of terracotta, the surface of which, in the best examples, lends itself reasonably well to smoothing if not polishing. It is of medium grain, neither excessively coarse nor very fine, and indicative of a fairly advanced technique. For here we find none of the unrefined materials that characterize products of a more tentative nature.

The treatment of the surface is interesting, for even in the earliest phase use is already made of an even coating of lamp-black to give a fine lustre to this ware. Again as far back as Loma Alta we find pieces decorated with red slip, a rendering of iron oxide applied before firing. This process is yet another indication of genuine expertise, as also of a certain grasp of the problems involved in the application of heat.

Here, as elsewhere in the pre-Columbian world, pottery was produced without the aid of the wheel, a device which, as we have already pointed out, was unknown to the Indians prior to the arrival of the Conquistadors. Instead, the pieces were either coiled or hand-moulded. A wide variety of types is apparent from the outset: bowls, cups, dishes, jars and cooking pots, as well as head-rests—an Amazonian tradition—and human figurines. In the case of vessels, these forms would seem to reflect a purely utilitarian concern, corresponding as they do to well-defined functions. Some derive from the gourd which served similar purposes in the pre-ceramic era. Indeed, the underside of some cups and plates reveals an indentation not unlike that found in the gourd at its base.

The gourd, one of the earliest plants to be cultivated by man, could be turned into a variety of receptacles, a bowl, shallow or deep according to whether the cut was made a few centimetres above the base or at the point of greatest girth. Again a bottle or a necked jar could be produced from a waisted gourd by cutting off the upper extremity or slicing the fruit through just above the waist. If, then, these specific functions were already established before the appearance of ceramics, terracotta vessels may be seen as more durable imitations of those produced from the gourd, and also preferable in the sense that they were heat, if not actually fire, resistant.

Some of the Valdivia dishes have three small, slightly projecting feet and, in some cases, an undulating rim. The spherical jars possess either concave necks, widening slightly at the mouth, or else a projecting rim. The edges of some of the plates are folded inwards in such a way as to produce a square. There are also jars, such as the aryballos, with narrow necks and pot bellies. Lastly, we have pieces in the Late Valdivia style (Phase 6 or 7), dating back to between 1800 and 1700 B.C., which have handles. For the most part the latter are squat, somewhat crudely fashioned and wanting in elegance; they would have served, not so much as grips, but rather as a means of suspending the vessel, perhaps over a fire.

These objects are of quite modest dimensions; the largest are seldom more than 25 centimetres high, while some of the smallest pots are tiny. The latter were probably used as containers for the lime which was masticated together with coca-leaves to help release the alkaloid.

Decoration usually took the form of incisions made while the clay was still malleable, or of engraving executed after firing. It might also consist of impressed repeat designs (we have already mentioned the use of maize for this purpose), of appliqué work, or of indentations made with the help of a shell. Many of the motifs are geometrical, for instance hatching,

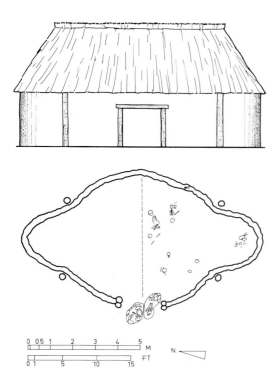

Plan and reconstructed elevation of the funerary hut at Real Alto, after Donald Lathrap.

15 Hollow figurine from La Balsita, Ecuador. Chorrera period, 1200–500 B.C. Standing in a frontal position, the woman is dressed in a short tunic and trousers. The stylized treatment is typical of the Chorrera period in which prehistoric Ecuadorean ceramics reached a high water-mark. The arms and legs are short while the head, with a hair style possibly inherited from Valdivia, is disproportionately large. Height 34.5 cm. Museo del Banco del Pacifico, Guayaquil.

16 Hollow Chorrera figurine from San Isidro, Manabi. The voluminous coiffure is accentuated by incised decoration, while the ears are perforated as in other female effigies of this type. Height 27.5 cm. Museo del Banco Central, Guayaquil.

17 This superb Chorrera statuette from Charcas, Manabi is one of the most perfect expressions of Ecuadorean anthropomorphic sculpture. The geometric decoration incised in the polychrome slip reproduces the designs on the garments. Also worthy of note is the facial painting and the stylization of the eyes. Height 32 cm. Museo del Banco del Pacifico, Guayaquil.

small crosses, triangles and so forth, sometimes used in conjunction with highly stylized human faces certain of which are so abstract as to be scarcely distinguishable from the geometrical motifs (Pl. 2).

The repertory of expressive forms is surprisingly rich. Alongside casual or slovenly workmanship we find evidence of a marvellous inventiveness inspired by a great variety of sources. It should, however, be remembered that the art of Valdivia spans nearly two millennia, which means that there was plenty of time for experimentation. Thus the final period saw the appearance of polychromy achieved by filling very fine incisions with kaolin powder to produce white lines on a dark terracotta background (Pl. 3).

This brings us to the renowned Valdivia figurines, the majority of which are solid and no more than 12 or 15 centimetres high. All display a considerable degree of schematization; the arms are reduced to their simplest expression, while the legs take the form of parallel cylinders in accordance with a symmetry that is strictly frontal. By contrast, the heads are strongly emphasized by means of an opulent coiffure reminiscent of the Egyptian wig. The hair is worn in a heavy fringe and, at the back, is cut straight across the shoulders. The features are punctuated or incised, the mouth being represented by one dot, the eyes by two, or by straight lines above which there may be eyebrows, also represented by lines. The nose is barely indicated. The sketchily modelled body seldom displays sexual organs, though the presence of what are sometimes ample breasts suggests that most of these are female figures, possibly fertility dolls. In any case, they are akin to similar archaic pieces found not only in Mexico, but also in Babylon, Persia and Mohenjo Daro—wherever, in fact, man has worshipped the Mother Goddess, or primitive *Magna Mater* (Pls. 1, 4-6).

But in addition we encounter symbolic figurines expressive of a similarly diffused dualism—monstrous, two-headed images such as also occur in the art of Tlatilco near Mexico City. It may well be that these little terracotta sculptures, antedated in some instances by equally tiny and even more stylized representations in stone, were intended to symbolize either the forces of nature or the spirits governing the intellectual world of these people, the first pre-Columbians capable of expressing their innermost beliefs through the medium of art (Pl. 8).

Small-scale though it may be, the art represented by these figurines sometimes achieves a genuine monumentality. The genius of the pre-Columbian craftsman is instantly apparent in the economy of expression and magical power of these pieces in which man's own image is so represented as to strip it of all realism in favour of a remarkably coherent symbolic code. Here, in an allusive, restrained and mysterious vocabulary, we perceive the image of man's apotheosis, an image already godlike, yet still retaining anthropomorphic features in which the monstrous and the spiritual are combined.

Art such as this could not fail to elicit a response and was soon to cast its spell on the people of the neighbouring regions who adopted it in a process of cross-fertilization. Its diffusion was in direct proportion to the originality and innovative character of Valdivia art, though it may, perhaps, also have been dependent on the general distribution of the myths for which that same art was the vehicle. The fact remains that pottery corresponding to the Valdivia style (dating from about 2200 B.C.) is met with, not only over the whole length of the Pacific coast, from northern

37

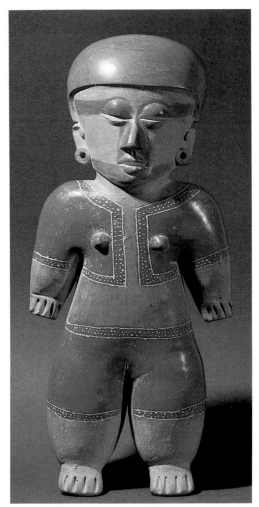

15

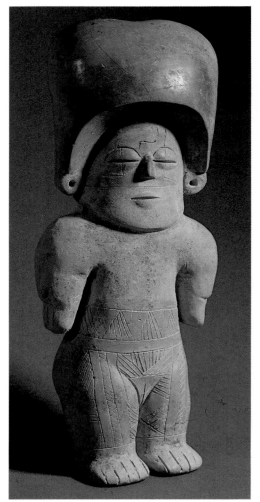

16

17

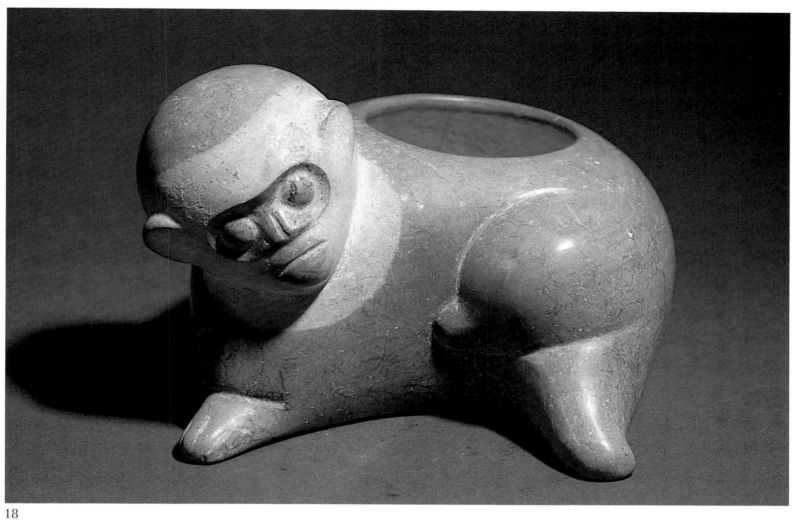

18

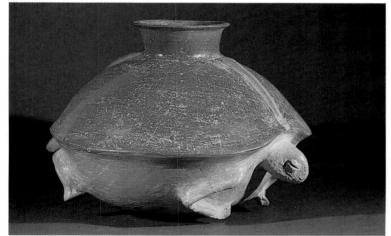

19

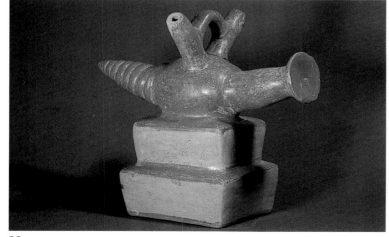

20

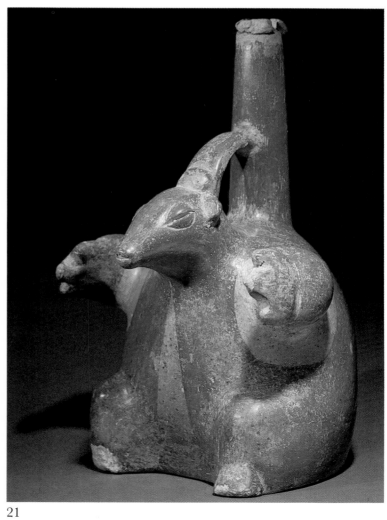

21

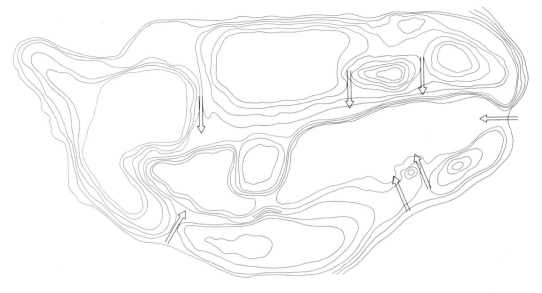

Relief of the Real Alto site before excavation by Donald Lathrap; hypothetical reconstruction of the settlement, comprising about 120 huts built on a mound:
1 Sunken plaza – north
2 Festival house
3 Funerary building
4 Sunken plaza – south

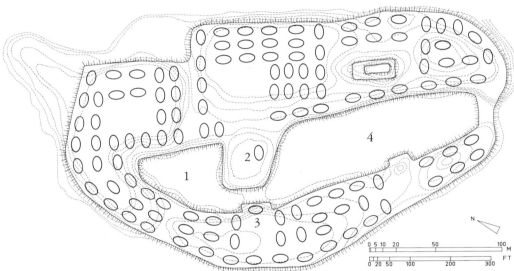

18 Terracotta Chorrera vessel from Calderón, Manabi. About 1000–500 B.C. This realistic representation of a capuchin monkey, accentuated here and there with buff-coloured slip, testifies to the skill of the potters and to their powers of observation. Length 13 cm. Museo del Banco del Pacifico, Guayaquil.

19 Chorrera vessel from Charcas, Manabi. The shell of the tortoise is rendered in red slip. Height 14.5 cm. Museo del Banco del Pacifico, Guayaquil.

20 Chorrera whistling jar from Manabi. Here a snail is represented surmounting a rectangular base consisting of two stages. This piece testifies to the formal complexity of which the potters of the first millennium B.C. were capable. Height 20 cm. Museo del Banco Central, Guayaquil.

21 Bottle from La Irene, Manabi. Chorrera style. This fine piece, with spout and bridge, portrays a small anteater known as a *tamandua*. The powerful anterior claws typical of that family are rendered with particular felicity. Height 25 cm. Museo del Banco del Pacifico, Guayaquil.

22 Whistling jar from Charcas, Manabi. This is one of the finest examples of Chorrera art. The spout and bridge construction integrates remarkably well with the zoomorphic theme. The areas of buff, red and brown colouring are defined by incisions made with a point and, together with the complex and harmonious modelling and fine expressiveness of the head, testify to a complete mastery of the techniques involved. It would seem that hairless dogs of this kind were bred for their meat in Ecuador no less than in Mexico. Height 27 cm. Museo del Banco del Pacifico, Guayaquil.

Ecuador to Central America, but also on the far slopes of the Cordillera along the banks of the rivers that flow into the Amazon basin. Again, traces of this culture have come to light round the lake of San Pablo which is situated 50 kilometres north of Quito at an altitude of 2,260 metres. The diffusion over a wide area was undoubtedly promoted by the close relations existing after the pre-ceramic era between the Ecuadorean plain on the one hand and the mountainous regions, if not the Amazon basin on the other.

The Ceremonial Centre at Real Alto

In 1974 and 1975 Donald W. Lathrap, Jorge G. Marcos and James A. Zeidler carried out excavations at Real Alto between the Pacific coast and the Río Verde valley. Their report, published in 1977 in *Archaeology*, provides us with invaluable information, not only on the Valdivia environment, but also on what is the earliest ceremonial centre in the New World. These investigations revealed a vast agglomeration occupying 12 or 50 hectares and laid out on a roughly rectangular plan measuring 300 by 400 metres. The sides of the rectangle are bounded by wide terraces upon which the huts are built in regular lines, while at the centre, on a slightly lower level, lies a great plaza.

The huts at Real Alto are oval in form and measure 12 by 8 metres, covering about 96 square metres. The walls would appear to have been sturdily constructed of stout posts embedded in the ground with weather-proof panels of wattle and daub between them. The single door, 1.5 metres wide, was doubtless the only source of light. These relatively large dwellings, which are believed to have had high roofs of palm or thatch, were capable of accommodating between twenty-five and thirty persons. Hence we must assume that they were not designed for a single nuclear family of father, mother and children, but rather for an extended family of, perhaps, three generations.

The agglomeration at Real Alto, in so far as archaeologists have been able to reconstitute it, must have contained between 120 and 150 huts of this type, housing up to 3,000 people, a surprisingly large number, given the tribal framework of society in the third millennium B.C.

At the edge of the plaza there were also two separate mounds, each supporting a communal building. Of these, one was probably a festival house used for public celebrations, the other a funerary temple where rites and sacrifices were performed in honour of the dead.

The excavation of these structures has provided an insight into the religious organization of the Valdivia tribes. At the entrance to the funerary building, for instance, is a carefully constructed grave lined with stone slabs, and containing the remains of a woman. To one side of it were found those of a sacrificial victim and, near by, the dismembered remains of seven others, along with the same number of ritual stone knives.

It would seem that human sacrifice was performed at regular intervals, perhaps in association with seasonal rites. Moreover cannibalism may well have been practised, as is suggested by the presence of human bones which have been broken, possibly in order to extract the marrow. Again, there is some evidence that sacrifice by dismemberment persisted here and there in Peru, as is borne out in particular by the bas-reliefs at Cerro Sechín in the Casma valley.

Thus, as early as Valdivia III, somewhere around 2300 B.C., we find that the Real Alto society had evolved a complex organization, involving a rigorous form of 'urbanism'. From this we may infer the existence of a broad popular stratum, possibly dominated by a priest or shaman, who was responsible for performing human sacrifices and who made oracular pronouncements with the aid of hallucinogenic drugs.

According to the authors cited above, the plan of Real Alto is not unlike that of the present-day villages built in the Brazilian jungle by the Gê tribe, whose continued adherence to certain prehistoric traditions might help to cast light on the organization of pre-Columbian societies some 4,000 years ago.

The Machalilla Phase: Retrogression and Innovation

Towards the end of the Valdivia period (Phase 8, around 1600 B.C.), art underwent a number of changes—indicating, perhaps, the arrival of a new population group. The style that now evolved is known as Machalilla after the name of the Ecuadorean coastal site some 50 kilometres north of Valdivia. The stylistic changes that occurred during this period are

particularly in evidence in the treatment of figurines, for the new potential discovered in the human figure by the Valdivia potters gives way in these anthropomorphic terracottas to a retrogressive tendency. The contours of the Machalilla pieces become increasingly laconic and allusive—one might almost say spectral. In these inert, massive statuettes we no longer find the opulent coiffure or the schematically structured body which had become the hallmark of Valdivia, but instead features occur which the latter had ignored: coffee-bean eyes with horizontal slits, and prominent, hooked noses (Pl. 11).

With the appearance of the hollow terracotta, which seemed a development in its own right, profound changes occurred in the plastic idiom of the Machalilla period. These little gnome-like figures, now happy, now sad, have stunted bodies and large heads adorned with flat head-dresses. The lower lip and edges of the ears sometimes display perforations intended, perhaps, to hold hair or feather ornaments, though nothing has yet been found that might indicate their true function (Pls. 13, 14). Strange, disconcerting and verging on caricature, these rather clumsy little pieces nevertheless provide a hint of the superb form of expression we shall find revealed in the hollow statuettes of the Chorrera potters.

While retaining certain features evolved during the later Valdivia phases, the vessels of the Machalilla phase show some interesting innovations. Thus dishes and cups acquire a base or splayed foot, while contours become more vigorous, articulated as these are by the sharp projecting or recessed arrises which define the planes. From now on base and bowl are differentiated; the mouth of the latter is usually provided with a well-defined and clearly accentuated lip.

All these very new plastic characteristics were to persist virtually without interruption into the Chorrera period (1200–500 B.C.). As in the late Valdivia period, the decoration was done after firing by incising the design in the red slip and filling the cuts with kaolin, but here a lighter and more delicate effect was achieved. At the same time the graphic vocabulary of these motifs became richer and more concise as it assumed the form of an uncluttered geometricality.

Here we should draw attention to one most important innovation, namely the stirrup spout introduced during the Machalilla phase. This unusual device consists of a container surmounted by a plastic element in the form of a hollow, stirrup-like handle, the two curved branches of which meet at the base of a tubular spout. It is an invention which would seem to derive from the double-spout vessel peculiar to the pottery of the Ecuadorean forest and the Upper Amazon (Tutishcainyo). Emilio Estrada may be right when he infers from the shape of certain sherds found at Valdivia that stirrup-spout jars had also been produced in the later stages of that culture. However that may be, the stirrup spout was to remain one of the most characteristic features of Peruvian ceramics—a form favoured not only by the potters of Chavín and Vicús, but also by those of Moche and Chimor (Pl. 12).

Another type that predominated in the Andean region was likewise a product of the Machalilla style, namely vessels whose bellies became increasingly anthropomorphic in character. At first the spheroid pot took on the appearance of a human face with sketchily drawn eyes, nose and mouth (Pl. 12). Later, the head was given a body, either squatting or kneeling. These modes of expression which, in Peruvian art, were to acquire an astonishing intensity as well as a considerable degree of realism,

23

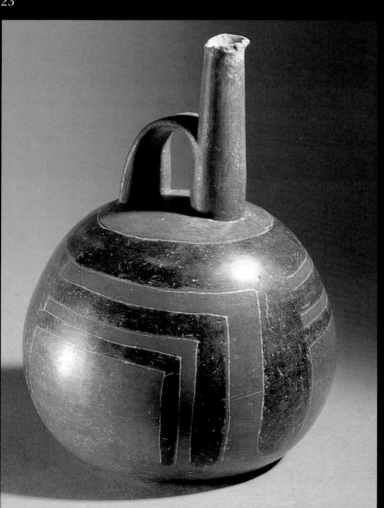

24

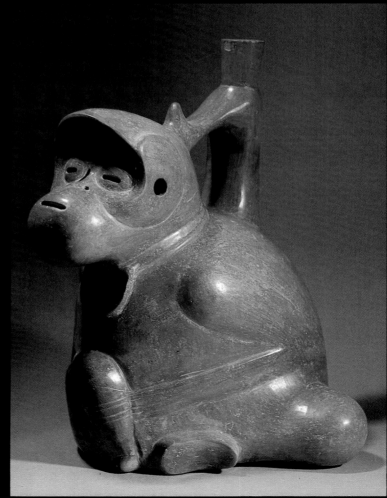

25

are represented more notably by the Mochica portrait vessels which may, perhaps, be regarded as the finest examples of pre-Columbian art (Pl. 72).

Thus the two main themes found in pre-Columbian ceramics are already present in embryonic form in the stirrup spout and in the figurative representations of the Machalilla style which may therefore be regarded as one of the fountain-heads of Andean formal evolution as a whole. Here we have a clear indication of the close links between the products of the Ecuadorean plain and those of the Peruvian littoral, links which become even more evident with the emergence of Chorrera art.

The Diversity of Chorrera Pottery

It was the English geologist, Geoffrey Bushnell—to whom we have already alluded—who, in the 1930s, came upon the first traces of the Chorrera culture. The name he gave it was Engoroy, after the site close to La Libertad on the Santa Elena peninsula where his discoveries were made. Chorrera, the term since adopted for this Ecuadorean culture which flourished between 1200 and 500 B.C., owes its name to the inland site beside the middle reaches of the Río Babahoyo in the Guayas basin.

The Chorrera period marks the heyday of prehistoric art in Ecuador, the culmination of twenty centuries of internal development. It kept alive the technique of incised decoration inherited by Machalilla from the last of the Valdivia potters. But the art of Chorrera also reveals a remarkable grasp of the plastic possibilities inherent in clay, for terracotta, even when of a utilitarian nature, is here translated into the realm of sculpture in the true sense of the term.

The period also saw the birth of animal art, the further development of figurative art and the appearance of faithful representations of the surrounding world. It is the infinite variety of themes embraced by Chorrera pottery that makes of it a cultural witness of prime importance to anyone seeking to gain some knowledge of the living conditions of that time.

Like its predecessors, Chorrera pottery assumes two aspects—on the one hand figurines of which the significance is probably symbolic and religious, on the other domestic ware, its repertoire constantly enriched by new forms and decorative motifs. These two aspects may be regarded as the sacred and profane faces of one and the same branch of technology, in this case ceramics.

In the figurines, the head appears to be imprisoned in a severe, spherical, helmet-like head-dress which may, however, be just natural hair arranged in a certain way and cut in a fringe over the forehead. As at Valdivia and Machalilla, the figures are governed by the principle of strict frontality. The limbs are short and thick, the hands and feet barely indicated. Wide hips taper slightly towards the waist. Both male and female figures are similarly dressed in short trousers and vests or open tunics adorned with geometrical motifs. The garments are rendered in dark red slip; the patterns on the cloth are made after firing by incising lines or punching dots upon the surface. Pieces without a slip coating are sometimes decorated with triangles or bands of hatching drawn with a point on the unfired clay.

The facial treatment of these figurines reveals a stylization that is both uniform and pronounced. The eyes are represented by no more than

23 Chorrera bottle in the shape of a white parrot with a red beak, from Manabi province. In this large piece a degree of elegance goes hand in hand with a distinct clumsiness of execution. Length 31 cm. Museo del Banco Central, Guayaquil.

24 Chorrera jar with spout and handle from Manabi. The piece, which whistles twice when liquid flows down the spout, displays an interesting form of geometric decoration in black and red, with incised outlines. Height 18 cm. Museo del Banco del Pacifico, Guayaquil.

25 Chorrera whistling jar from Manabi. The treatment of the monkey's head, with its sharp lines and well-defined orifices, is remarkably skilful, and gives evidence of a high degree of refinement. Height 24 cm. Museo del Banco Central, Guayaquil.

26 Pot from La Balsita, Manabi province, in the form of an owl. A fine example of the formal perfection and remarkable economy of line achieved by the Ecuadorean potters of the Chorrera period. Height 14 cm. Museo del Banco del Pacifico, Guayaquil.

27 Anthropomorphic bottle-jar with double whistle from Resbalon, Manabi. Chorrera style. Depicting a seated prisoner, his hands tied behind his back, the vessel has a spout and bridge. Height 27 cm. Museo del Banco del Pacifico, Guayaquil.

28 Anthropomorphic whistling jar, Chorrera style. The squatting flute-player, his face painted with black organic pigment, has a voluminous coiffure similar to that of the figurines in Plates 15–17. The fluting note emitted by the vessel when liquid is poured from it underscores the theme chosen by its creator. Height 26 cm. Museo del Banco del Pacifico, Guayaquil.

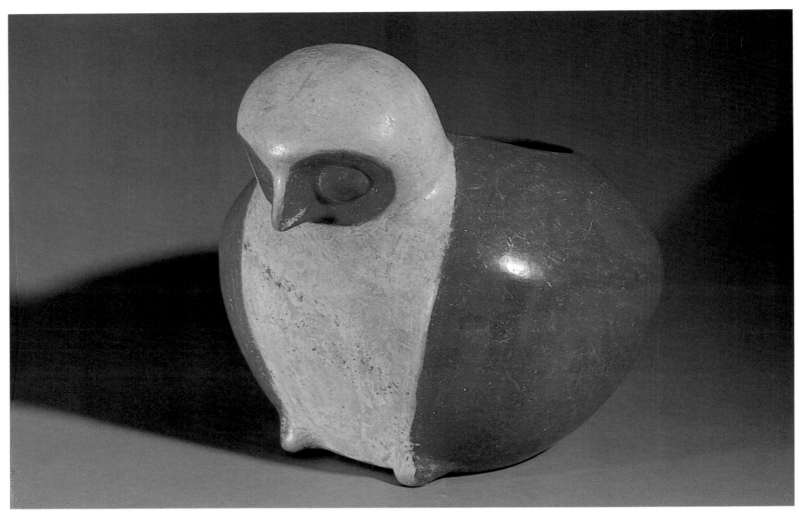

26

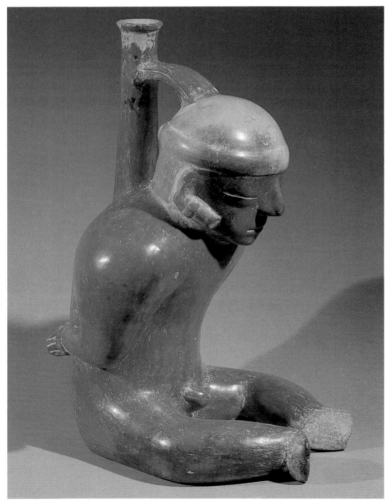

27

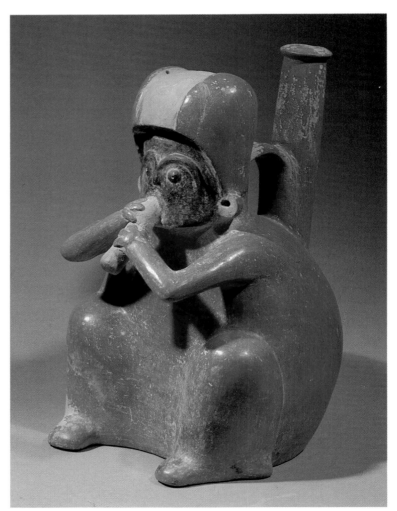

28

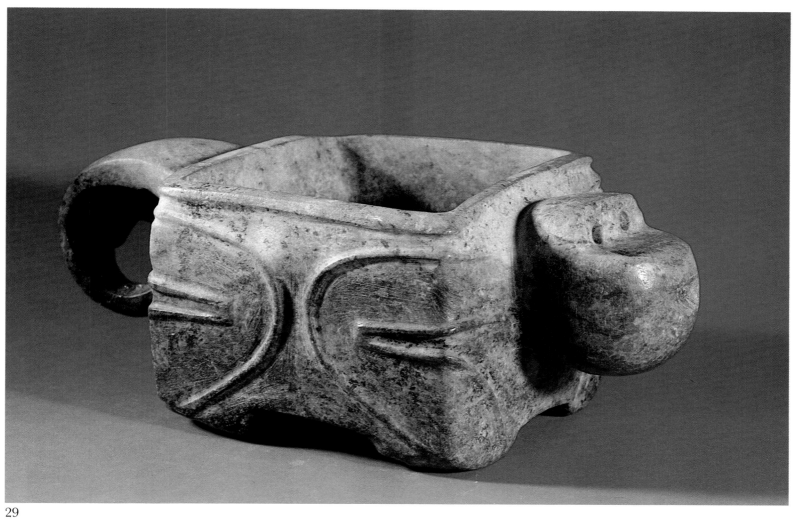

29

30

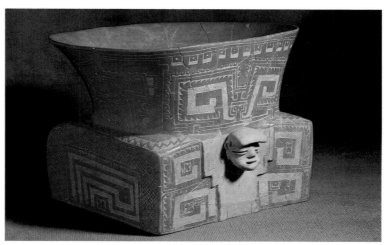

31

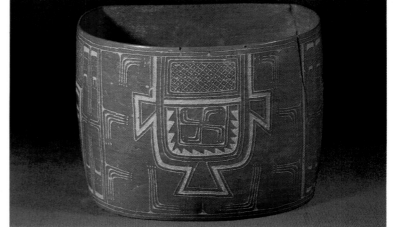

32

horizontal incisions in the protuberant mass of the eyeball—a derivative of the coffee-beans of Machalilla—while the clean horizontal line of the mouth emphasizes a straight, relatively small nose of triangular shape. The lobes of the ears are perforated for the attachment of ornaments. Face paint is reproduced by means of polychrome slip disposed either in bands at the level of the eyes and the mouth or in patches covering chin and cheeks.

The amplitude of the volumes as well as the originality and uniformity of the proportions shows that what we have here is a highly idiosyncratic schematization of the human figure, endowed as it is with an oversized head, powerful shoulders and short, thick limbs (Pls. 15–17).

Besides these anthropomorphic figurines, whose purpose was probably religious, the Chorrera potters manufactured a whole range of domestic ware in which they gave compact and harmonious plastic expression to the surrounding and, more especially, to the animal world. Here we find monkeys, domesticated dogs, kinkajous, coatis, armadilloes, agoutis, tamanduas (ant-eaters), bats, parrots, falcons, screech-owls and harpy eagles, not to mention lizards, snakes, toads and snails, fish and turtles, shell-fish and crabs (Pls. 18–23 and 25-6).

The designs on some of the vessels indicate certain sources of food such as the large larvae found in the heart of the palm-tree and accounted a delicacy by tropical forest-dwellers. In other words, what had been an Amazonian tradition is here perpetuated in the Ecuadorean plain. Again, the representation of almost hairless dogs, similar to those of Colima in western Mexico, proves that here, too, the animal was bred for its meat. On a Chorrera polychrome jar of great beauty (Pl. 22) we find the earliest known representation of the domesticated dog in the New World.

The vessels also show edible plants such as the gourd, the pineapple and the cherimoya fruit. The Chorrera potters succeeded in reproducing natural forms by evolving a technique which combined the methods both of the sculptor and of the moulder. It is difficult to see how they could otherwise have created volumes of such fullness, or masses of such sobriety and balance, in short a plastic vocabulary of such efficacity, and this despite a high degree of simplification which demanded the omission of all but the bare outlines, the essential characteristics. The synthesizing tendency that is evident in these works endows them with a modernity that is truly remarkable.

The zoomorphic art found in these vessels was not without its practical applications. While some of the pieces have a simple aperture at the top, either with or without a flared mouth, others are surmounted by a spout which, when used for pouring, may emit some kind of sound. Indeed, the people of Chorrera attained a high degree of perfection in the production of sound effects, for pots have been found which reproduce the noises made by the animals they represent—the cooing of doves, for instance, or the hiss of a snake, the croaking of toads or the screech of parrots or monkeys. The subject of these whistling—or flute—vessels may also be a human figure or, more aptly still, a flautist.

The whistling jar, with its long vertical neck in the form of a spout, generally has a curved handle attached at one end to the neck and, at the other, to the container as such. The handle, which is flat in section and surprisingly light, not only provides a good grip, but also serves as a reinforcement. Thus the whole gives an impression of perfect homogeneity, for this elegant device, which must be clearly distinguished from

29 Jasper mortar from San Isidro, Manabi province. The stylized feline is an example of the highly geometrical treatment typical of Chorrera art. Length 24.5 cm. Museo del Banco Central, Guayaquil.

30 Small anthropomorphic stone stela, Chorrera style. This is a highly schematic piece, the treatment of which is reminiscent of Valdivia. Height about 15 cm. Museo del Banco Central, Quito.

31 Vessel from Manabi. Above the square base, from which projects a head carved in the round, is a circular flaring neck. The sober forms, enhanced with incised motifs, are typical of the tendency to geometrization found in Chorrera art. Height 18 cm. Museo del Banco Central, Quito.

32 Chorrera vessel. Incised geometric decoration in white on red slip, disposed about a swastika. Height 19 cm, diameter 25.5 cm. Museo del Banco Central, Quito.

the stirrup spout mentioned above, provides a subtle link between the tubular neck and the actual body of the vessel.

In polychrome decoration, the art of the Chorrera potters was enriched by the introduction of new pigments. Lamp-black and the red slip, already familiar from Valdivia, were now joined by buff to create a palette which, while still sober, was nevertheless versatile and effective. Again, incisions filled with kaolin powder were used to produce graphic motifs on a dark ground or to demarcate and thus clearly define the different areas of colour.

Chorrera domestic ware also served as a vehicle for lively and spontaneous representations of the human figure in the shape of water-carriers, prisoners, flautists, invalids and cripples. The finely observed gestures of these figures were doubtless drawn from life and are in strong contrast to the hollow terracottas—possibly, like those of Valdivia, representing deities—which stand, rigid and symmetrical in an hieratic, frontal posture. But here our chief concern is with the stylistic differences between the two groups.

With regard to spouted vessels, it is interesting to note that the stirrup, which first made its appearance in the Machalilla phase, is virtually absent from Chorrera. And since this form was subsequently adopted by Chavín and Vicús as well as by the other Peruvian cultures, it might be pertinent to ask how it came to be transmitted. Between 1200 and 500 B.C. the vessels favoured on the coastal plain possessed a straight spout and curved handle, whereas in mountainous regions such as Azuay (an Ecuadorean province south-east of the Gulf of Guayaquil) the stirrup remained in use. This provides additional proof of the tropical origins of a form of spout whose appearance in Peru occurred immediately after the arrival of tribes from the forests east of the Cordillera in upland valleys, such as Chavín and Kotosh. The discovery on the Peruvian coast of a type of vessel already known in Ecuador during the Machalilla phase is therefore an indication that Andean tribes had by now reached the Pacific and settled in the region of Cupisnique, Tembladera and Vicús.

Finally, it should be said of Chorrera art that its naturalism is accompanied by an opposing tendency, namely the geometrization of forms, as may be seen in the zoomorphic mortars of hard stone, the angularity of which belies their subject-matter, and in the small anthropomorphic stelae in which the features attain an astonishing degree of abstraction comparable to that of the stylized faces of the Valdivia figurines. It also recurs in rigid, inert and sober terracottas, displaying a whole repertory of rhythmically angular motifs such as frets and swastikas incised on the red slip and forming decorative bands round the rims (Pls. 29–32).

This art serves as an admirable complement to the realist tendencies displayed by the animal pieces of the Chorrera potters. It shows how rich were the forms of expression at the disposal of a society which disappeared 500 years before our era. Thus, in Ecuadorean art we may observe the development of all those techniques that were subsequently adopted by the potters of Peru.

III. Chavín: The Birth of Classicism in Peru

Pottery was not the earliest form of artistic expression in Peru, for long before it first appeared the valleys and the coastal lands were inhabited by a succession of sedentary societies which depended for their existence on a relatively advanced form of agriculture and turned for their means of expression to perishable materials such as textiles and gourds. Hence, if we are to understand the origins of the forms that evolved in this part of the Andean world several centuries after the Valdivia period in Ecuador, we shall have to analyse every trace, however small, that has managed to survive thanks to the dry climate of the arid Pacific littoral.

Phases of Pre-ceramic Agriculture

Nowhere in South America was the appearance of agriculture an isolated phenomenon. Since the plants domesticated by man came from distinct and well-defined habitats, such as the tropical forest or the high plateaux, it was only by degrees that they could be adapted to climates different from their places of origin. So diverse were the types of vegetable thus domesticated by selection, that we may postulate a large number of localities where—though not necessarily simultaneously—the cultivation of useful and edible plants first began. By means of exchanges and mutual contacts, communities of cultivators were able to share the knowledge they had acquired. Thus a very wide range of vegetal species soon became available to the early agrarian societies.

One of the first species of which traces have been found in habitations dating back some 10,000 years is the gourd or calabash of which there are two main kinds, one spheroid, the other waisted. When dried, the gourd serves as a receptacle—a bottle or a plate, for instance. Cotton and the kidney-bean first appeared in about 4000 B.C., followed, in about 1500 B.C., by ground-nuts and maize, this time on the Peruvian coast. Later still come the quinoa of the high plateaux and the Chilean potato.

The gourd provides the earliest evidence of artistic activity in Peru, decorated fragments having been found on the Huaca Prieta site near Chicama in the course of excavations conducted in 1946 and 1947 by Junius Bird in association with the American Museum of Natural History.

At Huaca Prieta, a desert site on the shores of the Pacific, a vast mass of detritus was formed by the discarded shells of the marine animals. Not only were the latter an important source of protein, they also helped to

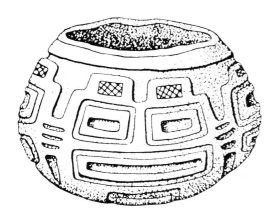

Gourd from Huaca Prieta (about 1950 B.C.). The receptacle, with a diameter of 6 cm, displays a pyrographic decoration of stylized human faces akin to those found in Valdivia pottery (Pl. 2).

supplement the scanty produce of what was still a primitive agriculture. According to radiocarbon measurements, the site was first occupied in 2125 B.C. In the large middens that characterize this region perishable materials have been found which, after 4,000 years, still remain recognizable if not intact, thanks to the dry climate. Of the 10,770 fragments of gourd uncovered on the site, thirteen show traces of engraving. In addition, there are two small unbroken gourds decorated with highly stylized human faces, the motifs having been burnt into the surface with a smouldering piece of wood. The two objects, 4.5 and 6.5 centimetres in height, are of quite exceptional interest.

Gourd Decoration and the Art of Weaving

Although the gourds had decayed to the extent of being 'less substantial than cigar ash', as Junius Bird puts it, they nevertheless held a surprise in store for archaeologists, for the motifs that adorned them were typical of those found in the Valdivia pottery of Phase 3 (Pl. 2), which in turn derived from the tiny stone figures of Phase 2 (Pl. 8). Thus, at Huaca Prieta, in a level dating from 1950 B.C., or well before the appearance of pottery on the Peruvian coast, gourds have been found with motifs based on a model as early as 2400 B.C. From this we may see how widely diffused was the art of Valdivia even at that remote date.

The Huaca Prieta gourds were small lidded containers, perhaps for lime, a substance which increased the hallucinogenic effect of the coca used on ritual occasions. They were presumably imported from Ecuador rather than the work of local craftsmen. At this point it might be pertinent to ask why stylization should have been taken to the point of reducing the human face to a mere pattern of horizontal and vertical lines. The remains at Huaca Prieta provide the answer: weaving.

It should be explained that the aridity of Huaca Prieta's coastal climate has helped to preserve, not only such objects as gourds, but also vegetable fibres such as cotton. Now weaving formed an important part of the activity of this pre-ceramic population. The cotton used in the manufacture of the fragments found on the site has been shown by scholars to combine characteristics peculiar on the one hand to the American and, on the other, to the African species, the seed of the latter having, they assume, been carried across the Atlantic by migrant birds. Its long fibres enabled the Huaca Prieta weaves to achieve most interesting effects and, indeed, the earliest known examples betoken what must already have been a very advanced technology. In this, as in most other cases, nothing has survived from the anterior stages.

In order to obtain their effects when restricted to only two colours, the weavers evolved a decorative repertory of extreme sobriety, the majority of their designs being based on inversions, warp transpositions and alternately reversed repeats. Owing to the deterioration of these fabrics, which are more than 4,000 years old, the colours are no longer visible; in order to reconstruct the design, a sample has to be examined thread by thread with the aid of a microscope. It will be apparent that, even at this early stage, the weavers were fully acquainted with the mysteries of their craft. However, as we have said, the first tentative steps elude us, as does the locality in which they were made.

Diagrammatic drawing of a bichrome textile design of a condor with a fish inside it. The treatment is rectilinear and schematic. The fragment dates back to 2050 B.C.

51

Because of the nature of the medium the motifs were, of necessity, highly stylized. Indeed the orthogonal pattern made by the warp and weft threads as they crossed each other imposed a schematization based essentially upon verticals and horizontals. This entailed reducing motifs such as the condor or harpy eagle, the snake or the crab to a strict formula and it was these lines, geometrized in response to the requirements of a particular technique, that were reproduced in other media. From this we may conclude that weaving influenced the designs used on gourds, designs which, in their turn, were taken up by the Valdivia potters whose bowls and jars were, so to speak, artificial gourds.

This early use of perishable media would seem to explain the absence —save in arid regions where examples have been preserved—of the experimental phases already noted in many other forms or archaic art. Both in decoration and in sculpture the use of materials capable of resisting the effects of the weather represents a phase of development subsequent to the emergence of a plastic vocabulary. In other words, the designs first evolved in media such as cloth, wood and basket-work were subsequently applied to stone, for example, or terracotta, thus acquiring greater durability and weather-resistance. Thereafter the imperatives imposed by the particular nature of the material initially employed were accepted without question, even though the necessity to do so no longer existed. Such an approach can alone explain the sudden appearance in pottery and sculpture of complex forms that would seem to have reached full maturity without prior experimentation.

Beginnings of Architecture

Among the sites occupied by pre-ceramic cotton-weaving societies on the Peruvian littoral, we should mention El Paraiso in the Chillón valley near Lima, which was excavated in 1966 by Frédéric Engel. In about 2000 B.C. a society of bean cultivators appeared on the coast where they built villages of stone houses, constructed partly below ground level and with roofs of rush matting supported by whalebones.

It was a village of this type, with a temple flanked by the residences of high dignitaries, that was uncovered at El Paraiso. There are a number of stone buildings cemented with mud, the wall facing being of smoothed clay. The main complex, which measures 40 by 50 metres, comprises halls, corridors, stairways and ramps. In its final state, after numerous enlargements, the centre comprised no less than twenty-five halls. One of these, obviously of a ceremonial nature, has four columns—no doubt roof supports—and a central basin and was reached by two flights of stairs and a vestibule. It is clear, then, that the architects already had at their disposal a complete repertory of forms and were sufficiently conversant with spatial organization to produce an ingenious system of labyrinths.

Some 100 kilometres further north, at the entrance to the Supe valley, is the pre-ceramic site of El Aspero which also possesses a temple, a pyramidal edifice crowned with several chambers and constructed of undressed stone bedded in clay mortar. The complex, known as Huaca de los Ídolos, measures about 20 by 30 metres and was excavated by R. A. Feldmann in 1970.

At the beginning of the 1960s excavations were carried out at Kotosh in the Cordillera by the Japanese archaeologists Seichi Izumi and Toshi-

33 Cerro Sechín, Peru. North-west corner of the reconstructed wall surrounding the temple. The stone slabs dating from the fifteenth century B.C., depict human sacrifice. At the top of the tall central slab are trophy heads with, beneath them, the figure of a man who has been sliced in two. The bristling hair and ghastly grimace underline the bloodthirsty nature of the rituals practised by the prehistoric Andean peoples.

34 Cerro Sechín. Large stela depicting another bisected sacrificial victim.

35 One of the high-priests of Cerro Sechín responsible for carrying out the sacrifices. Carved on a tall granite stela, he is shown carrying an axe with an obsidian blade and wearing a kind of tiara.

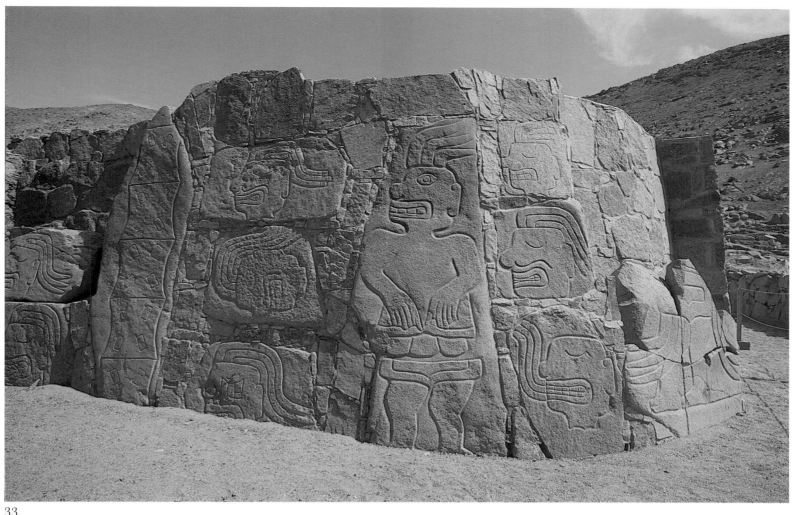

33

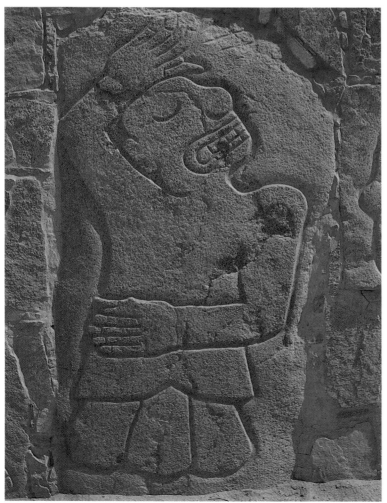

34

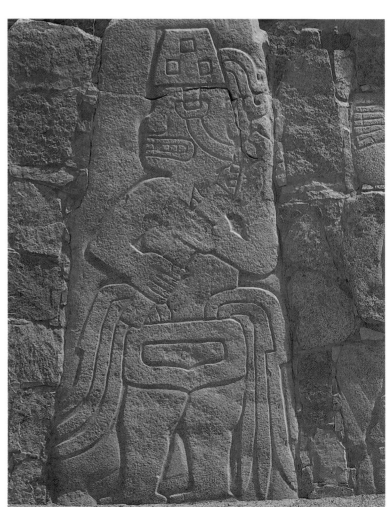

35

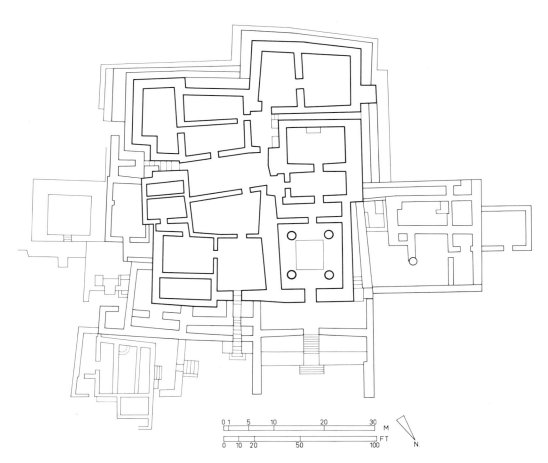

Plan of the pre-ceramic settlement of El Paraiso (or Chuquitanta) near Lima, which was inhabited in about 2000 B.C. At the centre a ceremonial hall with four masonry columns.

hiko Sono (their account appears in a work entitled *Andes II*, published in Tokyo in 1963). Here, at a height of 1,800 metres on the right bank of the Río Higueras near Huánuco, they discovered a structure in the form of an artificial mound measuring 20 by 12 metres. The site, previously investigated by Julio Tello, was to yield a vast quantity of information. Izumi and Sono named the edifice 'Temple of the Crossed Hands' after a partially obliterated stucco relief showing crossed hands and forearms, possibly those of a god. This sculpture, the first known example in Andean architecture, goes back to about 1850 B.C., or the end of the pre-ceramic period. The crudely made pottery of that time was decorated by means of incisions.

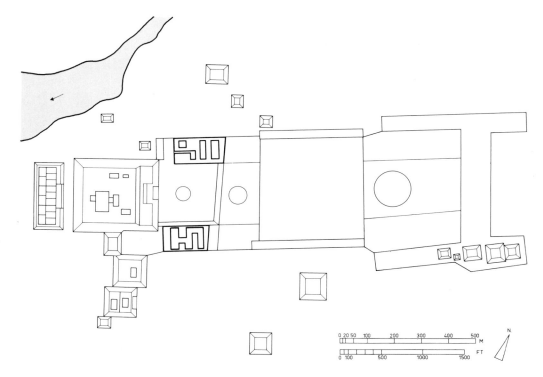

Sechín Alto, in the Casma valley. Plan of the huge ceremonial centre, with terraces and courts extending over some 1,700 m.

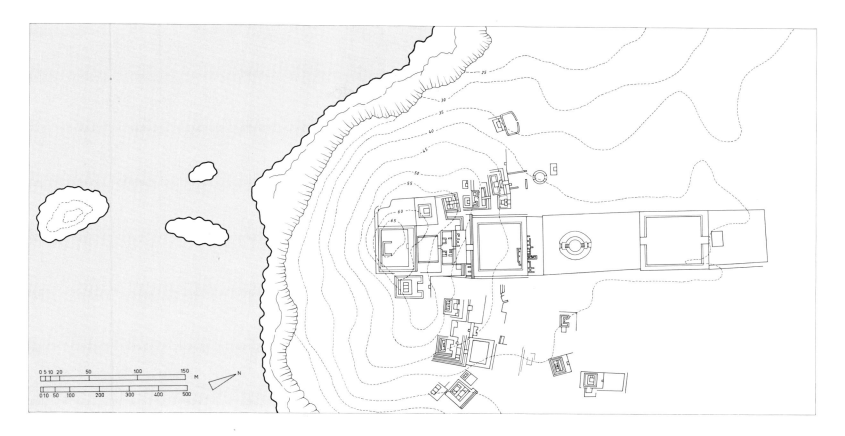

Las Haldas. Plan of the ceremonial centre which rises from the Pacific shore 30 km south of the Casma valley. The pyramid crowns a natural eminence.

Kotosh pottery later came to be regarded as an important milestone in the evolution of forms. The primitive phase, known as Wairajirca, was followed by Kotosh/Kotosh which saw the appearance of the first stirrup-spout vessels and, in about 1200 B.C., the beginnings of maize cultivation.

But here we must return to architecture and the low-lying Casma valley which contains a number of grandiose sites, notably the vast temple complex at Sechín Alto. Consisting of terraces and esplanades extending over 1,770 metres, it terminates in a pyramid preceded by a court and a platform at the centre of which, on the transverse axis, is a small sunken plaza, circular in plan. This structure is in turn preceded by a huge terrace with battered sides, beyond which is another small round sunken plaza occupying the centre of a quadrangle surrounded on three sides by platforms.

The buildings at Sechín Alto were constructed of rough-hewn stone laid without mortar in alternate courses of large and small blocks. This vast ceremonial centre, which presents an imposing perspective, was built as early as 1800 B.C. and was progressively enlarged over the next 800 years.

The use of an axial layout recurs, though on a more modest scale, at Las Haldas, a site on the Pacific coast 30 kilometres south of the Casma valley. Here a natural spur rising above the sea serves as a pyramid, while the remainder of the complex consists of six courts, terraces and plazas lined by platforms, the length of the whole being 400 metres. In the centre, on the main axis, a small sunken plaza, circular in plan and 20 metres in diameter, is reached by two axial stairways.

These buildings form a ceremonial centre with the same layout as that at Sechín Alto; construction was begun in 1630 B.C. and finally completed in 500 B.C., by which time some of the buildings must already have been in use for over 1,000 years. Indeed there can be no doubt that the more important structures belong to the period before 1200 B.C., notably

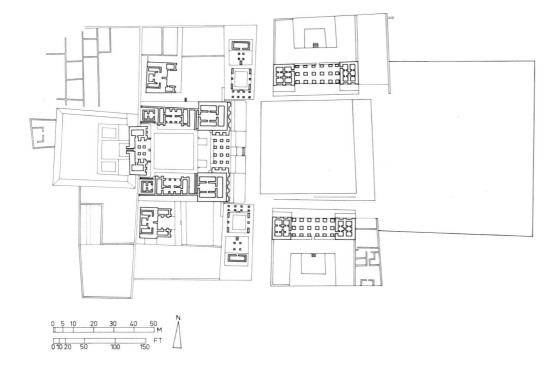

The assembly known as Huaca de los Reyes in the Caballo Muerto complex. Note its symmetrical and orthogonal disposition.

the small round plaza in which, as shown by radiocarbon measurements, a conflagration took place in about 1190 B.C.. This early phase was followed by a second occupation which lasted until about 900 B.C., while the third spans the period between 880 and 500 B.C. This rectilinear assembly, in which courts, terraces, plazas and enclosures are disposed along an axis terminating in a pyramid, is constructed entirely of stone. Now the chief interest of these largely ruinous buildings lies in the layout—pyramid, square terrace, small round sunken plaza—which recurs, with modifications dictated by the configuration of the site, in the great sanctuary at Chavín de Huántar.

Worthy of especial note is the Caballo Muerto complex and, in particular, the assembly known as Huaca de los Reyes dating from about 1300 B.C. It forms one of the eight groups of remains on this site in the Río Moche valley, but in none of the others has the plan been developed along such interesting lines. In a paper published in 1980 Thomas G. Pozorski shows that Huaca de los Reyes is laid out on an east-west axis in accordance with a strictly symmetrical plan. The plazas, courts and buildings of which it consists extend to the foot of a cliff *(quebrada)* upon which stands a square pyramid which must once have been crowned by temples. Built of stone and beaten earth, it comprises 40,000 cubic metres of materials.

Although the assembly is no more than 240 metres long and 170 metres wide, it boasts a complex orthogonal layout in which the ramps, platforms and plazas leading to the pyramid are surrounded by buildings disposed in an identical manner on either side of the transverse axis in accordance with a formula we shall again encounter in the twin sanctuaries at Moxeque. The site at Caballo Muertó is also of considerable interest by reason of the adobe bas-relief friezes which line the main plaza of the ceremonial centre. These sculptures herald the decorative system based on horizontal/vertical bands, as well as the jaguar masks which were to form part of the iconography of Chavín.

Though difficult to date, some of the other buildings put up during the second and first millennia B.C. possess interesting plans. Thus, at Moxeque, some 20 kilometres from Sechín Alto, we find a huge complex

Aerial view of the fortress with three enceintes at Chanquillo, south of the Río Casma.

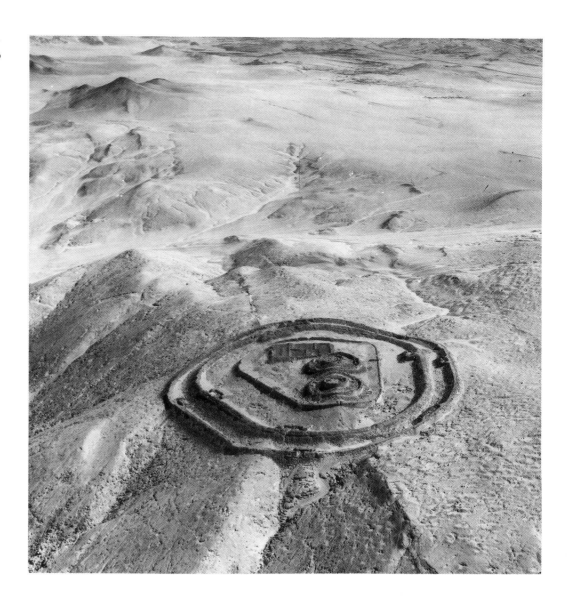

of plazas, courts and pyramids, the whole dominated by a stepped pyramid approximately 160 metres square and 30 metres high, constructed of large blocks of dressed granite, clay mortar and adobe. It is symmetrically disposed within a plan having rounded corners, and rises in a series of receding terraces ascended by an axial flight of stairs. At the summit are two platforms which must once have supported twin temples built, no doubt, of perishable materials. The stucco-clad top storey is adorned with painted reliefs depicting figures which appear to be weeping. It would not, perhaps, be too far-fetched to suppose that the flowing tears symbolize the life-giving water brought down from the mountains by the Río Moxeque which, with the Río Sechín, of which it is a confluent, becomes the Río Casma a few kilometres downstream.

Some 5 kilometres further south, on an eminence at the edge of the desert, stands the great fortress of Chanquillo. The triple precinct, surrounded by massive elliptical and concentric walls, as well as the staggered zigzag entrances, leave little room for doubt that this impressive structure, some 250 metres long and 200 metres wide, was built for defensive purposes. The walls, faced with stone and filled with rubble, are between 6 and 8 metres thick. At the centre of the precincts the uppermost esplanade accommodates three buildings whose plans are as curious as they are baffling. Two are circular, having two concentric walls, again with zigzag entrances; the third is square, measuring some 55 metres each way, and comprises a number of halls approached by ramps.

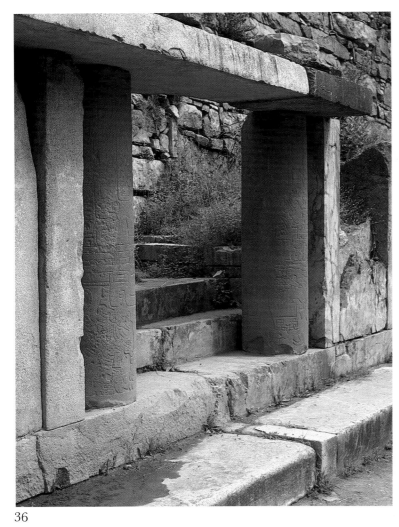

36

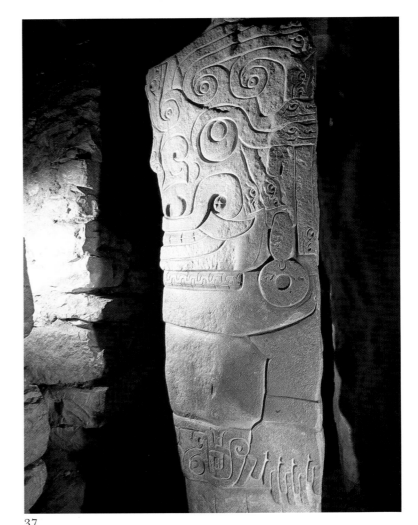

37

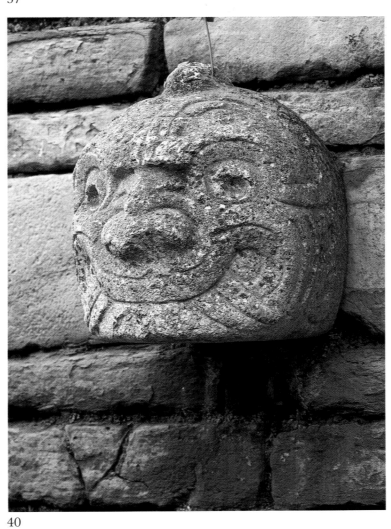

38

39

40

Pyramid at Moxeque, 20 km from Sechín Alto; longitudinal section and plan, showing the twin sanctuaries reached by wide axial stairs.

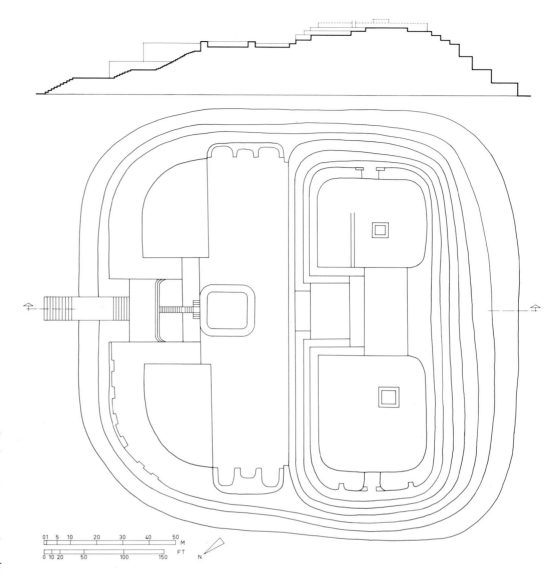

36 At Chavín de Huántar, Peru, a portal flanked by two monolithic columns, probably gave access to two stairs serving the two sanctuaries at the top of the pyramid. During the restoration of this structure, built between 550 and 460 B.C., part of a frieze was mistakenly used as a lintel.

37 The strange idol known as the Lanzón stands in a cruciform chamber inside the principal pyramid at Chavín. Representing a deity, half-man, half-beast of prey, the carved monolith dates from 850-800 B.C. and forms an integral part of the first building erected on the site. Height 4.6 m.

38 Detail of a very fine bas-relief of an 'angel-tiger' which encircles the northern, monolithic column of the Chavín portal. The motif, a stylized jaguar's head, serves as an anklet on the left leg of the monster.

39 Detail of feline motifs on the stela at Chavín known as the Lintel of the Jaguars. Here we find the principles of reduplication and split representation applied to elements such as serpents, fangs and eyes. Probably dating from between 700 and 460 B.C., it is a typical example of the classic decorative art of Chavín.

40 Of the forty or so carved heads tenoned into the wall of the pyramid at Chavín, only one remains in place. Here we find again the half-human, half-feline creature we have already encountered in the Lanzón. It is reminiscent of the trophy heads frequently noted in Paracas textiles.

Radiocarbon measurements of a carob-wood door lintel suggests that the building concerned was erected in 342 B.C., namely in a late Chavinoid phase. Considered in relation to the stone edifice of the Casma valley this would seem rather too late a date and should not, perhaps, be accepted without reserve. On the other hand, what we have here may be a later occupation of a site whose strong defensive position invited re-use and restoration. However, the fact remains that all larger buildings of this type are apparently of much earlier date. Furthermore, the pyramids and other edifices of the ensuing Mochica phase were constructed of adobe and not of dressed stone masonry.

To sum up, it may be assumed that the emergence of an architecture displaying predominantly rounded forms, such as is found at Moxeque and Chanquillo, is attributable to a different trend from that prevailing at Sechín Alto and Las Haldas. Rounded corners recur in the curious archaic temple at Cerro Sechín (Pl. 33), which is situated in the same district, at the confluence of the Ríos Moxeque and Sechín. The complex, which has recently been restored, is surrounded by a wall composed of large blocks of dressed and sculptured granite. It lies at the foot of an eminence the slopes of which were also fortified by a series of walls and, at the top, by several concentric enclosures.

The lower complex, which is known to have passed through two phases of development, is composed of six buildings, the most interesting

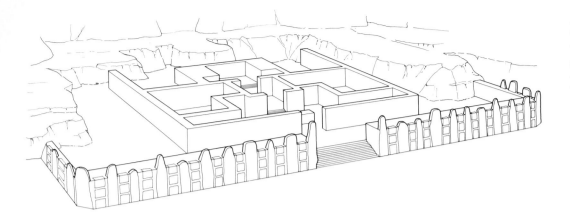

Axonometric drawing of the temple at Cerro Sechín with its high enclosure wall of tall sculpted stelae. Note the symmetrical plan of the sanctuary proper.

of which is the temple alluded to above. Standing with its back to the hill-side, it contains numerous symmetrically disposed chambers and is reached by an axial stair. The front and part of the sides of the wall which surrounds the temple precinct is lined by 300 sculptured stone slabs set on end like orthostats, twenty-two tall blocks being interspersed with smaller elements. As he approaches the temple, the visitor is confronted by these bas-reliefs in which standing human figures in profile alternate with viscera and severed heads and limbs. The subject of this macabre display would seem to be human sacrifice, performed by high priests armed with axes and wearing head-dresses reminiscent of a tiara (Pl. 35). Their bare-headed victims have undergone the most grisly tortures: some have been cut in half and have spilled their entrails (Pl. 34), while of the others nothing remains but dismembered parts—spinal columns stripped of their flesh, amputated arms, legs wrenched from their sockets, scattered entrails and so forth.

The numerous trophy heads with closed eyes and lips drawn back in a hideous grin constitute a sanguinary assemblage which evokes the sacrificial practices of the culture by which this complex was built (Pl. 33). Mention has already been made of Real Alto with its seven sacrificial victims, such ritual practices, it would seem, having been quite general in the Andean world between the fourth and the second millennium B.C. The art of Cerro Sechín, with its blatantly ferocious expressionism, is placed by archaeologists in the fifteenth century B.C., and thus preceded the emergence of Chavín classicism and its highly developed symbolism. Richard L. Burger is of a different opinion about the dating of Cerro Sechín.

The chief characteristic of this mode of expression, so brutal as to amount to artistic terrorism, is the immediacy of the message. Such a genre eschews realism to confine itself to the primary meaning—as, indeed, do most forms of primitive art, in which people are depicted not as they are, but as they are known to be, or rather in the form in which they are most easily portrayed. Thus the heads of the high-priests are presented in profile, the shoulders frontally and the legs again in profile, thereby eliminating all necessity for perspective or foreshortening.

The dislocated gestures of the sacrificial victims—in some way reminiscent of the Danzantes at Monte Albán in Mexico—the expression of terror on the faces of the dying and the hideous grin of the dead, are indicative not only of the wish to inspire terror, to use fear as an instrument of government, but also of an unmitigated contempt for the victims which in turn betrays an exceptional degree of brutality. The grimacing trophy heads displayed on the walls of the temple entrance at Cerro Sechín

41 The monolithic Tello Obelisk at Chavín represents a stela with iconography similar to the Lanzón. In the bas-reliefs with which it is adorned, Rowe and Lathrap claim to have discerned the great cayman, a beast revered in Amazonia. Probably dating from between 800 and 650 B.C., Height 2.42 m. Museo Arqueológico, Lima.

42 The Raimondi Stela depicts a deity who, with his jaguar's mask and tall head-dress of plumes and serpents, is invested with a truly awesome majesty. The rigorous stylization and symmetrical disposition of a bas-relief decoration that is accentuated by fine incisions marks the apogee of the aesthetic development of Chavín. Dates from between 460 and 300 B.C. Height 1.95 m., width 74 cm. Museo Arqueológico, Lima.

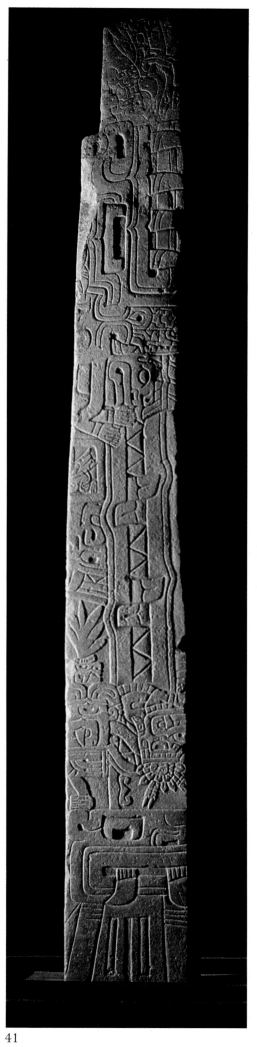

41

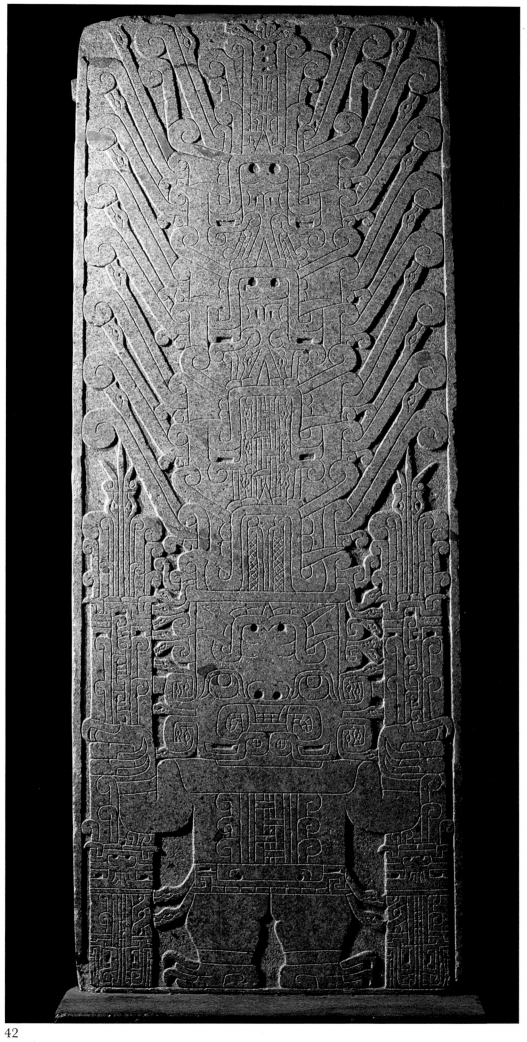

42

recall an ancient tradition common to the primitive Indian peoples and which figures in the art of the Maya–Toltecs at Chichén Itzá. It was encountered not only in the Chavín sanctuary, but also among the people of Paracas on the south coast of Peru.

The Chavín Sanctuary

The site of Chavín de Huántar lies at an altitude of 3,180 metres on the left bank of the Río Mosna which rises in the Cordillera Blanca and subsequently joins the Marañón, the main tributary of the Amazon. The valley on the eastern slopes of the Andes where the ruins stand is known as the Callejón de Conchucos. To reach it from Huaraz (Callejón de Huaylas) involves crossing a saddle more than 4,450 metres above sea-level, an ascent now reduced to 4,290 metres by a tunnel. The crest forms a watershed; to the west the rivers, of which the chief is the Santa, flow towards the Pacific, and to the east towards the Atlantic; the Santa drains the Laguna de Conococha.

Donald Lathrap is of the firm opinion that Chavín is the last site to have maintained a direct link with the Amazonian forest, a trait which, he believes, accounts for the retention in its art of iconographic themes drawn from the tropical forest—for instance, the jaguar, the cayman, the harpy eagle and the manioc.

The archaeological site as such occupies a narrow shelf in the steep-sided valley. Its base is threatened by the flooding of the turbulent river which, when in full spate, may leave its course and sometimes even break its banks. The upper part of the site is subject to landslides caused by rain falling on the steep and unstable mountain slopes. Thus the position of the temple of Chavín de Huántar is a precarious one, exposed as it is in this upland valley to the full fury of the elements.

At first glance few sites could be worse suited to the development of a ritual complex, having regard to the lack of space, the sloping, unstable terrain and the mist and rain that prevail on the eastern flanks of the Andes. Indeed, for archaeologists this curious sanctuary poses a great many questions. They cannot believe that it formed the heart of a large agglomeration for which there would have been no room. Rather, in order to explain the presence of an important place of worship in so incongruous a setting they suggest that Chavín might have been a centre of pilgrimage serving a vast territory ranging from the highland valleys to the coastal plains and from the Piura region (not far from the present Ecuadorean border) in the north, to the coasts of Paracas in the far south.

For between 850 and 200 B.C. Chavín was a religious and cultural—and therefore artistic—centre of the greatest importance. Its influence extended over almost the whole of present-day Peru with the exception, perhaps, of the high plateaux of Titicaca which, however, a 1,000 years later, were to witness the emergence of strangely Chavinoid reminiscences.

We must now turn to the architecture of the site. The nature of the edifices is difficult to determine because of their extremely ruinous state. This is attributable partly to weathering, but also to the activities of vandals whose depredations must have begun before the Conquest, by which time the site had already been in existence for at least 2,000 years. The largest building is a square pyramid with sides measuring some 70 metres. It has three stages and battered retaining walls, some still faced

Diagrammatic plan of the sanctuary at Chavín de Huántar, built between 850 and 200 B.C.

1 Principal pyramid
2 Remains of south temple
3 Remains of north temple
4 Double stairs and portal
5 Small square sunken plaza
6 Large square sunken plaza
7 Position of the Lanzón within the structure
8 Round sunken plaza

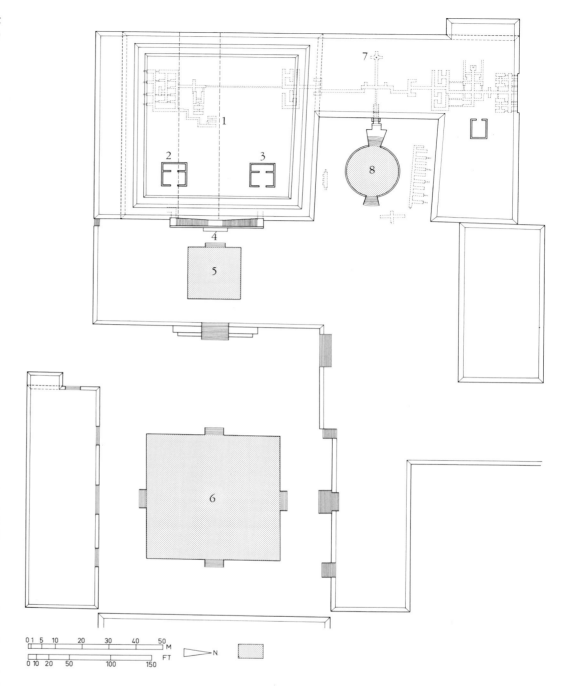

43 Bottle-jar from Chavín. Probably 850–600 B.C. The piece, decorated with complex symbolic motifs which stand out from the stippled ground, is typical of the style termed Ofrendas by Lumbreras. Height 20.5 cm. Museo Arqueológico, Lima.

44 Classic stirrup-spout vessel. Chavín–Cupisnique style. Probably 850–600 B.C. Here the jaguar is portrayed by means of incisions made on a black ground, the tone of the latter being obtained by reduction firing in which the surface of polished clay is coated with smoke in the kiln. Height 22.5 cm. Museo Arqueológico, Lima.

45 Stirrup-spout vessel from the Vicús region, northern Peru. Chavinoid style. Probably about 460 B.C. This exceptional piece displays a stylized half-face expressive, perhaps, of dualism. Height 24 cm. Museo del Banco Central de Reserva, Lima.

46 Stirrup-spout vessel from the Vicús region. Chavinoid style. About 200 B.C. This fine polychrome piece, depicting a monster with a jaguar's mask and serpent's body, provides an example of what is known as negative painting, a technique in which certain parts of the surface are reserved by the application of wax, so remaining free of slip. Museo del Banco Central de Reserva, Lima.

with well-dressed stone blocks in courses of varying widths, one course of larger stones to every two of smaller ones. The perfection with which they are laid and polished marks a considerable technical advance on the architectural examples we have considered up till now.

The sides of this square pyramid, which faces east, are oriented exactly upon the cardinal points. The portal in the east face consists of a pair of columns discovered among the remains of the building and re-erected in the course of a restoration (Pl. 36). They have been given a lintel in the form of a carved frieze, an arrangement that is probably at variance with the original. The portal which must have been of two colours, the right half black and the left half white, gives access to two lateral stairs leading to the first level. Here they turn through 90° before entering the mass of the second level, to terminate at twin temples (similar to those at Moxeque) which now lie in ruins on the terrace forming the third level. This arrangement would seem to suggest a dedication to nocturnal and diurnal deities.

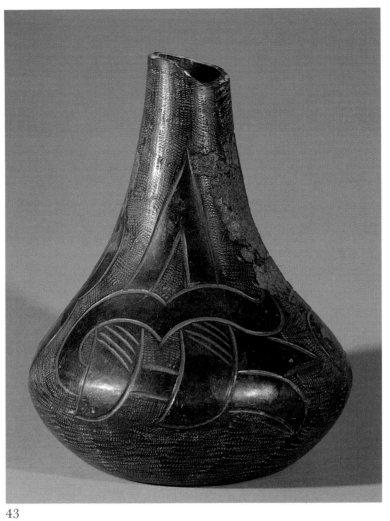

43

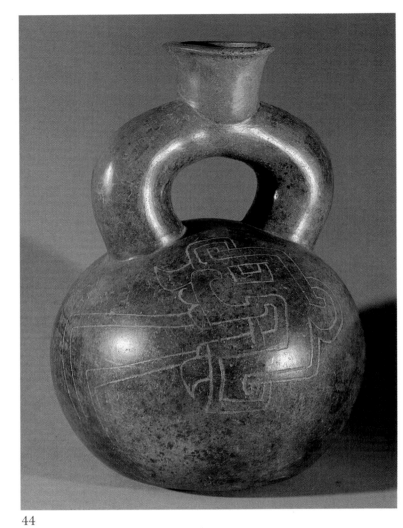

44

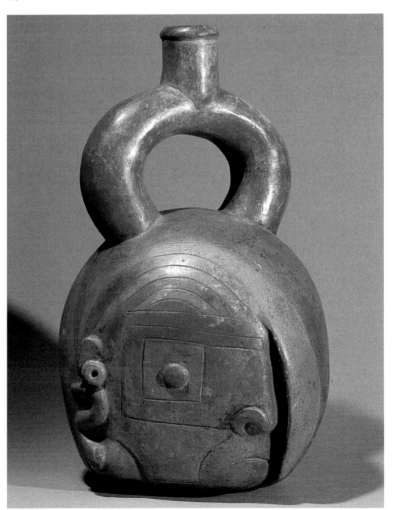

45

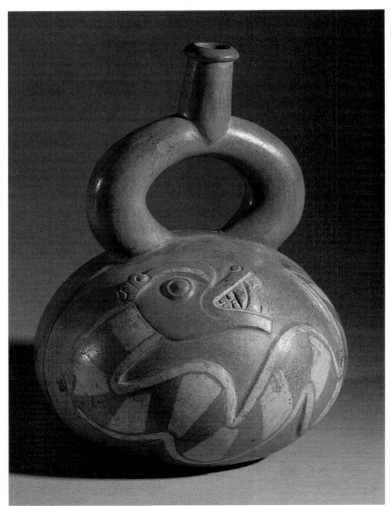

46

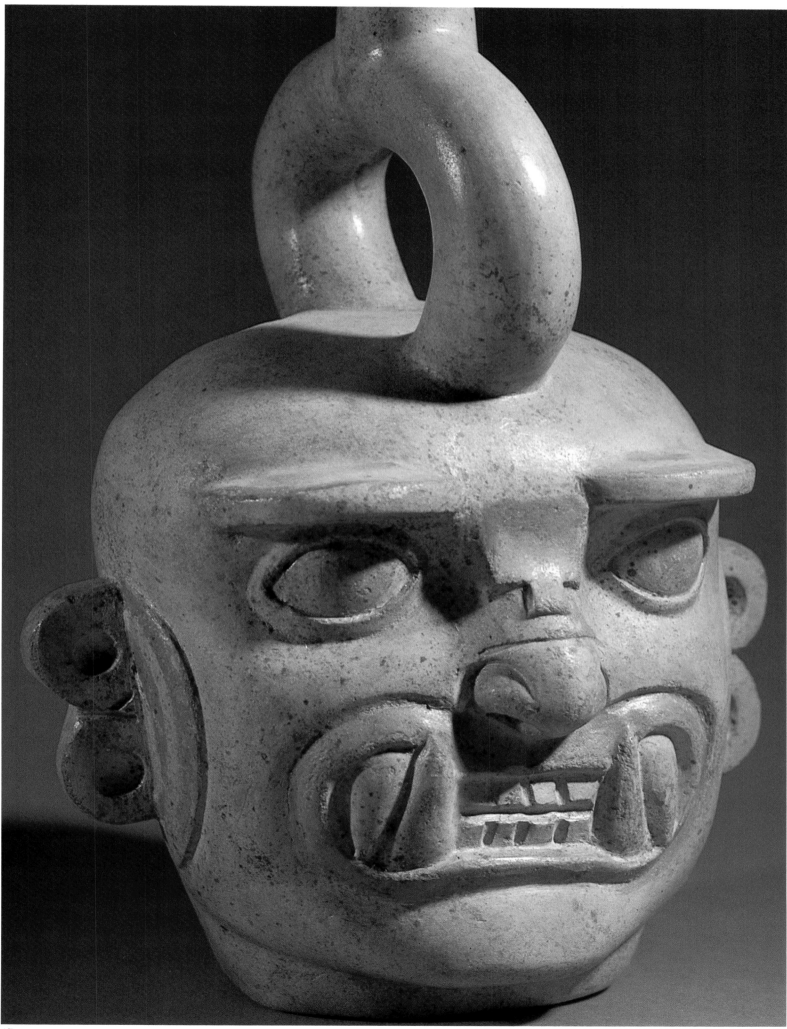

The main pyramid, some 15 metres high, is preceded by a stairway leading down from the portal to a small sunken court surrounded by terraces. Beyond and below this small court is a huge quadrangle which in turn encloses another sunken plaza with a stairway in each of its four sides. It lies almost on a level with the river and is flanked to right and left by sloping platforms, each with a stairway leading to its summit.

These three elements—pyramid, small square court and large open plaza—conform to a strictly axial layout and are situated between the mountain slope and the west bank of the Mosna, which has washed away part of one of the platforms flanking the plaza. There would have been no possibility of making further extensions either eastwards or westwards. North of the pyramid, to which they must in fact be anterior, are other elements, disposed along a parallel axis, also oriented east-west. To one side a sloping L-shaped platform runs from south to north before turning eastwards through 90°, thus producing a quadrangle at the centre of which a small, round sunken plaza was discovered by Luis G. Lumbreras during the last excavation of the site in 1972. This plaza, 21 metres in diameter, is lined with sculptured slabs and is reached by two stairs lying on an east-west axis. The broad western flight leads up to the first level of the platform from which entrance is gained to interior passages which, dark, low and narrow, are often described as subterranean, although situated in the body of the edifice, above ground level. The passage which lies on the median axis of the small circular plaza leads to a tiny cruciform chamber containing a large monolithic idol almost 5 metres high. This sculpture, known as the Lanzón, is the focal point of a magic and mystical place, the inner sanctum of the temple.

Indeed all the edifices are literally honeycombed with passages lined with masonry and roofed with heavy stone slabs. This system of dark tunnels and narrow, virtually unlit chambers accords with a strictly orthogonal plan, which also governs the entire Chavín complex. The passageways, which constitute what can only be described as a labyrinth, may have been used for purposes of initiation. So complex is this network that it has not yet been fully charted.

This brief description may permit us to draw some initial conclusions before we proceed to a consideration of the chronology of the buildings. The pyramid, the small square court and the quadrangle below it, all of which lie on the same axis, adjoin the buildings describing a U and embracing the small circular sunken court which, as already mentioned, is on axis with the gallery leading to the Lanzón. Instead of disposing the various elements in such a way as to create a single vista, as at Sechín Alto or Las Haldas, the architects were compelled to split up the range of sanctuaries into two adjacent groups, a restriction imposed by the topography of the valley. Thus the buildings are distributed along two parallel axes measuring 350 metres in all, although the space available between the mountain and the river amounts to no more than 200 metres. Accordingly, Chavín in its final stage merely repeated, if in modified form, the archaic sequence of buildings, courts, terraces and plazas.

However, the order in which the buildings have been discussed above does not in any way correspond to their chronology which, indeed, has recently been subjected to drastic revision as a result of radiocarbon measurements. In a paper published in *American Antiquity* in July 1981, Richard L. Burger has shown that Chavín does not, as previously supposed, go back to 1200 B.C., but is in fact no earlier than 850 B.C. His

47 Vessel from Vicús. Probably Phase I, about 400–200 B.C. Of Chavinoid inspiration, this fine piece is classified by Lumbreras as Vicús–Mochica but would seem rather to belong to Vicús Blanco. It represents a feline deity with projecting eyebrows. Height 20.5 cm. Museo del Banco Central de Reserva, Lima.

48, 49 Two black stirrup-spout vessels. Chavín style, probably about 400–200 B.C. The very abstract decoration is based on serpent and, perhaps, eagle motifs. Both are about 20 cm high. Museo del Banco Central de Reserva, Lima.

50 Spout and bridge vessel from the Vicús region. Vicús–Virú style, about 250 B.C. The piece, which depicts a feline, is executed in buff-coloured clay. Height 16.5 cm. Museo del Banco Central de Reserva, Lima.

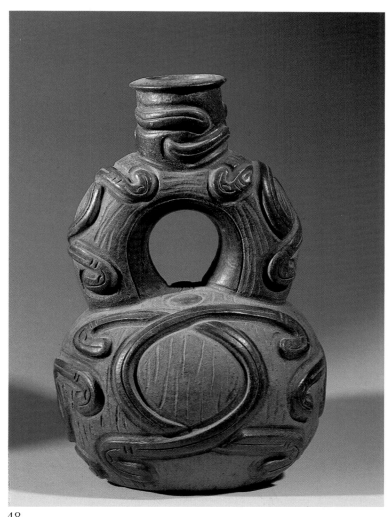

48

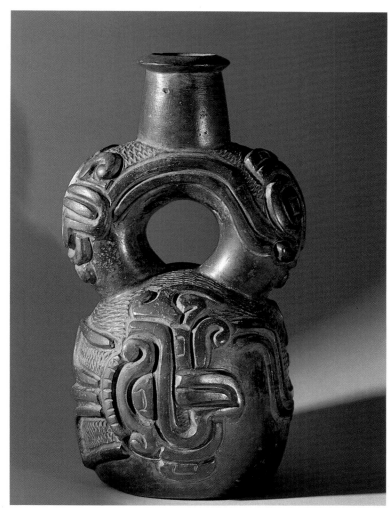

49

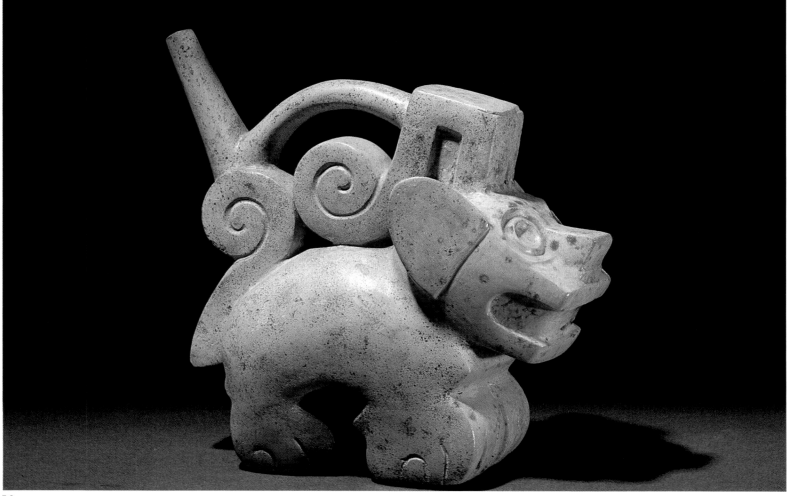

50

seriation is based on three ceramic phases, the first from 850 to 460 B.C., the second from 460 to 390 B.C. and the third from 390 to 200 B.C. We shall now attempt to reconcile these dates with the chronology of Chavín's architecture and sculpture.

The first building to be put up at Chavín between 850 and 700 B.C. was the pyramid containing the Lanzón. The same campaign must have included the small sunken circular plaza, together with the two platforms which flank it. These structures would have constituted the original sanctuary at Chavín.

The edifice was subsequently extended to the north and south. Between 700 and 460 B.C. further campaigns resulted in the creation of a new pile of later date than the original nucleus. This was to form the main pyramid flanked by columns which may have been added between 550 and 460 B.C. Of even later date are the small square sunken court and the large quadrangle flanked by platforms, which may not have been completed until about 300 B.C., while ornamental elements continued to be added until about 200 B.C.

Sculpture and Iconography

In the field of sculpture and decorative reliefs, Chavín was responsible for a number of innovations, both iconographic and technological. The consummate workmanship, the vigour of expression, and the nature, at once synthetic and symbolic, of the compositions led to the creation of 'idols' —stelae, orthostats and columns—that are masterpieces of Classic art.

At Chavín, then, pre-Columbian art suddenly achieves not only an accomplished classic style but also a remarkable maturity. All these works adopt the same formal vocabulary, conform to the same principles of composition, and address themselves to the same task of portraying universal forces in the guise of gods. What we have here is a coherent form of expression very far removed from the crude bas-reliefs of Cerro Sechín. Rigour, conformity and concern for composition—such is the message inherent in the great symbols which go to make up the composite figures, fearsome monsters in which the properties and emblems of various creatures combine to form a mythical entity. Here we find the jaguar, the cayman, the serpent and the condor or harpy eagle, as well as shells and plants. The resulting compositions are hybrids which may be read in many different ways, according to which key is selected for their decipherment.

Motifs such as masks, canines, claws, eyes, nostrils and paws form the basis of a plastic vocabulary which, from its earliest expression in the Lanzón or the Tello Obelisk, is conjugated in combinations of ever greater complexity to culminate in the Raimondi Stela. Here the principles of reduplication, symmetry and repetition have brought into being a work of art whose rhythms are of an almost abstract nature, a work that betrays an astonishing sense of composition in the relation of solids to hollows. At this point it might be pertinent to examine the representations of those deities, those 'idols', that embody the successive phases of Chavín sculpture.

The Lanzón is a monolith, 4,6 metres high, which still stands in the original place it occupied when the sanctuary was built some time between 850 and 800 B.C. (Pl. 37). The sculpture resembles a lance, the narrow shaft of which is firmly secured to the stone roof while the broad

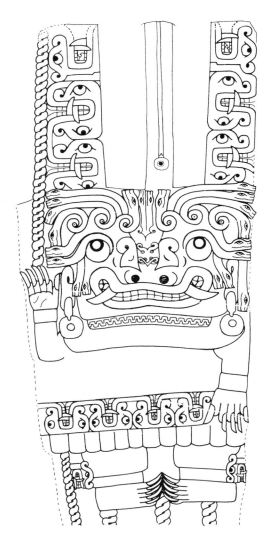

Diagrammatic drawing of the Lanzón showing both faces.

51 Spout and handle jar, in the form of a stylized owl's head, from Vicús. About 400 B.C. The lipped spout of this fine Peruvian piece betrays an interesting affinity with the products of Chorrera in Ecuador (Pls. 24, 25, 27, 28). Here is a clear example of Vicús's role as an intermediary between the Chorrera and the Mochica styles. Museo del Banco Central de Reserva, Lima.

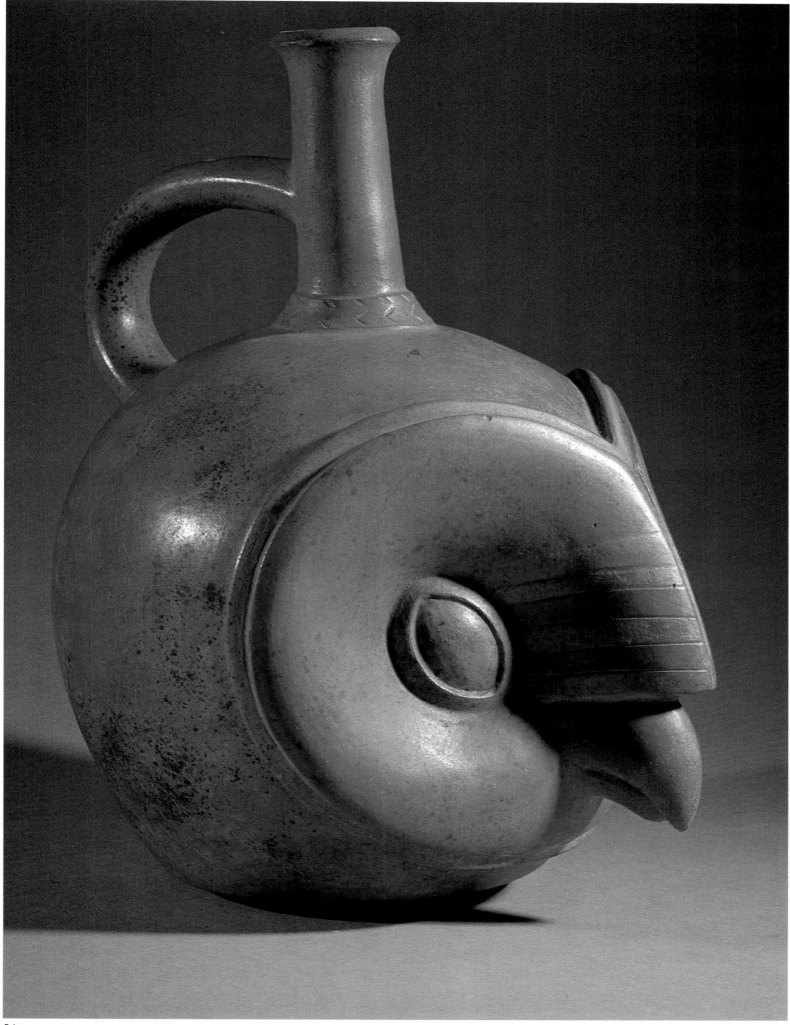

blade tapers to a point embedded in the floor. The work is possibly a representation—enlarged to monumental proportions—of a sacrificial knife for, as we have seen, seven carved stone blades have been discovered alongside as many sacrificial victims in the funerary temple at Real Alto. On the upper 'blade' edge of the Lanzón there is a channel for sacrificial blood which descends from a hidden chamber above through a hole in the ceiling over the forehead and nose of the Great Deity. Hence the natural association between victim and knife, in accordance with an unmistakable symbolic formula. This also applies at Cerro Sechín, where the sacrificers, wielding axes with which to dismember their victims, are shown side by side with the sacrificed.

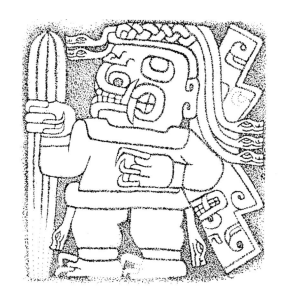

Detail of bas-relief from the round plaza at Chavín de Huántar. A winged feline deity holding a San Pedro cactus, used by the pre-Columbians as a source of a powerful hallucinogen.

It might even be supposed that, in addition to a ritual entailing circumambulation, the Lanzón called for human sacrifice performed in the cruciform chamber, its darkness relieved only by torches. The sculpture requires to be read as a whole when it will be seen to represent the Great Deity in human form, possibly an 'Earth Spirit': in the large mouth are fearsome canines similar to those of a jaguar; the eyes, with their eccentric pupils, are protuberant; the hair and eyebrows serpentine. Superimposed above the head is a series of jaguar masks with jutting canines. Alternately inverted, they form a kind of fret which is repeated around the waist. The arms—one raised, the other lowered—terminate in hands equipped, like the feet, with formidable claws.

These characteristics, all of which derive from an animal world still replete with totemic concepts, provide evidence of an accumulation of symbols calculated to evoke the might of the deity and to emphasize his religio-magical powers. In the shadowy under-world, the Lanzón, only partially visible and sculpturally all but indecipherable, awaits the newcomer. His huge mouth, hypnotic eye and hieratic posture can be known only to one who has walked round him. For the initiate will alone be able to apprehend the connection between this immobile, petrified mass and the message, the voice that issues from the furthest depths of the labyrinthine galleries.

For the Lanzón, firmly anchored between stone roof and floor, represents as it were the earth's axis. What we have here is undoubtedly a chthonic deity, as evidenced by the serpents and jaguars—an 'idol' reputed to speak. For Chavín was traditionally believed to have been the seat of an oracle, a myth perpetuated by some of the post-Conquest chroniclers, among them Velázquez de Espinoza, writing in 1616 and quoted by Federico Kauffmann-Doig. Indeed its labyrinth of passage-ways would have been peculiarly suited to prophetic utterances by voices issuing mysteriously from the bowels of the earth. In the context of an agrarian society, therefore, this, the earliest temple on the site, might well have been dedicated to an earth deity, in the tellurian and cosmological sense of the word, a deity connected with the rituals of seed-time and harvest. The small, round sunken court, its walls decorated with jaguars and priests in feral masks bearing hallucinogenic cactuses, would have served as a link between 'idol', oracle (mescaline-induced prophecy) and chthonic universe.

It was in the darkness of the cruciform chamber that the hallucinogenic drugs were at their most potent and thus able to cast light on the future and unite it with the past, just as the upper and nether worlds were united by the Lanzón, a monolith symbolizing a fixed and immutable axis. Today, after the passage of 3,000 years, it still retains the power of fascination which must have inspired mystical terror into Andean man.

The Tello Obelisk, which was discovered on the lower plaza of the site, is of somewhat later date, as is apparent from the style and composition which place it midway between the Lanzón and the Raimondi Stela, that is between 800 and 650 B.C., an estimate supported by the organization of themes in registers as well as by the delicacy of execution. The stela, 2.52 metres high and 32 centimetres at the point of its greatest width, has been the subject of an exhaustive study by Donald Lathrap (Pl. 41). All four faces of this 'idol' are carved with bas-reliefs illustrating a local religious myth and betokening the deity's powers. Unlike Tello, who took the monster to be a jaguar or puma, Lathrap, in company with J. H. Rowe, comes down in favour of the cayman or, to be more precise, the great black cayman which lives in the Amazon basin and does not hesitate to attack a human—hence the veneration in which it is held.

The very fact there should be some doubt as to the species of animal depicted on the Tello Obelisk—a doubt which persists despite the absolute certainty of line—indicates that the representation is deliberately 'occult', the underlying meaning being transposed into a plastic idiom which, despite certain naturalistic details, is allusive rather than realistic. What is expressed here is the idea, not the zoological reality.

Federico Kauffmann-Doig for his part considers that it has more the character of a bird, an opinion based on the feathery aspect of the monster's tail. In his view the obelisk is a representation, not so much of an alligator or a jaguar as of a hybrid creature, half-beast, half-bird of prey, features of which recur in, for example, the iconography both of Paracas and of Nazca. He describes it as a 'flying feline', a kind of dragon that dominates the Andean world.

It should not be forgotten that certain consequences are implicit in the formulation of religious art, inasmuch as it is symbolic and schematic. In the first place, the representation merely provides us with clues as to its meaning—as, for instance, the vertical treatment of the great deity evoked by the Obelisk and who figures on both the principal faces (A and B) of the parallelepiped. Secondly the image is synthetic; split representation involves complementary symbols on either face, while coherence demands that a message of more than one parameter be provided within a single whole.

From this there results a juxtaposition of traits disposed in accordance with a given structure, a structure which takes into account the importance and the interrelation of the various elements, but which, at the same time, is also a reflection of the intellectual and social organization of the culture it expresses. Thus, like certain totem-poles in British Columbia, it may reflect a cosmology, inasmuch as it represents the pattern of the universe.

On one face of the obelisk the monster is presented as 'lord of the waters and the subterranean world', on the other as 'lord of the skies and rain'. The first of these entities is of the nature of a spondylus, a mollusc symbolizing water; the second is surmounted by a large harpy eagle, which rules the air. In addition we find, as it were, scattered over the surface of the sculpture, the heads of serpents or felines as also of somewhat indeterminate living creatures, all of which seem to gravitate around the principal figure. Each of the two complementary faces is characterized by vegetable motifs drawn from domesticated plants—face B by the pimento and the gourd (in three stages of development—male flower, female flower and fruit); face A by a tuber (achira or *Canna edulis*), the manioc

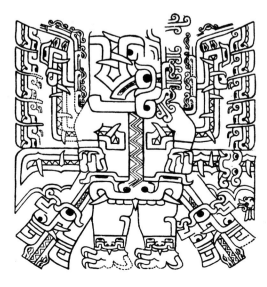

Diagrammatic drawing of the carved motif on the north column of the Chavín portal, representing a flying feline of the type known as 'angel-tiger'.

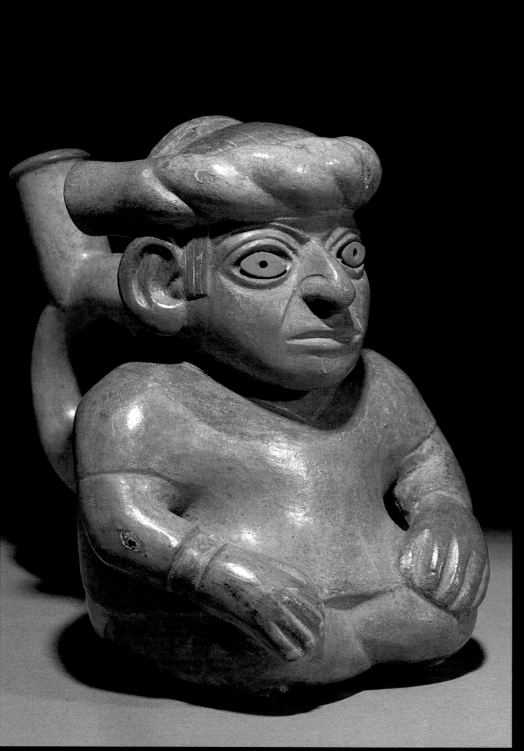

52

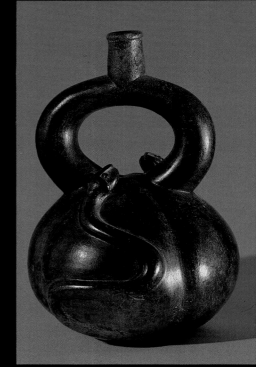

53

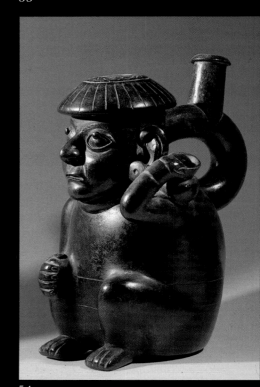

54

52 Anthropomorphic stirrup-spout vessel. Vicús style, probably Vicús–Mochica Phase I, 100 B.C.–A.D. 100. The turquoise eyes, glued into the sockets, lend a remarkable intensity to the gaze of this personage. Height 14 cm. Museo del Banco Central de Reserva, Lima.

53 Stirrup-spout vessel from Vicús. Probably about 300 or 200 B.C. The fine, glossy black surface of this piece has been obtained by reduction firing, while the serpentine decoration, of great sobriety and sinuosity of line, is probably of Late Chavinoid inspiration. Height 19 cm. Museo del Banco Central de Reserva, Lima.

54 Stirrup-spout vessel from Vicús. Mochica–Vicús Phase, 100 B.C.–A.D. 100. Deep black, like the preceding piece, this squatting figure should be compared with that in Plate 69 in which, however, the body has been given more elaborate treatment. Height 19.5 cm. Museo del Banco Central de Reserva, Lima.

55 Stirrup-spout vessel. Vicús–Mochica style, beginning of the first century A.D. The modelling of this jar, depicting an old man in a squatting position, is more advanced than in the preceding piece. The facial expression is vigorous, the gestures are freer and not so stiff, while the legs assume a more natural position. Height 17.5 cm. Museo del Banco Central de Reserva, Lima.

56 Stirrup-spout vessel from Vicús. Beginning of the first century A.D. A fine representation of a crab which testifies to the expertise and the refined plastic sensibility of the potters of that time, who must also have possessed acute powers of observation to produce such delicate natural colouring. Height 18.5 cm. Museo del Banco Central de Reserva, Lima.

57 Stirrup-spout vessel. Classic Vicús–Mochica, about A.D. 100–200. Here the gradual transition from hand to vessel bears witness not only to the potter's mastery of his medium, but also to his powers of imagination. Yet perfectly integrated though it is, the presence of the stirrup-spout in the palm of the hand cannot but strike one as incongruous. Height 17.5 cm. Museo del Banco Central de Reserva, Lima.

(yuca) and perhaps also maize. All of these plants played an important role in the life of the Andean peoples and all originated in the virgin forest. It would seem, therefore, that the god concerned was the dispenser of seed, nutritious plants and grain.

However, the Tello Obelisk, with its zoomorphic iconography disposed in densely imbricated bands within the overall composition of the sculpted block, is more than a mere token of gratitude erected by man in honour of the power which had bestowed agriculture upon him: it is a cosmic emblem. Here we may discern all the orders of creation, revolving round about an imposing symbol in which earth and sky become one.

The symbol of the flying feline recurs in the fine carvings on the cylindrical shafts of the two columns forming the central portal that precedes the main pyramid on this site. These monoliths, 2.3 metres high and 60 centimetres in diameter, are adorned with a design which, when 'unfurled' and seen as a whole, presents a superb, almost square, rendering of the 'jaguar-eagle' or 'winged dragon' of the Andes.

The style and treatment of these sculptures, dubbed *angel atigrado* or angel tiger by Kauffmann-Doig, reveals that they are later than the Tello Obelisk, dating from somewhere between 550 and 460 B.C. In these two bas-reliefs of remarkably delicate workmanship the tendency to articulate the forms by vertical and horizontal bands again asserts itself, while at the same time an already luxuriant ornamentation is further enriched by symbols constantly reiterated, if on different scales. Thus fangs are not confined to the jaws of the felines, but also appear on wings, body, legs and feet. Masks of wild beasts abound, accompanied by serpents' heads which so proliferate as virtually to engulf the composition in what might be described as an ordered luxuriance. At this stage we begin to perceive secondary motifs of a very curious nature. The knees of the flying dragon which adorns the column are presented frontally and together constitute an animal mask with two eyes and formidably fanged jaws. In addition each of the monster's legs has anklets in the form of a stylized jaguar's head (Pl. 38).

Thus we discover one of the fundamental principles governing this mystical composition, namely that each part is an independent whole, as if in an endeavour to express the unending dialogue between microcosm and macrocosm which characterizes the universe.

The place occupied by the Raimondi Stela among the other sculptures of Chavín is an exceptional one. The work, executed in a flat relief, reminiscent of champlevé, on a slab 1.95 metres high, 74 centimetres wide and 17 centimetres thick, probably goes back to the years between 460 and 300 B.C. The perfect symmetry of the composition distinguishes the sculpture from those previously mentioned in that it is completely axial. Moreover, being made of a material as technically demanding as hard, highly polished stone, it lent itself to a design that combines severity with the utmost delicacy and complexity, thereby testifying to the consummate skill of the artist who created it (Pl. 42).

The lower third of the stela is taken up by a thick-set frontal figure, its face a jaguar's mask with jutting fangs. The short, heavy legs terminate in feet with powerful claws and, girding a body wider than it is tall, is a belt made up of two pairs of serpents. In either hand the figure holds an upright staff—as it were a sceptre—ending in a point shaped like a fleur-de-lis. The head displays typical motifs such as a down-turned mouth with a pair of protruding lower fangs, eyes with eccentric pupils, and hair

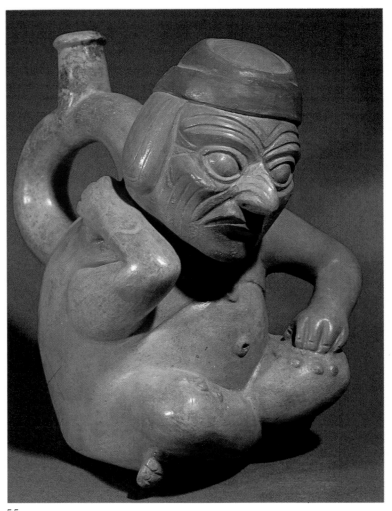

55

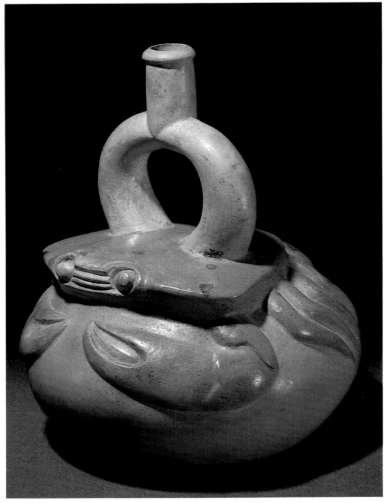

56

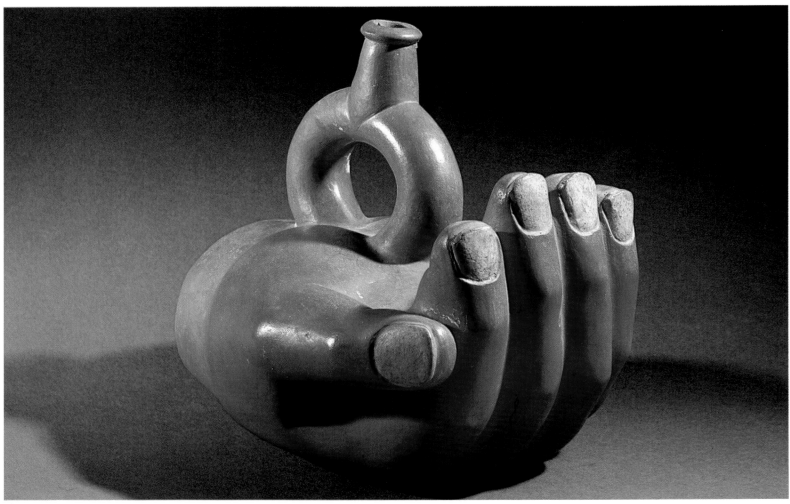

57

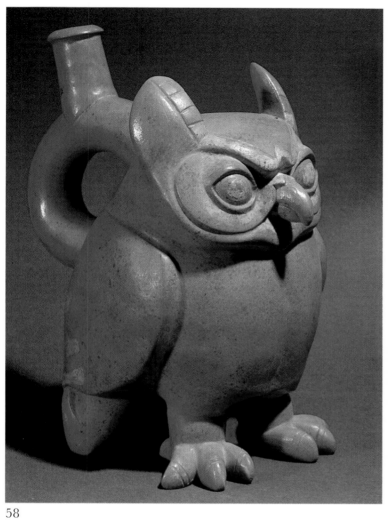

58

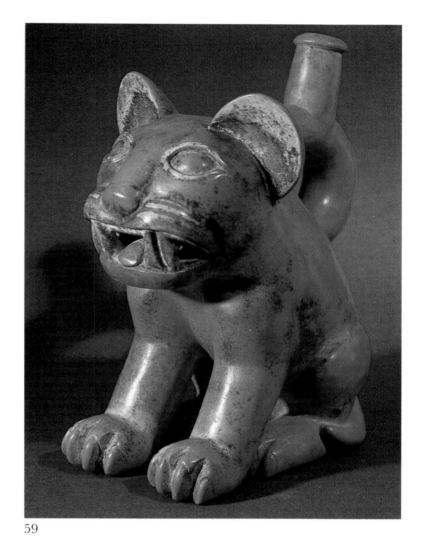

59

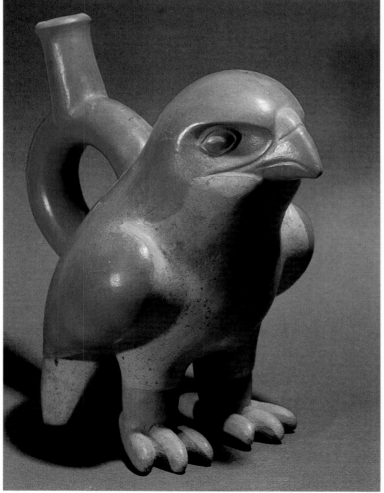

60

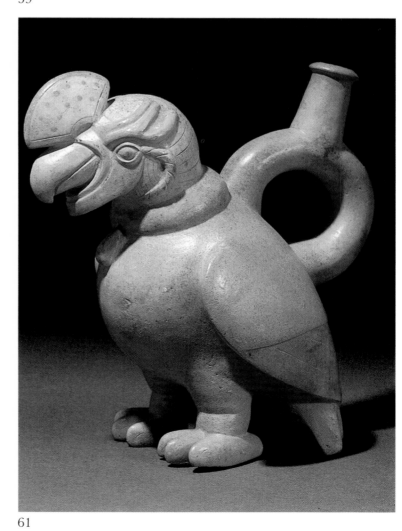

61

in the form of serpents. The whole is reduced to the utmost geometricity and is devoid of all expression, if we except an impersonal air of inflexibility and omnipotence. The graphic treatment of the figure reveals a high degree of schematization based on what is a rigidly horizontal/vertical arrangement.

It is in the middle and upper sections of the Raimondi Stela that problems of interpretation arise. Inverted, the motif surmounting the face might be seen as jaguar's jaws, in which case the eyes of the personage would become the eyes of the feline, in accordance with a combinative technique frequently employed in the symbolic and symmetrical works which, as Claude Lévi-Strauss has shown, occur throughout the Pacific area. In the bronzes of the early Chinese dynasties, as in British Columbian carving and, finally, in the Chac masks of the Mayas, we find the same curious predilection for reduplication, inversion and geometrization. Running through all these works, as it were in counterpoint, are split representations, extension and various forms of bi-lateral symmetry. The above-mentioned technique predominates in the tall plumed serpent head-dress surmounting the figure on the Raimondi Stela. Here we find eyes that may equally be read as nostrils or ears in a superimposition of masks, now human, now monster, surrounded by radiating feathers.

As Kauffmann-Doig, who set himself the task of interpreting this work, has ingeniously suggested, the plumed head-dress is in fact a trailing one which would normally hang down the wearer's back, but which here is made to extend upwards in obedience to the dictates of the design. He likens it to the plumed head-dresses still worn in the nineteenth century by the chiefs of North American Indian tribes. In support of this theory he cites analagous motifs used in the decoration of Nazca vessels. Again, and by way of complement to Kauffmann-Doig's interpretation, the motifs may be read as a series of masks inverted in relation to the deity they surmount, when the composition would be found to possess an affinity with certain totem-poles.

From the foregoing brief analysis it will be apparent that the Raimondi Stela may be accounted the most accomplished work of art in Chavín. In it we find specific forms taken to their furthest logical conclusion, and for this reason it is also the most difficult to interpret. A method of composition employing the juxtaposition and combination of symbols to create a mythical entity here attains not only the most consummate perfection, but also the greatest degree of abstraction. What kind of god, we may ask, was this intricate arrangement of superimposed masks supposed to represent? Perhaps no more than the incarnation of the various orders and levels of reality, of the multiple forms of universal life. Whatever the case, it would seem that what we have here is a god, the invertibility of whose features is expressive of his omnipresence just as the omnipresence of a pantheistic spirit has found its ultimate expression in the reduplication, on various scales of the symbols, already encountered on the columns of the portal.

Unlike the stelae and monoliths which are decorated with bas-reliefs, the frieze round the walls of the main pyramid once displayed heads carved in the round. Each of these projections was tenoned into the facing high up on the building near the cornice (Pl. 40). Above was a carved cornice ornamented with bas-reliefs depicting condors and jaguars in procession. Today, of the forty or so stone heads which formerly graced the principal pyramid at Chavín, only one remains in place. We might add

58–61 Four stirrup-spout vessels from Vicús. Here, in the field of animal art, the potters have given free rein to their predilection for fullness of form. Owl, jaguar, falcon and condor are all executed in a style that prefigures Mochica art. Heights vary between 18 and 19 cm. Banco Central de Reserva, Lima.

62 Spout and handle jar. Vicús–Salinar period, about 400 B.C. The Vicús style reveals an obsession with death, the expression of which became increasingly realistic and persisted until well into the Mochica period. Here, the emaciated head of a dead man seems as though it has been eaten away from within. This piece heralds the great art of the Mochica portrait vessel. Height 21 cm. Museo del Banco Central de Reserva, Lima.

63 Classic stirrup-spout vessel from Vicús. The morbid nature of the subject is accentuated by the wasted nose, fleshless jaws and staring eyes. Height 23 cm. Banco Central de Reserva, Lima.

64 Stirrup-spout vessel. Vicús–Mochica first or second century A.D. Even greater realism is evident in this representation of a *fardo* or mummy bundle in which only the head of the corpse emerges from the textile wrappings—an expression of death that remained unsurpassed until the Mochica period. (Cf. Pls. 74, 75.) Height 23 cm. Museo del Banco Central de Reserva, Lima.

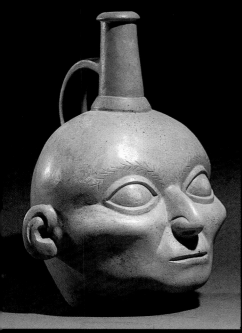

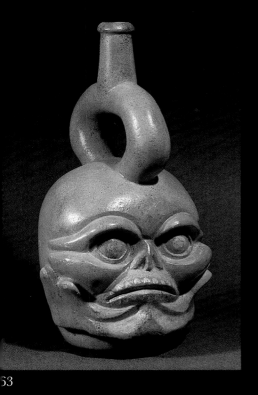

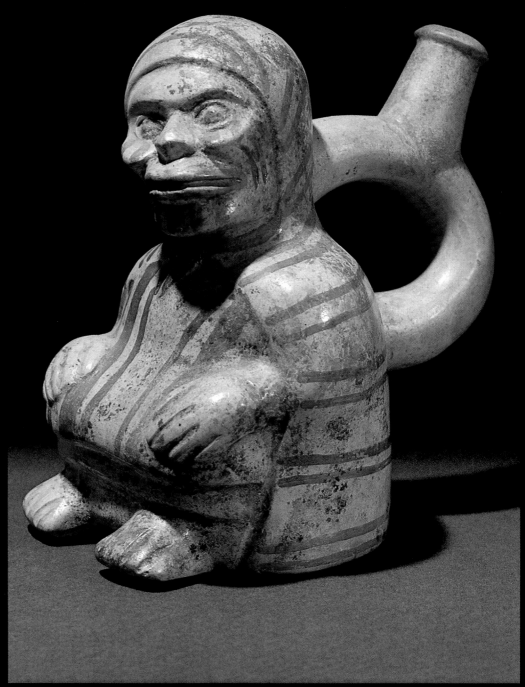

that this too has suffered damage, first from the catastrophic floods of 1945 and then from the landslide that followed the earthquake of 1970.

A number of these heads, discovered by Tello among the ruins, had been placed by him, together with numerous other sculptures, in a small museum erected on the site. The entire collection was lost during the 1945 disaster, and all that we now have, besides the plaster casts made by the archaeologist, are the few examples that have since come to light. Part human and part feline in character, and in some cases depicted with large fangs, these pieces might almost be trophy heads, and are reminiscent of the gruesome figures of decapitated victims in the Cerro Sechín bas-reliefs. The formula of sculpted heads integrated into the masonry recurs much later in the temple at Tiahuanaco. While possibly testifying to the retention of ritual decapitation, it may also indicate that the sculpture has become a surrogate for the flesh-and-blood victim. Though the practice of human sacrifice cannot easily be ruled out at Chavín, it would seem probable that the sculpted heads are more than mere representations of such victims, upon whom they confer a symbolic function bespeaking superior, not to say, supernatural powers. In this connection we should note that the remaining head on the frieze possesses certain traits akin to those of the Lanzón.

From Chavín architecture and sculpture, then, we may see that the pre-Columbian art of the Andean region reached its apogee during the first millennium B.C. What we have here is certainly not a 'Formative' stage, as supposed by many archaeologists who have been misled by the inadmissibly early date assigned to this style. Rather it is a classicism whose influence is discernible in almost every part of Peru and in which all modes of expression combine to produce an effect of remarkable maturity.

The Dawn of Peruvian Ceramics

In the galleries that honeycomb the interior of the Chavín temple platforms, archaeologists have uncovered a quantity of clay vessels of exceptional quality, many of which go back to the earliest days of the site. A number may therefore be assigned to about 850 B.C., a date which marks the emergence of superb burnished black ware in the form of bottles and stirrup-spout vessels. These pieces may be said to constitute the essence of Peruvian classicism in the field of ceramics.

This pottery, which evolved in the course of three phases (known as Urabarriu, Chakinani and Janabarriu) lasting from 850 to 200 B.C., gave rise on the Peruvian coast, notably at Tembladera and Cupisnique, to a Chavinoid style in which local influences were admixed. Thus in the Vicús region, in the extreme north of Peru, we find a blend of the Chavín style and that of Chorrera (Ecuador). For the discovery of the Vicús burial-ground in about 1960 revealed a direct affinity between pieces produced north of the Gulf of Guayaquil and those from its southern littoral. Forms, techniques and principal themes provide evidence of a continuity of evolution from Chorrera by way of Vicús to the full flowering of Mochica classicism.

To avoid imposing factitious subdivisions upon a development which continued for 1,500 years without interruption, we shall discuss the Chavinoid Vicús and Mochica styles, thus drawing attention to the continuity of a production which proclaims the plastic genius of the pre-Columbian potters.

78

IV. Ceramics and Gold-work: the Heyday of the Mochica Culture

During the Chavín period, virtually the whole of Peru came under the influence of a cult of which the custodians were doubtless hallucinogenically-inspired shamans. From this there sprang an extensive cultural community to which archaeologists have given the name Chavín Horizon, by analogy with Mexico's Teotihuacán Horizon. The ritual and cosmological thinking upon which it was based manifests itself in every aspect of the art of that period, and more notably in pottery which engendered what can only be described as an aesthetic idiom. Examples of Chavinoid work have been found all along the coast, in the lower valleys of the Lambayeque, Jequetepeque and Chicama in the north and—although at a much later date—as far south as Paracas and the Ica valley where iconographic feline themes are in evidence.

Chavín Pottery

A systematic series of radiocarbon measurements, published by Richard L. Burger in 1981, has shown that the buildings at Chavín de Huántar go back no earlier than 850 B.C. However, the culture which was responsible for that great centre of pilgrimage must certainly have been very much older. Archaeological sites such as Caballo Muerto, Pocopampa and Condorhuasi (Kuntur–Wasi), or again Alto de las Guitarras and Chongoyape, have yielded pieces indicative of Chavinoid influence. Nearer the coast, at Cupisnique in the Chicama valley and at Tembladera in the Jequetepeque valley, pottery has been found that is typical of the Chavín style and may well be even earlier than the examples found on the type-site during the excavation of the interior galleries of the temple in 1966. Luis G. Lumbreras, who conducted the work, was primarily concerned with the discovery of objects other than bas-reliefs and sculptures and, indeed, succeeded in bringing to light a number of exceptionally fine ceramic pieces in the Chavín style at its most classic.

Aside from their intrinsic value, these vessels are important in that, seen in their stratigraphic context and in relation to given phases of construction, they not only permit greater chronological accuracy but provide an insight into their role as votive offerings. If, then, the unbroken pieces discovered by Lumbreras were in fact dedicated to the deities of the place, this would help to explain the mentality of the artist–potters who created articles of great complexity and delicacy. For these works were agents serving, perhaps, a ritual function—hence the aesthetic quality they express and the care that was lavished upon them.

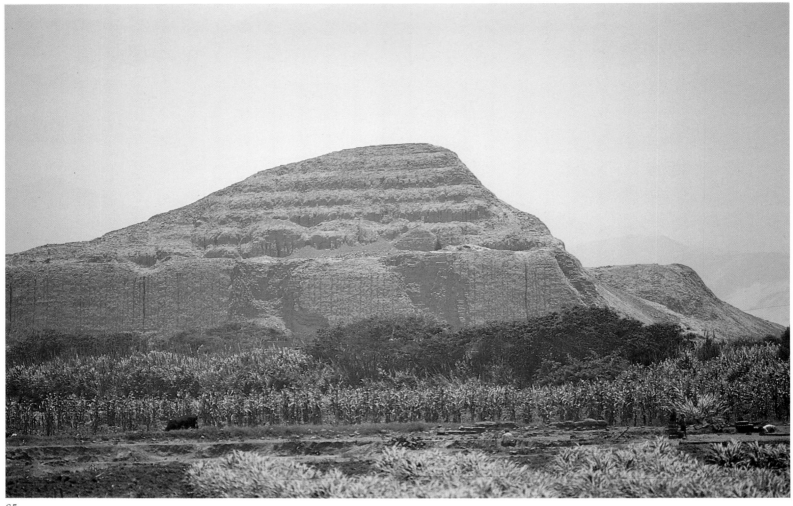

65

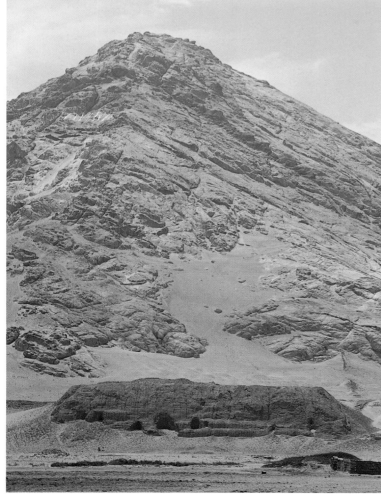

66

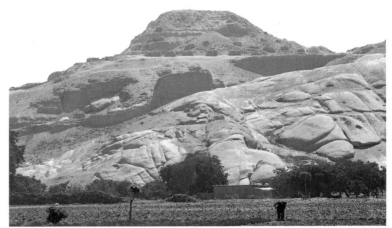

67

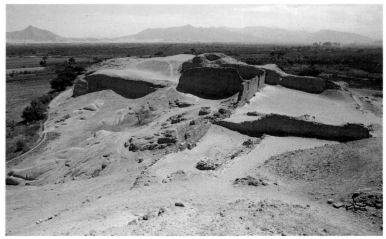

68

Such vessels must be relocated in the chronological sequence that began in the northern part of the region with the earliest manifestations of Peruvian pottery about 1800 B.C. and, in the south, some 800 to 1,000 years later. At this stage, however, the products were still lacking in elegance and were probably of an entirely utilitarian nature. There ensued a long period of development, marked at Kotosh, for example, by the Wairajirca phase (which bears some analogy to transitional Valdivia–Machalilla), and culminating in the more refined pottery known as Kotosh/Kotosh in which the decoration is enriched with anthropomorphic motifs and, more rarely, with feline emblems. From thence we proceed to the Kotosh/Chavín phase which saw the emergence of burnished black ware with incised decoration and probably dating from some time after 1000 B.C. From this sprang the great art of the Chavín potters who manufactured their wares not only at Chongoyape, Tembladera and Cupisnique, but also and more particularly at Chavín de Huántar itself, in phases coincidental with those of the sanctuary.

The subdivisions, namely Rocas—Transición—Ofrendas—Mosna, applied by Lumbreras and Amat to Chavín pottery (the sequence was amended by Lumbreras in 1974 when he placed Ofrendas before Rocas), have been replaced by Richard L. Burger with Urabarriu (850–460 B.C.), Chakinani (460–390 B.C.) and Janabarriu (390–200 B.C.). It will be apparent from this new chronology that the pottery is of much later date than had previously been thought. Not long ago it was still believed that pieces regarded as Early Chavín went back as far as 1400 B.C., whereas today they would appear to be no earlier than 1000 B.C. This demolishes Julio Tello's concept of 'Chavín as the mother of the Andean civilizations' (*Chavín: Cultura matriz de la Civilización Andina,* 1960). Similarly, Lathrap's hypothesis that it was a culture contemporaneous in all respects with that of the Olmecs of Mexico will have to be drastically revised if it is not to be abandoned.

The interest of the new chronology lies, not only in its inherent accuracy, but also in the evidence it provides that the refined art of Chavín pottery, far from constituting a 'Formative' phase, marks the culmination of a long period of technical development in the field of sculpture—a development in which are comprised two great cultural streams originating on the one hand in the Amazon basin (Tutishcainyo) and the Ecuadorean highlands (Azuay) and, on the other, at Chorrera in the Guayas basin. We shall presently consider by what means these two tendencies, dating back to the second millennium B.C., combined to produce the Classic flowering represented by the works of the Chavín–Vicús–Mochica potters.

The pottery that appeared at the beginning of the Chavín period consisted primarily of black ware decorated with incised motifs akin to those found in contemporary sculptures, although here the abstraction is taken to far greater lengths. The feline decoration on the bellies of the jars rarely goes beyond a mask, initially finely engraved (Pl. 44), then in the form of a relief (Pl. 46), developing finally into what is almost full-round sculpture in which human and zoomorphic traits are mingled (Pl. 47). But we also find a wider repertory of highly stylized animal motifs, rendered with great skill in applied relief and evoking say, serpents (Pl. 48) or an eagle (Pl. 49). Again, while the human face is not wholly absent, it is sometimes transposed in accordance with a curious dualistic convention of partial representation (Pl. 45). In terms of form, the earliest

65 Pyramid of the Sun, Moche. By the fifth and sixth centuries A.D. it had grown to a vast size, measuring 340 by 220 m, with a height of 41 m and a volume of 1.8 million cubic metres. It has been estimated that 180 million large adobe bricks were used in its construction.

66 Facing the Pyramid of the Sun at Moche, at the foot of the Cerro Blanco, is the platform known as the Pyramid of the Moon. This artificial esplanade must once have supported palaces and sanctuaries. Length 80 m, width 60 m, height 20 m.

67 The rocky spur, which dominates the fertile Nepeña valley, supports the temple of Pañamarca, a pyramid of six stages. Interesting frescoes have been discovered here. Dating from the Mochica period, they probably depict the sacrifice of prisoners of war.

68 At the foot of the pyramid at Pañamarca, and overlooking the valley below, are compounds which must once have contained the palaces of the nobility, priests and war-lords. The plan of the original Mochica settlement may be traced from the high enclosure walls built of adobe.

examples of simple pear-shaped bottles (Pl. 43) derived from Kotosh/ Kotosh models. The later Chavín potters were primarily renowned for the stirrup-spout vessel which was also to become the hallmark of their Vicús and Mochica successors.

Here we must revert to that strange manifestation, the stirrup-spout pot, in which the handle also acts as a pourer—a construction so complex as to suggest that a particular significance must have attached to this form. In our discussion of Machalilla pottery in Chapter II we noted that this type of vessel derived from the double-spout vessel first produced in Tutishcainyo on the Río Ucayali (a tributary of the Amazon) in about 1800 B.C. and subsequently perfected at Azuay and Kotosh. The fine stirrup-spout jars found at Chavín bear witness to an advanced technique. In these pieces the two curving branches of the tube are attached at the base to the container itself and terminate in a single spout, a design which probably argues a specific function whereby one branch, on tipping, would fill with liquid and the other with air. The gurgling sound that ensued was doubtless no less intentional than the whistle produced by the Chorrera jars alluded to earlier in this book.

Whatever the case, the particular design adopted by the potters when they created this form is not solely explicable in plastic terms. It was simpler to carry on with the system of handle and pourer, many examples of which have been found at Chorrera (Pls. 21-5, 27-8) and at Vicús (Pls. 50, 51), or of the double spout and bridge which found favour at Nazca, solutions that are both simpler and more functional (Pls. 111, 112).

The manufacture of an article as complex as the stirrup originally entailed three hand-made tubes or pipes: two curved pipes were thrust into opposite holes in the body of the vessel and luted to a straight pipe which became the spout. Subsequently the later Chimú version used a two-piece mould for the whole stirrup spout and another for the body, thereby paving the way for mass production.

The harmony of proportion between body and elegant stirrup spout, the generous volumes and the plastic variety displayed by a decoration of truly sculptural quality rapidly raised ceramics to the level of art in the true sense of the term. Before very long the Chavín potters progressed beyond the black and dark brown tones of the early wares, their palette being enriched first by red slip and then by a light brown pigment such as we have already encountered in Chorrera pottery. Finally came what is known as negative or resist painting whereby the design is executed in wax or resin and removed after the application of slip, thus leaving a light-coloured decoration on the red ground. Chavinoid pieces so decorated have been discovered in the cemetery at Vicús (Pl. 46).

As we have seen, this pottery had a religious function in so far as it served as votive offerings in the two temples. While that may have been its main purpose from a ritual point of view, it was also put to uses other than those of a purely utilitarian kind, for most of the pieces have been discovered in burial-grounds, from which it may be deduced that they were intended to accompany the deceased on their journey to the other world. Many of the jars found in the tombs show no sign of having been used for domestic purposes; they must have been viatica provided for a privileged élite belonging to the upper strata of the social hierarchy. Thus the richness of the grave-furnishings, as represented by the number of objects placed beside the deceased, increased in proportion to the standing he enjoyed when alive.

69 Anthropomorphic stirrup-spout vessel, early Mochica style. Even at this early stage, autonomous forms are beginning to emerge. The arms are no longer pressed against the sides, while the position of the legs is nicely observed. However, the facial features are still somewhat archaic. Height 18.5 cm. Museo Arqueológico, Lima.

70 Anthropomorphic vessel. Mochica style, probably dating from the early part of our era. The garments are faithfully rendered, as is the *nariguera* or nasal ornament commonly worn in Peru and Ecuador. Height 21 cm. Museo Arqueológico, Lima.

71 Stirrup-spout jar. Classic Mochica, fifth or sixth century. The genius of the Peruvian potters becomes fully manifest in portrait vessels of this type. Here the artist has admirably caught the mood of gaiety and benevolence expressed by the laughing face of this chief. Height 30.5 cm. Museo Arqueológico, Lima.

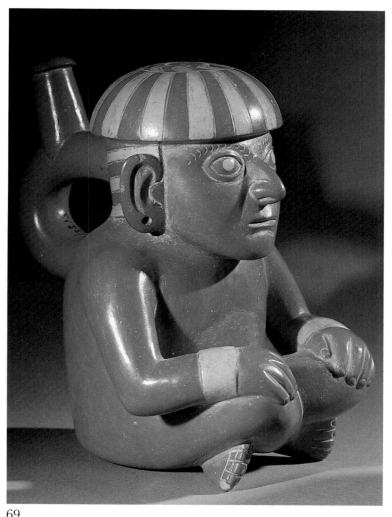

69

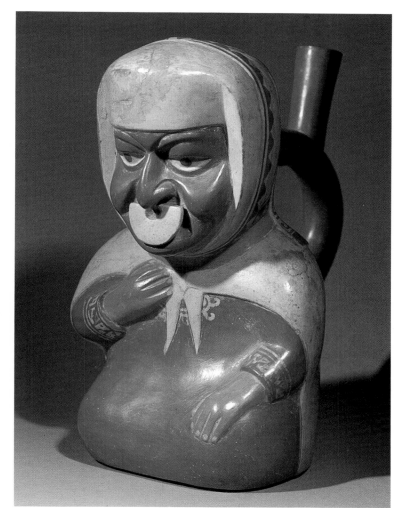

70

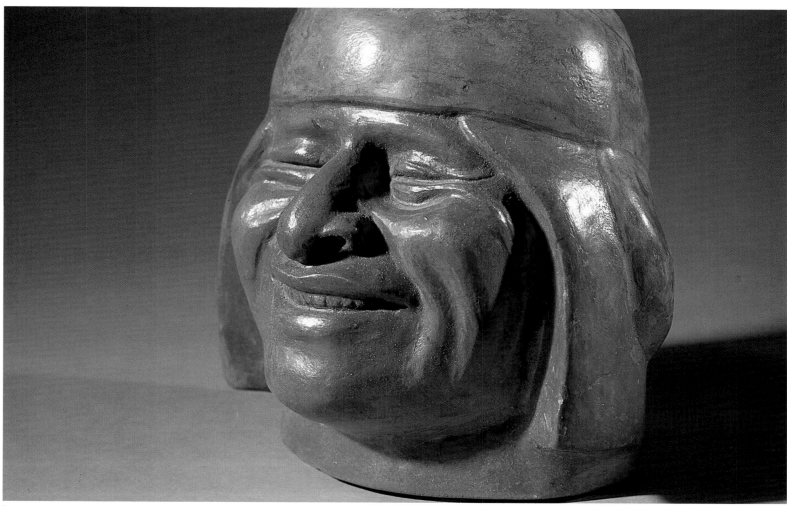

71

Indeed, sites such as Cupisnique or Tembladera consist of hundreds of tombs which once contained many thousands of Chavín-style vessels. These finds, however, have almost invariably been made by *huaqueros* whose illicit excavations amount to nothing more than treasure-hunts. Even the work carried out at Cupisnique by an 'enlightened amateur' such as Rafael Larco Hoyle has, for the most part, merely served to enrich his vast collection, now on display in the Museo Larco Herrera in Lima. It was by no means genuinely archaeological or scientifically authenticated work, however valuable and interesting the insights of which its author has given proof in his publications.

The Discovery of Vicús Pottery

The systematic ransacking of Vicús is but one example of the senseless destruction wrought by the *huaqueros* with the encouragement, more often than not, of a few big landowners who do not hesitate to bull-doze an entire site in the hope of gaining readier access to its tombs. Having thus destroyed at one fell stroke all the stratigraphic evidence, they select from the graves, which they have hastily opened up, only the unbroken pieces for disposal to collectors and to international antique dealers. It goes without saying that no heed is paid to any information that might be gleaned from, for instance, the disposition of a tomb, the method of burial or the association of objects. Nor for that matter is any attempt made to take such elementary precautions as would enable even a relative date to be assigned to the pieces.

The Vicús site, which was discovered in 1961, is situated in the extreme north of Peru on the banks of the Río Piura. Now a dry savannah, the region was once artificially irrigated and therefore fertile. That it waxed fat on its intensive agriculture is attested by the opulence of its grave-furnishings.

Uncontrolled excavations continued until 1964 when the site was exhausted. By that time 2,000 tombs had been robbed of innumerable pieces of pottery, in addition to articles of adornment worked in copper or gold. The majority of the tombs are shaped like a boot, with a shaft 10 metres deep leading to an oval chamber intended to house the deceased and the grave-offerings which were to accompany him into the next world.

It was only when the despoliation had come to an end that scientific circles grew alarmed and decided to investigate the now desecrated graves in the Vicús cemetery. They hoped to obtain at least a few datings from the residues of radioactive carbon in the organic remains on this, one of the richest sites in Peru. As chance would have it, however, the tombs from which the samples were taken all belonged to a relatively late period. The dates given by the measurements were A.D. 250, 410, 460 and 655, which led to a number of errors in the chronological ascription of the objects found at Vicús.

However, as early as 1966 Frédéric Engel, with the help of scientists at Cambridge (Mass.), was able to obtain an initial date—280 B.C.—which has nevertheless often been contested. Now, an examination of the pieces taken from the Vicús site should have shown that the style of the earliest samples is Late Chavinoid, while the latest are coeval with the end of Mochica. Thus the dates of the 2,000 graves discovered at

72 Stirrup-spout jar. Mochica style, A.D. 400–600. The face of the old chief, perhaps a shaman accompanying a dead man to his tomb, is instinct with wisdom. This superb portrait vessel exemplifies the consummate skill of the potter who has endowed what is an almost trivial medium with an emotive quality which enables us to realize how men thought and felt some 1,500 years ago. Height 27 cm. Museo Arqueológico, Lima.

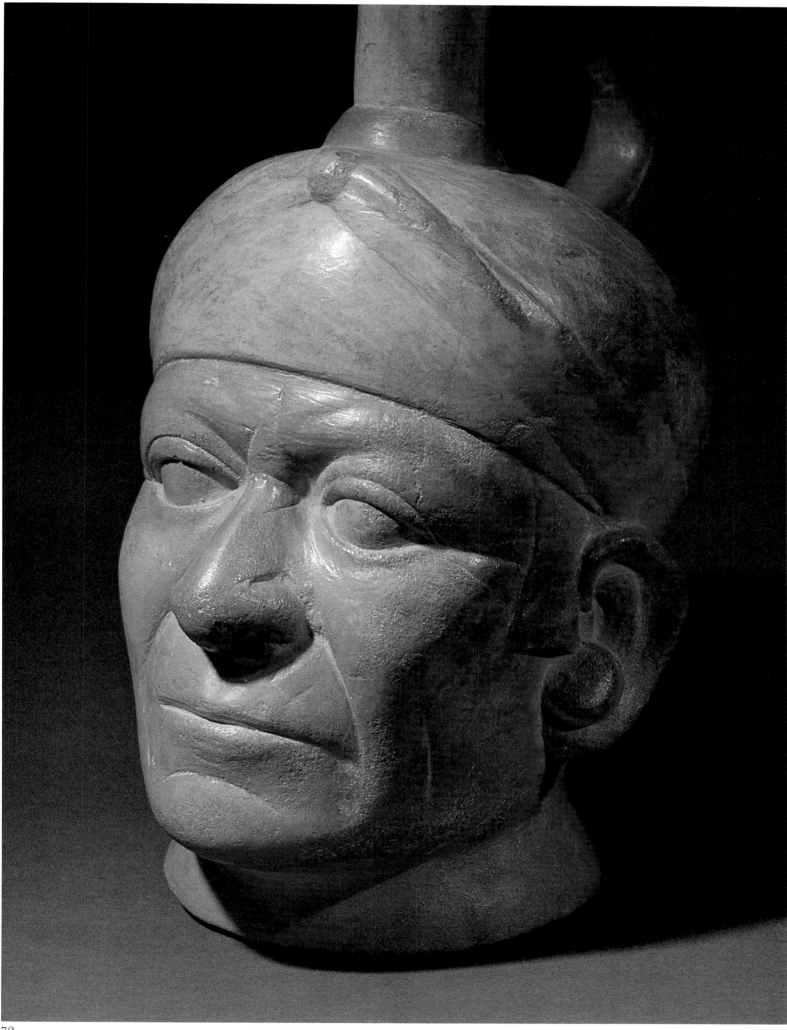

Vicús span a period of close on 1,000 years and provide, from one and the same site, landmarks of the utmost importance to an understanding of the development of Peruvian ceramics.

At the time Vicús was discovered, a Peruvian by the name of Domingo Seminario Urrutia formed a collection consisting of many hundreds of pieces from that site. This, the largest collection of its kind, was purchased a few years ago by the Banco Central de Reserva in Lima, and is now housed in the basement of the building formerly occupied by the bank and since transformed into a museum of exceptional quality which was opened early in 1982.

In addition to Chavinoid work, we also find numerous examples of Classic Vicús which testify to a remarkable feeling for formal concision and stylization. Amongst the works reproduced in this volume we would mention in particular the superb jar with spout and handle, the whole painted in red slip and representing the head of an owl (Pl. 51). The piece, which was probably produced between 400 and 300 B.C., bears striking affinities to the wares found on the by no means distant site of Chorrera. In fact, Vicús is situated no further than 200 kilometres from the Gulf of Guayaquil.

Like the Chorrera potters, those of Vicús must have felt a keen interest in the animal world, for their repertory includes serpents, crabs, birds and felines, all of which shared the environment of the inhabitants and in some cases served as their commons. In Plates 58, 60 and 61 we illustrate stirrup-spout vessels in the form of an owl, a falcon and a condor, in which a feeling for rounded and sober forms harmonizes with the expressionism of a feline piece which betrays the influence of Chavín (Pl. 59). What is particularly striking is the perfect adaptation of the figurative volumes to the function of the vessels. Here the potters have achieved, midway between realism and schematization, a style of great purity and economy of line.

What is new about Vicús art, however, as opposed to earlier works, is the wholesale introduction of human representation. Hence it has sometimes been described as proto-Mochica. In these anthropomorphic jars, some representing warriors or water-carriers, others old men, musicians and so on, the aim is to catch the subject's simple expression, his everyday gestures and immediate appearance, down to the very details of his clothing. True, the faces are still highly stereotyped, with almond-shaped eyes and features that are barely differentiated. Yet the figures with which the potter has peopled his world are now unmistakably human (Pls. 52, 54-5).

Finally, death enters the scene, now in the shape of a *fardo* or mummy bundle, wrapped in a polychrome shroud (Pl. 64), now in that of a disembodied head, hairless, emaciated and hollow-cheeked (Pl. 62), or reduced to a naked skull (Pl. 63). This striving after realism which characterizes Vicús artists also asserts itself in representations of various parts of the body such as the hand, in our illustration cunningly shaped into a stirrup-spout pot (Pl. 57). The original and powerful style created by Vicús potters, with its supreme command of techniques and forms of expression, marks a staging-post between Chorrera and Mochica.

We have alluded more than once to this affinity which, in our view, linked Chorrera with Moche through the medium of Vicús. Such a conclusion is not as obvious as it might seem. Indeed, when the first finds were made at Valdivia, followed by discoveries at Machalilla and Chorrera (called the Engoroy Phase by Bushnell), it occurred to no one that there

might be a connection between the earliest Ecuadorean culture and the products of Peru, for it was believed that a considerable period separated the two. Even after the discovery of the cemetery at Vicús, scholars failed to draw what, in our opinion, was the obvious conclusion. Indeed, Gordon R. Willey, in Volume II of his important work *An Introduction to American Archaeology*, published in 1971—that is to say, ten years after the first discoveries at Valdivia and Vicús—continued to adhere to the view that the links between Valdivia and Peruvian ceramics had not been demonstrated and still remained obscure. Frédéric Engel, on the other hand, showed greater perspicacity when, in 1972, he wrote that Ecuador might have been the source of the earliest Peruvian pottery. But he did not suggest that Vicús had played the role of intermediary.

That site has, however, found an advocate in the person of R. Larco Hoyle. For in his book *Peru,* published as long ago as 1966, he wrote: 'The latest discoveries at Vicús... have opened up new perspectives for the student of that Formative period which is of such vital importance to the development of the Peruvian cultures. Vicús thus represents a cultural pointer... It is the most important centre of hand-made pottery we have in Peru.'

This author and collector was particularly struck by the fact that the finds on this site comprised all those forms which subsequently spread throughout the rest of Peru—stirrup spout, spout and handle, double spout and bridge, and so forth. Again, some of the pieces are quite plain, while others may display incisions, polychrome painting or sculpture, if not all three together. Hoyle sees this pottery as subsuming the production of the Santa Catalina, Chicama and Virú valleys. Yet had he but continued in the direction indicated by the 'cultural pointer' to which he refers, he would have found himself crossing the Peruvian border into Ecuador. However, politico-nationalist considerations, still all too prevalent in this sphere doubtless caused him to overlook the fact that relations between early cultures had nothing to do with modern frontiers, for otherwise his pointer must have led him from Vicús to Chorrera, and from there to Valdivia.

Larco, despite his remarkable powers of perception, confines himself to the view that all the forms, and in particular the celebrated stirrup spout, derived from the Vicús style. He even goes so far as to maintain, not without a touch of chauvinism, that 'there is no reason to believe that these forms were of external origin.' However his dating of Vicús, which he regards as pre-Cupisnique, that is as anterior to Chavín, reveals true insight.

The affinity between the products of Chorrera and Vicús may, we believe, be demonstrated, without recourse to tedious morphological analysis, by comparing some of the works of these two cultures with the help of the illustrations in this book. For the closeness of the links becomes immediately apparent when we consider the Vicús effigy vessel depicting an owl (Pl. 51) in conjunction with the figure of an owl from Chorrera (Pl. 26). Even if the identity of theme be left out of account, the analogy is sustained by the simplified geometric and diagrammatic treatment of the two pieces. Similarly spout and handle establish the interrelationship of the Vicús jar mentioned above, the Chorrera vessel (Pl. 24) and the zoomorphic piece (Pl. 21). Again, if we disregard the stirrup spout, a feature virtually absent from Chorrera pottery, a comparison of the flute-player (Pl. 28) and the water-carrier (Pl. 54) reveals stylistic similarities

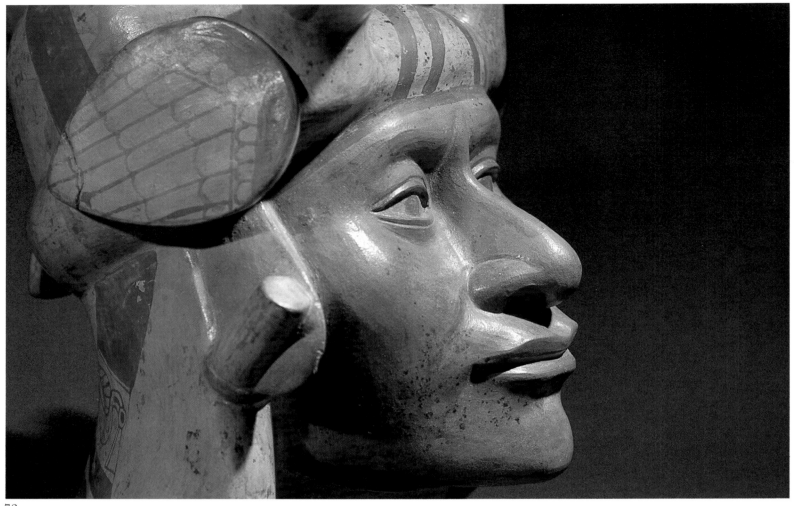

73

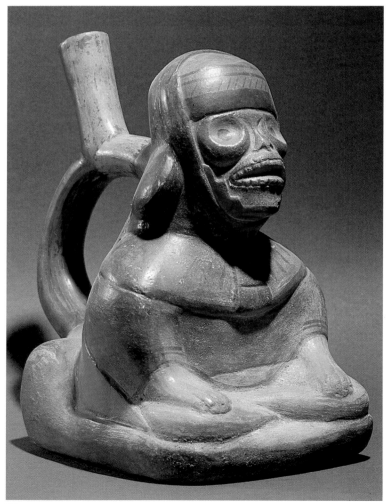

74

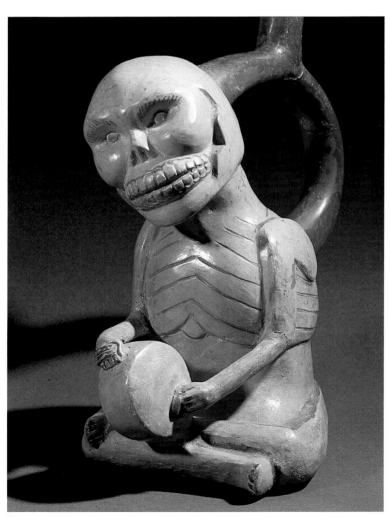

75

in the treatment both of limbs and of posture. Equally instructive is the simplification of line evident in the representation of birds (Pls. 23, 60). However, our Plates were not chosen for the specific purpose of demonstrating the above thesis, and there can be no doubt that a more thorough examination of similar pieces would bring out still more clearly the links in a chain going back more than three millennia from Vicús, itself the direct heir to Chorrera which in turn was the beneficiary of Machalilla and Valdivia.

During the early phase of the Vicús period the spout and handle continued in use, but thereafter the stirrup spout was generally adopted. As we have seen, it was derived from an Amazonian type that evolved in the mountainous districts of Azuay (Ecuador) and Chavín. The Vicús style, then, effected a synthesis of the important trends that existed in the alluvial plain of the Guayas basin on the one hand, and in the upland valleys on the other. Had it not been for the concentration of these various trends on one and the same site, Vicús could not have laid the foundations for the future development of Peruvian ceramics, notably that of the Mochicas.

Mochica Society

So easy is it to mistake early Mochica pottery for classical Vicús that some authors, among them Alan Lapiner, have dubbed the latter proto-Mochica. The transition from one to the other must therefore have been very gradual. Like Vicús, Mochica is, moreover, a conglomeration of widely differing techniques and styles and, as such, reflects the structure of the society which created it, that is to say the confederation of kingdoms occupying a cluster of valleys on the northern littoral of Peru.

The Mochica language was closely related to that spoken in the Manabí province on the Ecuadorean coast. Tradition has it that the Mochicas arrived by raft from the north, which would seem to confirm our view of Vicús as an *entrepôt* between Chorrera and Mochica. The end of the stylistic unity commonly known as the Chavín Horizon somewhere between 300 and 200 B.C. and the collapse of a civilization based upon a dynamic cult, was followed by the rise of a number of small autonomous kingdoms and the emergence of as many artistic trends. Because of the frequent wars arising out of the rivalries between these kingdoms, strongly fortified cities were built on sites that were readily defensible. If this was the age of the 'warring kingdoms', as Willey calls them, it was also one of rapid progress in technology and the arts.

These belligerent conditions were probably due to a population explosion, itself the consequence of substantial technical advances in the field of artificial irrigation which had led to a marked improvement in the standard of living. The rise of the Mochica Confederation can be traced through the medium of the arts. During the early Transitional Phase, lasting from about 200 to 100 B.C., there is evidence of the survival of the Salinar and Gallinazo cultures whose pottery was influenced by Chavín as well as of the Cupisnique style in the Virú valley. Before long, however, the societies unified by the Mochica leaders had again become a cultural entity, even though certain individual traits might still persist.

During the period of its greatest expansion, between A.D. 100 and 500, that cultural entity, formed under the aegis of the Mochicas, embraced the

73 The aquiline features of this young Mochica warrior, immortalized between A.D. 400 and 600, testifies to the intensity of expression which the potters of that time were able to achieve. Height 32.5 cm. Museo Arqueológico, Lima.

74 Stirrup-spout jar. Mochica style, A.D. 300–400. Here death obtrudes more strongly than ever in the shape of a mummy-witch, stressing the tragic fate to which all flesh is doomed. However, it should not be forgotten that these vessels served as funerary offerings. Height 19.5 cm. Museo del Banco Central de Reserva, Lima.

75 Vessel. Late Mochica, about A.D. 600. The man portrayed here, though a mummified corpse, still plays a tambourine, as if to accompany a dance of death. No better example can be found of the fascination exerted by death upon several of the pre-Columbian peoples. Height 25.5 cm. Museo Arqueológico, Lima.

valleys of the Ríos Leche, Lambayeque, Reque, Zana, Jequetepeque, Chicama, Moche, Virú, Santa and Nepeña. Its heyday was followed by a period of stagnation and, from 500 to 700, of regression, at a time when the Huari culture was gradually asserting itself.

Thus the Mochica Confederation was born of wars fought between neighbouring valleys—wars which were to prove a valuable source of slave labour. During the archaic period and up to the time of Chavín, it had been customary, on the morrow of victorious battles, to sacrifice the captives as a token of gratitude to the gods, as has already been seen at Cerro Sechín. The time came, however, when prisoners were taken in such large numbers that there could be no question of their all being put to death; indeed, the majority were employed on the major works demanded by the reorientation of a society henceforward dependent on the irrigation of the coastal plains.

The rudimentary techniques invented by the Gallinazo culture were adopted and perfected by the Mochicas. In order to feed their large urban populations, they needed more arable land, which in turn demanded the construction of a vast network of canals for the distribution of water from the permanent rivers. The Mochicas showed considerable skill in the art of conveying this precious liquid over large distances to the foot-hills, whence contour-line ditching enabled it to be carried to vast and previously arid tracts, which could thus be brought under cultivation. Today most of this area has reverted to desert.

Notable instances of such works are found in the lower Santa valley, occupied by the Mochicas some time between A.D. 150 and 200, and subjected to a regular programme of colonization supported by force of arms. Further north a system of canals was built to connect the Río Lambayeque with its neighbouring watercourses, the Río Reque in the south and the Río Leche in the north. Similarly, the Ríos Moche and Chicama, in the heart of the Mochica kingdom, were linked by means of the great Moro Canal. Here, too, in the Chicama valley, was built the vast Ascope aqueduct which is no less than 113 kilometres long; some attribute it to the Mochicas, others, such as Paul Kosok, who has made a special study of the hydraulic techniques of prehistoric Peru, to the Chimús.

Thus the Mochicas initiated a series of major public works, thereby creating an infrastructure which further encouraged demographic growth. The construction of canals and aqueducts produced vast zones of arable land calculated to arouse the cupidity of less developed neighbours, which in turn necessitated the erection of earthworks and fortresses. All this must have entailed a concerted effort such as would not have been possible without an abundant supply of slave labour, working under the direction of hydrological and agricultural experts.

The methods of cultivation varied greatly from area to area. In the plains, irrigation demanded rigorous collective discipline, not only in the matter of sharing out the water, but also in the performance of tasks such as the maintenance and cleaning of the canals. In the upper valleys, on the other hand, where cultivation depended on annual inundations, the peasants were not subject to these dictates and had to be content with one, albeit uncertain, harvest a year. It was on the coast, however, that a form of agriculture was practised, the originality and sophistication of which remained without equal in the pre-Columbian world. The fields in question lay more or less at sea-level and owed their fertility to the sweet

76 Stirrup-spout vessel. Mochica style, probably A.D. 300–500. The motifs, painted as they are on a light cream ground, place this pot in a special category. In the example shown here sculpture, as represented by the small seated figure of a *chasqui* in front of the stirrup, is combined with a painted frieze of *chasquis* or runners. Height 28 cm. Museo Arqueológico, Lima.

77 Stirrup-spout vessel. Mochica style, A.D. 500–600. This receptacle of very classic form is decorated with a fish whose ventral fins are suggestive of hands. Height 24.5 cm. Museo Arqueológico, Lima.

78 Stirrup-spout vessel. Late Mochica style, as indicated by the flattened loop of the stirrup. About A.D. 600. The painted motifs may represent either tributaries about to make obeisance to their lord or a 'presentation theme' associated with a religious rite. The artist gives prominence to costume and to what may be insignia of rank. Height 30.5 cm. Museo Arqueológico, Lima.

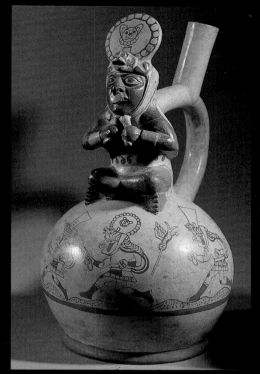

76

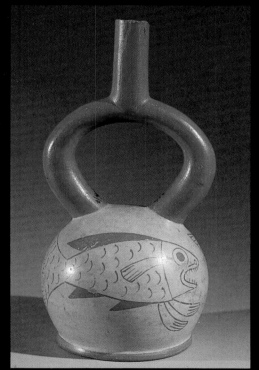

77

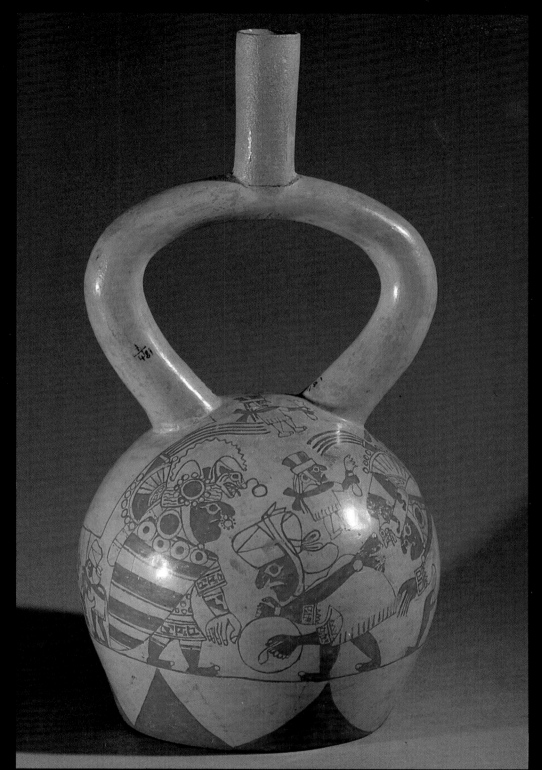

78

water that accumulated underground near the mouth of a river. This accumulation was, in effect, held back by the denser sea-water, thus forming an extensive water-table which the cultivators, with considerable ingenuity, contrived to exploit. Since they did not possess the pump, they excavated their fields to a depth that would bring the surface close to the level of this water-table. Protected from the sea by a strip of land which they reinforced with the spoil, they were then able to engage in intensive cropping throughout the year.

These sunken fields, which did not have the benefit of rich alluvial deposits, would, however, have been quickly exhausted had not the cultivators had recourse to guano, a natural fertilizer obtained from the off-shore islands upon which, for thousands of years, sea-birds had left their droppings. The land enjoyed a further advantage in that it did not suffer from the excessive salinity to which, in the absence of rainfall, artificially irrigated soil is subject, especially when intensively cultivated. Today most of this low-lying land is no longer cropped. The shore has again been invaded by sand beneath which the geometrical pattern of these prehistoric sunken fields is still discernible.

Architecture and Town Planning

The astonishing system of irrigation for which the Mochicas were responsible and which was to be expanded and perfected by their Chimú and Inca successors to the full extent permitted by the technology of the time, would not, as we have seen, have been possible without the help of slave labour. This work force also played an important role in the construction of the great urban assemblies and, notably, of the vast pyramidal sanctuaries.

Now, town planning was the product of the Mochica civilization, whose agglomerations constituted a distinct advance on the peasant village, however large. Indeed, society now became stratified. At the base was a large slave population with, above it, a peasant class, also of considerable size, which supplied the prerequisites of wealth. Next came the merchants and specialized craftsmen (potters, metal-workers, weavers, etc.), followed by the warrior caste and, finally, the ruling class of nobles and priests.

The urban civilization outlined above was characterized by the presence of a sizable city in each of the valleys constituting the Mochica Confederation. While not all of these survived the demise of the latter, others continued to prosper under the Chimú dynasty, so that it is not always easy to decide whether or not a site is of Mochica origin but with Chimú additions.

Of the various cities that came into being in the heyday of the Mochica period, Moche, in the valley of the Río Moche, must be singled out as the probable capital of the confederation to which it gave its name. Others we might cite are Pañamarca in the Nepeña valley, Tomabal or Tomaval in the Virú valley, Pacatnamú at the mouth of the Río Jequetepeque, and Pampa Grande in the heart of the Lambayeque valley. Perhaps we should also include in this list the first stage of El Purgatorio on the Río Leche with its six or seven huge pyramidal structures which subsequently received Chimú additions.

79 The Vicús region saw the first notable advance in Peruvian gold-work. In the early pieces, such as this bowl decorated with repoussé work, the precious metal is extremely thin and is alloyed with copper. Hammering, however, would seem to be a technique that was mastered several centuries before our era. Diameter at the mouth 12.5 cm. Museo del Banco de Reserva, Lima.

80 Pair of votive hands from a tomb. Mochica style. Though their plastic quality cannot be denied, the gold sheets of which they are made have been fastened together somewhat clumsily. They would not appear to have been intended for wear by the deceased. Heights 19 cm and 22 cm. Museo Oro del Peru, Lima.

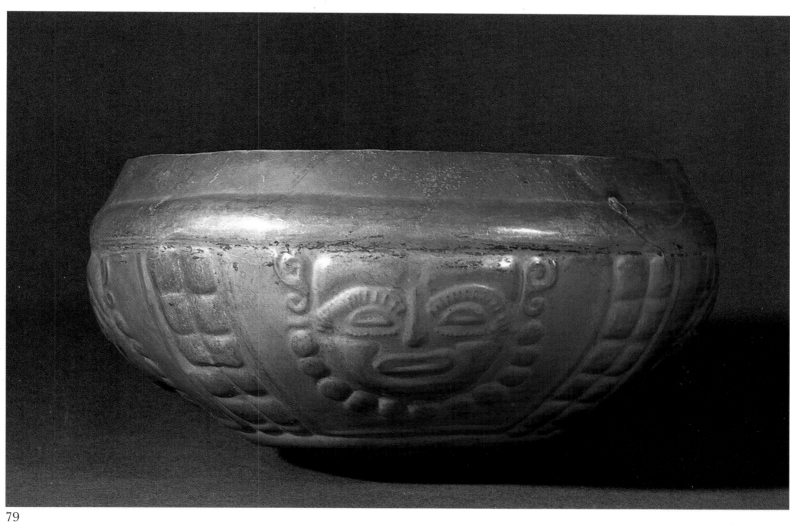

79

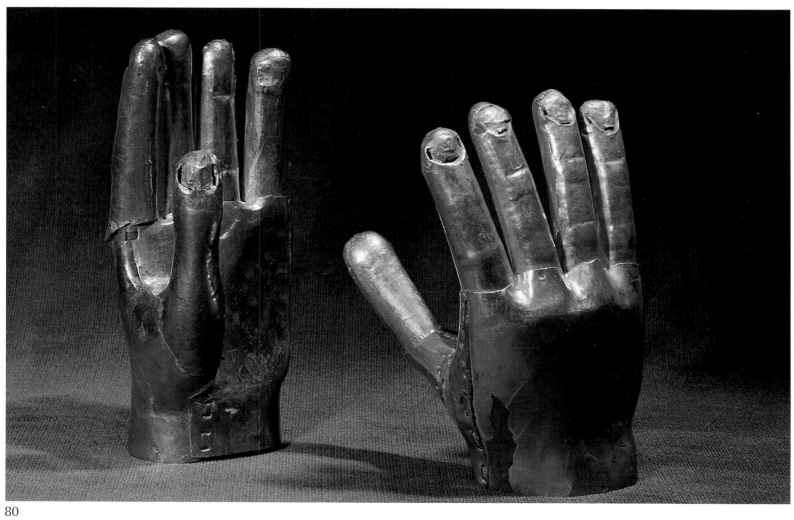

80

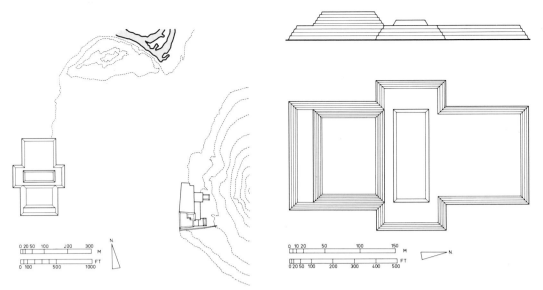

Archaeologists have not always devoted sufficient attention to the Mochica sites, about the architecture of which little is as yet known. Being constructed chiefly of large, unbaked adobes, the buildings are not, it is true, very attractive in appearance. The wind and the admittedly sparse rainfall have contributed to their destruction no less than the activities of would-be grave-robbers. For the great pyramids which dominated the Mochica ceremonial centres sometimes sheltered the tombs of high dignitaries containing funerary offerings of gold-work and ceramics. It was the gold which drew not only the *huaqueros* but also the Spaniards, when looting, officially sanctioned by the viceroy or a provincial governor, would take place on a grand scale. Thus, the year 1602 saw the deliberate demolition of what was the largest pre-Columbian edifice, the Pyramid of the Sun at Moche, when the course of the Río Moche was diverted so that its waters might wash against the adobe mass and bring to light some of the treasures it contained. So profitable did these operations prove that today perhaps only one third is left of a vast and complex structure which must have been the fruit of several building campaigns extending over a long period.

In its final stage the Pyramid of the Sun, which dates from the fifth or sixth century A.D., would have been about 340 metres long with a maximum width of some 220 metres, a maximum height of 41 metres and an average height of 30 metres. Consisting of several stepped platforms and laid out on a symmetrical plan with a crowning terrace, this vast edifice contains some 1.8 million cubic metres of materials, all of which would have had to be manhandled (Pl. 65).

A comparison with two other great human undertakings might help us to gain a better idea of the importance of the Mochica civilization and of the resources needed for the construction of this one temple at the heart of the Mochica kingdom. In terms of volume it comes between Teotihuacán's Sun Pyramid in Mexico with one million cubic metres (225 by 222 by 65 m high) and the great Cheops pyramid at Giza with 2.5 million cubic metres (230 m square and 147 m high). Account must be taken however of the different materials used in these three gigantic structures. At Moche they consisted entirely of adobes, or moulded, sun-dried bricks and at Teotihuacán of uncut volcanic stone mixed with clay, while mortar was confined to the cladding. At Giza the builders used large limestone blocks, each with a volume of between 0.8 and 1.5 cubic metres and weighing between two and four tons. Aside from these differences,

however, which dictated the methods whereby the materials were transported, lifted, extracted and prepared, the cost in terms of effort varied little between the three civilizations and was of the same order of magnitude as the amount of labour required on the site.

If, when considering the investment in labour represented by a work such as the Sun Pyramid at Moche, we wish to apply quantified norms to the various operations—for example, the provision of clay and water, the manufacture of bricks and the transport of those bricks to the actual site, we must confine ourselves in the first instance to the final operation, namely the conveyance of the latter from the yard and their incorporation into the building. Assuming a volume of 1.8 million cubic metres and material having a density of 1.35, we arrive at a total of about 2.5 million tons. If we further assume that each adobe brick is, on average, 32 centimetres long, 22 centimetres wide and 15 centimetres high, or about 10,000 cubic centimetres, and that there are 100 bricks, each weighing 13.5 kilograms, to a cubic metre, the total would amount to 180 million bricks. When newly manufactured, three sixteenths of their volume consists in water, that is, 450 million litres or 0.45 million tons, which subsequently evaporates. Thus the total weight of materials actually handled would be in the order of three million tons.

But to revert to the transport of the dried bricks from yard to site, and their final incorporation into the structure, we may assume that if each workman carried two bricks (27 kilograms) per trip, the distance between the two points being approximately 500 metres, and if he made twelve such trips a day, he would cover 12 kilometres and carry 324 kilograms in all. Thus the investment in labour involved in this single operation may be expressed in terms of 7.5 million man-days; in other words, if 500 workmen were employed for 300 days a year, it would take them fifty years.

In fact, the distance between brickyard and site would be at least 500 metres because of the amount of space needed for puddling, moulding and drying, all of which were obviously done on a vast scale. Many millions of bricks must have been made in one batch for, if 500 labourers each carried 24 bricks a day, this would represent a daily delivery of 12,000 to the site. But since adobes may take up to fifteen days to dry, a permanent stock of between 120,000 and 180,000 bricks would be necessary, which alone would call for an area of more than 1.5 hectares.

If we take into consideration all the other operations—provision of clay and water (from the near by Río Moche), puddling and moulding, we shall have to double if not treble the number of operatives. Thus we may posit an investment in labour in the region of 1,000 or 1,500 workers over a period of fifty years which, in terms of board and lodgings alone, is very considerable.

In fact the building site was not in permanent use for, as we have seen, this edifice—unlike, say, the Cheops pyramid—was the result of several building campaigns, when successive additions were made. Initially it must have been a simple platform on a square plan. During the next campaign a few decades later, two stages were added to the original structure and another platform was erected in front of it. It was thus by gradual additions that the pyramid acquired its complex if symmetrical form, the completion of which may have taken several centuries.

This investment in labour should thus be seen as a series of operations calling for varying numbers of operatives. For example 200 for five years,

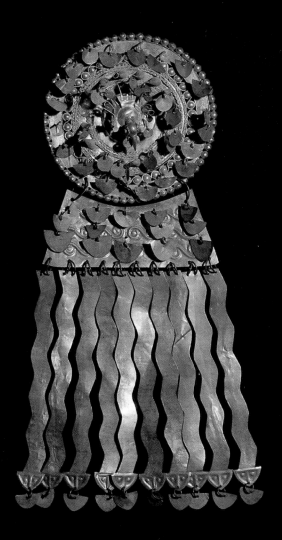

81

82

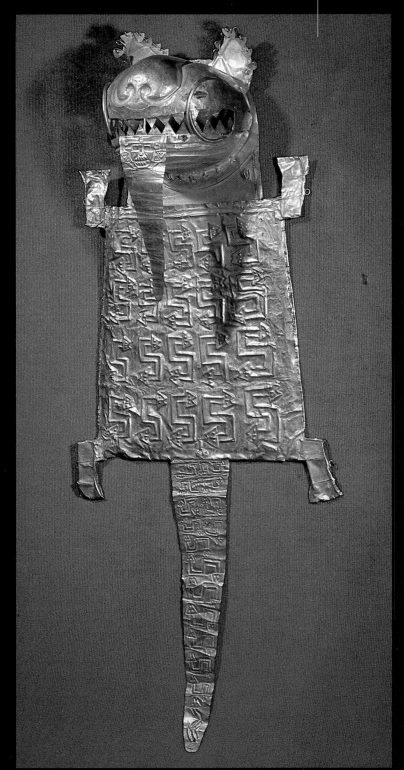

83

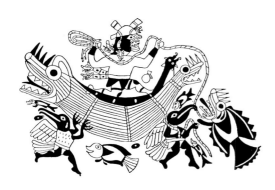

Fishing scene; detail of decoration of a Mochica vessel, showing a fragile craft made of rushes, known as a *caballito de mar*.

81 This piece, which once formed part of one of a pair of identical pendants testifies to the astonishing virtuosity of the Mochica goldsmiths. The three stages, which are hinged together by links, display various techniques such as punching, repoussé, filigree and soldering; the cire-perdue method was used for the beads and the figures of birds. Height 29 cm, diameter of disc 10,5 cm. Museo Oro del Peru, Lima.

82 Ear plug. Classic Mochica period, about A.D. 300–500. This gold piece, decorated with a turquoise and mother-of-pearl mosaic representing a winged *chasqui* wearing a bird mask, testifies to the consummate skill of its creator. Museo Oro del Peru, Lima.

83 Puma skin, an example of Mochica gold-work from the Frias region in the far north of Peru. The highly stylized head is modelled in the round, while the body, decorated with two-headed serpent motifs, forms a receptacle in which the coca-leaves used in shamanic rites were kept. Height 64 cm, weight about 650 gr. Museo Oro del Peru, Lima.

followed by 400 for eight years, then 500 for ten years and so on, until the final and most ambitious stage, when as many as 1,000 or even 1,500 men would have been employed on the final shaping of the structure. Between each campaign the pyramid was used as a place of worship. Its volume must have increased along with the growth of the kingdom's power and as a function of the size of the active population, the latter in its turn being dependent upon the area brought under cultivation in the course of major public works. It might even be supposed that, after a victorious war, the number of slaves employed on building work momentarily rose by between 300 and 500 per cent, according to the availability of food.

This additive phenomenon to which the ruins bear witness is by no means confined to Peru. Indeed, it is one of the chief characteristics of pre-Columbian architecture in Mexico, where it takes the form of a series of superimpositions in which the old building disappears beneath the new. In Peru, however, these campaigns were due, not so much to a system, as to the dynamic and prosperous phases of Mochica.

On the Moche site, facing the Pyramid of the Sun across a distance of some 600 or 700 metres, stands the Pyramid of the Moon (both are post-Conquest appellations). This edifice, which projects from a stony hill-side, is 80 metres long and 60 metres wide and attains a maximum height of 20 metres. It is an extensive adobe platform which would appear to have served as an esplanade supporting a palace quarter flanked by sanctuaries (Pl. 66). Around the platforms are precincts and walls, behind which there must have been large buildings that are now difficult to identify, so much have they been eroded by nature and by the illicit depredations of the *huaqueros*. Remains of painted plaster on their walls of beaten earth show that they must once have been clad with plaster to serve as a ground for frescoes such as those at Pañamarca where scenes of some importance to the study of Mochica ritual iconography have been uncovered (Pls. 67, 68).

Pañamarca and Pampa Grande

The temple of Pañamarca in the Nepeña valley is a pyramid some 20 metres high crowning a rocky hill in the midst of a cultivated plain (Pl. 67). It is the centre of an agglomeration and like all the others in the coastal region is so sited as not to encroach on productive agricultural land. Of adobe construction, it has six stages and a cladding of plaster on clay rendered with whitewash to serve as a ground for paintings. Amongst the subjects here displayed are prisoners threatened by jailors carrying hooks as well as creatures, half-man, half-fox, who offer up blood in ritual vessels, probably of gold or silver, similar to those found in the tombs. Priests and high dignitaries are recognizable by their sumptuous garb and elaborate head-dresses. Around the pyramid are a number of high-walled courts reserved for the clergy and the nobility (Pl. 68). These in turn are surrounded by the more lowly dwellings, now mere shapeless heaps, of traders, cultivators, craftsmen and soldiers.

But Mochica architecture does not consist solely of pyramids and enormous esplanades, as may be seen from the works published in 1978 by Izumi Shimada on Pampa Grande in the valley of the Lambayeque. The author provides an insight into the urban planning of the vast

agglomeration which, extending over an area of from 4.5 to 6 square kilometres, was built during the final phase of the Mochica culture, between A.D. 500 and 700, and served as the new capital of the kingdom after the abandonment of Moche.

Here the domestic buildings are clustered together in compact districts served by such few alleyways as were necessary in the absence of wheeled vehicles. The passages or narrow corridors led to courts and various open spaces, parts of which may have been covered by light pentice roofs. These multilateral depressions, as the author calls them, generally consisted of a sunken space lined by battered adobe walls to form a sort of precinct. The multilateral depressions would seem to have been used as meeting-places where the inhabitants engaged in a variety of domestic activities such as husking maize or grinding it in the metate *(metate y mano)*, spinning, weaving and, in short, carrying out all the day-to-day tasks which, thanks to the climate, could be performed in the open air. As to the dwellings themselves, the accommodation they offered was extremely cramped. They were simply shelters, disposed without much regard for order, within a framework, the scale of which was determined by that of the juxtaposed elements. The density of the population was relatively high despite the fact that none of the houses had more than one storey. From this point of view the urban agglomeration probably differed little from the simple agrarian village.

From Portrait Vessels to Polychrome Pottery

After our brief survey of the architecture and society of the Mochicas, we can now return to their pottery, an art which, as exemplified in the vessels found in the tombs, now attained its apogee. It perpetuated the forms and decorative motifs characteristic of Vicús and, indeed, so close are the links between the two that the provenance of certain pieces is sometimes difficult to determine. Allowing for slight differences in colouring and pose and, in the Mochica vessel (Pl. 69), for a greater suppleness of gesture indicative of its later date, there is no mistaking the affinity between this piece and the Vicús jar depicting a small squatting figure with a domed head-dress (Pl. 54). Information on the types of ornament and dress worn at this time may sometimes be gleaned from anthropomorphic pieces such as the Indian wearing a typical Andean nose ornament *(nariguera)* and a Mochica head-dress (Pl. 70).

But it is in the portrait vessel that the full genius of the Mochica artist becomes apparent. The lively and forceful image of man presented in these objects suggests a real capacity for introspection: we need only cite the face of the old chief, at once alert and thoughtful, whose every feature is instinct with wisdom (Pl. 72), or again that of the debonair laughing man, his joviality expressed in the screwed-up eyes and the lips parted to reveal the teeth (Pl. 71). The Mochica sculptor's power of individualization is also apparent, if in more idealized vein, in the arrogant and resolute expression of a young warrior (Pl. 73). Finally, the theme of death, already encountered in Vicús pottery, is here invested with striking realism and dramatic force (Pls. 74, 75).

High though the quality of these portrait vessels may be, we have not thought it necessary to provide many examples in this book, since they have already been amply documented elsewhere. Nevertheless, certain

aspects of this art still remain obscure. For instance, specialists are unable to agree as to the techniques used in its production. In his book, *Treasures of Ancient America,* Samuel K. Lothrop suggests that the majority of Mochica vessels were press moulded. According to him this process consists in modelling an archetype which is then coated with clay. Before the coating is completely dry, it is cut vertically in two and then fired. Replicas are obtained by pressing a thin layer of clay into this mould and subsequently joining the two halves together when almost dry.

Lee A. Parsons is also of the opinion that the mould was first introduced at the beginning of the Mochica period. Though at a later date, under the Chimús, mass production was to lead to a loss of quality, he believes that the beauty of Mochica pottery was not impaired by recourse to this technique.

Unlike these two specialists, the archaeologist Frédéric Engel maintains that the best portrait vessels were sculpted while the clay was still malleable and that only pieces of inferior quality were produced with a mould. It may be a matter for surprise that such divergent views can be expressed on the subject of the technique used in producing these famous works. In our own opinion, the solution proposed by Lothrop would seem to answer the problems inherent in sculpting a thin layer of malleable material. Thus the quality of a piece—its individuation and polychromy—would be the result of touching up after removal from the mould. The use of the latter does not necessarily imply its re-use, but rather suggests that moulding may long have remained the only known method for 'one off' production of hollow ware, notably of the stirrup spout which could hardly have been manufactured in any other way. Mass production was a later manifestation, and it was at that stage, perhaps, that ceramics lost their potency, their significance, their individualized function, in short, their magic.

Indeed, Anne-Marie Hocquenghem, who has studied a number of these portrait vessels, is of the opinion that the more realistic of the moulded pieces were not intended for reproduction. She believes them to be portrayals of shamans and relates them to a funerary rite which alone would enable the deceased to pass into the other world. A vessel of this kind would then constitute a viaticum.

Another type of pottery, peculiar to the Mochicas and of particular value as a source of information on their beliefs and religious practices, is the painted fineline vessel. Here the decoration is executed on a light cream ground in black, brown or red pigment and consists of animated scenes drawn with great vivacity. Initially the vehicle for simple and, perhaps, prophylactic motifs such as a fish equipped with hands to evoke water and its properties (Pl. 77), these vessels later displayed mythological themes. Thus the *chasqui* so frequently depicted may be assumed to be not just a runner, but also and in addition a messenger of the gods—as it were an Indian Mercury (Pl. 76). The larger scenes, possibly deriving from a mythological cycle, present us with a veritable *dramatis personae*, peopled as they are with courtiers or worshippers who prostrate themselves before a king or deity. Christopher B. Donnan, who has studied these scenes, has found here what he calls the 'presentation theme' in which priests offer up the blood of sacrificial victims to a god (Pl. 78).

The same author also discusses a large range of painted vessels whose subject-matter is based on burial themes, while at the same time seeming to depict the infernal powers and the world beyond the grave. This pro-

84 Head ornament or diadem in punched and embossed gold leaf, depicting a feline mask surrounded by 'rays' in the form of serpents. The piece comes from the island of La Tolita in the north Ecuadorean province of Esmeraldas and has been attributed to dates which vary between 500 B.C. and A.D. 500. Width 49 cm, weight 245 gr. Museo del Banco Central, Guayaquil.

85 Gold funerary mask from La Tolita, Ecuador. The nose has been applied, which suggests that the goldsmiths were still feeling their way, despite the sophisticated treatment of the eyes. The nose ornament is known as a *nariguera*. Height 16 cm. Museo Casa della Cultura, Guayaquil.

86 Gold funerary mask, also from La Tolita, with almond-shaped eyes and recessed pupils. Like the preceding piece, it probably dates from about A.D. 200. Height 18.5 cm. Museo Casa della Cultura, Guayaquil.

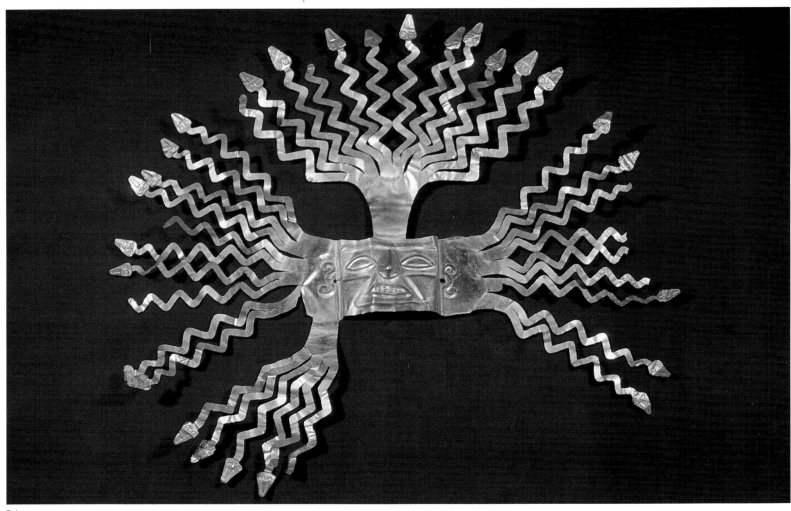

84

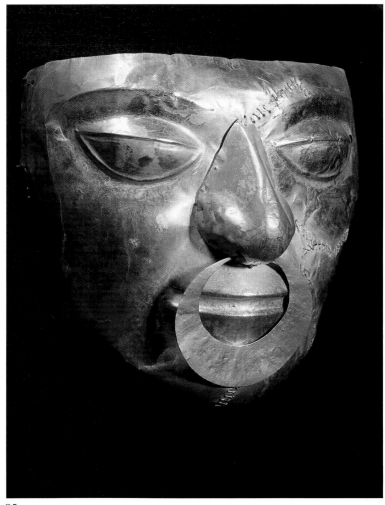

85

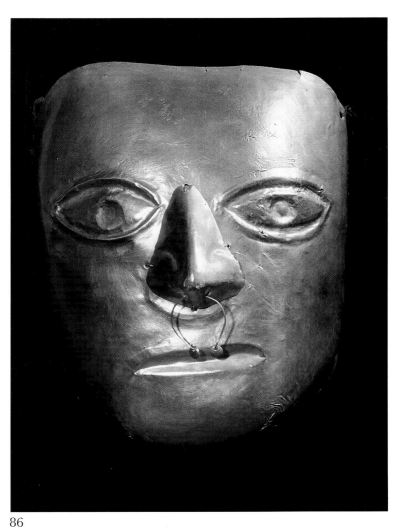

86

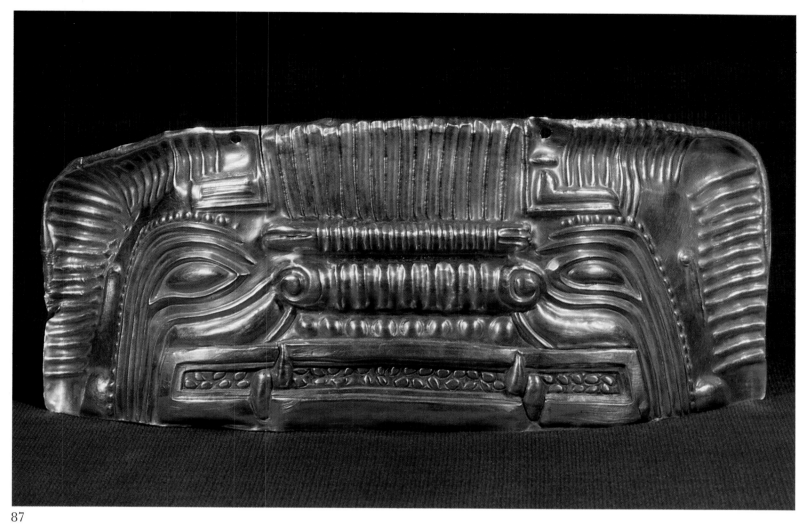

87

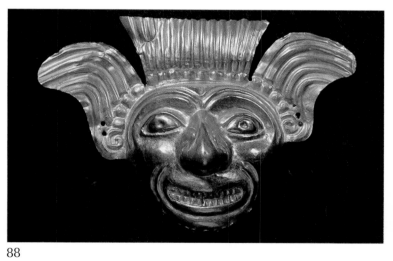

88

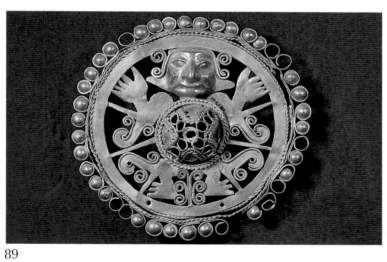

89

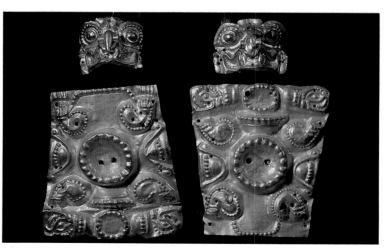

90

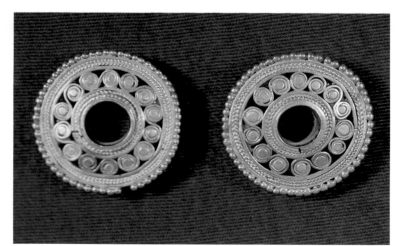

91

vides clear evidence that the jars must have played a role in funerary rites, as does the fact that all the pieces that have come down to us have been discovered in cemeteries. Whatever the case, these works, with their lightness and vivacity of line, add to our knowledge of Mochica design, as do the all too rare remains of mural painting which would seem to have been inspired by the same mythological cycles and to derive from the same style.

Ceramics and Art

The pottery of the early Andean civilization, like that of many other New and Old World cultures, is of considerable interest not only because its durability enabled it to serve as a signpost in what is necessarily a relative chronology, but also by reason of its privileged position as a medium of artistic expression. All manner of preoccupations is reflected in the work of the pre-Columbian potter as it is in that of his Corinthian or Attic counterpart. Here we may find anything, from erotic obsessions and everyday themes, such as food and domestic animals, to the personification of deities or the forces of nature in the shape of monstrous beings composed of anthropomorphic and zoomorphic symbols. Later, at a more advanced stage of civilization, pottery became the vehicle for human representation in which men are depicted in typical attitudes and attire as they go about their daily business. This thematic eclecticism was followed by a form in which the vessels are clearly portraits of specific individuals. Here, thanks to his astonishing powers of observation, the potter succeeds in conveying his sitter's personality in terracottas that are the crowning achievement of Mochica art.

It is an art that bears comparison with the finest examples of antique sculpture, with Roman naturalism at its most faithful, presenting as it does an image of man so precise as to embrace every subtle nuance, and which shuns neither the peculiarities, the deformities, nor the ailments of the person portrayed. What was the purpose of these works? They depict reality in such minute detail, reveal such assurance of vision, and interpret an expression so truthfully that they transcend all idea of a mere likeness. Were they, perhaps, *doppel-gänger* intended for use in some magic ritual?

At all events, it is this talent for plastic synthesis which particularly fascinates when we consider the art of the potter in the great pre-Columbian civilizations, in particular during the period from Chavín to Mochica. Everywhere we find a rejection of straightforward naturalism or, as we should say today, of hyperrealism, dull, lifeless and stereotyped; but everywhere, too, a measure of fidelity to the model, though not so close as to preclude the suggestion of a movement, a glance, an attitude. For it is a form of figurative art that is wholly intent upon expressing the quintessential and which, no matter how apparently trivial the vehicle—a jar, say—is a form that succeeds in transcending itself. Now—and this cannot be said too often—however admirable the expression attained by, for example, a Greek urn, it represents only one aspect among many others of an art that includes not only bas-reliefs and sculpture in the round, whether in bronze or marble, but also and by extension, literature and music. But in Mochica art, in addition to metal-work and painting (represented by a few very poorly preserved frescoes), only pottery plays a major role. Upon that medium, still curiously linked with its original

92

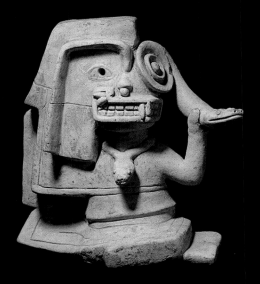

93

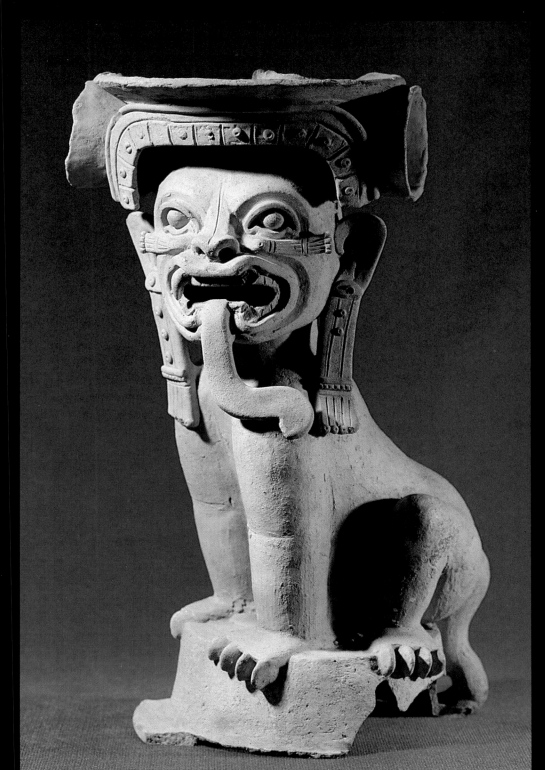

94

functionalism, devolved the whole responsibility for conveying the plastic message of great art, and it was through that same medium that man found his highest form of expression 1,500 years ago.

This can be explained in terms of the role played by these objects, for it may well be that, in addition to the simple and utilitarian pots of the earliest period, vessels of the highest quality were subsequently manufactured expressly for the purpose of furnishing the tombs of persons of high rank. Many of these pieces would appear never to have been used. In some cases the portrait vessel may also have served as proxy for the sacrificial victim, human sacrifice having been abandoned in favour of a simulacrum. However its funerary function probably derived from an even earlier practice when it was used as a votive offering, a theory endorsed by the discovery of fine Chavín vessels in the galleries of the oracle's temple.

Art and Archetypes

The convergences between civilizations which are related neither historically, geographically nor chronologically are, indeed, something of a conundrum. The occurrence of grave-goods amongst the ancient Greeks, the Etruscans, the pre-Columbians, the Chinese and the Persians, to name only some of the cultures which placed vessels in the tombs of their notables, poses innumerable questions of some complexity.

Why, we may ask ourselves, should certain peoples have felt the need to place carved or painted objects alongside the deceased, and what was the role played by zoomorphic, vegetal and even anthropomorphic vessels? In the case of the latter, the intention may have been to perpetuate the features of the dead person by reproducing them in a non-perishable material such as the gold used for making masks, while the function of vessels portraying warriors might be of a tutelary nature, as in the case of the Eternal Guard of the Chinese emperors. Where the pots or their decoration assume the form of plants, these may represent a perpetual source of food, a similar concept being embodied in the bas-reliefs in Egyptian mastabas or tombs. Of certain Mochica pots displaying mythological scenes, it might be asked whether they were not, in fact, a religious symbol—as it were a 'Book of the Dead'—for in the absence of texts the decorative bands applied to the body of these vessels might be regarded as the equivalent of a viaticum or vade-mecum, guiding the deceased to the deity, and thus placing him under the exalted protection of the god portrayed.

But apart from these questions, many of which admit of no answer, there is another and more persistent one: How can we account for the adoption of analogous modes of procedure by cultures between which there has been no contact? The civilizations of the Old and the New Worlds, irrespective of the different ways in which they developed, all took a similar view of the function of art, that is to say of the beautiful. Artistic creativity was everywhere intimately linked with the gods on the one hand and with death on the other. This similarity of function, conditioned neither by influences nor by diffusion, may be explained in terms of man's concept of the soul, the dream, the imaginary and the eternal. These he sought to materialize in the above-mentioned media which he 'informed' in order that the latter might participate in his

95 Ecuador was the home of another highly original art, that of the coastal Jama Coaque culture which flourished in the northern part of the country. This house vessel from Cojimies takes the form of a pyramid ascended by an axial stairway which leads to a goddess enthroned in the sanctuary at the top. This piece is decorated with applied elements. Height 19 cm. Museo del Banco Central, Quito.

104

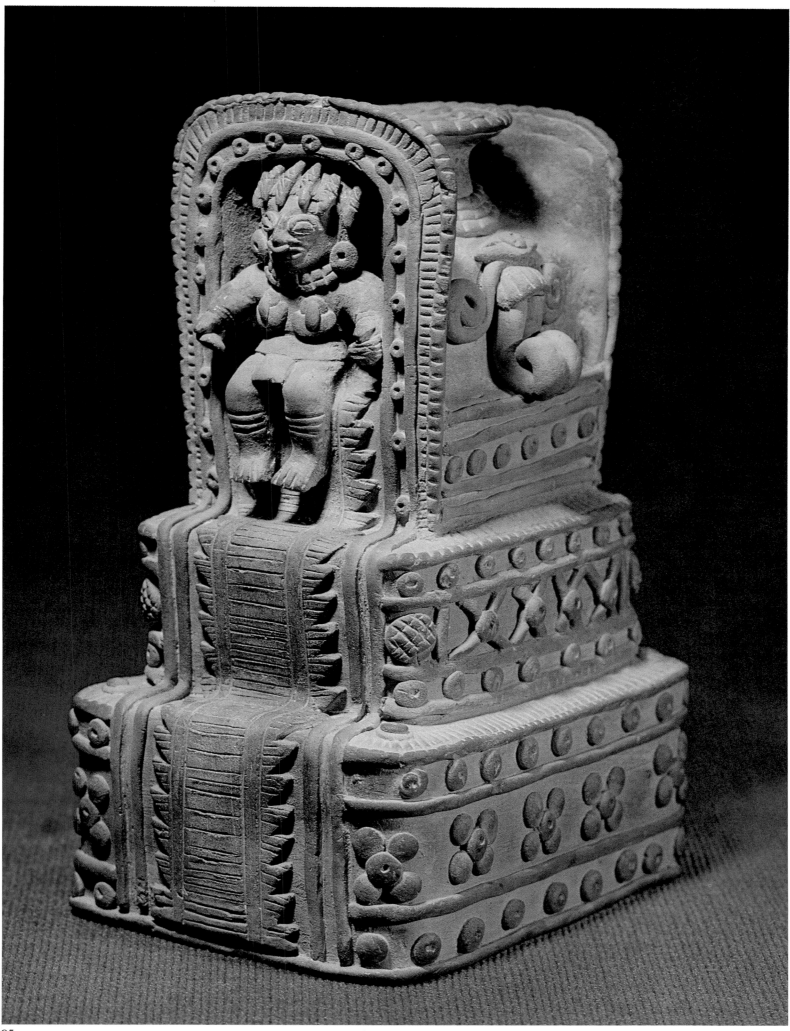

myths, help him to elude mortality and raise him above his fortuitous and transient condition.

This in turn gives rise to the question of why, at a certain stage of social and technological development, so many analogies should exist all over the world between peoples whose contacts with each other ceased some 10,000 years ago, before the first pyramid was built, or pottery and gold were used to furnish tombs and provide imperishable masks for the dead. No less puzzling is the fact that peoples separated in time by several millennia and in space by many thousands of kilometres, should have had recourse to identical methods in applying identical materials in similar forms to specific functions.

We would suggest that Darwinian principles cannot adequately explain the affinities between the functions performed by art as an intermediary in the sense of a viaticum, of an Open Sesame to eternal life. Rather we should invoke the concept of the archetype as defined by Carl Gustav Jung, for what we are concerned with here is the quintessential in man, the characteristics he shares with his fellows, irrespective of race, creed or custom.

In this respect the role of art is the best indicator of what it is in man that transcends such material considerations as food, shelter and reproduction to elicit from the intellect a response to his aspirations to eternity, perfection and beauty. This alone will enable us to understand why works of art are capable of moving us, regardless of their message or historical context. They are, as it were, a cry from the heart proclaiming what in man conforms to his spiritual desires, frees an ephemeral existence from the trammels of time, endows particular modes of expression with a particle of universality, and opens a door to the eternal through which he may escape from his mortal condition. It is these works that reveal the brotherhood of man.

The Emergence of Metallurgy

Metallurgical techniques were mastered far earlier in South America than in Mesoamerica, where the Mixtec craftsmen of Mexico lagged behind their Peruvian, Ecuadorean and, indeed, Colombian, counterparts by more than 1,500 years. In the Andean countries (disregarding Colombia which lies outside the framework of this book), the arts of casting, hammering, repoussé and riveting and, later, of wire drawing, soldering and *cire perdue,* were confined in the main to ritual and funerary ornamental work. The earliest examples of gold objects belong to the Chavín period, round about the fifth or sixth century B.C., and consist of gold leaf cut out to produce the rigorously structured feline motifs typical of that style. Other ornaments take the form of serpentine hair or solar rays and here we might also cite the undecorated goblets, assigned to this early period because of their starkness and simplicity, which bring out the beauty of the material. Gold was obtained by washing and sifting the auriferous sand from the beds of streams which remained the only source of that metal in pre-Columbian times.

During the Vicús and, later, the Mochica period, pride of place was given to ornamentation. It was as though goldsmiths, hitherto content with the still novel appearance of the material, now proceeded to enrich it with extra detail by exploiting to the full a malleability that contrasted

Diagrammatic drawing of a hammered and punched gold ornament in the form of the mythical feline of Chavín.

with the relative inertness of ceramics. Vicús gold-work includes cups, bowls and other vessels decorated with repoussé and covered with a layer of gold leaf so thin as to suggest that the metal was still in short supply (Pl. 79). A technique developed at the same time was that of copper-smithing, as the rich finds made in the Vicús tombs at Loma Negra go to show. These contained an exceptionally large number of ritual objects and ornaments produced between 300 B.C. and A.D. 300. The pieces, some of them very complex, testify to an all-embracing command of techniques that included the gilding of copper and the insertion, by inlay or gluing, of pieces of shell to enhance eyes or teeth.

Like ceramics, metallurgy reached a high-water mark during the Mochica period when the smiths attained a degree of skill never to be surpassed in the Andean region. Quantitatively Chimú proved far richer, but it cannot match the refinement and delicacy of this branch of Mochica art.

Hinged pendants for affixing to the breast of a garment, or again ear ornaments in the form of gold discs embellished with turquoise mosaics showing winged and bird-faced *chasquis* (Pls. 81, 82), are consummate examples of the jewellers' art. The utmost precision was required to make the small, perfectly spherical gold balls, or the little hanging discs which glittered as they moved. The same theme that inspired the fine Vicús jar in the shape of a votive hand (Pl. 57) recurs in the two gold hands found in a grave (Pl. 80) which represent an unusual type of offering—'a part in lieu of a whole', perhaps. At all events, S. K. Lothrop insists that these hands would not have been intended as substitutes for those of the deceased, as would have been the case in Egypt, for example. Rather they would have been placed beside him as a viaticum. When considering these remarkable objects one is struck by the complexity of the work involved in producing such technical *tours de force* without undue expenditure of precious metal.

Of even higher quality, perhaps, are the products of the Frias culture in the far north of Peru, within the Vicús sphere of influence, which are distinguished by fine workmanship and plastic sensibility. As an example of this highly developed art, we would cite a jaguar's skin, produced by embossing and hammering, of which only the head, armed with pointed fangs, appears in relief (Pl. 83). Comparatively large, it would seem to have served as a container for coca-leaves, since the body consists of two sheets so fastened together as to form a pocket. Indeed, since very earliest times the jaguar had been associated with the shamanic use of hallucinogens.

La Tolita and Jama Coaque

We opened this discussion of gold-work with a review of Mochica production in order to place it in the context of that people's architecture and pottery. Yet the first experiments in metallurgy were almost certainly made in Ecuador and Colombia.

La Tolita is an island in the Río Santiago delta near Esmeraldas in the northernmost part of Ecuador. As far back as the beginning of this century the site, which was to prove one of the richest so far as gold-work was concerned, had aroused the interest of the American archaeologist Marshall H. Saville, who was to revisit the island in 1928. A few years

Motif from a terracotta seal, Jama Coaque style, Ecuador.

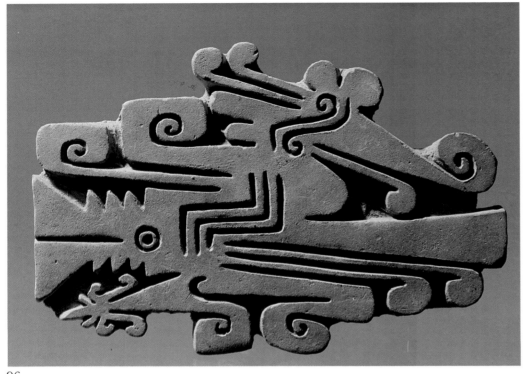

96

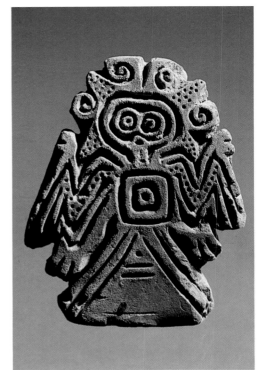

97

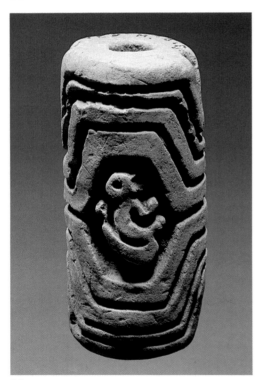

98

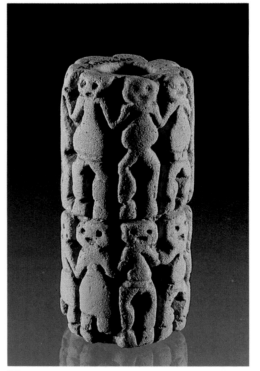

99

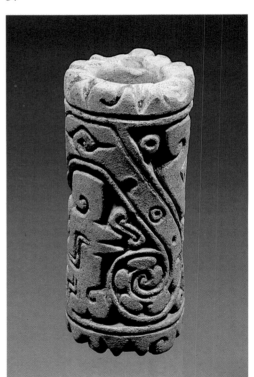

100

Two impressions made by cylinder seals, Jama Coaque style (Cf. Pls. 98 and 99).

96, 97 Terracotta seals. Jama Coaque style. The products of this culture are impossible to date with any accuracy and can only be assigned to the period between 500 B.C. and A.D. 500. These very schematic pieces are of extreme elegance. Number 97 shows traces of red pigment. Heights 9.8 cm, 6.3 cm. Museo del Banco del Pacifico, Guayaquil.

98–100 The Jama Coaque cylinder seals are akin to those discovered near Tembladera and Chicama in Peru. The left-hand seal (height 7 cm) is decorated with a monkey framed by meanders; the central seal (height 5.8 cm) with two tiers of small dancing figures; the right-hand seal (10.6 cm) with a complex design of volutes. Museo del Banco del Pacifico, Guayaquil.

later, between 1933 and 1940, according to Peter Baumann's account, an Italian using mechanical excavators removed from the subsoil articles which, when melted down, yielded some 1,700 pounds of gold. This he subsequently sold to the government.

In 1968 the discovery by an American, James Judge, of a gold mask with platinum eyes gave archaeologists considerable food for thought. Now, the art of La Tolita spans the period between 500 B.C. and A.D. 500, but it was not until about 1730 that the West succeeded in building furnaces capable of fusing platinum which calls for a temperature of 1755 °C. Given the state of their technology, such an operation was, of course, far beyond the capacity of the pre-Columbians. However, native platinum was available not only in the form of nuggets, but also in combinations with gold which meant that the melting-point was lower despite the relatively high platinum content. Thus platinum nuggets may have been hammered and then inserted into a gold object with the aid of solder.

It will be seen that the products of La Tolita display a wide range of styles, the formal variations being accounted for by the sheer longevity of this culture. The phases of its history, which spans 1,000 years, are difficult to distinguish. Some of the works would seem to have been inspired by the great movement devoted to the cult of the jaguar and the serpent such as we encounter in Chavín. In this connection we might cite a fine essay in horizontal stylization, suggestive of a feline mask (Pl. 87), or again a diadem of gold leaf. Here the motif, cut out with great precision, consists of a central face executed in repoussé and surrounded on three sides by serpentine hair. The impression is that of a deity endowed with an intense radiance (Pl. 84). In the funerary masks the nose is applied rather than beaten out, since the latter process might well result in rupturing the laminated sheet. But it is the eyes, now almond-shaped with punched pupils (Pl. 86)—a form that recurs amongst the Chimú —now asymmetrical and altogether more realistic (Pl. 85), which distinguish these objects and lend them their own particular style. Both masks have been given a nose ornament known as a *nariguera*.

However the delicacy of La Tolita craftsmanship is most apparent in the smaller pieces. The use of gold in combination with metals having a high platinum or silver content enabled the smiths to obtain a variety of polychrome effects as in the gold pectoral and ear discs (Pls. 89, 91). No less exquisite are the small pendants depicting a human face, but here the effect is achieved by silvering portions of the gold leaf itself so as to accentuate the teeth and eyes (Pl. 88). In addition we would cite the many gold ornaments intended to be sewn on to garments, as is evident from the holes made for that purpose (Pl. 90).

The stylistic diversity and variety found in the gold-work of La Tolita similarly characterizes its pottery. Some of the pieces are no less remarkable than they are puzzling. For example, we encounter now a delicately drawn idealized face (Pl. 92), now a Picasso-like cubist figure of a deity with serpents (Pl. 93), or again an architectural piece reminiscent of a Chinese lion, say, or the guardian of a Khmer temple, and so Asiatic in appearance that no art historian would spontaneously pronounce it to be of Ecuadorean origin (Pl. 94).

The alien quality of these forms is also discernible in some of the products of Jama Coaque, a coastal site south-west of La Tolita, whose culture likewise evolved between 500 B.C. and A.D. 500. Further scientific

investigation of the site will be required before a more accurate chronology can be established.

A fine Jama Coaque terracotta depicts a temple in the shape of a stepped pyramid embellished with delicate appliqué borders. From the base, a stair leads to a richly attired female deity seated on a throne (Pl. 95). The style, as well as the use of varying tones of blue, are suggestive rather of South-East Asia than of a pre-Columbian culture.

Again a number of terracotta seals, the decoration of which is schematic to the point of abstraction, recalls Sumero-Babylonian or Indusian work (Pls. 96, 97), thereby compounding the mystery of these Ecuadorean cultures. We might add that, during this same period, another civilization, that of Guangala on the Guayas coast, produced terracotta spindle whorls decorated with analogous motifs, of which Johannes Wilbert has made an exhaustive study. In this context it should be noted that such seals are not confined to Ecuador, for cylinders of the same type as the Jama Coaque seals have also been found at Tembladera which was subject to the influence of Chavín. The stylization of these pieces suggests a similar preoccupation with schematism and with economy of expression.

If, then, we were to sum up the most striking characteristics of Ecuadorean art in its Classic phase, we would cite its diversity and lack of homogeneity, as well as its richness and the revitalization of the forms inherited from Chorrera. What we have here is, as it were, a testing-ground, a centre of intellectual ferment and of trial and error, in which the experiment is rated more highly than the result. But there is nothing comparable with the astonishing unity that characterizes the development of Mochica with its vast pyramids, nor anything approaching the profound humanity of that culture's portrait vessels.

V. Artists and Craftsmen of Paracas–Nazca

Climatically the south coast of Peru is even drier than the northern littoral. It has been said that no rain worthy of the name has fallen there since the time of the Conquest. In this vast rocky expanse, with its huge dunes of shifting sand, a few isolated valleys provided a fertile terrain propitious to agriculture and to the establishment of human societies.

The coast south of Pisco comprises bays and a large peninsula, the Paracas; seaward of these are rocky islands, once rich in guano and now the habitat of a prolific fauna. Besides sea-lions and otaries, sea-birds such as pelicans, cormorants, penguins, petrels and others find sustenance in the well-stocked waters of the Pacific, while whales, grampuses and shoals of fish such as anchovies and sardines, as well as molluscs and crustaceans, feed on the plankton so abundantly supplied by the Humboldt current.

The ocean, teeming with life, contrasts strongly with the vast arid hinterland stretching away behind cliffs pounded by the Pacific rollers. While it was the richness of these marine resources that first attracted settlers to the coastal desert, there is also the possibility that, 4,000 or 5,000 years ago, what are now dry river-beds still brought a trickle of water down to the coast and with it vegetation and life, thereby encouraging men to establish a few scattered settlements. Indeed, subterranean rivers still exist enabling vegetation to grow in sheltered hollows and here wells have been dug so as to ensure a supply of life-giving water. Acacia and carob woods provide cover at various points along the coast, while rushes must once have grown in the lagoons.

Four Thousand Years of Evolution

Some 5,000 years ago the Paracas Peninsula was inhabited by a pre-ceramic people engaged chiefly in fishing and the gathering of shell-fish, a people to whom cotton was as yet unknown. In order to protect themselves against the wind that lashes the coast, they built semi-underground dwellings with a roof of matting supported by branches or whalebone. Their mode of existence, which must have continued for 1,000 years or more, was responsible for the creation of vast mounds of discarded shells, some of them as much as 100 metres long and 10 metres wide. Such deposits are particularly in evidence at Otuma where they were laid broadside on to the prevailing wind to serve as shelters. Kitchen middens of this type were first discovered in Denmark, hence the term *Køkkenmødjing* used by some archaeologists.

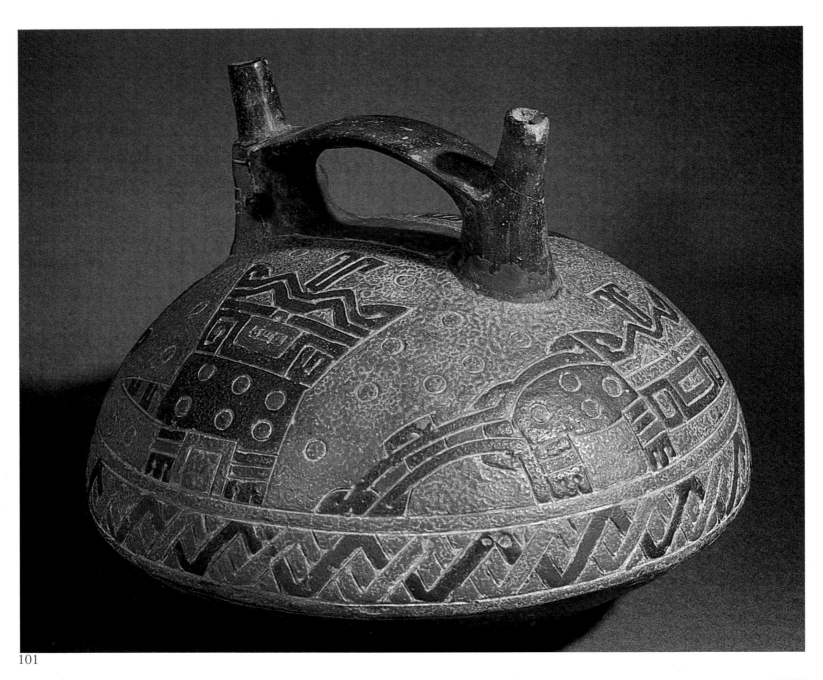

101

102

Though still very primitive, these people buried their dead, the bodies being wrapped in rush mats and, sometimes, in the skins of animals such as the llama and alpaca. By 1000 B.C. their burial practices had become more complex. They were still without pottery, but possessed textiles, both looped and twined, and cultivated maize, mani (peanuts), cotton and beans. Not until 700 B.C. did the coastal Chavinoid style reach the Paracas region. Indeed, the iconographic influence of Chavín marks the emergence of pottery on the southern part of the coast. It was at this time, too, that the dog became domesticated.

The south Peruvian littoral emerged from oblivion at a relatively late stage. As is the case with most of the Peruvian cultures, the establishment of a chronology presents considerable difficulties. With regard to the pre-ceramic phase of Paracas in particular, it is to the work of Frédéric Engel, carried out between 1955 and 1959 and published in 1960, that we owe our knowledge of these societies. We are also indebted, first to Julio Tello who carried out the earliest examination of the site in 1925, his crowning achievement being the discovery of a cemetery containing 429 *fardos* wrapped in sumptuous cloths, and, secondly, to Max Uhle who, in the region of Ica in 1911, discovered the provenance of Nazca jars. This was the fruit of a series of investigations, conducted after the manner of a police enquiry, into the source of these beautiful pieces, several examples of which had been unearthed by treasure-hunters and had subsequently found their way into various museums and collections.

The Chavinoid influence already discernible in the Paracas pottery of the seventh century B.C. continued to exert itself on the art described by Julio Tello as Paracas–Cavernas and now termed Middle Paracas (500–300 B.C.). While still retaining an iconography that derives from Chavín, this art evolved an original technique whereby the pieces were painted in polychrome after firing. The colours, mixed with a hard resin, constituted a rich, strong, glowing palette, and were applied to areas defined by incisions. By way of explanation we might also add that the term Cavernas was used by the above archaeologist to denote underground tombs reached by shafts, and capable in some cases of accommodating dozens of *fardos*.

This phase was followed by Late Paracas (formely Paracas–Necropolis in Tello's seriation) which covers the period between 300 and 200 B.C. and saw the production of the celebrated Paracas textiles to which we shall presently revert. Nazca art proper had its beginnings in an intermediate phase between 200 and 100 B.C. known as proto-Nazca, but there is no gap between the Paracas and Nazca cultures, if allowance be made for the introduction of new beliefs and certain artistic developments, possibly resulting from an influx into the region of new peoples who became assimilated with the existing population. At all events, notable changes are apparent, particularly in the field of pottery in which polychrome painted decoration was now applied before firing to produce brilliant colouring and a magnificently polished surface.

In considering the Nazca style, we propose to follow the chronology of Dieter Eisleb which is based on the work of A. H. Gayton and A. L. Kroeber, John H. Rowe and Dorothy Menzel, as well as Alan R. Sawyer and William D. Strong. His subdivisions are as follows: Early Nazca (100 B.C.–A.D. 200), Middle Nazca (A.D. 200–300), Late Nazca (A.D. 300–600) and finally Nazca–Huari (about A.D. 600–700), a style that was influenced by the art of Huari–Tiahuanaco.

101 Double spout and bridge vessel from the south coast of Peru. Paracas–Cavernas, about 500 to 300 B.C. This fine piece displays a decoration of two stylized felines, one frontal, the other in profile, and thus betrays the influence of Chavín and, more notably, of the worship of a feline deity. The colour has been applied after firing. Height 17 cm. Museo Amano, Lima.

102 Shallow bowl, Paracas–Ocucaje style, 500–300 B.C. The outer rim is decorated with a beautiful polychrome design of stylized felines, applied after firing in the course of which the black ground was obtained by the reduction method. Diameter 22.5 cm. Museo del Banco Central de Reserva, Lima.

From Paracas Pottery...

At the time when the influence of Chavín art had begun to wane there grew up in the Paracas region agglomerations in the form of small villages ringed by two, if not three protective walls—evidence of the chronic insecurity of that period. Inter-tribal struggles for land which by now must already have become scarce account for the number of trephined skulls that have been discovered. Some of these skulls display a callus, a sure sign of the success of the operation and of the patient's complete recovery.

Tello's *Cavernas* are, as we have said, underground tombs hewn out of the hard rock of the Paracas Peninsula. Their shape is similar to that of a decanter with a long neck, the hemispherical burial-chamber being reached by a shaft. In these chambers, each of them capable of accommodating up to fifty-five *fardos*, the mummified dead were disposed in a foetal or doubled up attitude, some of them having had their viscera and more important muscles removed. Wrapped in long strips of cloth, some of fine gauze in several colours, others of a coarser quality and used for bandaging, the *fardos* reposed in wicker baskets.

Because the Paracas climate is extremely dry, despite the immediate vicinity of the Pacific Ocean, the remains found in the tombs are extraordinarily well-preserved even after the elapse of 2,500 years. The finds consisted not only of mummified bodies and their textile wrappings, but also of decorated gourds, wooden objects such as arrows and looms, and even vegetable remains in baskets. Also found in the tombs alongside the *fardos* were pots whose decoration, applied after firing, betrays a certain Chavinoid influence inasmuch as the iconography includes felines with jutting fangs. The extreme schematization of these motifs is reminiscent of the preoccupation with rigorous structure noted in Chavín art. This geometrization is discernible both in the decoration of interlaces, bands and circles, and in the treatment of the mythological animal figures (Pl. 101).

These vessels, many of which have a spheroid or lens-shaped body, are surmounted by two spouts joined by a flat bridge or handle. The opening of one of the spouts is sometimes blocked by an object in the form of a head. Dishes, cups, bottles and bowls make up the range of forms which serve as vehicles for the multifarious ornamental themes found in this pottery. Some of the vessels have a superb coating of lamp-black, providing a perfect background for the resin-based polychrome pigment (Pl. 102).

Very few examples of the stirrup spout, so widely distributed among the Chavín, Vicús and Mochica cultures, have been found in Middle Paracas. This fact, together with the absence of fired polychrome, shows that the art of the south coast potters evolved independently. Their originality is further attested by the advent in the Late Paracas (Tello's Paracas—Necropolis) phase of a cream-coloured slip which rarely occurs in Chavín and Vicús. And since this introduction was not accompanied by the use of the stirrup spout, we may conclude that Paracas pottery constituted a specific tendency that was little subject to the influences of the northern cultures save in the matter of a few iconographic borrowings.

... to the Art of the Nazca Potters

The Nazca people, who inhabited a region extending from Cañete in the north to Arequipa in the south, were the direct heirs of the Paracas

103 Spheroid double spout and bridge jar. Nazca, Middle Period (Phase 3), A.D. 200–300. Nazca pottery, with its highly schematized painting and its beautiful warm tones of black, brown, ochre, yellow and white, displays a symbolism that is often difficult to interpret. Our example may be either a trophy head or a fertility god. Height 20.5 cm. Banco Central de Reserva, Lima.

104 Anthropomorphic vase. Nazca, Phase 3, A.D. 200–300. The fruit carried by the sumptuously attired figure identifies him as a fertility god. He wears a gold diadem and a nose or mouth ornament suspended from the nostrils. On his wrists is an effigy similar to that depicted on the jar in Plate 103. Height 21.5 cm. Museo Arqueológico, Lima.

105 Spout and bridge jar. Nazca, Phase 3. The beautiful, rounded forms of the sea-bird are executed with great elegance. Height 14.5 cm. Museo del Banco Central de Reserva, Lima.

106 Spheroid double spout and bridge jar. Nazca, Phase 3. This fine work, decorated with a condor motif in polychrome on a white ground, testifies to the Nazca mastery of graphic design. Height 16 cm. Museo Regional de Ica.

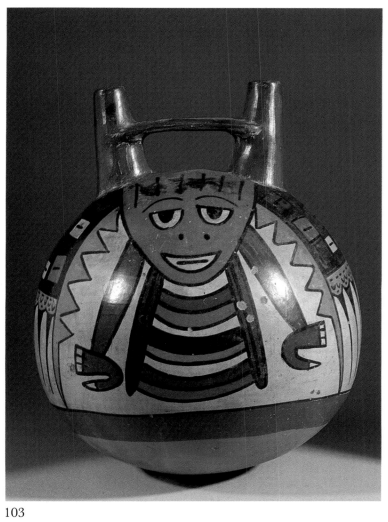

103

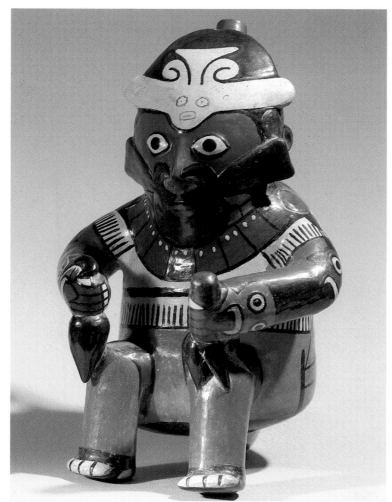

104

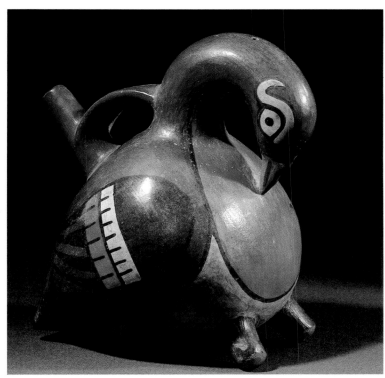

105

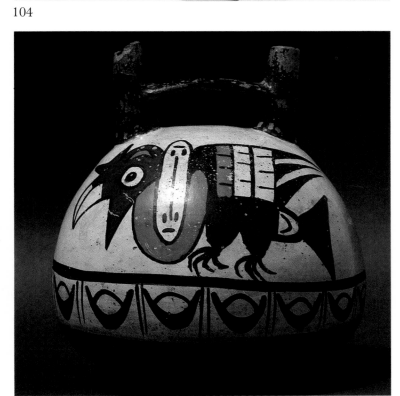

106

culture. They formed petty principalities in the valleys of the Ríos Pisco, Ica, Grande de Nazca, Lomas and Ocoña. Since the Nazcas were an agrarian people whose farming depended on irrigation, there was constant strife over the possession of the conduits. In order not to encroach on productive land, they lived on its periphery in large villages consisting of wattle huts with thatched roofs, and clustered round pyramids built of adobe.

The largest city was Cahuachi, 6 kilometres south of Nazca, where six architectural complexes are dominated by a stepped pyramid 110 metres long by 90 metres wide and 20 metres high. Not far from this ceremonial centre is La Estaqueria, a vast assembly with twelve rows of twenty posts about 2 metres apart, which must once have served as supports in what was probably the largest pre-Columbian covered building, measuring 40 by 25 metres, or a total of 1,000 square metres. What type of roof covered this great wooden building is not known, but the remains testify to the existence of considerable forests in this region, at any rate until the beginning of our era. Again, some of the villages in the neighbourhood of Paracas must have possessed stone buildings rising above ground level as opposed to the semi-subterranean dwellings of the preceding periods.

The profound transformation which, according to available evidence, this society would appear to have undergone, probably took place gradually and without a break. It was to find expression in a new type of pottery decorated with kiln-fired polychrome slip. At first the traditional forms of Middle Paracas persisted in globular double spout and bridge vessels, though with certain notable modifications. The body is often spherical with a rounded base so that it can bed down into the sand, while the spouts, joined by a bridge, are almost vertical in the early pieces (Pls. 103, 106), but markedly divergent in later jars (pl. 111). No matter how complex the form or plastic the treatment, all these vessels are shaped by the method known as coiling, and not in moulds like most Mochica ware.

It would seem that the only purpose of these pieces, whose rich palette may comprise as many as eleven enamel colours separated by black outlines, was to serve as a background for the decoration and to keep company with the deceased in his tomb. The chief interest of these remarkably delicate and accomplished objects lies in the beauty of a design wholly innocent of realism, and in the confident distribution and harmonious juxtaposition of colours. But they also display a fascinating iconography quite different from that which had attended the flowering of Mochica art. Here, along with marine creatures—whales, grampuses and various kinds of fish—or birds such as pelicans, toucans, condors, divers and colibri, we encounter mythical or divine personages in which an astonishingly exuberant imagination has been at work. Here the Chavinoid feline gives way to a masked monster invested with vegetal symbols, or a being amply endowed with animal attributes such as feathers, tongues and beaks. The latter recalls the proliferation of motifs displayed by the Raimondi Stela but lacks its symmetrical organization (Pl. 112).

The forms of the pottery are simple, and subordinated to the figural art for which they are the vehicle (Pl. 109), yet sometimes the treatment is almost sculptural as in a wonderfully concise zoomorphic piece (Pl. 105), or in a figure of a god or masked man wearing a diadem and a mouth ornament consisting of long whiskers, possibly symbolizing those of the emblematic feline (Pl. 104).

116

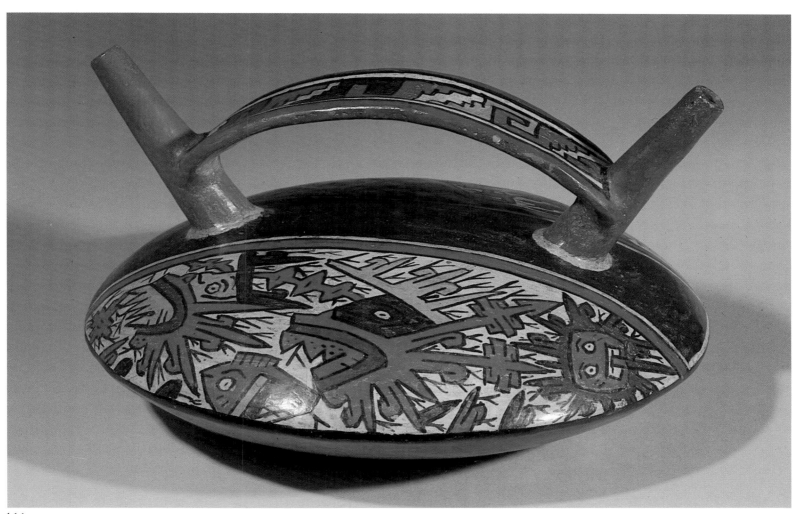

111

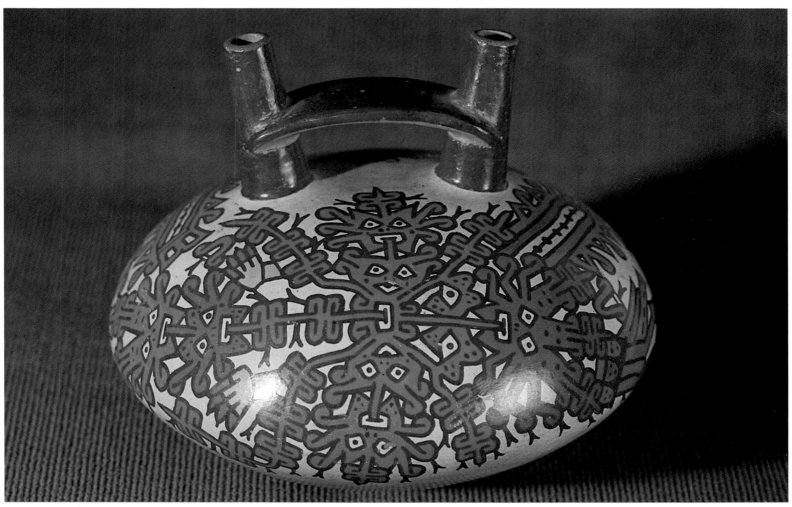

112

107 Curious terracotta. Nazca, Phase 6, A.D. 550–700. The otherwise naked figure, probably male, wears a loin-cloth and cap. On his chest is a shell pendant. Height 30 cm. Museo Arqueológico, Lima.

108 Seated female statuette. Nazca. The style resembles that of the preceding piece, while the motifs, possibly tattoo marks, are similar to those found on many other Phase 6 vessels. In this figure, which recalls an obese mother-goddess, the plastic treatment of the arms imperceptibly gives way to painting. Height 25 cm. Museo Regional de Ica.

109 Terracotta bowl. Nazca, Phase 4, A.D. 300–400. The decoration comprises a head similarly adorned to that in Plate 104. On the right are the rudiments of a plumed head-dress analagous to those portrayed in textiles and also in the Raimondi Stela. Museo Arqueológico, Lima.

110 Anthropomorphic terracotta. Nazca, Phase 4. Here again, in the hands and pan-pipes, we may discern a gradual transition from sculpture to painting. The treatment of the musician, who wears a kind of diadem, is highly schematic. Height 22.7 cm. Museo del Banco Central de Reserva, Lima.

111 Lentiform vessel. Nazca, Phase 6, A.D. 550–700. The bridge or handle joining the two long spouts of this vessel is of very elegant design. The motifs—deities with plumed head-dresses terminating in forked tongues symbolic, perhaps, of Chavinoid serpents—have a tendency to effloresce. Diameter 21.5 cm. Museo Arqueológico, Lima.

112 Double spout and bridge vessel. Nazca, Phase 6. Another fine example of what is known as the 'proliferating' style. Here heads crowned with plumes and forked tongues luxuriate in plant-like fashion, once again symbolizing fertility. Diameter 12.5 cm. Museo Arqueológico, Lima.

beside it. These splendid and unusual garments, named *mantos* by the archaeologists, which sometimes, as we shall presently see, required years of work to complete, display an overall decoration of embroidered or tapestry motifs and mark the apogee of the art of weaving in prehistoric times. In addition, this site yielded large quantities of grave-furniture in the form of gourd food containers, feather fans, gold tweezers and arrows.

Samuel K. Lothrop, who excavated Paracas with Tello, describes the textiles that accompanied one of the mummies, No. 49, to which Junius Bird has also devoted a paper. In addition to actual garments—eleven *mantos*, twenty ponchos, eleven skirts, six turbans and five belts, most of them decorated with brightly coloured embroidery—this rich collection comprised twenty-six lengths of plain cloth, the largest of which, measuring 28 by 4 metres is woven all in one piece.

Technically speaking, the Paracas *mantos* represent a remarkably skilful achievement, which merits discussion if only because of the complexity of the processes involved. They are mostly made of three strips of cloth joined together to produce a piece measuring about 2.5 by 1.5 metres, or 4 square metres. Both the warp and weft of the wider, central strip are of alpaca, while the warp of the outside strips is of cotton into which wool threads are woven to produce tapestry designs. Embroidered motifs may also be superimposed.

The stuffs did not need to be hemmed because the warp thread was continuous and as such had to be passed back and forth hundreds of times. This, combined with the fact that all three strips had to be of exactly the same length, despite differences of composition, will give us some idea of the problems entailed in the production of *mantos*. The central strip, moreover, displays an overall design consisting of figures, now right way up, now upside down, disposed in quincunxes and, on the outer strips, head to foot in single rows. These personages or monsters are alike only so far as the drawing is concerned, being otherwise differentiated by the coloured wools used in their embroidery. Each part of every figure is coloured now red, now yellow, now green, while the heads of these mythical beings and the ornaments they wear may be brown, buff or black. A *manto* may possess anything from fifty to a hundred such figures whose every detail is subject to so many and such complex permutations as virtually to preclude exact repetition.

The designs are of two kinds. The first, and earliest, are angular and geometric representations, usually of felines, and betray the same concern for rigid structures as is found in Chavín art. The second, curvilinear designs show persons wearing rich garments and carrying weapons such as javelins, spear-trowers or ceremonial knives *(tumis)* and, in many cases, also trophy heads. In the Nazca period these personages—possibly gallant warriors—become what can only be described as mythical, monster-like deities endowed with masks, mouth and nose ornaments, a diadem and, in some cases, wings and claws reminiscent of the 'flying felines' of Chavín. Sometimes accompanied by vegetal symbols they, too, carry trophy heads, the cult of which developed during the Late Nazca phase.

Although these beautiful stuffs were first discovered at Paracas, this should not be taken to mean that the art of weaving was confined to that period alone. Rather, it enjoyed a considerable vogue throughout every period of Andean art up to the time of the Huari–Tiahuanaco and Inca cultures, when it attained an exceptional degree of perfection.

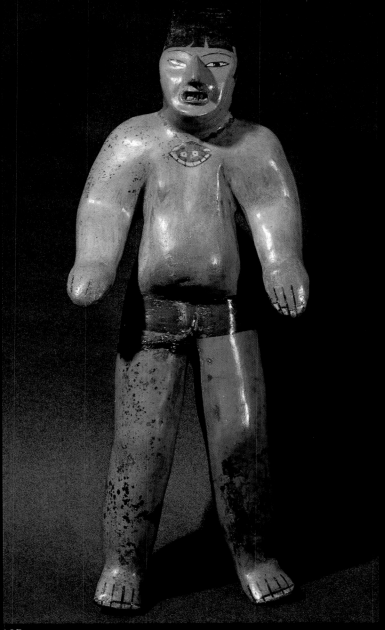

107

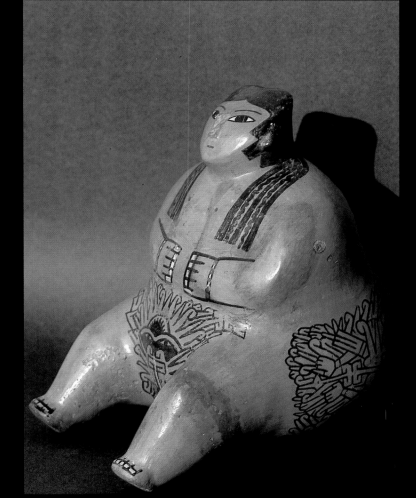

108

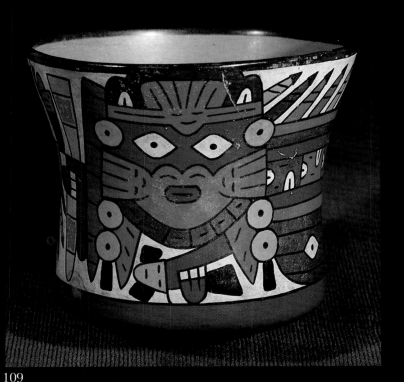

109

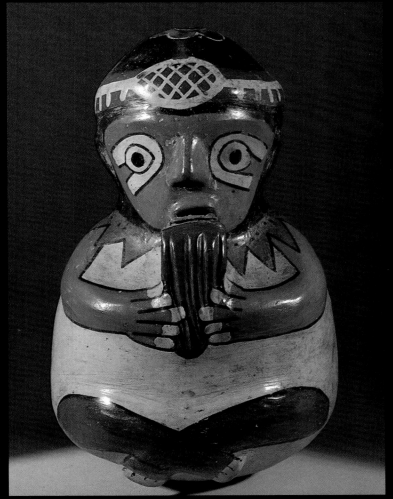

110

We also encounter rather more prosaic anthropomorphic jars depicting everyday episodes—for instance a man playing pan-pipes and a man rubbing his knee (Pls. 110, 113). But here again we find a schematism very far removed from the realistic vision of the Mochica potters. What is particularly striking about these pieces is the extraordinary feeling they display for the interchangeability of modes of expression; so allusive is the modelling that, in the second piece just cited, it merges into painting in the representation of the hands. Like the zoomorphic jar (Pl. 105), this vessel has reverted to the single spout and handle typical of the Chorrera and early Vicús pieces, but here rendered in a different sculptural style that is almost expressionistic.

Finally we should mention the terracotta statuettes whose function is, however, totally unrelated to that of a vessel and in which plastic techniques are employed for their own sake. Thus, in this Late Nazca ceramic phase, we again encounter pieces reminiscent of Chorrera figurines and which comprise two different types—the first, beautifully proportioned and relatively long-legged standing figures; the second, effigies of seated, unmistakably callipygous women. Touches of paint highlight the sexual organs which, like the buttocks, display efflorescent tattoos whose graphic style is reminiscent of the plumed deity (Pls. 107, 108).

The Development of Textiles

In Chapter III we alluded to the discovery at Huaca Prieta of the first textiles dating back to 1950 B.C.. Consisting of fragments of cotton they bear witness to a weaving technique already sufficiently advanced to admit of a two-colour design.

Again, at Pampa Gramalote, cloth has been found dating from 1350 B.C. and made entirely of cotton with a woven design. The next to appear were textiles whose decoration reveals that the influence of Chavín had now spread from the upland valleys to the coast. By comparison with the earliest fabrics of pre-ceramic times, there is a marked advance which manifests itself in the development of new techniques and treatments, such as the use of *Camelidae* fibres (alpaca), tapestry weaves, and the imposition of embroidered or painted designs upon the finished cloth. Indeed the influence of Chavinoid iconography in the Paracas region may, perhaps, be attributed to the popularity enjoyed during the Chavín period by such painted textiles, several examples of which have recently been discovered on the south coast.

Excavations conducted on the Paracas site by Tello in 1925 brought to light a collection of sumptuous pieces belonging to the phase named by him Paracas–Necropolis. Attention had already been drawn to the importance of this southern industry by the discovery of the more simple textiles of the Paracas–Cavernas phase. It was, however, the uncovering of 429 *fardos,* disposed about a walled enclosure of some 260 square metres, that provided conclusive evidence of the astonishing degree of expertise attained by Paracas craftsmen in the third century B.C.

The *fardos,* large conical bundles, 1.5 metres high and 1.5 metres wide at the base, contain a mummy in a crouching posture, the skull of which sometimes shows a deliberately induced malformation. The body may be cocooned in anything up to 150 pieces of cloth, while in some cases sumptuous and carefully folded garments have been laid on the ground

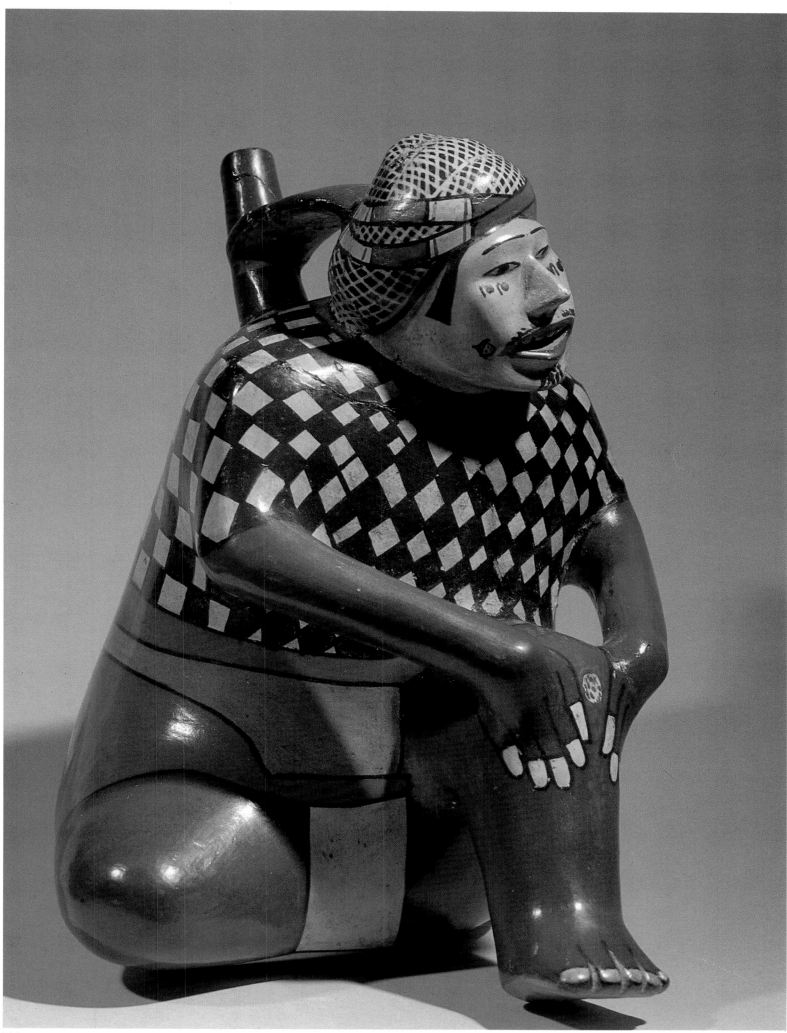

113

If we consider the sheer weight of fine quality cloth produced by the Paracas–Nazca weavers, we cannot but be amazed at the amount of effort it must have entailed, especially having regard to the successive stages of manufacture:

1 Harvesting the cotton crop and sheering the alpacas.

2 Spinning—namely the manufacture, using spindle and whorl—of yarn, the consistent quality and thickness of which is attested by samples that have come down to us. Substantial quantities were required (as we shall presently see, continuous warp threads have been discovered which measure between 150 and 160 kilometres).

3 Dyeing in different shades of red, brown, orange, yellow, grey, ice blue, sea-green and olive green. The dyes, vegetable and sometimes mineral, were fixed with mordants such as silica or alum in a process that called for very considerable expertise. According to Raoul d'Harcourt, they were based on cochineal, indigo and, in the case of yellow, on the bark of the pepper-tree.

4 Warping, in other words the preparation of the warp threads prior to weaving (this does not, of course, apply to knitted cloth).

5 Weaving, the stage at which the cloth is actually produced on the loom by the interlacing of warp and weft threads. The pre-Columbians of the Andean region were familiar with a remarkable range of qualities and constructions: reps, twills, gauzes, brocades and a fabric resembling velvet, to mention only a few.

6 Decoration, often introduced at the weaving stage by employing weft threads of different colours, was also effected by means of tapestry, embroidery and three-dimensional knitting to produce designs of breathtaking complexity.

There can be little doubt that the Peruvian weavers devoted most of their time to the manufacture of fabrics for the dead. Although thousands of samples have come down to us, an uncounted number must have been lost. Here the question necessarily arises as to whether they might have been destined to clothe not only the dead, but also living persons of high rank. True, the samples found in the tombs show no signs of wear. But that is not necessarily conclusive, since the cerements, as we have seen, were new, whereas clothing in daily use would have been completely worn out and hence would not have come down to us. Whatever the case, the garments found in the tombs—*mantos,* ponchos, shirts, skirts, belts and shawls—are of so eminently practical a nature as to suggest that identical articles were made for everyday wear.

On the other hand, some of the cloths used in the *fardos* would have been far too big to be worn by a living person. Woven all in one piece, some of them measure as much as 20 by 6 metres—the largest ever to have been produced on primitive looms.

Mysterious Drawings in the Desert

Having considered the textiles of the South Peruvian littoral, we shall now turn to what are the most puzzling and controversial of the remains left by the Paracas and Nazca cultures, namely the vast system of lines that extend over the desert known as the Pampa de San José between Nazca and Palpa, on either side of the Pan-American highway.

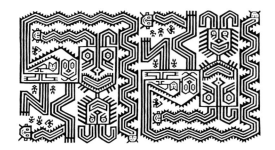

Diagrammatic drawing of Paracas Necropolis textile design, showing stylized felines and serpents.

113 Anthropomorphic spout and bridge vessel. Late Nazca, Phase 6. The bearded and moustached figure portrayed in this outstanding work is shown in a squatting position, pointing to a wound on his left knee. He wears a turban and a magnificent checked poncho. A highly schematized sculpture, notable for its economy of line. Museo Arqueológico, Lima.

114 Detail of border of a superb *manto.* Paracas–Necropolis, about 300–100 B.C. Here we have an example of the constant and almost obsessional reduplication of a single motif, namely the stylized feline. These sumptuous cloths, from the *fardo* enwrapping a corpse, are usually tapestries, sometimes with superimposed embroidery and nearly always with a cotton warp and woollen weft. The detail illustrated here, 50 cm long, comes from a piece 3 metres square. Museo Arqueológico, Lima.

115 Detail of funerary *manto.* Paracas–Nazca style, 100 B.C.–A.D. 100. The tapestry design shows a warrior armed with a javelin and wearing a trailing feather head-dress similar to the upright version surmounting the figure in the Raimondi Stela at Chavín. From his belt hang two trophy heads. Abegg Foundation, Riggisberg, Berne.

116 Another fragment from the border of a Paracas–Nazca *manto,* this time showing a deity surrounded by trophy heads and serpentine motifs, as also a mask which should be compared with the decoration on the jar in Plate 104. The iconography of these ritual cloths from southern Peru still remains veiled in mystery. Abegg Foundation, Riggisberg, Berne.

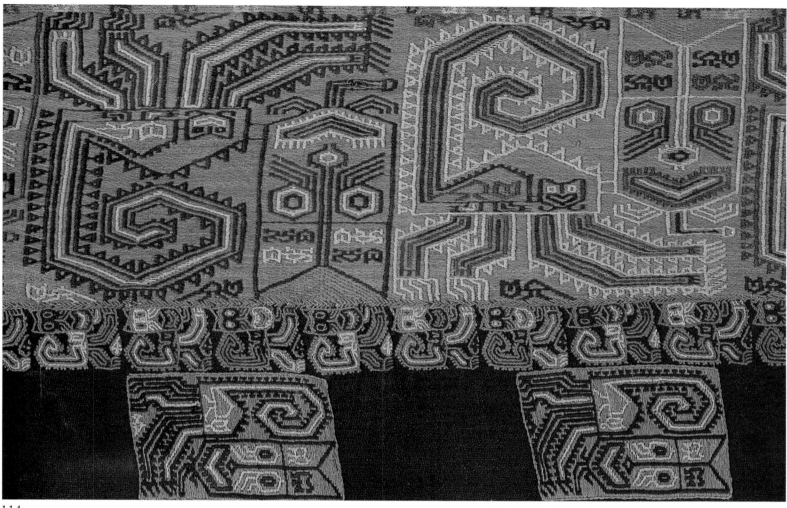

114

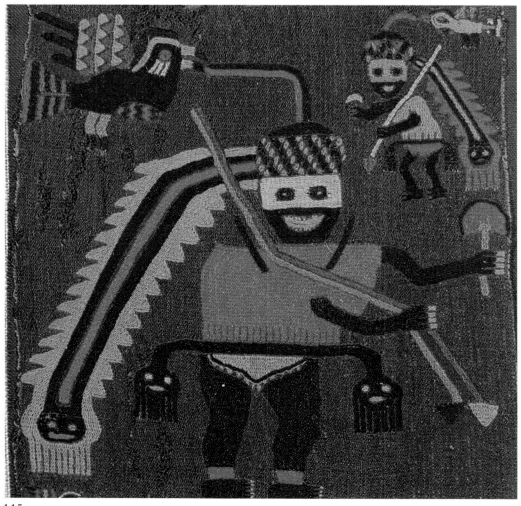

115

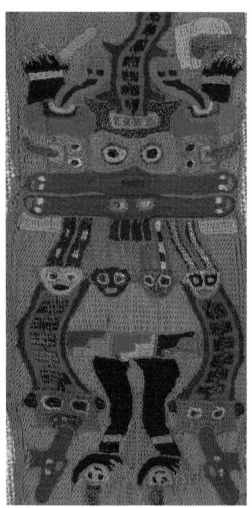

116

Two kinds of drawings, rectilinear and curvilinear, are inextricably intermingled on the surface of the desert. Besides spirals and zigzags, there are also immense effigies between 50 and 300 metres long, of animals and insects such as monkeys (Pl. 117), dogs, spiders, condors, pelicans, herons, colibris (Pl. 118), fish, lizards, killer whales, and whales. Again, what seems to be a masked giant, is delineated on an incline at the edge of the desert (Pl. 121). In addition to the intersecting straight lines which may extend for hundreds of metres if not kilometres, there are huge trapezoidal and rectangular shapes from 300 to 800 metres long and 30 to 100 metres wide—an area covering up to 8 hectares (Pls. 119, 120).

The scale of these drawings is so large that, looked at from the ground, they are virtually invisible save to the trained eye. However, as we know from Cieza de León, a Spanish chronicler who alluded to them in 1550 as 'signals', a better view can be obtained by climbing one of the near by hills. But it is only from the air that the full extent of this fantastic network of lines and drawings becomes apparent. In 1939 Paul Kosok of the University of Long Island took aerial photographs of these astonishing remains. Their publication amazed prehistorians and general public alike and aroused an intense interest in what was described as a 'mystery'.

The area in which most of the drawings and geometrical forms are concentrated, and therefore most clearly in evidence, extends over some 750 hectares. How, we may ask, were they executed? The desert or pampa, of which the soil is gypseous and hence light-coloured, is covered by small stones possessing a high iron content. These become oxydized on contact with the air and thus produce a dark surface. A pale line might therefore be obtained by removing the dark stones along the desired path and piling them on either side to form a dark border, an effect sometimes enhanced by small furrows roughly 25 centimetres deep.

The survival of what are relatively fragile artefacts over a period of 1,500 to 2,000 years must be attributed on the one hand to the total absence of rain and, on the other, to the surface covering of dark stones which, by absorbing the heat and causing up-currents of air, keeps out the sand-laden winds and, by the same token, shifting sand dunes.

To produce absolutely straight lines over such rugged ground the Nazcas must have had recourse to cords stretched between wooden pegs. The latter, many of which have been found in their original upright position, have given a radiocarbon date somewhere between A.D. 14 and 550. Indeed, no fewer than 300 such pegs have been discovered in the Great Rectangle alone, which measures 800 by 100 metres. Moreover archaeologists working in the Nacza pampa have found quantitites of sherds associated with the drawings, most of them belonging to the Early and Middle Nazca phases from 100 B.C. to A.D. 300. It would seem then, that these colossal artefacts may have come into being between 100 B.C. and A.D. 550

The most far-fetched hypotheses have been advanced concerning the origin and role of these markings. One somewhat eccentric best-selling author would have us believe that they were 'landing strips for space ships' manned by extra-terrestrial pilots. Others, less extreme, regard them as 'antiquity's most fantastic calendar' or as 'the greatest astronomical book in the world'. Like Paul Kosok and, notably, Maria Reiche, a German mathematician who lived in the desert for thirty-five years, they are at pains to show that this jumble of lines served a definite purpose.

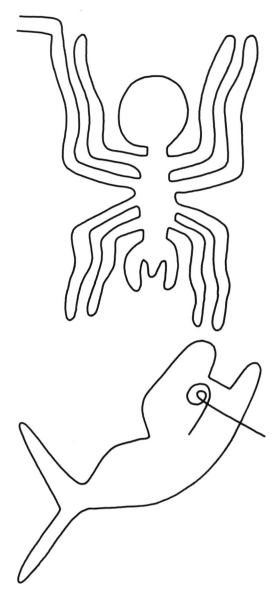

Two drawings in the Nazca desert: a spider 46 m long and a whale 68 m long.

117 A monkey with a spiral tail. Drawn in the desert between Nazca and Palpa, it is among the motifs that have intrigued archaeologists for the past forty years. It will be seen that this huge image is delineated in the gypsous soil by means of a single furrow. The drawings are believed to have been done between 100 B.C. and A.D. 300, or perhaps 500. Unfortunately inquisitive tourists have driven vehicles on to the site, with the result that tyre tracks are liable to be taken for pre-Columbian lines. Length 90 m.

118 The huge colibri, another drawing on the above site, is also delineated by a single furrow. These figures, which have a totemic character, may be connected with a propitiatory ritual. Thanks to the dry climate these remains adjoining the fertile plain have survived the passage of more than 1,500 years. Length 95 m.

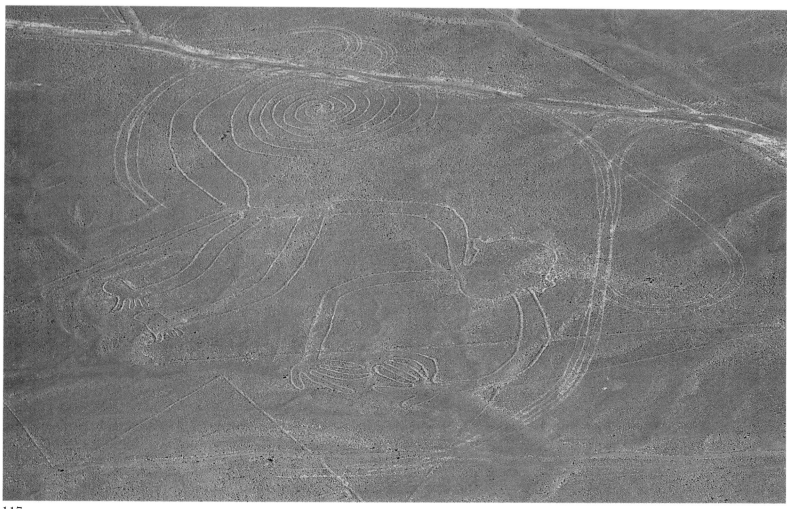

117

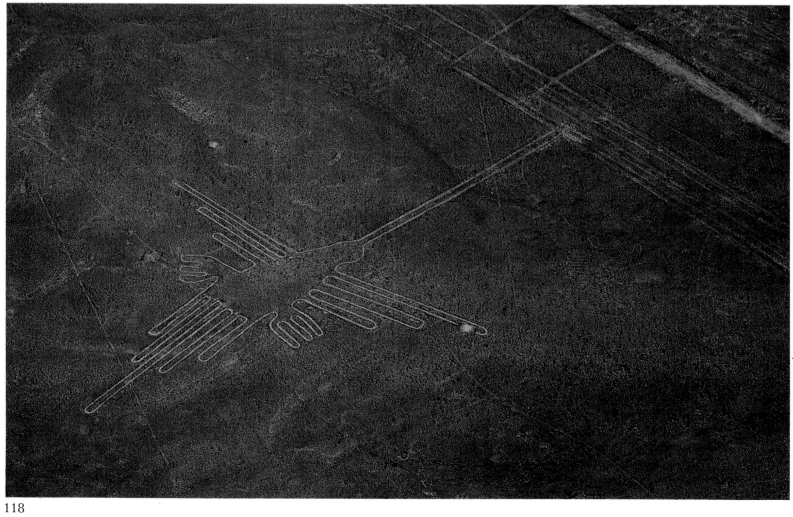

118

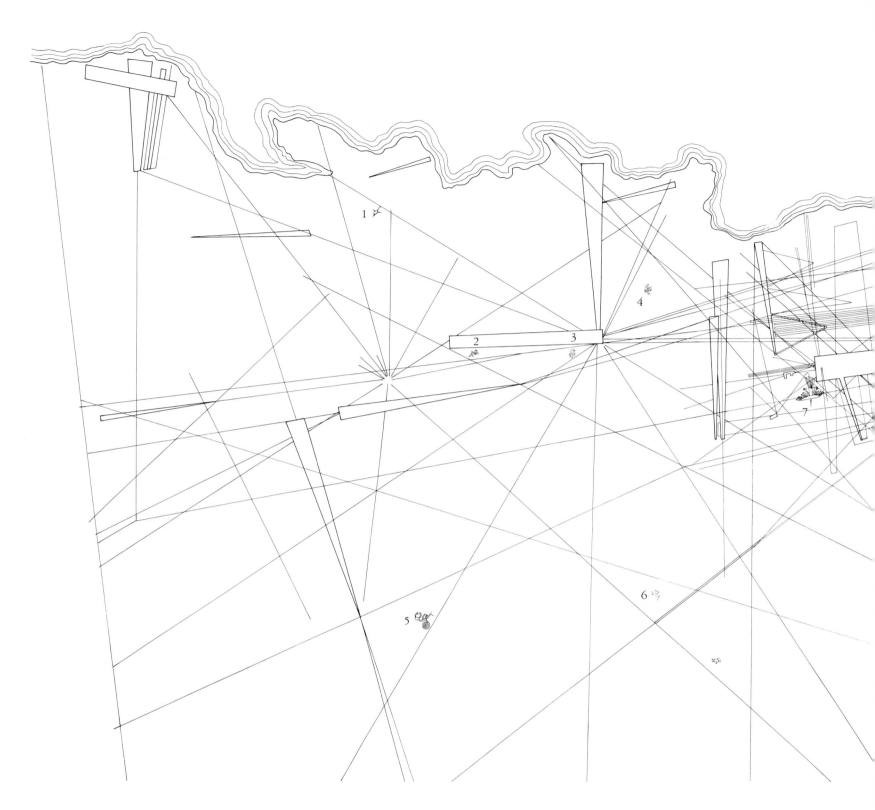

Miss Reiche contends that they mark the points on the horizon at which celestial bodies rise or set: the sun, for instance on 22 June and 22 December, at the solstices, and on 22 March and 22 September, at the equinoxes, or, again, the constellations of Ursa Major and the Pleiades on a date round about A.D. 610. These calculations take into account the fact that, as a result of the precession of the world's axis, the aspect of the sky changes in accordance with a 26,000-year cycle and that the sighting-lines cannot therefore be regarded as constant. Since the lines are only 2,000 years old, this variable must be brought into the equation. On the other hand no heed is paid either to the multiplicity of the lines and the infinite number of possibilities they present, or to the potential meaning of the 'other' lines, namely those which, when plotted, admitted of no interpre-

Plan showing the tracks, lines and drawings in the desert between Pampa and Nazca.
A The Great Rectangle
B The so-called Sun Plaza
The principal figurative drawings represent:

1 A colibri	9 A spiral
2 A killer whale	10 A lizard
3 A fish	11 Roots
4 A pelican	12 Hands
5 A monkey	13 A crane
6 A dog	14 A bird
7 A condor	15 An eagle (?)
8 A spider	16 A whale

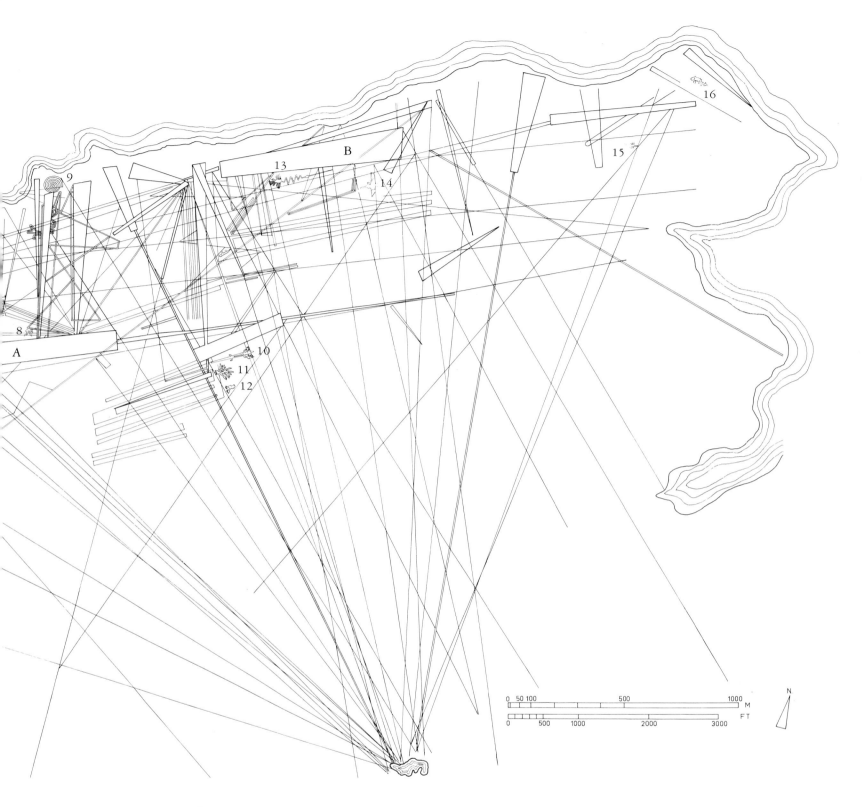

tation and which, therefore, play no role in the astronomical system postulated by Miss Reiche.

In order to decide the matter one way or another, Gerald S. Hawkins, of the Smithsonian Institution Astrophysical Observatory at Cambridge (Massachusetts), carried out a study with the aid of a computer, and his findings were published in 1969. Together with a team of specialists in prehistoric astronomy, he set out to establish whether the ninety-three lines on the pampa between Nazca and Palpa were oriented upon the rising and setting of any one of the forty-five celestial bodies most visible to the naked eye in the southern hemisphere. The result was negative, except in the case of sunrise and sunset where a correspondence was established in respect of certain dates. But in view of the great numbers

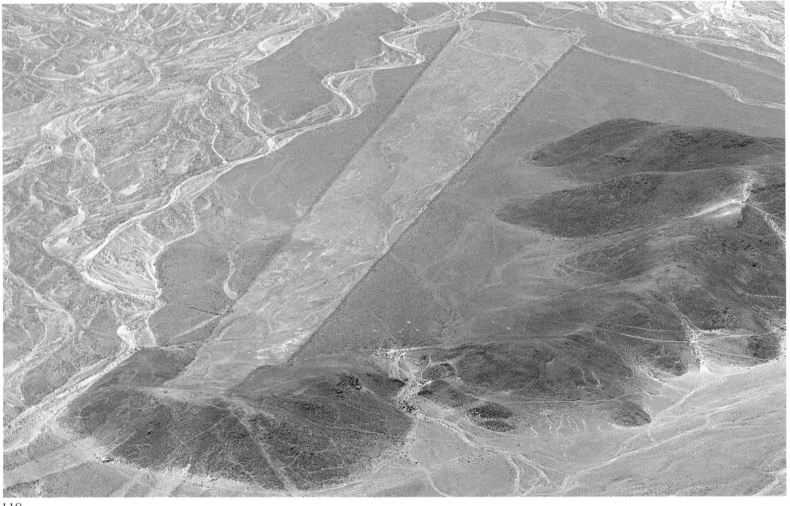

119

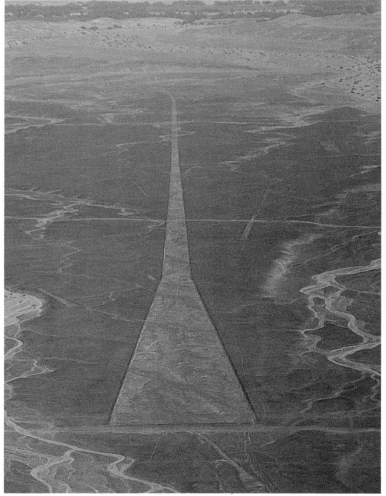

120

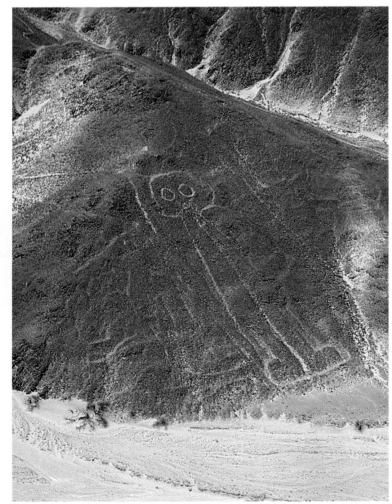

121

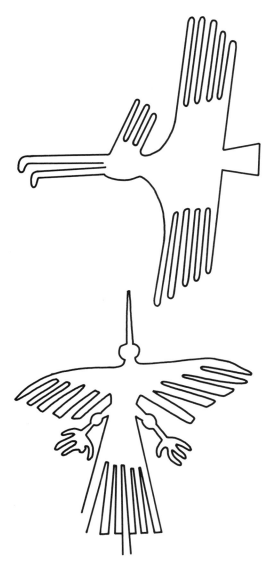

Two drawings in the Nazca desert: a condor 135 m long and a bird.

119 In addition to figurative drawings, a number of long tracks, trapezoidal in shape and measuring up to 800 m, have been made on the surface of the desert. The one illustrated here, more than 400 m long terminates on a natural (?) eminence that might almost be a pyramid. The light, gypsous soil has been denuded of its covering of dark pebbles which have been piled on either side to form low, straight walls.

120 Another track in the desert between Nazca and Palpa. More than 800 m long, it takes the form of two trapeziums. With its carefully prepared surface adjoining the irrigated portion of the valley, it is believed to be one of the more recent drawings, dating back to about the fifth or sixth century.

121 A round-eyed human effigy, as it were engraved on the flank of a hill at the edge of the desert. Dating from the early part of our era, it is more crudely executed than the large horizontal drawings on this site. Height 25–30 m.

of lines and their many and various orientations, this was merely a matter of statistics.

Thus the astronomical hypothesis, which is based primarily on sighting-lines obtained by the plotting of the lines and 'shapes'—rectangular or trapezoidal surfaces—must be abandoned. Other historians, who base their theory primarily on the figurative designs, maintain that these fantastic markings were messages addressed to the gods who alone would have been capable of seeing, from their empyrean, the images that had been reverently constructed in their honour. It has also been suggested that there may have been some connection between these figures and totemic or tribal signs. For the record, we might add that, according to the most recent hypothesis, the lines and drawings served as an arena for the training and selection of the *chasquis* whose task it was to travel the country carrying messages.

What cannot be disputed, however, is the fact that most of the designs have their analogues on the surfaces of polychrome vessels where, if allowance be made for differences in scale on the one hand and of the vehicle on the other, the stylization of the zoomorphic motifs is remarkably similar. This connection between what are sometimes known as Nazca geoglyphs and the pottery typical of the same region lends added weight to the chronological data cited above. Finally, excavations have uncovered what can only be described as foundation offerings, in the shape of jars covered by plates and buried at intersections or where two lines met at an angle.

As yet the problems raised by the Nazca geoglyphs have not been resolved. Though considerable intellects, scientific and otherwise, have applied themselves to the task, and despite the many solutions that have been advanced over the past twenty years or so, the desert continues to guard its secret.

We ourselves, however, are presently engaged in research that will enable us to put forward a new concept capable of producing a scientific and technological answer to these questions. Neither mythico-religious interpretations nor astronomical theories (as the computer has shown) have so far succeeded in doing so and it is our belief that the various superimposed designs in the desert near Cahuachi are explicable only in terms of practical use.

In order to support our hypothesis, further investigations on the spot are necessary and it would therefore be premature were we to seek at this juncture to provide the reader with a key to our interpretation which, in any case, has very little to do with art.

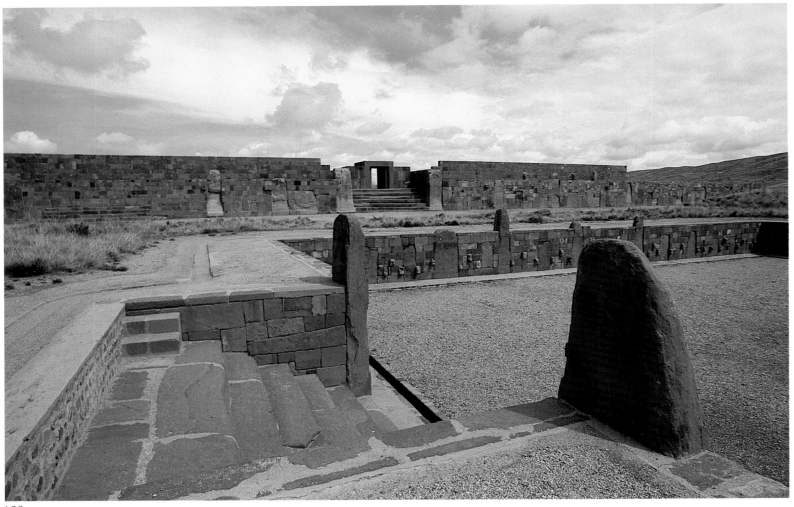

122

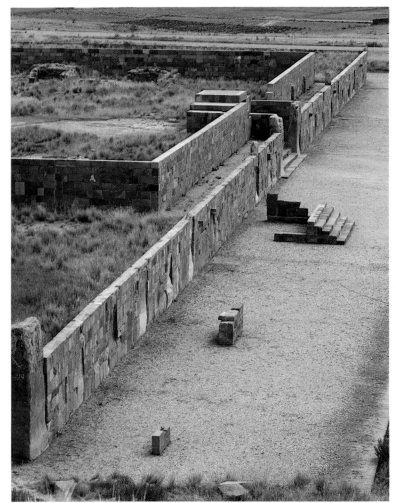

123

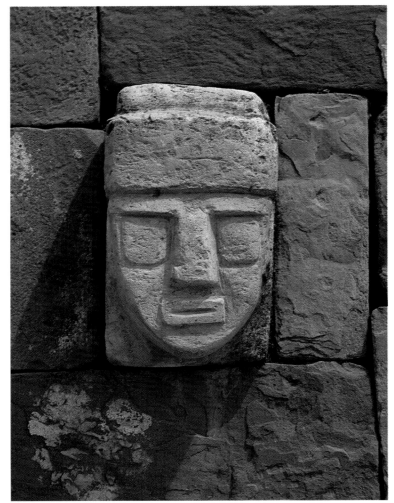

124

VI. Art and Architecture of Tiahuanaco

The development of the Paracas–Nazca civilization, which flourished on the southern littoral of Peru, was furthered by its interchanges with the high plateaux where its strange world of bird-tigers, half-human, half-feline monsters and, notably, trophy heads, was to merge with the traditions of the altiplano, home of the radiant god Viracocha.

Human sacrifice was a feature common both to the fertility cult, aimed at securing an abundant harvest, and, of course, to the trophy-head cult involving as it did the ritual decapitation of the sacrificial victim. The existence of the latter cult in the Paracas–Nazca area is attested, as already seen, by textile motifs, as well as by mummified heads found in tombs alongside the deceased. It is encountered at a still earlier date at Chavín, in the stone heads tenoned into the outer masonry of the principal pyramid, and will recur in the Semi-subterranean Temple at Tiahuanaco in Bolivia, whose interior wall is punctuated by carved human faces, while hundreds of effigies of such victims are disposed around its perimeter.

Thus a confluence of the artistic trends—one peculiar to the coast, the other to the altiplano—would seem to have occurred in the region of what is now Ayacucho (Peru), an intermediate zone which was to see the rise of Huari, the second centre of Tiahuanaco civilization.

If this development is to be understood, it should not be forgotten that there were no isolated provinces in Peru, poor though communications may have been. We need only cite textiles to show that this was the case. Wool produced on the high plateaux where the alpacas grazed was exported to the low-lying coastal regions at a very early stage, while cotton, which grows only in tropical conditions, was in turn exported to the highlands. As early as the first millennium B.C. both these regions were actively engaged in reciprocal trade.

On the high plateaux between Puno and Cuzco, and notably at Maracavelle, 4 kilometres south-east of the latter, pottery has been found which radiocarbon dating assigns to the period between 1000 and 650 B.C. This again not only provides evidence of the early connection between the high plateaux and Andean cultural development generally, but also indicates a measure of synchronism with the appearance of pottery on the coast, both at Cupinisque and at Paracas.

Large stelae in the so-called Pucára style have been discovered in the Titicaca basin at, among other places, Yapura, Arapa, Taraco and Copacabana, as well as on the north-west shore of the lake where they occur in particularly large numbers. Some display abstract geometrical and symmetrical motifs, while others, such as the Yaya-Mama stela, are somewhat clumsy carvings of the human figure. According to present estimates,

122 View of Tiahuanaco, Bolivia. In the foreground is the Semi-subterranean Temple with its entrance stairs flanked by two tall monoliths and its quadrangular court, the walls of which are punctuated by carved stone heads reminiscent of those at Chavín. In the background above the temple is the somewhat over-restored enclosure known as the Kalasasaya with a portal preceded by wide stairs.

123 View of the Kalasasaya from the Acapana Pyramid. Probably sixth or seventh century A.D., the assembly, with its double enclosure wall, has been subjected by Carlo Ponce Sanginés to a pseudo-scientific restoration, the only merit of which is to accentuate its vast perspectives. The exterior of the precinct measures 128 by 118 m.

124 Detail of one of the heads tenoned into the wall of the Semi-subterranean Temple at Tiahuanaco, probably dating from between the second and fourth centuries A.D.

based on analogies with Paracas–Nazca textile designs, this group of stelae may be assigned to the period between the first century B.C. and the fourth century A.D. For it has been established that the mobility of textiles was one of the factors responsible for the diffusion of ornamental styles and themes.

Thus we may observe a distinct, if as yet unobtrusive movement of ideas and forms from the south Peruvian coast to the high plateaux. Such exchanges between the altiplano and the Pacific littoral, initiated by Paracas–Nazca painted textiles in the Chavinoid style, were to increase appreciably after the Nazca period, from A.D. 650 onwards. It was then that a new style came into being in the region south of Lake Titicaca and more notably in the capital, Tiahuanaco, which for the next few centuries was to be the leader of the Andean pre-Columbian world.

Both Mochica and Nazca art were classical manifestations which came into being during the periods of struggle for supremacy. For the 'warring kingdoms', that struggle culminated in the powerful Mochica Confederation, but on the south coast, in the valleys between the Ríos Pisco and Ocoña, the feuds continued. The resulting fragmentation of power tended to break down cultural resistance and thus facilitate the penetration of Tiahuanacoid forms into the Paracas–Nazca region. However, as we have just seen, the art of the altiplano was to benefit in its turn from the advanced techniques of the coastal potters and weavers.

For centuries the peoples of the Titicaca basin had constituted a pastoral community dependent on the rearing of llamas and alpacas, and speaking a common language, *Aymará*, which persisted after the Inca occupation. As early as the second century Tiahuanaco, at that time beside the lake but now 20 kilometres away, would seem to have been a leading city and to have become an important administrative and religious centre. Possibly founded at the beginning of our era, it was destined to rule over the highlands and gradually to extend its sway to the Pacific coast where, by the sixth century, it had become fully established. Thus Tiahuanaco was to dominate what some historians have called the Middle Horizon.

Huari, which may be regarded as a second Tiahuanacoid capital, lay within Tiahuanaco's sphere of influence, being situated half-way between the Pacific littoral and the high plateaux of the *puna*. Whether or not it was subordinate to Tiahuanaco is a moot point not unconnected with national susceptibilities. For the Peruvians are reluctant to admit that the culture of what is now Peru should have been impregnated by a culture emanating from what is now Bolivia or, indeed, have been subject to the influence of Tiahuanaco. Thus, even scholarly circles have shown a tendency to accentuate the differences between the Huari and the Tiahuanaco civilizations, the former being dubbed the centre of an 'empire' of which the latter would then have been no more than the religious capital.

By road, the cities are 1,250 kilometres apart, a distance sufficient to account for stylistic variations all the more marked in that Tiahuanaco, at an altitude of 3,800 metres and surrounded by the *puna,* is subject to abrupt changes of temperature as between night and day, while Huari, 3,000 metres lower down, lies among meadows and fields and enjoys a mild, temperate climate. These two factors, distance and climate, have helped to give each city its own particular stamp, even though, as is evident from their pottery, both used the same iconography.

True, the importance of Huari as a cultural centre has been inflated by Peruvian nationalists, only too pleased that a culture comparable to that

125 The famous Gateway of the Sun at Tiahuanaco, a carved monolith. The reliefs display, at the centre, the creator god Viracocha flanked by forty-eight winged effigies, thirty-two having a human face and sixteen a condor's head. Here again we find highly stylized sculpture reminiscent of Chavín. Height 2.8 m (opening 1.4 m) width 3.8 m.

126 Detail of Viracocha bearing sceptres or javelins. The god, who is frontally posed, wears a radiant headdress in which are discernible pumas' or jaguars' masks.

127 Today the Ponce Stela stands at the centre of the Kalasasaya enclosure. This hieratic and vigorously schematized statue is embellished with delicate bas-reliefs and represents a richly caparisoned figure bearing objects probably connected with the celebration of a religious rite.

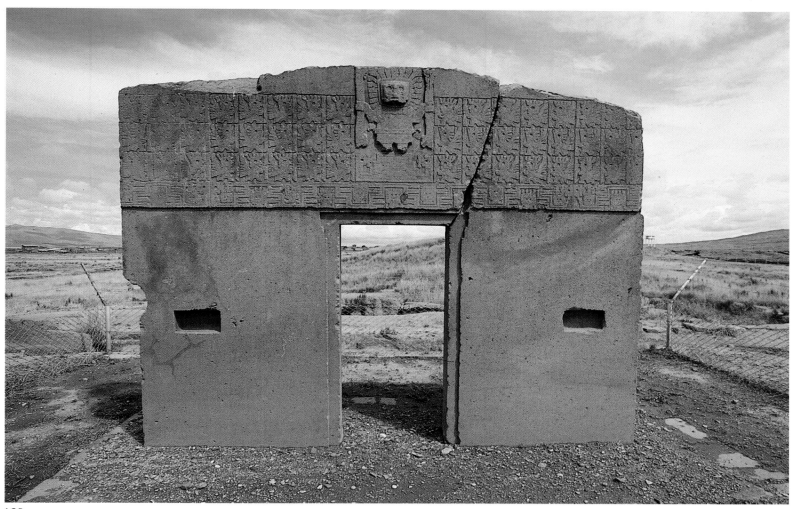

125

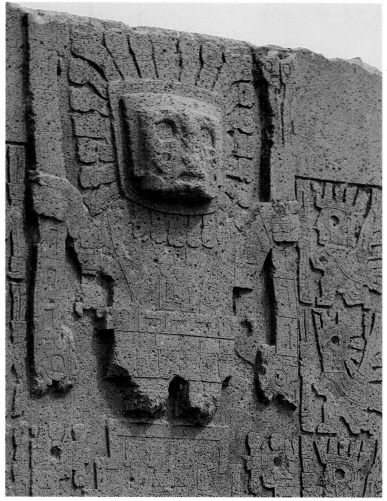

126

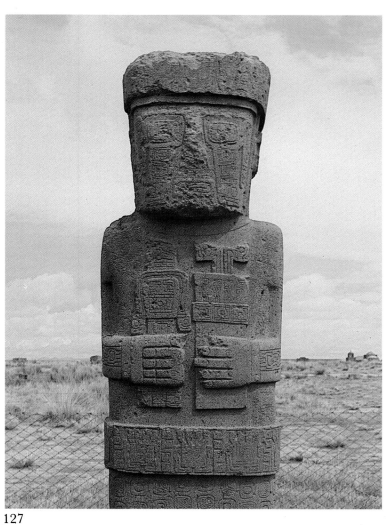

127

of Tiahuanaco in Bolivia should have been discovered on their own soil. Yet there is no denying that Huari, which dates back to the third or fourth century A.D., was subject to the cultural, artistic and religious influences of Tiahuanaco, even if we allow that it remained unconquered and that the two cities achieved their imperialist aims in different areas. In that event, Tiahuanaco's sphere of influence would have embraced the whole of the Titicaca basin and extended to Cochabamba in the south and to the southern extremity of the Peruvian littoral, while Huari, in the Mantaro basin, would at a very early date have established close links with the Nazca region, the birthplace, of a style that was slowly progressing northwards. Whatever the case, Tiahuanaco–Huari products found their way to Callejón de Huaylas, the Urubamba valley and the middle reaches of the Marañón, before continuing up the coast as far as Pachacámac and a few isolated settlements further north.

Indeed, there is something factitious about Huari's supposed independence vis-à-vis Tiahuanaco, since it is suggestive rather of the aspirations of Peruvian patriots such as Larco Hoyle than of a rigorously tested, archaeological theory.

We shall not enter into this thorny question but instead use the term Tiahuanacoid to denote the products attributed to Huari. And while the precedence of Tiahuanaco in the religious, cultural and artistic sphere can hardly be disputed, the question of whether there were two empires or only one still remains unresolved. According to William Isbell, who carried out excavations at Huari in 1978, there is little evidence to support the view that it possessed an empire, while in the opinion of Frédéric Engel the existence of a Tiahuanaco empire is no more than 'hypothetical, a pretty fantasy at most'.

The fact remains that in the seventh century large numbers of Tiahuanacoid articles found their way to the coastal regions where communities from the altiplano had established colonies. But that does not connote the total domination of Peru. Perhaps it would be more correct to speak of a form of religious proselytism which came to an end in the tenth century with the abandonment of Tiahuacanoid themes.

Mythical City

In archaeological terms the Tiahuanaco period evidently leaves a number of questions unanswered. No doubt it is its very nebulosity that has been responsible for the many far-fetched works on the subject and for the mystification that surrounds the site itself. The first to propagate such myths were visitors from the West. In 1548 the Spaniard, Cieza de León, appointed 'First Chronicler of the Indies', remarked of Tiahuanaco that it was 'the most ancient ruin in the whole of Peru'. Since then, no site anywhere in the world—save, perhaps, the Great Pyramid at Giza—has inspired so many fable-mongers and exploiters of human gullibility. Cranks and false prophets have vied with one another in telling tall stories about the city's immemorial antiquity, the generation of giants who built it, the catastrophic flood, the visitors from outer space, and so on. Perhaps we might consider why this should be.

It is a question to which the dispassionate observer will be hard put to find an answer. Perhaps the pure air at so high an altitude (4,000 metres) had gone to the heads of a few enthusiasts, or perhaps the sheer remote-

ness of the site—at any rate up till quite recently—has encouraged impostors and hoaxers of every description. At all events, the past fifty years have seen a proliferation of books aimed at a credulous and sensation-loving public. We need only cite the writings of Edmond Kiss or of H. S. Bellamy and P. Allen, or again, and for good measure, the 'theses' of those French 'wizards', Louis Pauwels and Jacques Bergier. Nor should we omit the absurd pseudo-archaeological science fiction of Erich von Däniken who introduced astronauts, space-ships and extra-terrestrial beings into Tiahuanaco and, for that matter, into Nazca in an attempt to explain the 'tracks' in the desert.

We mention these extravaganzas and divagations if only because it is apparently the fate of certain sites to be subjected to the wildest flights of fancy. Now in our view there is nothing in the nature of Tiahuanaco that might justify such a flood of oracular pronouncements. Lying in a vast, arid upland where llamas graze the coarse grass known as *ichu*, in a bleak landscape reminiscent of a steppe whose ring of rolling, featureless hills denies the visitor even the unlimited horizons of the *puna*, Tiahuanaco is first and foremost a place of devastation, a place plundered and pillaged by man.

Architecture of Tiahuanaco

The ceremonial centre at Tiahuanaco is made up of the same components as the majority of such pre-Columbian sites in the Andean region, namely, a pyramid, an esplanade—in this case a square platform—and a sunken plaza such as we have already encountered at Sechín Alto and Las Haldas, as also at Chavín where, however, it was circular in plan, as opposed to being square.

The pyramid at Tiahuanaco, known as Acapana, is on an irregular cruciform plan and is oriented east-west. Built of earth, it is some 200 metres square and 15 metres high, and must once have possessed a cladding of stone slabs. At the top of the now very ruinous structure is a large pit dug by generations of treasure-hunters, including the inevitable *huaqueros*.

Flanking the pyramid to the south are the remains of a canal which linked the city to Titicaca in the days when the capital of the high plateaux still stood in the immediate vicinity of the lake. Now it is some

Plan of site at Tiahuanaco (Bolivia)
1 Gateway of the Moon
2 Kheri-Kala enclosure
3 Putuni enclosure, also known as Palace of the Sarcophagi
4 Kalasasaya enclosure
5 Gateway of the Sun
6 Semi-subterranean Temple
7 Acapana Pyramid
8 Kantatayita (containing what may have been an architect's model for the Kalasasaya)

128

129

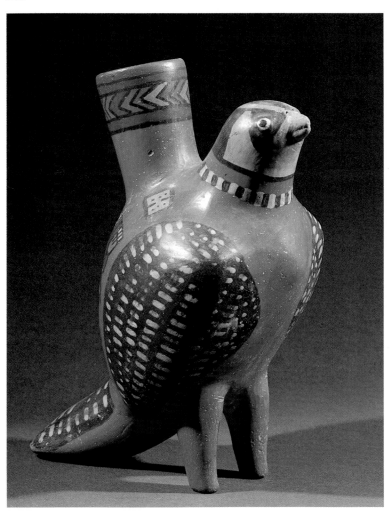

130

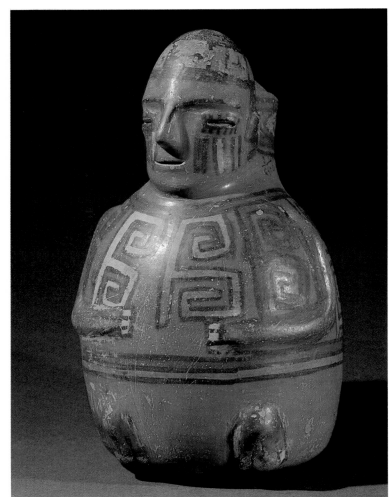

131

20 kilometres away, the water-level having fallen in the course of two millennia.

To the north of Acapana lies the sunken court known as the Semi-subterranean Temple, restored in the 1960s by the Bolivian archaeologist Carlos Ponce Sanginés. Measuring 26 by 29 metres, it is almost square in plan and lies 2 metres below ground level. The court is lined by retaining walls constructed of upright posts, or stiffeners, linked by a filling of smaller cubical blocks. Affixed to the latter are stone heads in various sizes, which recall the tenoned heads at Chavín (Pls. 122, 124).

The Semi-subterranean Temple is reached by eight high steps, 5 metres wide, built into the angle of the wall and flanked by two posts which rise above ground level. At the centre of the court are three stelae, one of which, Stela 15, was discovered *in situ* in 1932 by Wendell Clark Bennett. Of distinctly rustic appearance, it was lying alongside the enormous Stela 10, 7.3 metres high and weighing 17 tons, which now graces a square in La Paz.

To the west of this temple we come upon a huge esplanade in the form of a quadrangular platform enclosure known as Kalasasaya (128 by 118 m). The procedure is the reverse of that adopted for the sunken court where the wall was centripetal, for here the piled-up mass of material is held in place by an imposing revetment 4 metres high. However, both the temple and the esplanade share the same system of posts or stiffeners linked by walls of dressed and irregularly shaped stone, so that the vertical elements alternate with an infilling laid in horizontal courses. This method of construction recalls the archaic technique adopted at Cerro Sechín although here, at Tiahuanaco, the outer side of the walls is innocent of carvings.

Unfortunately the same Bolivian archaeologist responsible for the very overdone restoration of the Semi-subterranean Temple, also ventured on a similar operation in respect of Kalasasaya, notably its west face. Aside from the question of taste, it is the kind of restoration which, carried out as late as the 1970s, cannot fail to shock. Both the wall and the portal surmounted by a lintel and leading to the inner court are more reminiscent of a Hollywood film set than of a serious essay in archaeological reconstruction (Pl. 123).

The gateway, which faces the Semi-subterranean Temple, is situated in the east face of the quadrangle. It still retains six of the original steps of a stairway 7 metres wide, flanked at the point of entry by two tall monoliths which also buttress the rebuilt wall of the enclosure. The portal itself—the child, be it said, of Ponce Sanginés' imagination—gives access to an inner court (80 by 65 m) once presumably lined by buildings which, however, are now in so ruinous a condition that not even their layout is discernible. At the centre of this court or patio there now stands the Ponce Stela, surrounded by a hideous barbed-wire entanglement, while the El Fraele Stela has been resited in the far south-west corner of the Kalasasaya. At the latter's north-west corner the famous Gateway of the Sun remains in the position it has occupied since the beginning of this century. It, too, is now encircled by barbed wire, thereby calling to mind a military installation rather than a work of art.

Amongst the other highly ruinous remains of this city, which for centuries has served as a quarry for new buildings—including the local church and, notably, the colonial houses of La Paz—we might cite the Putuni, or Palace of the Sarcophagi (approximately 48 by 40 metres),

128, 129 Two sides of a ritual vase from Tiahuanaco. Classic period, A.D. 600-800. The vessel, a precursor of the Inca *kero*, shows a condor and a jaguar or puma. Height 17 cm, diameter at mouth 15.5 cm. Museo Arqueológico, Lima.

130 Vessel in the shape of a bird from the Huari region. Early Huari phase, about A.D. 500-600. The treatment of the falcon is still somewhat primitive. Height 17.5 cm. Museo Arqueológico, Lima.

131 Anthropomorphic terracotta. Early Huari style. As in other pieces of this kind, the treatment is somewhat summary, while the dull tones show that the highland potters had not yet fully benefited by the techniques evolved on the coast. Height 19 cm. Museo Arqueológico, Lima.

situated west of the Kalasasaya, as also the Kheri–Kala enclosure still further to the west, and the mound on which stands the small monolithic Gateway of the Moon. The Kantatayita, another noteworthy structure, lies to the east of the Semi-subterranean Temple and houses a carved block believed to have been the original architect's model of the Kalasasaya but which might also have done duty as a miniature votive temple.

Some 1,500 metres south-west of the ceremonial centre we come to Puma Puncu, now a mass of ruins save for a few stone platforms constructed of monoliths, some of them as much as 7 metres long, 4 metres wide and 1.8 metres thick. Not until the Inca period do we again encounter such impeccably dressed masonry. These blocks, with their strictly rectangular interlocking joints would seem to have formed the floor of a sanctuary, the walls of which must have consisted of large and finely dressed slabs. The layout of this complex, which has been the subject of many hypothetical reconstructions, suggests a series of small juxtaposed cells.

We might further note that the ruins of Puma Puncu have yielded the remains of three monolithic doors similar to the Gateway of the Sun, but less finely decorated. The latter monument, to which we shall presently return, was not therefore an isolated feature but, as its name might suggest, only one of the components of an architectural system of interlocking monolithic elements. The rules of that system are reflected in structures such as those found at Puma Puncu, which proclaim the virtuosity of the Tiahuanaco masons in the fashioning of large blocks of stone.

Town Planning and Chronology

It is surprising to discover, in so far as any form of town planning is discernible at Tiahuanaco, that this complex was not the outcome of a rigorous and coherent design. While the Acapana or main pyramid is oriented east-west, roughly parallel to the walls of the Semi-subterranean Temple—which, however, is on a south-north-axis—there is a slight axial deviation relative to the Kalasasaya, suggesting the existence of a gentle declivity towards the south-west. In short, while Tiahuanaco possessed the typical elements of Andean ritual town planning—pyramid, quadrangle and sunken plaza—there is no coherence about the disposition of the various components, nor is this governed by a single axis.

To give some idea of the chronology of these various buildings, it should be assumed that the Acapana and the Semi-subterranean Temple belong to Phase III or, by Sanginés's reckoning, to the period between A.D. 133 and 374. They were followed by the Kalasasaya in the fourth or fifth century and, in the sixth or seventh—the heyday of this complex—by Puma Puncu. These estimates are, however, no more than conjectural. In the chronology which Sanginés has sought to establish, dates based on radiocarbon measurements are claimed to be accurate to within one year; yet, as everyone knows, the results of such tests can only be approximate and allowance should be made for a margin of error of, say, fifty to eighty years plus or minus over a period of 1,500 to 2,000 years, in other words a spread of between 100 and 150 years. Such being the case, it may be asked why Ponce Sanginés should advance figures for Phase III such as 133 to 374 instead of restricting himself to, say, 250 ± 150.

In 1966 Jeffrey R. Parsons attempted to determine the area occupied by Tiahuanaco. At the time of the city's greatest expansion the inhabited zone, expressed in distances from the Acapana, extended 850 metres southwards, 1 kilometre eastwards, 500 metres northwards and, in all probability, 1 kilometre westwards. These irregular boundaries would therefore have embraced an area of some 2.4 square kilometres capable of accommodating, according to the author's estimates, a maximum population of about 20,000. Tiahuanaco was, therefore, a place of habitation and not, as long has been supposed, simply a centre of pilgrimage.

Sculpture and Iconography

The sculptural interest of the buildings of Tiahuanaco lies in the high quality of the materials used and the excellence of the workmanship. The stone blocks are sometimes huge—some at Puma Puncu weigh as much as 130 tons and have been described as 'cyclopean', though these are as nothing compared with the monolithic colossi of Ramses II weighing 1,100 tons, or the Karnak obelisks of more than 600 tons. So clean are the cut surfaces and so sharp the arrises, however, as to suggest the use of a punch, and indeed these blocks give evidence of meticulous preparation and accurate dressing never before encountered in Andean pre-Columbian art save, perhaps, in certain elements such as the columnar portal at Chavín. However, this strict stereotomy, like the use of metal cramps, arguing as it does a consummate command of technology, is not apparent throughout the complex. As yet barely discernible in the Semi-subterranean Temple, it manifests itself more strongly in the Kalasasaya and comes fully into its own both at Puma Puncu and in the few elements, such as the Gateways of the Moon and Sun, that have survived more or less intact. Here, however, the stereotomy tends to merge with other techniques such as carving and decoration.

Though some of the slabs used in the platforms are very large (7 by 4, by 1.8 m, as already mentioned) they were probably transported without undue difficulty across Lake Titicaca from the quarries on its further shore and then by canal direct to Tiahuanaco, at that time much closer to the lake than it is today. It would seem that the slabs were ferried across on the trunks of balsa-trees felled in the Amazonian forest.

As for the Gateway of the Sun, upon which so much ink has been expended, the visitor may well be disappointed by this piece of architectural sculpture since, contrary to his expectations, it is relatively small. The andesite monolith is, in fact, 3.8 metres wide, 2.8 metres high and is nowhere thicker than about 70 centimetres. Hence its weight is in the region of 13 tons, if we take account of its reduction by carving and of the opening made for the doorway itself. The latter, which is only 1.4 metres high and 60 centimetres wide, is more reminiscent of a cat-hole than of an imposing portal. Indeed, it prompts us to ask whether the population of giants postulated by sundry cranks was not, in reality, a race of dwarfs (Pl. 125).

However, the real interest of the monument lies in its decoration consisting of high and low relief carving, and in the craftsmen's recourse to a vigorously structured iconography. The *modus operandi* here is akin to that at Chavín: at the centre, and dominating the door-way, is the effigy of the god Viracocha which bears certain analogies to the similarly frontal

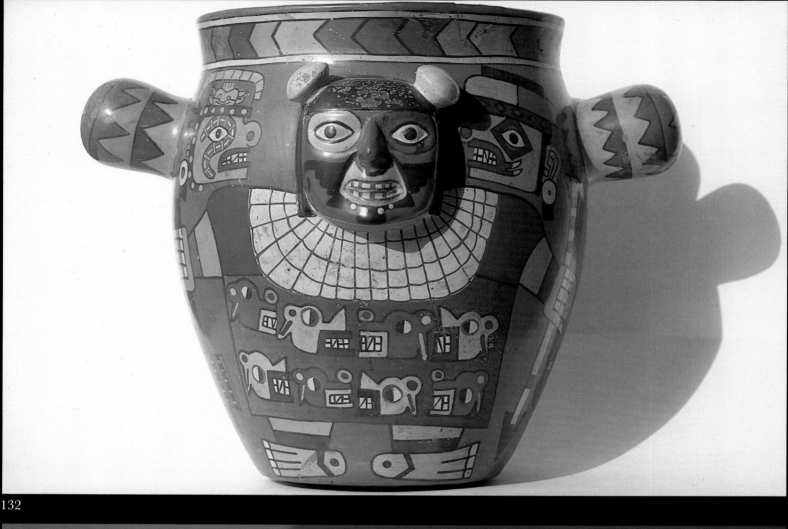

132

133

image on the Raimondi Stela. Viracocha is flanked by forty-eight attendants disposed in three rows—sixteen winged figures with human faces in the top and bottom rows and sixteen condor-headed figures, also winged, in the middle row—that is, eight on each side, in accordance with a tradition deriving from the frieze at Chavín. In the latter the figures are haloed by serpentine hair or emblematic jaguar's masks, whereas here they are not only repeated with mechanical precision, but also characterized by an astonishing wealth of detail. No less ornate than the god himself, who holds ceremonial arms or sceptres and is clad in sumptuous attire adorned with trophy heads, all the attendant figures are bestrewn, again as at Chavín, with miniature heads of pumas and condors. Also worthy of note are the tears in the form of felines that trickle down the cheeks of the god and which have their analogues in, for example, the Bennett Stela and the Ponce Stela. These weeping eyes are reminiscent of the painted reliefs at Moxeque, executed more than 1,000 years earlier. Were they, perhaps, also intended to evoke a fertility god, the bringer of the seasonal rains? That may well be, although the availability of sweet water was far less of a problem on the altiplano than on the coast (Pls. 126, 127).

In short, the chief merit of these Tiahuanaco sculptures rests in the exceptionally delicate bas-reliefs which would seem to derive from the graphic motifs evolved in weaving and are reminiscent of the superb Tiahuanacoid textiles whose designs were in turn influenced by those of the Nazcas. From this affinity between motifs cut in hard stone on the one hand and tapestry designs on the other—an affinity which governs the construction of the image—the art of bas-relief derives, not only its density, but also its hieraticism.

Diffusion of Tiahuanacoid Forms

It may reasonably be supposed that the fifth century saw considerable demographic growth in the intermediate zone near Ayacucho. As a result, the pastoral Huari people, who had hitherto led a nomadic existence in their own valleys, were compelled, as David L. Browman has shown, to expand northwards into the Junín region since all southward movement was blocked by Tiahuanaco.

A confrontation between the two cultures thus became inevitable and, indeed, Tiahuanaco's iconography and architectural techniques, which had already reached the Nazca valleys, were soon to spread to Huari. By the sixth century, typical Tiahuanacoid forms had appeared in that city, as is evident from William Isbell's discovery there of a semi-subterranean temple in the form of a sunken court almost identical to that in Tiahuanaco and containing monolithic sculptures which, though less finely carved, recall the El Fraele and Ponce stelae. Similarly, funerary chambers built of huge finely dressed slabs and set together with the utmost precision bear witness to the spread of Puma Puncu architecture to Huari, possibly some time after A.D. 750.

This expansion of Tiahuanaco art, soon to be followed by that of Huari, left its mark on a large number of cities, all of which were given enclosures on a rectangular plan. They included Viracochapampa, Pikillaqta, Huatun Huillay, the huge city of Cajamarquilla in the Rimac valley and, finally, Pachacámac, south of present-day Lima, with its great Pan-Andean ceremonial centre. The spread of these influences as far north as

132 Ceremonial bowl from Pacheco. Tiahuanaco coastal style, about A.D. 700–800. With its two hollow handles, the vessel testifies to the consummate technique of the potter. The stylized decoration, directly inspired by the Gateway of the Sun at Tiahuanaco, comprises an effigy of Viracocha in a garment covered with jaguars' masks. Height 31 cm. Museo Regional de Ica.

133 Shallow bowl. Tiahuanaco coastal style, decorated with winged jaguars or pumas. In this piece a serpent is clutched between the front paws of the feline. The uncluttered geometricality is typical of the Classic period. Diameter 26 cm. Museo Regional de Ica.

134 The style of this bowl, though described as Huari *expansivo,* is barely distinguishable from Classic Tiahuanaco, as is evident from its decoration comprising a jaguar's mask and small condors' heads. Height 8 cm. Museo Arqueológico, Lima.

135 Anthropomorphic terracotta, Huari *expansivo* style. About A.D. 800–900. The face of this very schematized figure appears to be tattooed with geometrical motifs, while his clothing displays Tiahuanacoid coastal elements. Height 28 cm. Museo Amano, Lima.

136 Anthropomorphic jar. Huari *expansivo* style. Here the modelling is less elaborate than in the preceding example; the hands are no longer depicted in relief. The polychrome is also noticeably less rich. Height 29.5 cm. Museo Arqueológico, Lima.

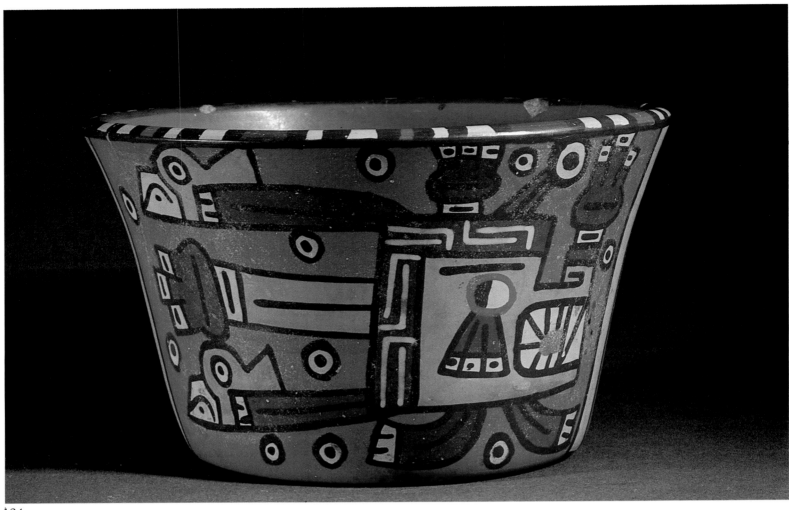

134

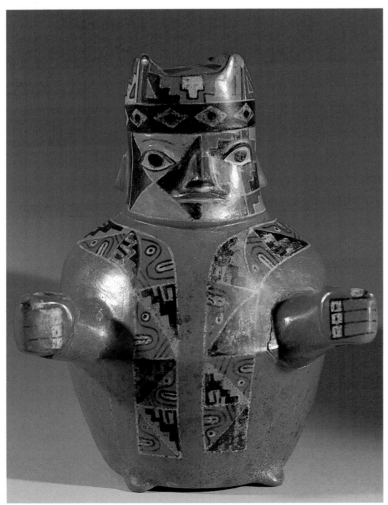

135

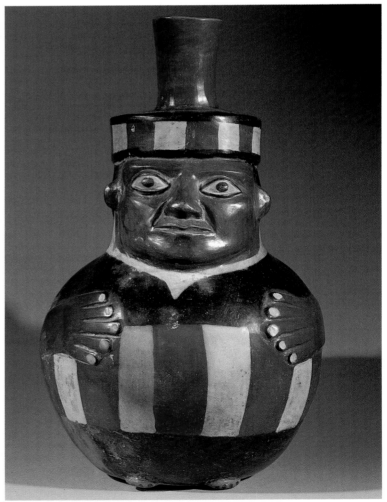

136

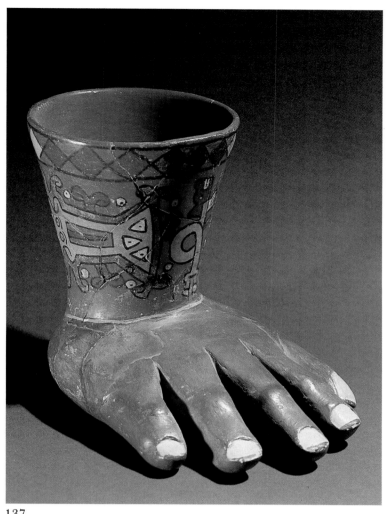

137

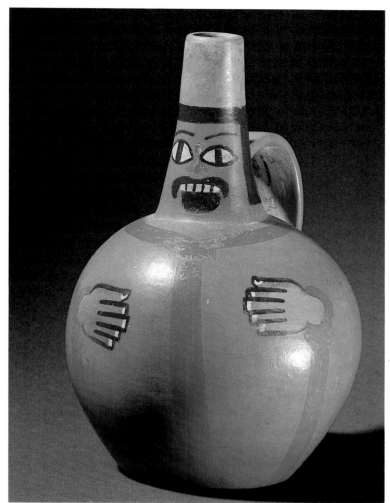

138

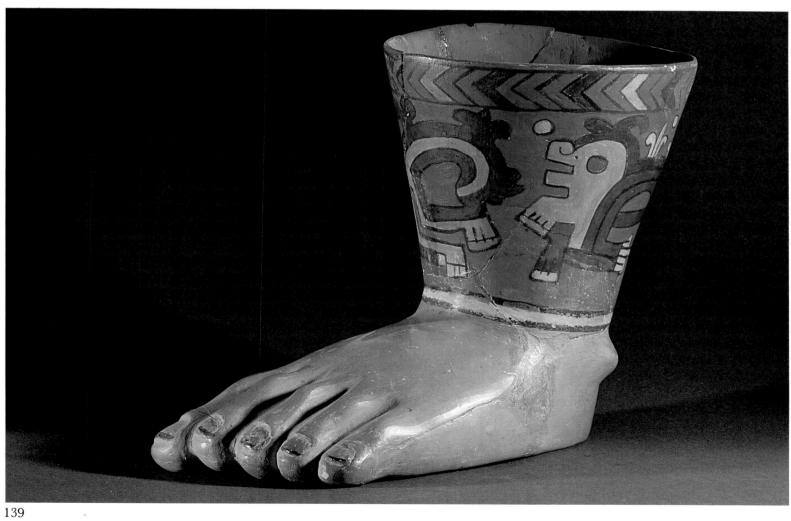

139

Lambayeque and Cajamarca is attested above all by their pottery which, as is so often the case in archaeology, still remains the best source of information.

Indeed, the development of pottery provides an excellent illustration of the differences that existed between the art of Tiahuanaco and that of Huari, before the latter came under the influence of the themes elaborated by the civilization which flourished on the shores of Lake Titicaca. The Classic pottery of Tiahuanaco found its expression in vessels with flaring mouths which prefigure the *kero* of the Incas. Although still technically inferior to Nazca wares, these jars with their decoration of stylized pumas and condors nevertheless exhibit a lively sense of colour and an unmistakable concern for drawing (Pls. 128, 129).

Meanwhile, during the first half of the first millennium A.D., the style of the early Huari pottery remained purely vernacular and altogether free from Tiahuanacoid influence. The treatment of anthropomorphic pieces tends to be summary (Pl. 131), while zoomorphic vessels, such as a schematized falcon (Pl. 130) may take the form of somewhat crudely executed polychrome terracottas. It was not until about A.D. 650, when the mythologically derived iconographic themes of Tiahuanaco were married to the skills of the Nazca potters that the Tiahuanacoid art of ceramics experienced its heyday.

Paradoxically enough, it was in the coastal regions rather than in the mother city itself that this superb pottery was first brought to light. For the site of Tiahuanaco, having been plundered for centuries on end, now yields little but sherds. On the coastal sites, however, and notably at Pacheco in the Nazca valley, there have been numerous finds of beautiful monumental urns of a ritual nature displaying the effigy of Viracocha flanked by trophy heads, puma masks and the heads of condors, from which we may conclude that new forms of worship had been imported from the altiplano (Pl. 132).

In the meantime the influence of these cults had also made itself felt in the neighbourhood of Ayacucho, as is evident from finds of Tiahuanacoid objects at Conchapata in the intermediate Huari zone. Here, too, enormous urns were discovered, some of which stand over 1 metre high and are the largest polychrome vessels known to have been produced in the Andean region. They are believed to date from the second half of the seventh century.

Though drawing on the techniques of Nazca ware, famed for its brilliant polish, clean drawing and polychrome designs outlined in black, Huari pottery evolved in accordance with its own principles. Its dishes are embellished with themes, combining serpents and winged pumas, remotely recalling the iconography of Chavín, yet treated in accordance with a style that is entirely new (Pl. 133).

Bowls in the shape of an inverted truncated cone, with wide mouths and slightly concave sides, provided a ground for generous, if increasingly, schematic ornamentation (Pl. 134). This schematization is particularly apparent in Huari work in which portrait vessels deriving from monumental urns gradually became ever more allusive, a process that went hand in hand with a diminution of technological expertise over a period extending from the ninth to the eleventh century (Pls. 135-6, 138).

We have already discussed votive objects depicting parts of the human body, such as the hands executed in gold by the Mochicas and in terracotta by Vicús. It was a tradition that lived on in Huari pottery, but here

137 Tiahuanaco–Huari funerary ceramics, like that of Mochica and Vicús, may take the form of votive offerings representing parts of the body. The somewhat clumsily executed hand with its stubby fingers serves as the base of a vase, the decoration of which is unmistakably Tiahuanacoid. Museo Arqueológico, Lima.

138 Jar. Late Tiahuanaco–Huari. This little vessel, decorated with highly schematic anthropomorphic paintings, exemplifies the development which led to what was an increasingly summary form of sculpture. (Cf. Pls. 135, 136.) Height 16.5 cm. Museo Arqueológico, Lima.

139 Terracotta votive foot. Tiahuanaco–Huari style. (Cf. Pl. 137.) With its stylized jaguar decoration this piece derives both its symbolism and its polychromy from the coast. Height 13.5 cm. Museo Arqueológico, Lima.

140 Funerary structures at Wilcawaín above Huaraz (Upper Peru). The stone huts, built without mortar, are roofed with inclined slabs. This site, dedicated to the cult of the dead, is difficult to date, but may have come into being some time during the first millennium A.D.

141 The largest of the buildings at Wilcawaín contains a number of funerary chambers at different levels. Each served as a repository for a *fardo*.

142 Sculpted ovoid *fardo* from the Huaraz region. The very expressionistic style is contemporaneous with the Huari culture.

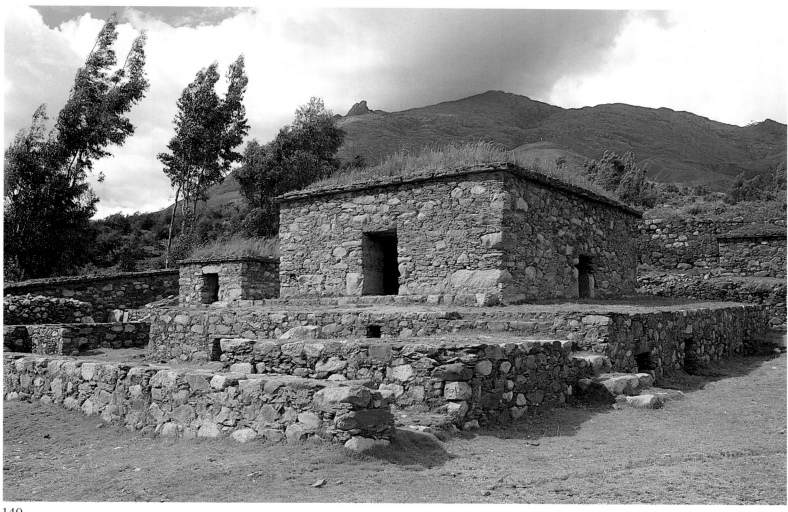

140

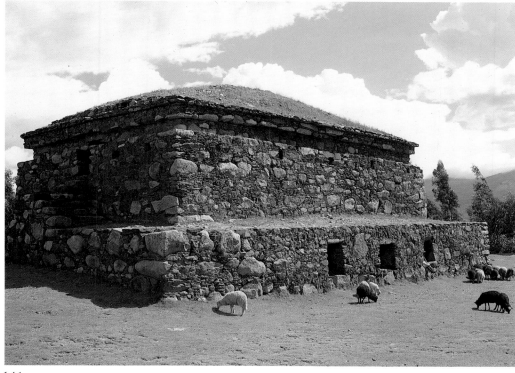

141

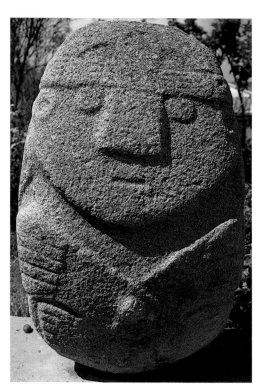

142

the hand or foot, in most cases of very sober design, served as a vessel which, with its wide conical neck, lends itself to the same type of decoration as the bowls previously mentioned (Pls. 137, 139).

There is little consensus among scholars with regard to the civilization which dominates the Middle Horizon. Some believe that Tiahuanaco art, which flourished throughout virtually the whole of Peru, was disseminated by a dynamic religion, while others, among them J. H. Rowe, contend that this pre-eminence in the formal sphere could never have been achieved without the establishment of what can only be described as a Tiahuanaco empire. Is this to suggest that the diffusion of Chavinoid themes and forms necessarily presupposes the existence of a Chavín empire in the first millennium B.C.? And do those major phases known to archaeologists as Horizons invariably postulate military subjugation? In opposition to those who argue in favour of ideological proselytism alone, Rowe adduces an illuminating comparison which seems to us worth citing, namely the analogy between the diffusion of Tiahuanacoid and of Inca forms respectively. Now the latter, which represents the Late Horizon, patently coincides with the phase of Inca expansionism.

We would no more seek to argue the point than to intervene on the subject of Huari's status vis-à-vis Tiahuanaco. Many campaigns of excavation will be required before any real idea can be gained of the political and/or religious mechanisms underlying the general diffusion of artistic forms that constitutes the Middle Horizon.

Recuay Pottery and the Wilcawaín Tombs

Finally we must turn to the products of the Callejón de Huaylas region, which was also to come under Tiahuanacoid influence during the expansionist phase but which, in the early part of our era, saw the emergence of Recuay pottery, an astonishingly original style named after an agglomeration in the upper Santa valley.

Recuay became diffused over a wide area, from the Río Pativilca in the south to the Río Virú in the north, and is believed to have persisted from about A.D. 100 until the middle of the first millennium. The people of Recuay would appear to have allied themselves to the Mochicas and to have come within their sphere of influence. Nevertheless, they adhered to their own idiom so far as pottery was concerned, making use of a very hard, fine-grained kaolin to produce wares of quite exceptional quality.

The house vessels depicting an inhabited dwelling with a central court are a particular feature of this art (Pl. 145). The spherical jars have a wide, delicate, everted rim with, beneath it, a short tubular spout from which the liquid might be poured straight down the throat. The contrasting motifs are executed with much vigour (Pl. 144).

The llama, which was reared in the valleys and plateaux of the Andes, occupies an important place in the iconography of Recuay. Here we encounter a form of pottery depicting this creature alongside a personage wearing a tall head-dress of juxtaposed discs. The figure may be that of a god or possibly of a high-priest entrusted with the task of sacrificing the llama, a beast which had brought into being a pastoral culture similar to that existing in the Huari and Tiahuanaco regions at the same period (Pl. 143).

143 Terracotta figurine from the Santa valley. Recuay style. A very elaborate piece representing a warrior-priest in a tall head-dress adorned with discs and serpents and surmounted by the image of a deity. Beside the priest is a sacrificial llama. Height 27 cm. Museo Amano, Lima.

144 Jar with long spout and flaring mouth. Early Recuay style. Beginning of our era—A.D. 300 or 400. The vessel, which is decorated with anthropomorphic and zoomorphic motifs, combines negative painting with sculptural elements. Height 17 cm. Museo del Banco Central de Reserva, Lima.

145 Recuay house-vessel. The occupants of the dwelling may be seen in the central court. The style is Classic Mochica (A.D. 400–500), i.e. somewhat later than that of the preceding piece. Height 24 cm. Museo Arqueológico, Lima.

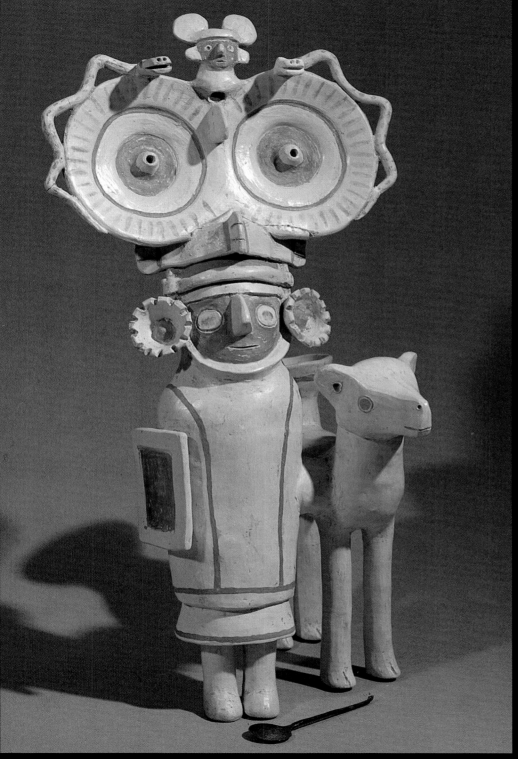

143

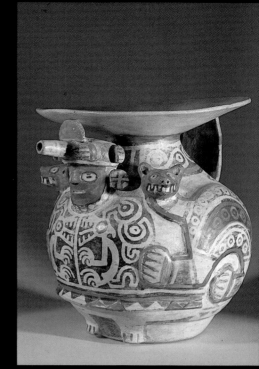

144

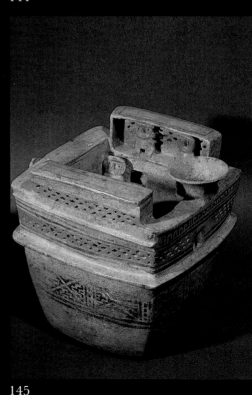

145

Again in the Santa valley very roughly executed sculptures have been found, usually ovoid in shape and carved in hard rock. They are restricted to summary representations of a cadaver in the fœtal position already encountered in the *fardos*. These objects, interesting examples of which are preserved in the Huaraz Regional Museum, probably date back to the Huari period, between A.D. 600 and 1100, as do the funerary monuments at Wilcawaín, above Huaraz, consisting of stone huts covered with large inclined slabs, which are amongst the best-preserved pre-Inca buildings known to Peruvian archaeology (Pls. 140, 141).

Thus the tendency inspired by Tiahuanaco, which led to the widespread use of stone in funerary architecture, succeeded in implanting itself not only in Huari but also—and perhaps through the agency of that city—in the upper Santa valley which, lying at much the same altitude (nearly 4,000 metres) as the valleys of the Titicaca basin, presented a similar environment, although separated from them by a distance of more than 1,000 kilometres.

VII. Mass Art in the Chimú Empire

We shall now return to the Pacific littoral of Peru, where we shall consider the emergence of the Chimú empire, sometimes known as the kingdom of Chimor. However, the period of Tiahuanacoid influence, which intervened between the Mochica apogee and the first appearance of Chimú forms of expression, is not easy to define in that, as mentioned above, there is no real means of telling whether a homogeneous style has been engendered by a military occupation or by the diffusion of religious ideas. The Tiahuanaco–Huari Horizon, embracing those areas which came under the direct influence of the upland cultures, would seem to have extended from the Tacna coastal region in the south to Pachacámac in the vicinity of present-day Lima. But whether or not political expansion and colonization extended northwards as far as Lambayeque is, in our present state of knowledge, a matter for conjecture. Yet excavations would seem to show that as far north as Chanchán at the mouth of the Río Moche buildings in the Tiahuanacoid style preceded those erected by the Chimús.

The fact remains that what had hitherto been Mochica style pottery suddenly underwent a change after the appearance of motifs characteristic of Tiahuanacoid art, as did decoration and burial customs. Tiahuanaco–Huari influence, which would seem to have persisted from the eighth to the tenth or eleventh century, does not appear to have affected the regions north of Lambayeque where the Late Mochica culture continued to survive and develop as an independent entity. It was these autochthonous traits that contributed to the emergence of the Chimús.

So gradual, indeed, was the transition from Mochica to Chimú that as little as thirty years ago Mochica painted jars were still subsumed under Early Chimú by no less an authority than Gerdt Kutscher. And yet a gap of 200 or 300 years is known to have existed between the two cultures. There can, however, be no doubt that by about the end of the tenth century Tiahuanacoid influence had ceased to make itself felt, and autochthonous styles had begun to reassert themselves, almost as if reverting to earlier origins. The period between the twelfth and fifteenth centuries saw the rise of the Chimús. The very name of their language, *Muchíc,* is an indication of its Mochica origins and, in fact, the Chimú potters followed in the footsteps of their Mochica predecessors so closely as to verge upon archaism, both as regards forms and ornamentation.

The public works of the confederation were also taken over by the Chimús who perfected and extended them in response to new demands. But here again there is little sign of discontinuity—so little, in fact, that Mochica and Chimú works are often indistinguishable. For the advent of

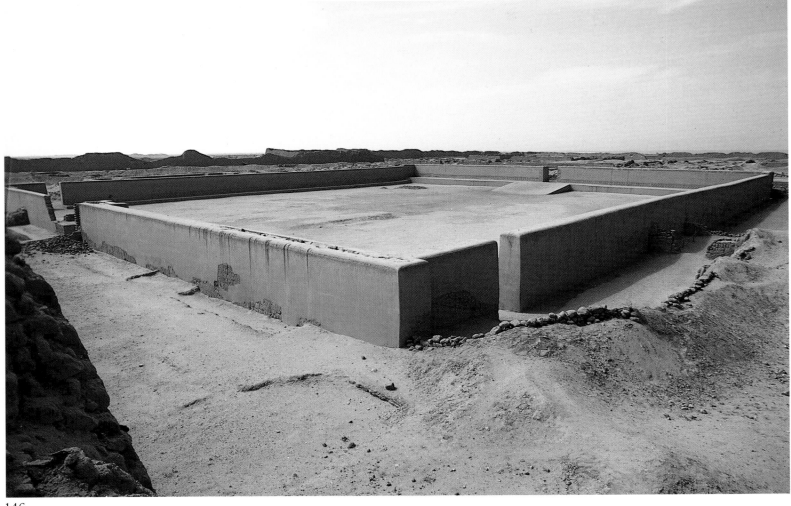

146

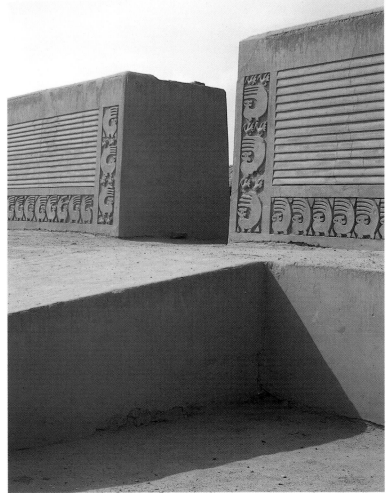

147

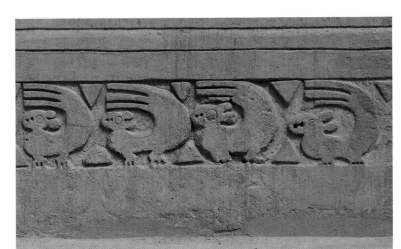

148

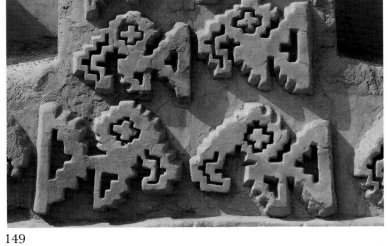

149

the Chimús marked the beginnings of a powerful agrarian empire with a vast and extremely advanced infrastructure. That empire extended from the Río Tumbes in the north to the Río Fortaleza in the south and comprised seventeen coastal valley-oases. In this region the Chimús constructed an astonishing irrigation system which began in the foot-hills where water from the permanent rivers was diverted into canals. Contour ditching then carried the precious liquid to other canals, in some cases as much as 100 kilometres away, thus permitting the irrigation of previously arid valleys where the natural courses frequently ran dry. This system, despite obstacles such as mountain spurs, extended from valley to valley, bringing fertility to land that had previously been barren but was now capable of yielding up to three maize crops a year.

Amongst the spectacular achievements of the Chimú engineers we might cite the following: a canal 140 kilometres long, 2.5 metres wide and 1.8 metres deep, the construction of which called for the displacement of 1.5 million tons of material; a dam, 24 metres thick at the base, erected in the Nepeña valley to form a reservoir measuring 1,200 by 800 metres; finally, a system whereby one valley was connected to the next by canals such as the Moro and the Vichansao or, again, the Mochica Alta and La Cumbre (probably dating from the Mochica period), which ran between the Chicama and the Moche basins. All these combined to form a vast productive entity at the heart of the empire.

Building of the Chimú Empire

According to a legend recorded at the beginning of the seventeenth century, the Chimú dynasty was founded by Tacaynamo. Twelve generations of his descendants succeeded him, the most prominent member of the line being the great conqueror Minchanzaman who ruled during the period of the territory's greatest expansion. Tacaynamo and his people are said to have arrived by sea on board balsa rafts, which suggests that they came from the north where ample supplies of this wood might have been obtained from the tropical regions close to the Ecuadorean coast.

The Chimús cannot have advanced very much further south than the Fortaleza valley, for at that time the Lima region was held by the powerful city of Maranga which they would not appear to have conquered. Whatever the case, the desert north of the temple-fortress at Paramonga is generally believed to have marked the southern frontier of the Chimús, even though their cultural influence may have spread as far as Pachacámac, south of Lima. Their empire, which eventually extended over 900 kilometres of the coast, was not, of course, acquired all at once. According to tradition, the Chimús occupied the same territory in 1370 as had their Mochica predecessors half a millennium earlier. It was not until about the mid-fourteenth century under Minchanzaman that the empire attained its utmost limits. But by that time a new protagonist had arrived on the pre-Columbian scene—the Inca people, whose imperialism was to clash with that of the Chimús. And, indeed, during the reign of the Grand Chimú Ancocoyuch in the third part of the fifteenth century, Chimor finally fell to the Incas.

The most characteristic feature of the Chimú empire was urban growth, of which the origins must probably be sought in Peru and the great centres of the Tiahuanaco–Huari Horizon. Under the Chimús this

146 This ceremonial plaza was recently uncovered in the southern part of the vast enclosure known as the Tschudi compound or palace at Chanchán, capital of the Chimor empire. These adobe structures, although built by the Chimús little more than 550 years ago, have been eroded by the wind as well as by the torrential rains which, once or twice a century, batter the Peruvian coast in the neighbourhood of the Ecuadorian border.

147 According to the chronology now generally adopted, the Tschudi compound at Chanchán was the last but one of some ten huge enclosures built between 1150 and 1460. It may therefore be assigned to about 1420. The detail of the restored portion of the ceremonial plaza shows the walls with their anthropomorphic and zoomorphic decorative friezes.

148 Detail of original bas-relief in the ceremonial plaza of the Tschudi compound. Executed in adobe, it represents mythological creatures, half-bird and half-quadruped.

149 Another detail from the same source, this time in high relief and representing stylized sea-birds.

process acquired an astonishing dynamism with the building of large cities in the area between the Moche and Chicama estuaries and around the capital of Chanchán, not far from present-day Trujillo. The same process also occurred further north, between the Lambayeque and the Leche, where no fewer than sixty Chimú towns were built during this period, in particular, Tucume, Apurlec and Batán Grande. Another important city, which dominated the Pacific from a fortified promontory between Chanchán and Lambayeque, was Pacatnamú or La Barranca whose origins probably go back to Mochica times.

In this vast complex of irrigated land between the Río Motupe and the Río Virú, the urban explosion of the Chimú era provides evidence both of rapid demographic growth, and of a remarkable capacity for organization. It similarly presupposes a powerful administrative system which was later to serve as a model for the Incas, notably in such spheres as centralized government, mass production and communications. In the latter case news was rapidly transmitted by runners using a road network furnished with post-houses. While all of the foregoing achievements probably date back to the Mochica period, their development by the Chimús was to give them a new dimension and turn them into a formidable instrument of power.

Here we should mention another spectacular Chimú achievement which, despite its vast size, was not discovered until 1932 when aerial photographs were taken by the Shipee-Johnson expedition, namely the wall known as de Mayao which was built north of the Santa valley, presumably along the boundary resulting from the first phase of Chimú expansion. It crosses the desert between the coast and the mountains for a distance of 65 kilometres, and is equipped at intervals with fifty forts, either round or square in plan. Three metres high and 4.5 metres wide, it takes hills and valleys in its stride, like Hadrian's Wall in Northumberland (England). This formidable defensive work is fully on a par with the work of the Chimú civil architects and hydraulic engineers.

In the east the empire relied for its defence on various alliances with the peoples of the high valleys. For example, the kingdom of Cajamarca was bound by a treaty with the ruler of Chanchán. The security of the highlands was absolutely vital to the plain-dwellers, for an enemy had only to cut off the water supplies to starve out the entire population. And in fact this is precisely what the Incas did when they resolved to deal their adversaries a mortal blow.

The Chimú cult would not appear to have included a creator god commanding a pantheon, as did Viracocha, the Tiahuanaco–Huari deity. Their chief divinity would seem to have been the moon to which they sacrificed young children and domestic animals. The Moon God was held responsible for plant growth and harvest as also, of course, for the tides. To a people so closely connected with the sea he was, therefore, of greater importance than the sun, which was regarded as the Father of the Sacred Stones—rocks allegedly endowed with supernatural powers. Whales were also worshipped, as was a sea deity for whom white maize flour was considered an appropriate offering. Other objects of veneration were the constellations of Orion and the Pleiades, the latter being of especial importance to the agricultural calendar since its appearance marked the beginning of the new year.

The Mochica confederation may, in a sense, be equated with Classical Greece in that, under its rule, the valley-oases of the north Peruvian

150 The Huaca el Dragón, a pyramid north-west of Chanchán. Probably thirteenth century. That it served a funerary purpose is clear from the cells, sunk into the upper part of the structure. These shaft-like chambers are not covered.

151 The Huaca el Dragón, a Chimú monument on the outskirts of Trujillo. Recently restored, the surface of the structure is richly embellished with bas-reliefs, possibly symbolizing the rainbow. Here, two mythical beings confront one another. They are surmounted by an arch supported by gnomes and are flanked by masked figures carrying javelins and possibly participating in a religious ceremony.

152, 153 The Huaca Esmeralda near Chanchán. Consisting of two pyramids, one of three, the other of two stages, each ascended by ramps, the assembly is decorated with bas-reliefs similar to those found in the Tschudi compound. It owes its name to traces of colour which have now disappeared.

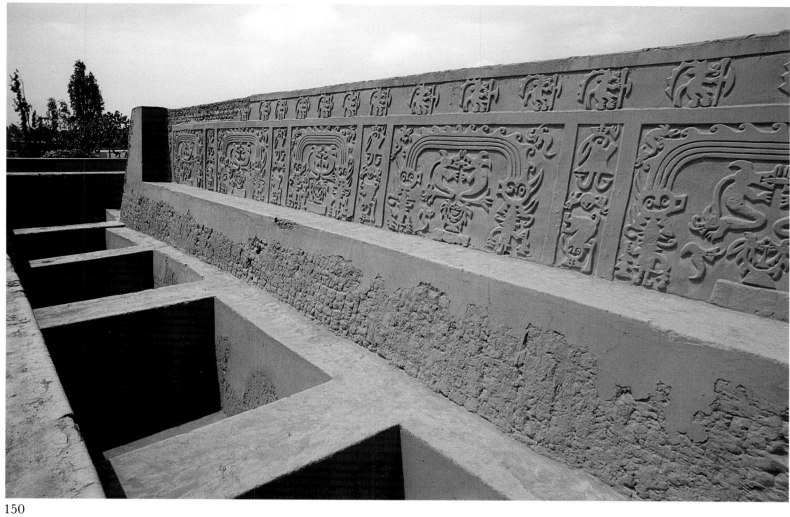

150

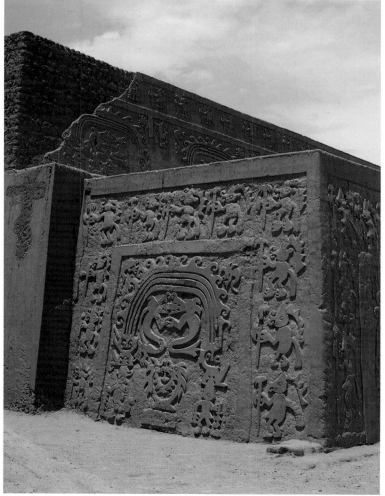

151

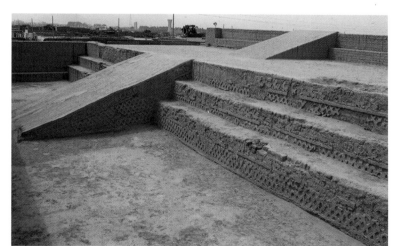

152

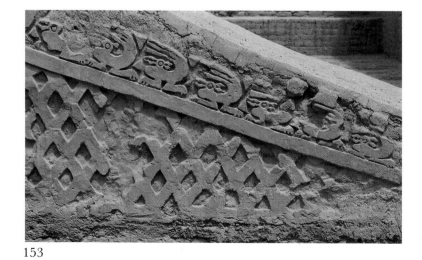

153

littoral experienced a period of artistic and technical efflorescence. Similarly the Roman empire may be invoked as a parallel to the rise of the Chimús and their establishment of a unified polity permitting urban and demographic growth, which in turn resulted in the invention of mass-production techniques in the field of agriculture as in that of art. This 'industrialization' is discernible, not only in pottery, but also in gold-work, henceforward of quite exceptional opulence.

It was a development that went hand in hand with the growth of slave labour which was to assume ever greater importance, for it represented the only means of exploiting the country's rich mineral resources—gold from the rivers and copper in the form of atacamite. Tin, probably introduced along with Tiahuanacoid influences since it came from what is now Bolivia, made possible the production of bronze (an alloy of tin and copper), thus revolutionizing technology. The pre-Columbians now entered what might be described as a Bronze Age (foreshadowing the Inca florescence), itself the immediate heir to the Copper Age inaugurated by Vicús. We might therefore be justified in saying that the Neolithic, Chalcolithic, Copper and Bronze Ages of Europe and the Middle East possessed their parallels in Andean America.

Before the arrival of the white man the Peruvian littoral must have been densely populated, to judge by the intensive urban growth revealed by an analysis of Paul Kosok's aerial photographs. It marked the final stage in a process of evolution from the hamlet or tribal village through the urban ceremonial complex to the great city with a population of many thousands and numerous administrative and religious centres, all of them contained within a vast organism. By transforming the social structure, however, urban growth was to give rise to classes, to guilds of specialized craftsmen and traders and to a military and administrative hierarchy headed by an omnipotent caste of kings and priests.

However, there can be little doubt that in these new circumstances religion had dwindled in importance by comparison with the power of the sovereign and his immediate family, for the Chimús would seem to have been less subject than the Mochicas to the dictates of the church, important though this still remained. From now on the top place in the hierarchy was occupied by the civil power which reigned supreme, with, needless to say, the backing of the priests. And this development, too, was an epiphenomenon of urban growth.

The restructuring of society engendered by the rise of large cities had, for its concomitants, the diversification of social classes as well as the division of labour. Gone was the era of self-sufficiency when the farmer made his own pots, wove his own garments, grew his own food, and went hunting and fishing. Each of these functions was now the responsibility of a group of specialists.

The first to confine themselves to a single occupation were probably the metal-workers who thus became specialists at a very early date. The potters, having learnt to apply mass-production methods, soon followed suit, as did the builders, engineers, architects and other types of artist. But specialization also invaded other fields such as administration and trade. Thus society laboured beneath an unwieldy bureaucracy which directed and controlled its every activity, while traders took over the machinery of exchange, not only on their own door-steps but also further afield, so helping to develop the contacts that had always existed between highlanders and lowlanders.

154 Detail of gold handle of Chimú sacrificial knife or *tumi,* representing a hero by the name of Naymlap. Small rectangular wings may be seen protruding from behind his shoulders. He wears a rainbow head-dress of which the front over the forehead is enhanced with turquoise, as are the ear plugs. Height of detail 19 cm. Museo Oro del Peru, Lima.

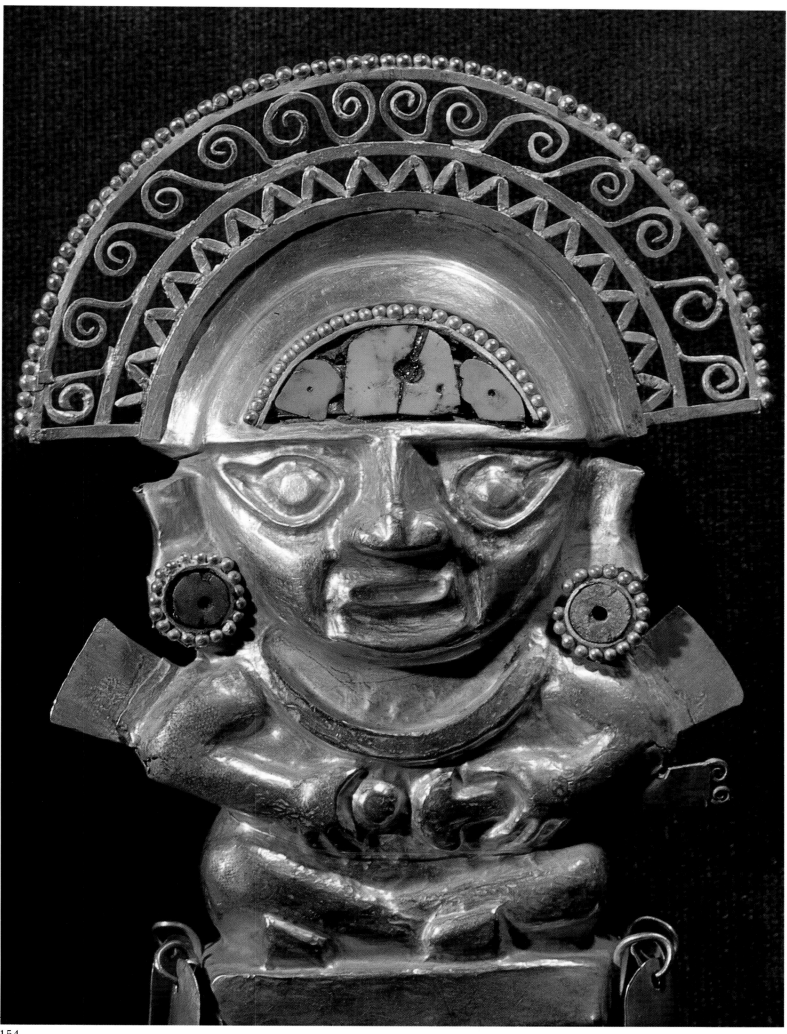

There was now a marked distinction between the cultivators and those whom intensive cropping on irrigated land had freed from the necessity of tending it, thus allowing them to engage in other pursuits. The town became a meeting-ground and market-place for the two groups. Coronations, victory celebrations, religious festivals and popular gatherings demanded suitable venues affording adequate opportunities for pomp and circumstance. That demand was met by plazas, courts, patios and avenues, which now took their place alongside the more mundane markets, granaries, workshops of all kinds, storehouses for produce and raw materials and, finally—to protect all these things from the cupidity of outsiders—walls, fortified gates, bastions and barracks manned by a guard under the direct control of the central power. Complementing these buildings was the opulent residence of the sovereign and his court. The palace compound might also comprise a funerary centre with a chapel for the worship of defunct royalty.

The programme to be fulfilled by the builders of a new urban centre was therefore a considerable one, though the concept was not entirely new. Moche, for instance, with its gigantic pyramid and a walled complex reserved for the priest-king, had already possessed many of the above-mentioned architectural components in the Mochica period. Now, however, as we shall show in our discussion of Chanchán, it was the sheer scale of the 'functional' buildings, the huge palaces and vast storehouses, that was to put the earlier ceremonial centres in the shade.

Chanchán: A Study in Urban Planning

Chanchán, the capital of the Chimú empire, lies on the Pacific ocean between the Ríos Moche and Chicama. It is situated on dry ground, away from the irrigated area, for pre-Columbian settlements were generally built at the edge of the desert next to cultivated land. Originally a Mochica site, it became a Tiahuanacoid agglomeration some time before A.D. 1000. The plain on which it lies descends gently westwards, thereby facilitating the supply of drinking-water which was conveyed by the Mochica Alta irrigation canal. North of the city, a system of water-ways linked the Chicama and Moche rivers, one being the Vichansao Canal (fed by the Moche), 1,500 metres from the earliest walled enclosure, the other the Mora Vieja Canal (fed by the Chicama), some 4,000 metres further north. Thus, so far as water supply was concerned, the capital occupied a strategic position and ran no risk of suffering from the droughts that prevailed in the surrounding deserts.

At right angles to the coast a stately avenue, 4 kilometres long and absolutely straight, proceeded in a south-westerly direction from the Mora Vieja to the city below. This immense complex consisted of ten or eleven walled enclosures 200 or 300 metres wide and 400 or 500 metres long, and occupying an area of some 12 to 15 hectares. Known as 'palaces' or 'citadels' these compounds together form a vast rectangle measuring 5 by 2.5 kilometres, that is to say about 12.5 square kilometres. But allowing for peripheral buildings and works of a similar nature, the total area of Chanchán would probably have been about 25 square kilometres.

According to estimates which can only be of a very rough and ready nature, the population of this vast capital might have been of the order of 50,000. Hence it was not only the most ambitious example of pre-

General plan of the city of Chanchán on the Pacific littoral. The following are the principal palaces or compounds in the now accepted chronological order:

1 Chayhuac
2 Max Uhle
3 Tello
4 Labyrinth
5 Gran Chimú
6 Squier
7 Velarde
8 Bandelier
9 Tschudi
10 Rivero

Notable features are:

A Wall
B Avenue
C Huaca Obispo
D Huaca las Conchas
E Huaca Toledo
F Huaca las Avispas
G Huaca el Higo

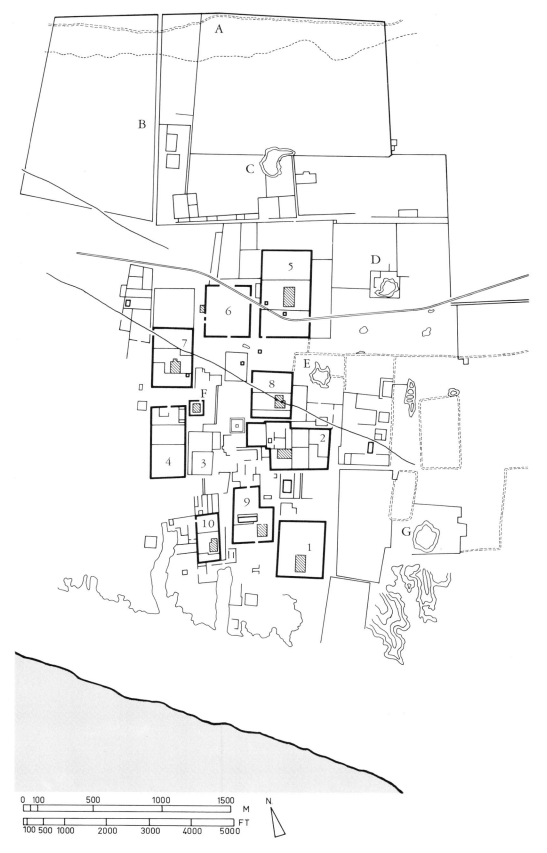

historic town planning in the Andes, but also possibly the most important pre-Hispanic capital in South America.

The different compounds, as well as the units into which they were subdivided, were built on an orthogonal plan. The walls surrounding them were between 6 and 9 metres high, with a marked batter necessitated by the friable nature of the building material, namely beaten earth, and no longer unbaked bricks as in the Mochica period. The method known as *tapia* consisted in compressing a mixture of adobe and aggregate in forms, somewhat after the manner of the shuttering used today in

157

concrete construction. Thus the enclosure walls formed enormous man-made 'monoliths', though all have been eroded to a greater or lesser extent by the *garua* or wet sea mist and the rare but torrential rain that occasionally falls on the coast with such devastating results.

The compounds rarely had more than one entrance and each contained a variety of structures comprising a large walled ceremonial plaza, a religious centre, and a funerary complex of which the chief feature was a pyramidal platform ascended by ramps; in addition there were palaces and houses, store-rooms and factories and a huge sweet-water cistern fed by a water-table, which in turn was replenished by the irrigation works above the city. All these structures were disposed in orthogonal groups and separated by thoroughfares which were similarly lined by high walls.

It is clear that the various compounds were subdivided in accordance with a rigorous plan, though not so rigorous as to preclude such changes and modifications as might become necessary. Vast assemblies of store-houses, with cells ranged in compact groups, often symmetrically and systematically disposed, create a rhythm that recalls prefabricated architecture, so obsessively are similar structures repeated, now in their tens, now in their hundreds.

There is good reason to believe that within each compound further subdivisions separated the houses of the élite, the servants' dwellings and the storehouses. The habitations were usually arranged around a rectangular court, each of the above categories being isolated from the rest by walls and thus constituting an independent entity. In every compound there are open spaces that show no sign of having been occupied—gardens, per-

Aerial view of the so-called Labyrinth Compound at Chanchán. Laid out on a rigorously orthogonal plan, it is 550 m long.

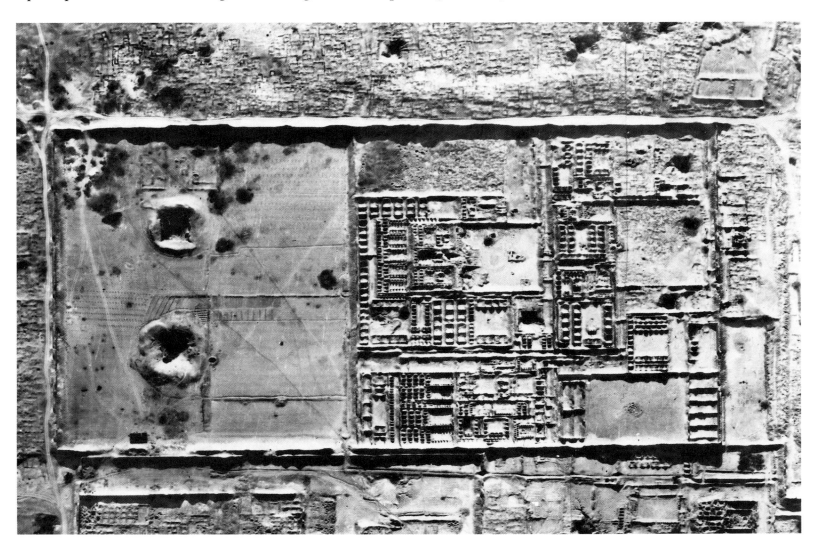

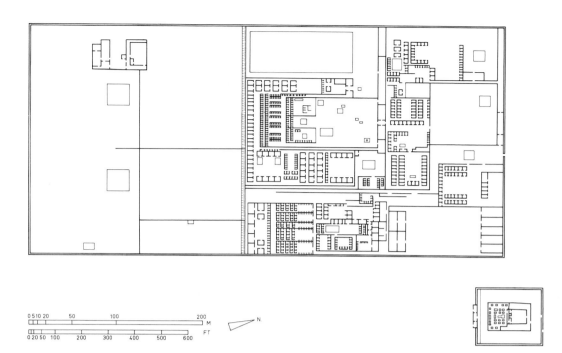

Plan of the so-called Labyrinth Compound with (right bottom) the Huaca las Avispas, the funerary platform of a king of Chanchán.

haps, that have now disappeared owing to lack of water, or land reserved for some future development that never materialized. It has been noted by Tschudi, for example, that some of the compounds were laid out on an irregular plan, which strongly suggests an extension outside the original wall. All this raises the question of how a walled enclosure grew and what purpose it served.

The Role of the 'Citadels' or 'Palaces'

What is striking about the architecture and urban layout here encountered is the evident urge to enclose everything, from the smallest and most elementary court to the largest and most elaborate group. It was a system based on centripetal structures, each encased within the next or, if of the same size, juxtaposed. The question of growth this raises in the case of an individual 'citadel' or compound—in which, moreover, the components may be symmetrically disposed—becomes even more complex when we consider the city as a whole. In other words, was one compound added to the next in order to cope with a growing population or were they all built simultaneously to accommodate different communities such as craft and trade guilds, social classes and possibly even clans?

Once a walled compound had reached a certain size, it might indeed have been adjudged preferable to build a new, adjoining one—as it were a satellite—rather than extend the original; beyond a certain limit, problems of transport would have arisen in a society unfamiliar with the wheel. What cannot be disputed is the fact that the additive principle had already been applied in earlier cities such as Pacatnamú on to which the Chimús subsequently grafted their own administrative centre, and that this same principle had been followed by the Tiahuanaco–Huari people in many cities occupied by them, for instance Pikillaqta, Jargampata, Viracochapampa and Cerro Churú. Moreover the remains of stone structures discovered among the Chanchán compounds are of Tiahuanacoid origin and thus may conceivably have served as models for those who planned that capital.

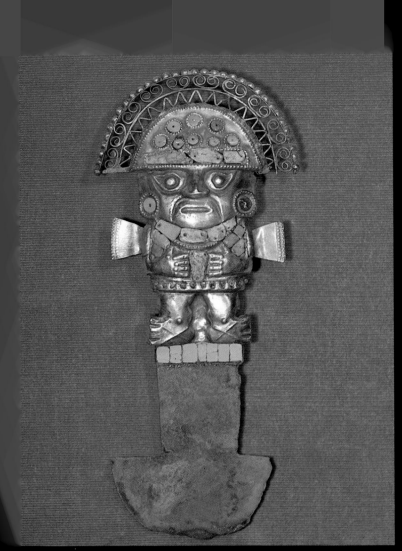

55

156

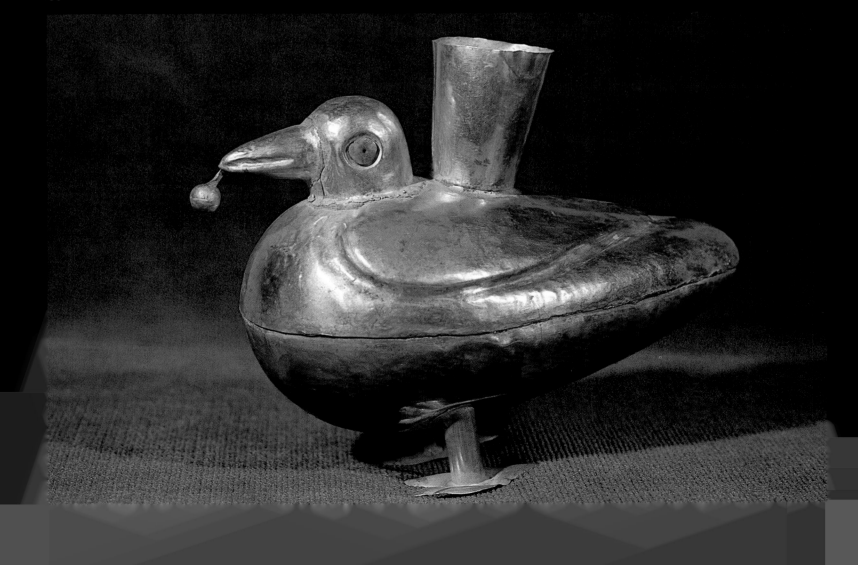

155 Chimú sacrificial knife with gold handle and silver blade enhanced with turquoise. Like the preceding piece, it shows Ñaymlap wearing a semicircular head-dress and equipped with little wings. The almond-shaped eyes are typical of Chimú–Lambayeque art. Height 32 cm, weight 600 gr. Museo Oro del Peru, Lima.

156 Magnificent Chimú necklace in which hollow gold balls alternate with large pieces of turquoise. Overall length, 2.30 m. Museo Oro del Peru, Lima.

157 This gold vessel in the form of a dove with turquoise eyes is attributed now to the Mochicas, now to the Chimús. Length 16 cm. Museo Oro del Peru, Lima.

158 Chimú gold vessel with double spout and richly ornamented bridge. This piece, in the Lambayeque style, was inspired by the pottery of that name. The small figures on the body of the vessel show Ñaymlap in the act of swimming. Height 21 cm. Museo Oro del Peru, Lima.

159 Terracotta double spout and bridge vessel from Lambayeque. Here we may discern the source of the forms embodied in the preceding piece. The highly ornamental bridge may, perhaps, represent a rainbow—a constantly recurring theme in Chimú–Lambayeque art. The container displays relief decoration in the form of crayfish. Height 19 cm. Museo del Banco Central de Reserva, Lima.

160 Head in hammered gold from Batán Grande, Lambayeque. This piece is characterized by its powerful plasticity and the classic stylization of the eyes. Height 13 cm, weight 400 gr. Museo del Banco Central de Reserva, Lima.

However, the walled compounds of Chanchán have engendered a number of very different theories. They were long believed to have housed groups of the nobility from different parts of the empire who, by their presence, testified to the political unity of the great Chimú kingdom. With their ethnic groups, these provincial nobles were at once allies and hostages, representatives of their provinces and advisors to the Gran Chimú. As witnesses to the 'confederation' of equal peoples, they must have reflected the political structure of the country as a whole. For just as the latter consisted of relatively self-contained valleys separated by deserts so, it has been suggested, the capital consisted of compounds of which the enclosures provided tangible evidence of the divisions between that empire's constituent parts.

That theory has now been abandoned as a result of the work carried out by Geoffrey W. Conrad of Harvard University in collaboration with Thomas G. Pozorski, Alan L. Kolata and Kent C. Day. Their investigations, conducted in 1981 and published under the editorship of Michael E. Moseley, have shown that each of the walled compounds was founded by a different monarch. During his reign the city he had built served as a palace and a religious and administrative centre. On his death, the funerary platform, to which access was gained by ramps, became at once a tomb for himself and his close relations and a place of worship dedicated to his own person.

Indeed, the ten or eleven walled compounds, which would seem to be well suited to the description of palace, comprise nine funerary structures. Shafts were sunk into these platforms to form chambers, the largest of which is T-shaped and was destined, it would seem, to house the mummified body of the dead king, as well as the remains, not only of the sacrificial victims who were to accompany him into the next world, but also of members of his immediate family. Around the walls of the chamber are square recesses intended, no doubt, for funerary offerings of gold-work, textiles, pottery and wood carvings. These recesses, some of which were undoubtedly ossuaries, would not appear to have been roofed, unless with a movable covering.

At Huaca de las Avispas, for example, excavations have revealed ninety-three intact skeletons in the same position in which they had been left by the looters who abstracted the treasure. One chamber, smaller than the rest, contained thirteen skeletons and the remains of eleven others. All were those of adolescents. These figures would seem to indicate that the interment of a monarch entailed the sacrifice of between 200 and 300 young people of both sexes.

Later enlargements round the edge of the mausoleum have also yielded human remains, from which we may conclude that the cult of a dead sovereign persisted for a considerable period. The ritual in honour of the deceased was probably performed in the large walled court which precedes the north face of each platform.

Thus the principle would seem to have been that each king of Chanchán erected one such walled city to contain his administrative centre, his palace and, eventually, his mausoleum.

Sequence and Duration

Basing themselves on these deductions, archaeologists have attempted to discover in what order the various walled compounds and concomitant

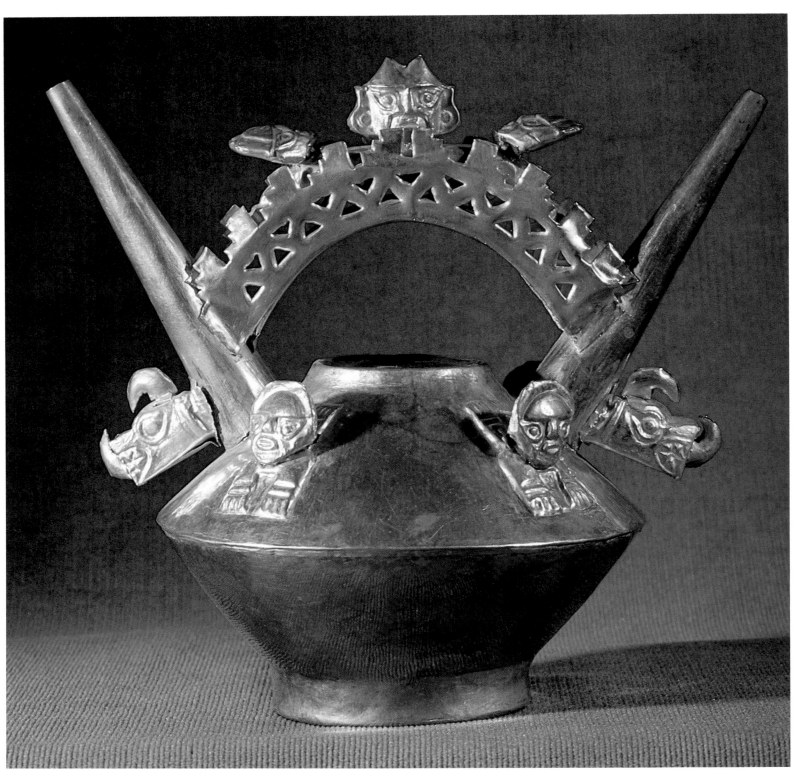

158

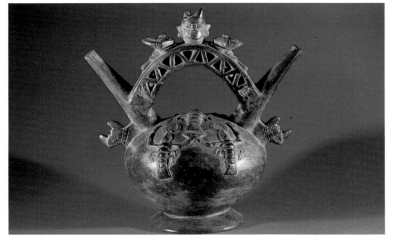

159

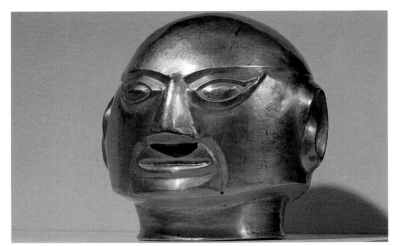

160

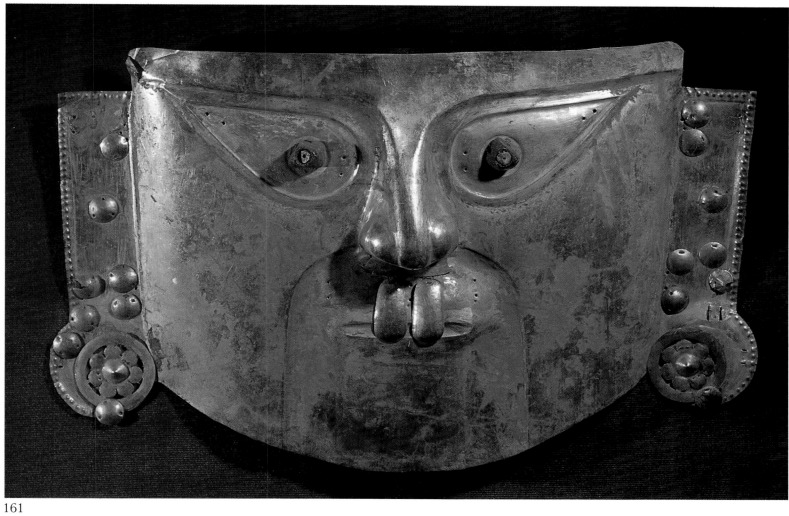

161

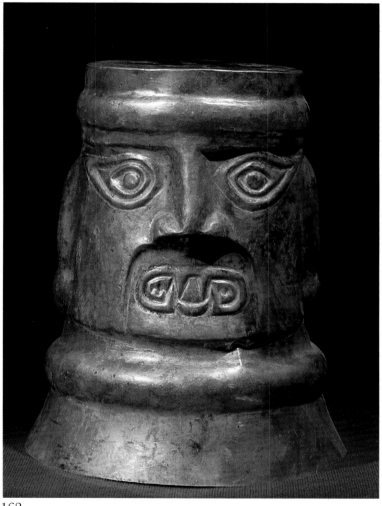

162

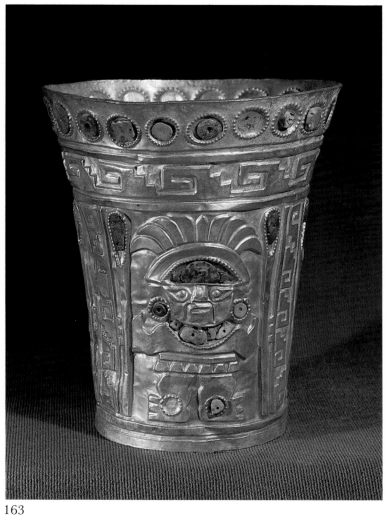

163

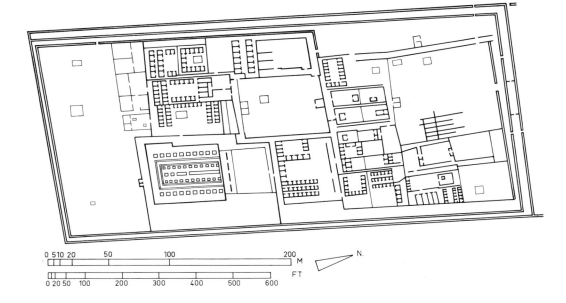

Plan of the Rivero Compound, Chanchán, with its double, if not triple, enclosure wall.

funerary constructions were built. They have concluded that the compounds were erected in the following sequence: Chayhuac, Uhle, Tello, Labyrinth, Gran Chimú, Squier, Velarde, Bandelier, Tschudi and Rivero.

It is not really possible to suggest a precise date for the founding of Chanchán as the Chimú capital. A developed city is known to have existed on the site at the height of the Tiahuanaco–Huari period, in the ninth or tenth century, and must already have been a place of some importance by the time of the Chimú empire. But any attempt to estimate the time taken to build the various palace compounds calls for the utmost caution. Assuming that operations were begun between 1150 and 1200 and ended in about 1460, before the Inca conquest, this would allow from 250 to 300 years for the construction of, say, ten compounds, or twenty to thirty years at the outside for each reign, that is, roughly a generation.

However, we must also bear in mind the enormous expenditure of energy represented by the succession of building operations which ensured the city's uninterrupted growth, a growth which, however, involved, not only new buildings and new compounds, but also new inhabitants, notably large numbers of priests and courtiers with their attendants, servants and personal guards. Officials and aristocrats, of idle and extravagant disposition, constituted an ever growing élite which laid an ever heavier burden on the shoulders of the working classes. For a compound remained in use long after the death of its founder, and funerary rites were still performed there at prescribed intervals, while the palaces continued to be occupied by the late ruler's next of kin. On the other hand, the unintermittent labour entailed by the building of new centres of government, new palaces, and vast mausolea called for a dynamism which must have extended to the entire Chimú nation, an empire of millions at the heart of a region grown rich and productive, thanks to the farsightedness of its rulers.

Architectural Decoration

Recessed and projecting adobes are used to decorate the walls with geometrical reliefs in repetitive designs. These consist of simple motifs

161 Gold funerary mask. Chimú, twelfth-fifteenth century. The mask has ear plugs and symbolic jaguar's fangs, while touches of haematite signify life. The protruding eyes with a turquoise at the centre of each pupil may be later additions. Width 45 cm, weight 370 gr. Museo Oro del Peru, Lima.

162 Shaped like an inverted vase, this anthropomorphic Chimú piece in gold repoussé comes from the Lambayeque region. It represents a deity with jaguar's fangs. Height 24 cm. Museo Oro del Peru, Lima.

163 Chimú ritual vase in embossed gold enhanced with turquoise. Beneath a key-pattern frieze Ñaymlap is shown wearing a semicircular plumed headdress and two little wings. This vase is a typical example of Chanchán gold-work. Height 19.5 cm. Museo Oro del Peru, Lima.

164 Unlike the black ware which predominated during the Chimú period and whose manufacture continued into the time of the Incas (Pls. 195-7), this beautiful stirrup-spout vessel, depicting two *fardo*-bearers, is decorated in sober polychrome. Height 20 cm. Museo Amano, Lima.

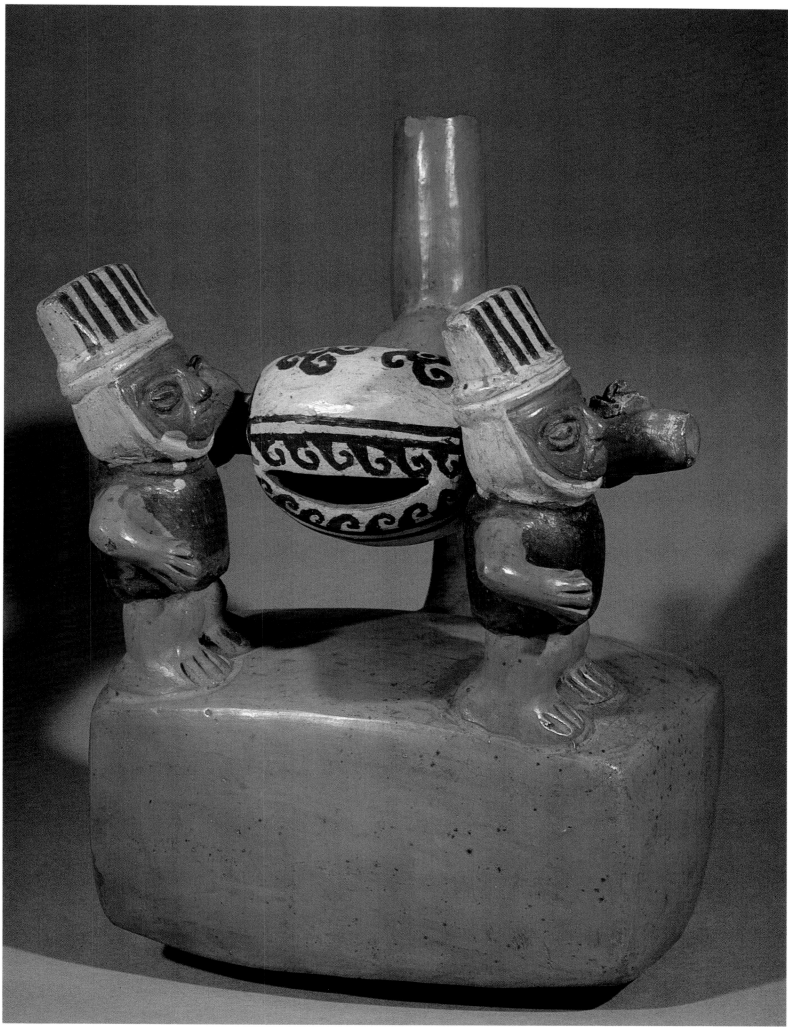

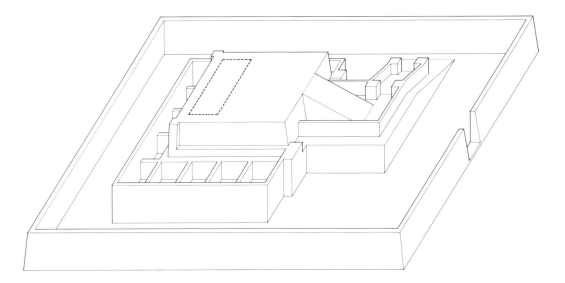

Axonometric drawing of the Huaca el Dragón near Chanchán. Around the pyramid are funerary cells within an enclosure wall.

such as squares, lozenges and meanders, alternating with schematic representations of mythical beings, foliage, and animals such as birds and fish, and are comprised within a sober, simple and architectonic system which makes play with light and shade to produce dynamic rhythms. This form of decoration may consist of long friezes or of panels covering the whole surface of a building.

Side by side with the above technique was another mode of decoration which allowed for greater variation and delicacy. The effect was achieved by moulding the clay facing of a wall to produce regular repeats in two planes in which salient and recessed elements were equally balanced. By this method—the embossing, as it were, of the surface—it was possible to produce, but with far less effort, much the same effect as that of ornamental brickwork, yet in a style that was fluid and cursive. It reflects the Chimús' obsession with mass-produced, stereotyped motifs which were now to extend over literally kilometres of surface. The almost imperceptible loss of vigour and fine detail is attributable to the fact that the material did not lend itself to an unduly elaborate finish. The overall effect, attained by the reiteration of the same motifs, underlines the monumental character of the architecture and accentuates the grandeur of a city planned on a scale in keeping with the vast landscape of the Pacific littoral.

The same decorative systems recur in two complexes, the Huaca el Dragón and the Huaca Esmeralda, on the outskirts of Chanchán. According to Richard Schaedel, the first of these buildings antedates the construction of the capital by some 150 years, while Conrad believes it to be contemporaneous with the first two compounds, the Chayhuac and the Uhle. Dedicated to the rainbow, it is a walled temple platform with bas-reliefs displaying warriors, serpents and foliage. A ramp gives access to the first stage where there are cells, or rather shafts which probably served as funerary chambers such as those found in the Chanchán mausolea. The Huaca Esmeralda, further to the south, is likewise a platform ascended by ramps. In this case the decoration consists of geometric and zoomorphic motifs, the latter comprising fish, sea-birds and foxes.

The Chimús thought in terms of size and quantity, being the first exponents of an art that extolled open spaces and unlimited horizontals. Like their decoration, their planning testifies to a predilection for the repetition of forms, whether they be cells, chambers or store-rooms, and

bespeaks a strict and rigorous organization subject to the imperatives of an agricultural system based on irrigation. For the vast infrastructure represented by the water supply—canals, aqueducts and dams—would not have been conceivable in the absence of unquestioning submission to a superior authority. Here, then, an entire society was governed by concepts to which its art bears witness.

Ceramics and Gold-work

In the kingdom of Chimor the production of pottery, textiles and gold-work also assumed 'industrial' proportions. Articles were designed to be produced in bulk and the mould, introduced by the Mochicas, was now used for the manufacture of large batches rather than of a single piece. At the same time polychrome was abandoned in favour of black, an effect achieved by reduction-firing, that is to say, by hermetically sealing the kiln towards the end of the firing process and thus starving it of oxygen. This results in a concentration of smoke which coats the surface of the pots, giving it a deep and lustrous shade of black, a method still retained on the north coast after the Inca Conquest (Pls. 195–7).

The reversion to black ware might be seen as a form of archaism, a return, that is, to the techniques diffused by Chavín. But, as Richard L. Burger has shown, the Chimú potters also drew their inspiration from the Mochicas in that they imitated the sculptural decoration of the latter's vessels. However, there can be no doubt that mould production in batches of tens if not hundreds often led to a marked deterioration in the quality of the relief.

Metallurgy was, as we have seen, one of the fields in which the Chimús were particularly advanced and, indeed, their metal-workers were past-masters of their craft. Such was their fame that, when the Incas came to power, the entire guild was removed to Cuzco. These craftsmen manufactured not only ceremonial pieces in gold and silver for the court and for ritual use in the form, for example, of funerary offerings, but also bronze weapons and implements such as halberd heads, levers, needles and tweezers. The use of this metal, which was stronger and harder than copper and also gave a sharper cutting edge, was to revolutionize Indian technology.

While the Chimú goldsmiths were no more skilled than their Mochica predecessors, there can be no denying the quality and splendour of the pieces, embellished with turquoise, which were destined for the royal tombs. The gold funerary masks, the ritual goblets with embossed decoration and the sacrificial knives or *tumis,* may be accounted amongst the glories of pre-Columbian art (Pls. 154, 155, 161-3).

It is somewhat difficult to follow the reasoning of authors such as Larco Hoyle who see Chimú gold-work as quite distinct from that of Lambayeque. First, the latter belonged to the Chimú empire, secondly, since most of the pieces were illicitly abstracted they are usually of unknown provenance and, thirdly, it is by no means always easy to say whether a vessel in, for example, the form of a bird, may not actually be of Mochica origin (Pl. 157). Pieces whose attribution is not in doubt, however, are the gold double spout and bridge jars from Lambayeque, which were copied exactly from the clay vessels typical of that region. While they may be fakes—always a possibility in gold-work—they undoubtedly reflect the Lambayeque style (Pls. 158, 159).

65

In the same way the handle of a *tumi* often takes the form of a personage who may be identified as Ñaymlap, the Lambayeque national hero. Like the founder of the Chimú dynasty, he is said to have arrived with his people by sea on board balsa rafts. He, too, is equipped with wings and in this he not only resembles the Mochica deity known to the Spanish chroniclers as Ai Apaec, but also reveals an affinity to the 'winged tigers' of Chavín and the flying felines of Paracas–Nazca. Each of these may relate to one and the same personage, an object of worship of the Andean pre-Columbians, all of whom shared the same mythological tradition.

Such was the form of artistic expression disseminated by the Chimús. It sprang from a vast and highly stratified population living in close-packed agglomerations. Here was an art that answered to the concept of the many governed by the few—a far cry indeed from the individualism of Vicús and the Mochicas.

Chancay and Ica Regions

South of the Chimú frontier, on the central coast of Peru, were two other important centres—Cajamarquilla, eventually, perhaps, wiped out by its Chimú neighbours, and Maranga, the site of a huge pyramid at the mouth of the Rimac valley. To the north, the Río Chancay basin saw the emergence of an original culture after the end of the Tiahuanaco–Huari Horizon.

Between 1946 and 1950 Julio Tello discovered no less than 1,300 graves on the Chancay site which is still being exploited by treasure-hunters. Amongst other things, it has yielded textiles of the very highest quality. Buried for five or seven centuries in graves covered with timbers supporting a layer of earth, the most delicate fabrics have come down to us in a truly remarkable state of preservation. They include a number of superb transparent gauzes—now the pride of the Amano Museum at Lima—whose delicate texture and subtly worked motifs testify to the astonishing skill of the pre-Columbian weavers (Pl. 165).

The reversible cloths, which rely for their effects on two sets of differently coloured warps, are as precise and regular as the products of the modern power loom (Pl. 166). The survival of traditional themes is apparent in the iconography of certain tapestries where figural motifs deriving from the Paracas–Nazca region clearly betray Tiahuanaco–Huari influence. In particular we would cite a representation of Viracocha in a frontal pose and carrying two sceptres or lances (Pl. 167).

On the southern littoral, the culture known as Ica–Chincha was to fill the gap between the Tiahuanacoid phase and the arrival of the Incas. Here the manufacture of sumptuous textiles went hand in hand with another, extemely perishable art, namely feather-work. This was effected in most ingenious fashion by inserting the quills one by one between the warp threads and then bending back the tips. By a careful choice of feathers of many different colours, the pre-Columbian craftsmen succeeded in producing vibrant polychrome fabrics of incredible vitality. Though feather-work is a very ancient art, most of the surviving pieces date from well after A.D. 1000. Some of these almost convey the impression of having been composed as pictures and, indeed, there is an heraldic quality about the feather-work found in certain *mantos,* ponchos and pennants.

165 Detail of a fragment of gauze from the Chancay cemetery. The extraordinary delicacy of the construction reveals the skill of the weaver and his ability to produce stylized motifs. Here a repeat design of a monkey tied to a post is carried across the piece in diagonal bands. Width of fragment about 15 cm. Museo Amano, Lima.

166 Detail of a fine Chancay cotton textile from Pisquillo Chico. The reversible cloth is woven in two colours, russet and white; the motifs are symmetrically disposed in diagonals. This sample demonstrates the extreme degree of abstraction attained by figurative themes. Length about 30 cm. Museo Amano, Lima.

167 Polychrome woollen band from Pisquillo. Probably thirteenth century, like the preceding pieces. While perpetuating the tapestry traditions of the Paracas–Nazca weavers, Chancay textiles also embody the symbols of the Tiahuanaco–Huari culture, as for instance in this image of Viracocha who is holding sceptres or javelins. Museo Amano, Lima.

The use of this material, which came from the tropical *selva*, testifies to the close links that existed between the coast-dwellers and the cultures then inhabiting the edge of the virgin forest; they, in their turn, being engaged in a profitable barter trade with the Amazonian plain. Traces of two of these cultures have recently been discovered, the first at Gran Pajatén by a Peruvian military expedition as late as 1963, the second at Tantamyo by the French explorer Bertrand Flornoy in 1945.

The fascination exerted upon the craftsmen by the plumage of birds such as the toucan, the macaw and the parrot is not difficult to explain, for they had no other source of colour so vivid and intense as the feathers of these fowls. The glittering palette they offered proved an irresistible attraction to all the Indian peoples, who made use of this material for the manufacture of objects which must have been of incalculable value.

One such piece of exceptional quality derives from the Ica–Chincha region (Pl. 168), where the graves proved to be a rich source of gold funerary offerings. However, the articles of adornment are less ornate than Moche or even Chimú work, though their very sobriety lends them added vigour (Pls. 169, 170).

Here we would stress the importance attached to textiles, feathered or otherwise, by the Andean peoples. In their eyes a piece of fine cloth was of much higher value than an article made of gold since the labour expended on its manufacture was manifestly far greater. When the Conquistadors divided up the spoils of the Inca empire, their lust for gold objects and, more particularly gold as such, was incomprehensible to the Indians.

168 Feather mantle from the south coast of Peru. Ica–Chincha culture. Prior to the Spanish Conquest, probably thirteenth or fourteenth century. A polychrome of remarkable intensity characterizes the three figures with their geometrized silhouettes. It is an exceptionally rare example of pre-Columbian art. Width 98 cm. Museo Amano, Lima.

169 Two embossed plume-holders depicting birds (?). The Ica region, a rich source of pottery and textiles, has also yielded gold articles intended to accompany the deceased into the tomb. Height 7 cm. Musée d'Ethnographie, Geneva.

170 Armlet in embossed gold from the Ica region. Inca period. Height 13 cm. Musée d'Ethnographie, Geneva.

168

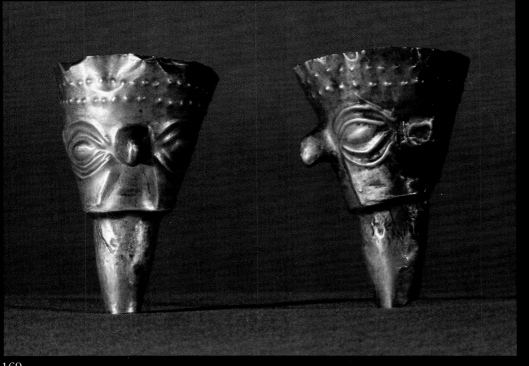

169

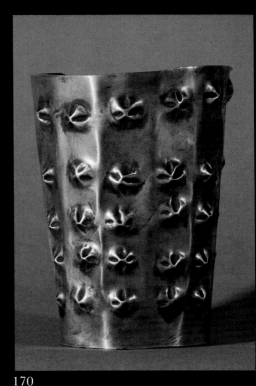

170

VIII. The Inca Empire

Organization and Social Welfare

During the Inca period, between 1438 and 1533, the century preceding the Spanish Conquest, the Andean world was to experience its last phase of unity, both cultural and political, a unity which constituted one of the Horizons of pre-Columbian America, as Chavín (850–200 B.C.) and Tiahuanaco (about 650–950) had done before it.

It was an era which saw the rise and consolidation of a theocratic military power. At first a small totalitarian state, it grew into a vast empire equipped with a powerful army, an efficient civil service, and a collectivist system embracing what might be described as social security or national insurance. As well as stylistic and aesthetic homogeneity in the arts and crafts, it also boasted a state religion over and above the local cults and based on the worship of the sun which was regarded as the father of the Incas.

A Proliferation of Witnesses

For us, however, the Inca period also marks the transition from prehistory to history. Eyewitness accounts of this advanced culture, overthrown by the Conquistadors, now come thick and fast. The reports of the Spaniards who, in company with Francisco Pizarro, were the first white men to arrive on the west coast of Andean America in 1532, tell us of the people, their cities, dress, beliefs, and manners and customs. Having previously had nothing to help us envisage the cultures of the prehistoric past save mute documents and archaeological remains, we suddenly find ourselves plunged into the everyday life of the Incas. We know what they looked like, what they were called and what they wore. We are told of their struggles for power, and of the petty squabbles between noble factions in Cuzco itself. We are made party to their inmost thoughts, their reactions in the face of betrayal, defeat and death, their intrigues and hopes. Finally, we learn about the political motivation of these men in confrontation with a handful of western adventurers.

A few mythico-legendary traditions have survived concerning the rulers and the origins of the Chimú people, who were conquered by the Incas only sixty-five years or so before the arrival of the Conquistadors. But where the Incas are concerned, the abundance of eyewitness accounts and of letters and chronicles containing information gleaned after the collapse

of the empire confronts us with a difficulty which is the reverse of that posed by the earlier pre-Columbian cultures. For in the absence of all written testimony regarding, say, Valdivia, Chorrera, Vicús, Mochica or Nazca, our only source of information has consisted in a few sherds. And what little we know is rendered comprehensible only by archaeologists and the finds they have made, whether fortuitous or otherwise.

In the case of the Incas, there is, as we have seen, no lack of first-hand accounts: some are the work of Spaniards who took part in the Conquest, others of Indians intent on recording for posterity the knowledge acquired by the last representatives of the conquered nation. As might be expected, these writings are coloured in the first instance by a desire to prove that the Indians, as impious sinners and sodomites living in ignorance of God, must be won over to Christianity; in the second, by the urge to recall the power, wealth and majesty of the nation to which they had once belonged. Such slanted and contradictory accounts obviously demand interpretation rather than uncritical acceptance, for they are, moreover, the work of men with little or no training in scholarly disciplines. What interested the Spaniards above all was the alien and the exceptional; they tended to emphasize the 'barbarian' and picturesque elements at the expense, as often as not, of art, institutions and beliefs. The Hispanicized Incas for their part tended to insist on genealogies, great events, and stupendous achievements rather than on administrative organization; nor did they choose to ventilate such subjects as the cruelty of punishments and sacrifices.

In short, certain reservations must be borne in mind when considering these divergent if complementary and, indeed highly informative sources, amongst which we would cite, on the Spanish side: Pedro de Cieza de León (1550), Cristóbal de Mena (1534), Pedro and Hernando Pizarro (1571), Sancho de la Hoz (1534), Fernando de Santillán (1562), Father José de Sarmiento de Gamboa (16th century), Father José de Acosta (1590), Father Francisco de Ávila (1585) and Miguel Cabello de Valboa (1586); on the Indian side: Santacruz Pachacuti (1570), Tito Cusi Yupanqui (16th century), Guaman Poma de Ayala (1587) and Garcilaso de la Vega (1609), whose writings are replete with fascinating information. But in all cases the reader should beware not only of the writers' subjectivity and preconceived ideas, but also of their apologetic tendencies.

Traditions relating to the pre-Columbians were modified, adulterated and falsified for a number of reasons, one and by no means the least being the contamination of Indian informants by Christian thought. The Spaniards sought to show that there were analogies between the two faiths—an attempt at assimilation that had already begun when, for instance, a church was substituted for a temple and its idols. A further reason was the desire to please the victors, and to tell them what they wanted to hear.

Account should also be taken, however, of the inexperience of some of the chroniclers who, incapable of ethnographic work in the true sense of the term, viewed the world in the light of their own religious and intellectual preconceptions. Their Indian counterparts, on the other hand, by now cultural hybrids, would have had difficulty in assimilating western modes of thought, and would thus have adopted a different approach to facts and events.

This is not, of course, to detract from the astonishing ability of some of these writers—for instance, Cieza de León, an observer of extraordinar-

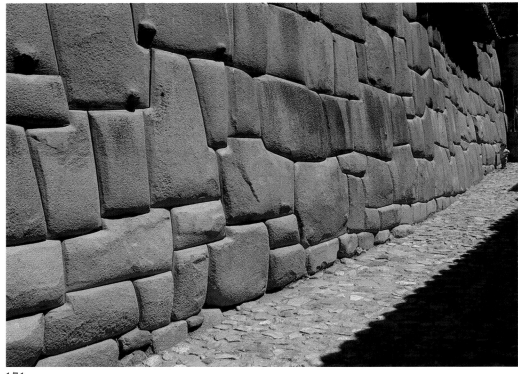

171

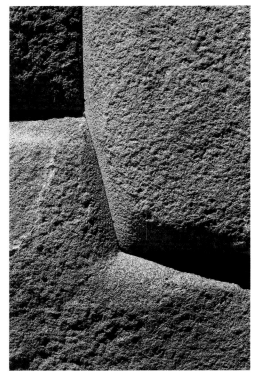

172

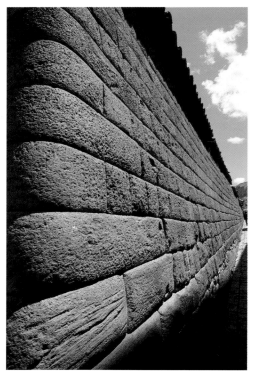

173

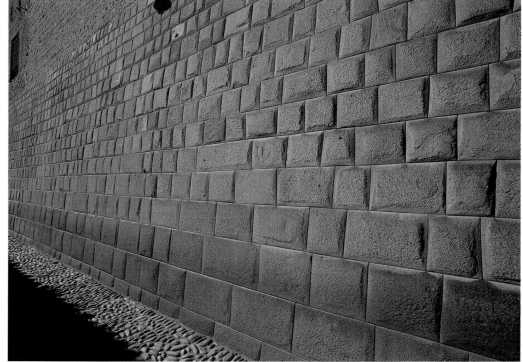

174

ily true and perspicacious vision. He was not only an ecologist before his time, recording details of climate, vegetation and habitat, but also an ethnographer, noting down manners and customs. No less admirable is the compendium by Garcilaso de la Vega of the traditions of his people, in which he gives a detailed and fascinating account of their history, institutions and customs. Yet indispensable as they are, these documents which suddenly bring the pre-Columbian past into historical focus, should not be regarded as entirely trustworthy, for as the products of two different types of civilization and religion they suffer from a strong cultural bias.

It was this sceptical approach—essential in greater or lesser degree when considering an historical document—that led John Victor Murra, one of a group of eminent modern writers who have revitalized Inca studies, to turn to other less colourful but also more objective sources, known as the *visitas*. Prepared by Spanish officials immediately after the Conquest, they contain quantitative information and quasi-statistical data on a nation which, though disrupted by colonization, still retained the traditions and customs of the pre-Columbian era. These recently discovered documents have been responsible for the notable advances made in Inca historiography.

Historical Perspective

A full history of the Inca people does not, of course, fall within the scope of this book. Nevertheless the broader outlines of that history must be given if we are to understand the evolution of their art.

The valley of Cuzco, lying at an altitude of 3,500 metres in the highlands of the Cordillera Oriental north-west of Titicaca, originally sheltered a number of different tribal elements, including Aymara-speaking peoples and Incas whose language was Quechua. The Incas first irrupted into history in about A.D. 1200 under Manco Capac, a tribal chief of the altiplano.

They began by establishing a confederation with tribes in the neigbourhood of the valley where they had built their capital. Folk tales, going back to prehistoric times, provide a mythical setting for their arrival. They were said to be the sons of the Sun who, after long wanderings (similar to those of the Aztecs in Mexico at the same period), settled in this region where they had found fertile soil. The word Inca means lord, and they therefore belonged to a race of lords which would one day hold sway over the whole of Andean America, from the Colombian border in the north to the Argentino-Chilean pampa in the south. But the empire did not attain this size until the fifteenth century during the reigns of two royal commanders, Pachacuti and Tupac who embarked upon an epic series of lightning conquests. Not until the reign of Huayna Capac (1493–1525), however, did Inca expansionism reach its apogee, a bare five years before the Conquest, when the empire included some 5,000 kilometres of the Pacific coast.

How, we may ask, was this rapid unification of the Andean peoples brought about? To answer that question, we shall have to recapitulate. At the time of the accession of the Inca Pachacuti—the great conqueror who founded the Cuzco empire—the pre-Columbian world was made up of a number of autonomous tribes and kingdoms, some occupying a single

171 The north-east wall of the Cuzco palace of the Inca Rocca, who reigned during the latter part of the fourteenth century. This imposing example of Inca masonry consists of polygonal blocks, some with as many as twelve sides, each stone being fitted to the next with the utmost precision.

172 Detail of polygonal masonry, palace of the Inca Rocca, Cuzco. The mortarless joints describe grooves between the heavily rusticated blocks.

173 The Inca wall lining the southwestern side of the Callejón de Lorero at Cuzco once formed part of the Amarucancha, the palace of Huayna Capac whose reign lasted from 1493 to 1525. The small size of the blocks, the horizontal courses and the rounded arrises lend this masonry an almost rustic air.

174 North-eastern side of the Callejón de Loreto. The wall, which formerly enclosed the Acllahuasi, or quarter of the Temple Virgins, is painstakingly built in horizontal courses with deep joints between the rusticated blocks. The masonry wall is surmounted by an adobe superstructure, as so often in Inca architecture.

175

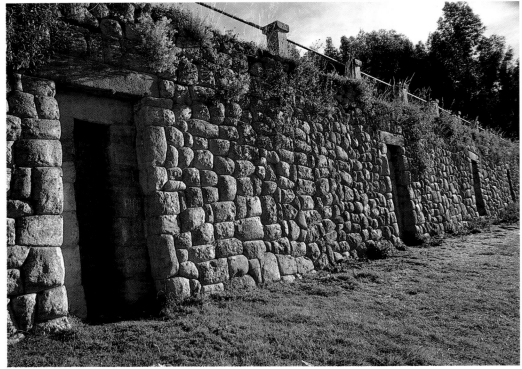

175

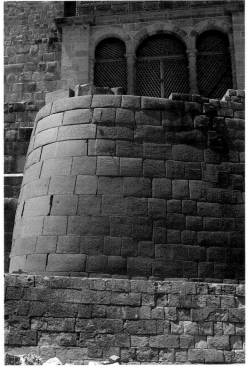

176

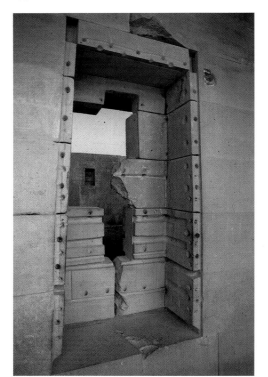

177

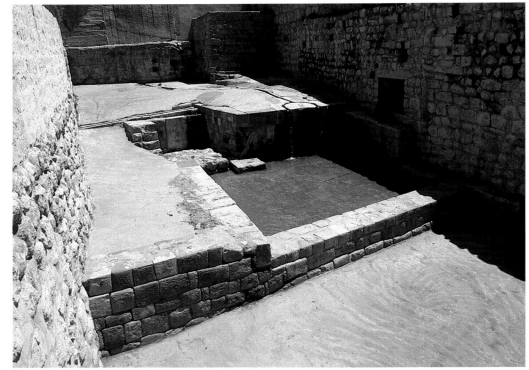

178

175 The Palace of Collcampata, which dominated Cuzco, was supported by a terrace of which the retaining wall comprises eight blind doors with double jambs. The original palace on this site is believed to have been the residence of the legendary Inca Manco Capac who may have reigned about A.D. 1200. Length 90 m, height 3.5 m.

176 The rounded wall of the Coricancha or Temple of the Sun at Cuzco, built by the Inca Pachacuti who reigned from 1438 to 1471. The Inca sanctuary was pillaged and virtually razed by the Conquistadors. Constructed of smooth masonry, the rounded wall enclosed a shrine upon which the altar of the Church of San Domingo was subsequently superimposed. The church itself, seriously damaged by earthquakes, has had to be rebuilt several times.

177 Reconstructed in the course of recent restorations, the 'Tabernacle' at Coricancha is believed to have been the Holy of Holies. Around the opening and inside the niche are holes by means of which gold plates could have been affixed to the walls.

178 A recently discovered spring, adjoining the Coricancha, with several basins cut in the living rock to receive the water. This may have formed part of the famous Golden Enclosure described by the chroniclers.

179 Door in the second surrounding wall of Sacsahuamán, above Cuzco. The first wall has one principal entrance and an ancillary postern, while the second and third have five and four respectively.

180 The Throne of the Inca overlooks the triple wall of Sacsahuamán. Carved out of the living rock, it is in fact an *usnu*, a holy place that probably did duty as a sacrificial altar.

181 The three rows of zigzag walls before the fortress of Sacsahuamán, seen from the direction of the throne of the Inca. This view of the central section of the structure enables us to admire the redoubtable cyclopean masonry of the first tier. The figure on the right, in front of the wall, gives an indication of the size of the blocks, some of which are as much as 5 metres high. The mighty construction was begun in the mid-fifteenth century by the Inca Pachacuti and took more than fifty years to complete. Total lenght 410 m.

valley, others forming larger confederations comprising several political and geographical entities. All were engaged in a struggle for supremacy.

We should cite in particular the immediate neighbours of the small Inca kingdom in the territories surrounding the Cuzco valley, namely the Chancas in the western Abancay region, the Huancas and the Tarmas in the north-west, the Lupacas in the south, and the Collas in the Titicaca basin. These peoples were the first to confront the Incas and to fall under their yoke. On the Pacific coast, the Incas were to meet with opposition from various large groups including the Chincha kingdom, a confederation extending from the Nazca to the Pisco valley, and the kingdom of Chuquimancu around Cañete; also Cuismancu in the Pachacámac region, Chancay, Ancón and, last but not least, the huge and powerful Chimú empire, supported in the highlands by its ally, the ruler of Cajamarca. None but the Chimús, however, offered a sustained resistance, for they alone were powerful enough to cause Pachacuti embarrassment. Thanks to their highly developed metallurgical techniques and their ample reserves of men and matériel, they presented a formidable obstacle to the Inca warriors.

In the extreme north of the Andean world, in what is now Ecuador, were the Cañari and Palta tribes, distant descendants of the Amazonian peoples on the one hand and of the developed coastal cultures on the other. Finally, south of the altiplano in what is now Chile and Argentina, the Incas met with stubborn resistance from tribes who still led a more or less barbarian existence (and have consequently bequeathed nothing of artistic or cultural interest).

Hans Horkheimer believes that some four centuries elapsed between the arrival of the Incas in the Cuzco valley and their conquest by the Spaniards, in which case Cuzco itself would have been founded in the twelfth century by its semi-mythological king, known to the chroniclers as Manco Capac. About 100 years before the arrival of the Conquistadors a political upheaval would appear to have taken place in Cuzco, sparked off, perhaps, by the Pachacuti Inca Yupanqui's decisive victory over the Chancas. As a result, political power passed from the hands of the philosophers or priests into those of the military represented by their sovereign. But the philosophers still remained the custodians of the law and of tradition, thus retaining a hold over the monarch, whom they had helped to institute, and a consequent say in political matters. The church upheld the power of the state of which, indeed, it was the foundation, for it was the priests who nominated the Inca while the latter, on ascending the throne, himself partook of divinity.

The fact remains that, having vanquished the Chancas in 1438, the Inca armies never looked back. From then on they advanced inexorably, subduing the peoples, near and far, who opposed their hegemony. Before long all of them were grouped within the entity known as the Incanato.

So rapid was this conquest that it bears comparison with the lightning campaigns of Alexander and Genghiz Khan. It began when the Pachacuti Inca Yupanqui seized the lands of the Chancas stretching from the Apurimac to the Río Grande de Nazca. Next came his victory over the Collas, shortly after which he gained control of the highlands up to Lake Titicaca. In the north he reached Cajamarca, and in so doing dealt the Chimús a serious blow. On the coast, Pachacuti subjugated the Nazca, Ica and Chincha peoples before reaching the north to capture the great temple of the oracle which overlooked the Pacific at Pachacámac. Con-

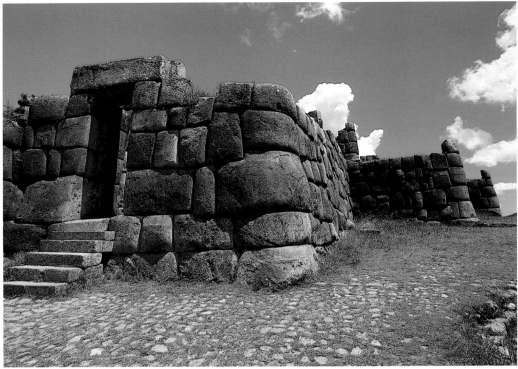

179

180

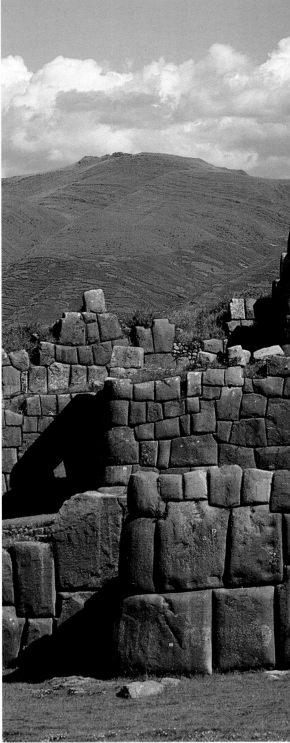

181

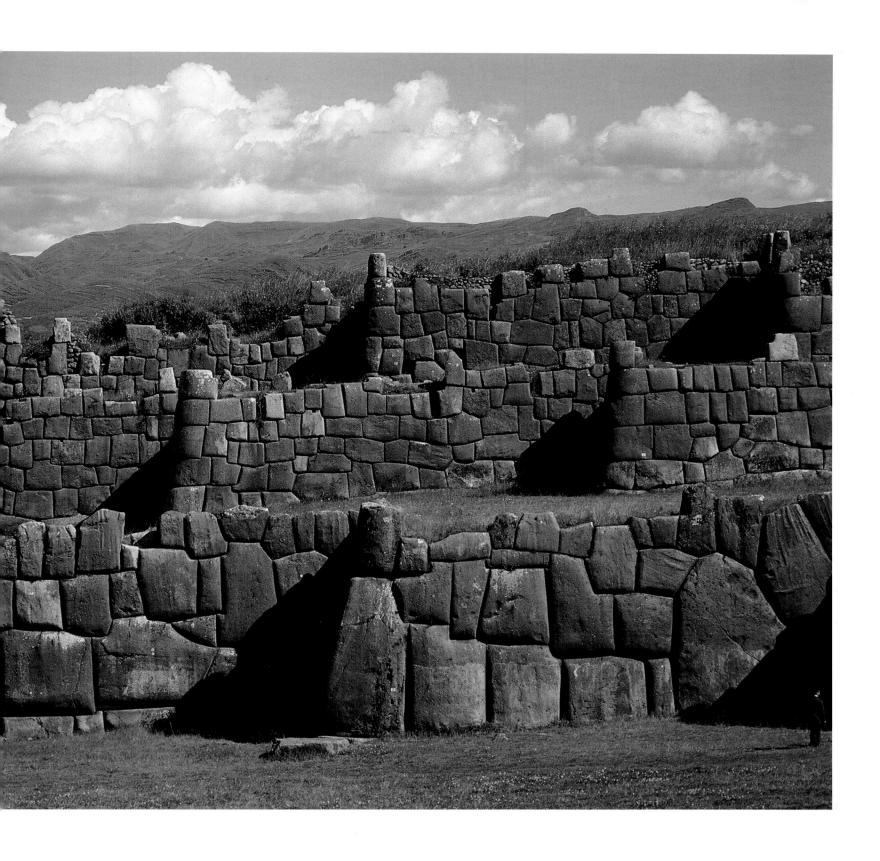

tinuing in the same direction, his armies pressed forward to Tumbes, thus avoiding the kingdom of Chimor and a direct confrontation with its forces of whose efficiency they had already had a taste.

In fact, no such confrontation with their powerful enemy ever took place. From their positions in the mountainous hinterland which they had held since their subjection of Cajamarca, the Incas were able to cut off the supplies of water which fed the Chimús's irrigation system. The resulting drought and famine completed the work. Doomed by this ecological disaster, the peoples of the coast surrendered. This bloodless victory (about 1465) was crucial to the future of the Incas and their world, for through it they acquired the well-tried and efficient administrative techniques of a huge kingdom, as well as a road network, a well-organized information service, and a body of craftsmen of great technological expertise. All this was to contribute, within the Incanato, to the success of the Incas' experiment in unification.

We should note that Pachacuti was not only a successful soldier but also an architect who undertook the complete remodelling of Cuzco with the intention of turning it into a capital worthy of the empire he had created. Amongst the new buildings he commissioned was the temple of Coricancha, dedicated to the sun, which was to play a key role in the deification of the Inca. The development of Cuzco was influenced by Pachacuti's victory over the Chimús in about 1465, for Chanchán would seem to have been used as a model by the Inca emperors who each in turn built a new palace, thus making provision for his own cult on his death.

Pachacuti reigned over an empire stretching from Lake Titicaca to what is now the Ecuadorean border and, as a prudent man, involved his son in his conquests and in the exercise of his power. When the latter succeeded him under the name of Inca Tupac Yupanqui (1471-93), he continued to pursue the imperialist policy so brilliantly inaugurated by his father, but with considerably less success. For the attack he launched against the peoples of the *selva*, far from resulting in territorial gain, was repulsed with terrible losses. To make matters worse, the subject peoples on the coast chose this moment to rise. But the speedy reaction of Tupac's forces averted the disaster, and a possibly formidable rebellion was repressed.

He was then able to address himself to the task of organizing his vast empire covering about 900,000 square kilometres and consisting of four regions known collectively as Tahuantinsuyu, and individually as Chinchasuyu in the north, Contisuyu in the west, Antisuyu in the east and Collasuyu in the south. All four provinces had Cuzco for their centre whence roads fanned out to serve the various parts of this enormous territory.

On the eve of the brutal and unexpected irruption of the Conquistadors, Peru, under Inca domination, had thus become a formidable sociopolitical macrostructure whose functioning depended on rigorous organization and on the disciplining and regimentation of the labouring class. What was the nature of that organization which controlled the last of the great pre-Columbian civilizations?

Social Structure

The autocratic and centralized system which formed the basis of Inca society differed little from that of the great agrarian empires of the Old

182 The cave sanctuary at Kenco, not far from Sacsahuamán. Within a semicircular wall, of which only two courses now remain, a great mass of eroded limestone is preceded by the place of sacrifice. The fact that the Incas made no attempt to refashion it testifies to the importance they attached to natural features of curious shape. Height of single rock 6 m.

183 A natural fissure at Kenco, in which passages and altars have been cut out of the rock to form an Inca shrine, is said to have been consecrated by Huayna Capac. Caves of this kind, in which natural elements are combined with hand-hewn stones, are characteristic of the Inca religion.

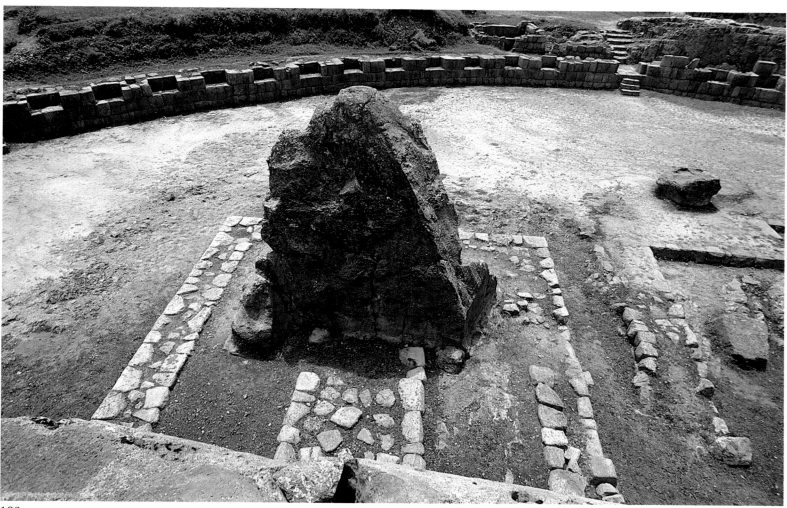

182

183

World. It was typically pyramidal with, at its summit, a sole and absolute authority in the person of the emperor or Inca, the deified representative of the Sun and object of a state religion which took precedence over any other form of worship practised by the vassal peoples. All the power, then, whether civil, military or religious, was vested in the Inca, and the unity created by force of arms was established and consolidated by the church. We could want no better example of a system in which field-marshal's baton and pastoral staff are wielded by one and the same man.

Like the pharaohs of Egypt, the Inca took the principle of endogamy to its logical conclusion by marrying his own sister. True, the custom was not always strictly adhered to, for the official consort might often find herself surrounded, not only by secondary wives, but also by numerous concubines chosen from among the daughters of subject princes. Yet it is a custom that underlines the tribal nature of the system. What we have here is a small, inward-looking group, preoccupied with its own preferment by which it alone stands to benefit.

Moreover the Inca tribe or family, which had its origins in the small Huatanay valley watered by a tributary of the Vilcanota, was to rule the empire as though it was their own personal property. They were the 'people of *the* god' and all male descendants bore the right to the title of Inca which automatically invested them with extraordinary powers within the machinery of state. In Cuzco these nobles constituted an élite body of *orejones* (big ears) so named by reason of the gold ear plugs they were entitled to wear. Jewels, the insignia of their rank, were progressively added to these ornaments, with the result that the aperture made by the piercing of the lobe grew larger and larger.

Together with the emperor, the Inca tribe formed the summit of the social pyramid. Others, however, could acquire the title, thereby becoming nobles of second rank, a class whose privileges were associated with a particular reign. Its members, who lived in the capital, were drawn from the neighbouring valleys. The same privileges also extended to the rulers of subject states. Next came the priests, philosophers, soothsayers and temple virgins, none of whom were subject to tribute. Known as the *mita,* this tax took the form of a corvée and/or material contribution (then the only form of currency) from which, needless to say, the nobility was exempt.

Below these upper strata was an intermediate class of functionaries and administrators representative of the state. On a par with these were the military leaders, in so far as they did not belong to the nobility. The craftsmen, another class not subject to the *mita,* were accorded a social position of their own by virtue of the services they were able to render a state-controlled collective economy.

Next came the smallholders whose land was known as an *ayllu.* A typically Inca institution, the *ayllu* was a plot of land cultivated by the peasant for himself and his family who were thereby enabled to attain a measure of self-sufficiency. It was, in effect, one of a group of plots owned collectively by a family or clan. In a predominantly rural society the *ayllu* holders made up the great majority of the population. The private land they tilled had, for its corollary, the land owned by the state upon which they also worked in order to discharge the obligation represented by the *mita.*

At the bottom of the social scale were the servants and those who possessed no property. Known as *Yanaconas,* they were little more than

slaves, many of them being prisoners of war. As such they formed a vast pool of labour that could be drawn on at will.

A word or two more must be devoted to the *mita,* a concept arising out of the tripartite division of property upon which the Inca system of land tenure was based. We have already mentioned the collective family holdings known as *ayllus* which formed one of the three divisions. The other two consisted on the one hand of Inca property whose revenue accrued to the state and, on the other, of land appertaining to the sun which served to sustain the temple, or rather the pillars of the established church.

True, this tripartite division, which enabled taxes in the form of harvests produced by subject labour to be levied at source, should not be taken to mean that all the available land was divided into three equal parts. We can no more suppose that the state arrogated to itself 66 per cent of the harvest than that it confiscated two thirds of the cultivated land in the conquered territories. Rather the system would seem to have depended on major public works devoted to land reclamation and the improvement of the infrastructure.

The chroniclers tell us that for reasons associated with the organization of labour, the entire able-bodied population was divided into units of production equivalent, in military parlance, to formations such as sections, companies and brigades, and numbering roughly 10, 50, 100, 500, 1,000 and 5,000 workers. However we should not allow ourselves to be misled by these figures which simply represent orders of magnitude, for the decimal system supposedly used to compartmentalize the empire's population may well have been thought up by the chroniclers in an endeavour to give statistical support to their theses. While the Incas would undoubtedly have attempted to deploy the labour force in a manner suited to the projects in hand, the above subdivisions seem to smack of theory rather than fact, since accurate estimates would not have been possible in view of the constant fluctuations in the size of the population.

Similarly, the categories cited by the chroniclers—childhood, maturity and old age—are simply those prescribed by nature. They served to determine the number of people available for *mita* service, which as a rule was obligatory for those between twenty and fifty years of age. However, women and children also took part in communal work such as spinning and weaving.

Public Works

The whole purpose of the social structure outlined above was to maximize the amount of labour at the disposition of the state as represented by the nobility. For the Inca empire was characterized by a feverish, ant-like activity directed towards managing the land and modifying the environment in such a way as to raise its productivity.

All this, as we have already pointed out, was based on the principles of the *mita* and of the collective ownership of land. The latter was not an Inca institution but went back to the time of the early pastoral societies whose flocks of llamas and alpacas had been herded on common grazing grounds. It was these mountain pastures that constituted the first step towards collectivism.

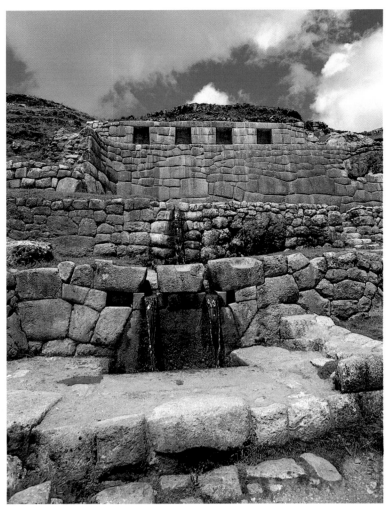

184

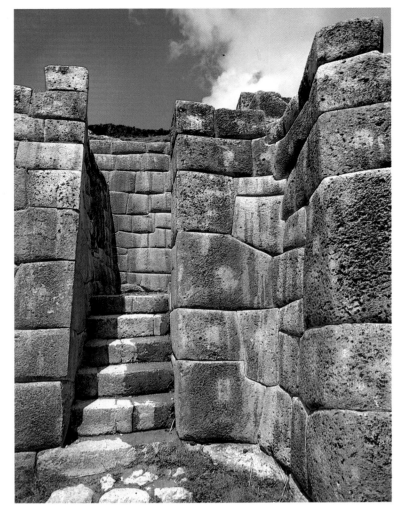

185

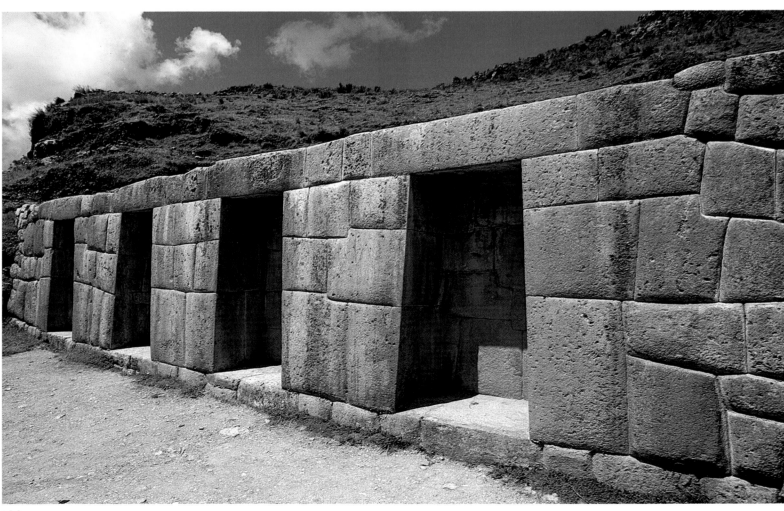

186

The *mita* system was introduced by the government in order to fund its social policy and implement the major public works necessary to its proper functioning. Although *mita* labour was primarily employed on cultivating land belonging to the state and, by extension, to the church, it might also be used for constructional work associated with agriculture. Alternatively it might be diverted to operations of a non-agricultural nature, for instance the building and maintenance of roads and the manufacture of cloth for all sections of the population, irrespective of rank.

However, it was in the field of major constructional undertakings that the collective system produced its most spectacular results. Only with a large well-managed and efficient labour force would it have been possible to implement the ambitious projects which were literally to transform the landscape of this section of the Andes. Since agriculture was the chief source of production, improvements in that sphere were clearly of vital interest to the Incas who had recourse, according to region and altitude, to two main methods: the first, which might almost be described as agrarian architecture, consisted in building retaining walls to produce cultivatable terraces or *andenes* on the steep flanks of the valleys; the second, in complementing and perfecting the irrigation network of aqueducts, dams, canals and embankments inherited from the Mochicas and the Chimús.

Both methods were used in conjunction in the highlands where *andenes* were very numerous. Here, at altitudes ranging from 3,000 to 4,300 metres, the Incas built thousands of kilometres of wall to provide supports for their terraces. The latter not only enabled crops to be grown on gradients of as much as 60°, but also helped to prevent erosion. Increased productivity was also achieved by the damming of, for example, the Río Huatanay, or of the upper reaches of the Urubamba known as the Vilcanota.

Such great projects would not have been feasible without strict social discipline on the one hand and a system of collective ownership on the other. For the taming of nature and its adaptation to human needs called for the combined efforts of all concerned, the more so since the population was growing at a tremendous rate. Everywhere in Peru an artificial environment was coming into being as a result of the manipulation of the laws of ecology. Nothing less could have produced the hallucinatory landscape proffered by the upland valleys with their immense stairways ascending the impossibly steep slopes, or the scarcely less impressive coastal oases surrounded by unrelieved desert.

Nor is such an infrastructure conceivable without legislation governing, for instance, the distribution of water, the times of irrigation, the maintenance of terraces and canals, and the rotation of crops.

In Peru, the work done by the pre-Columbians in adapting their agriculture to suit not only the precipitous, unstable terrain of the highlands, but also the vast, arid plains of the coast, must rank among the finest efforts ever made to improve man's day to day existence. Like the paddy-fields of China and Angkor, the irrigation systems of the pharaohs and Babylonians and the drainage canals of the Mayas, these constructional undertakings in the Andean region cannot but compel our admiration. Nor should it be forgotten that they conditioned the social structure of the Incas.

However this enormous potential, based as it was on intensive agriculture, would have been of no avail had not a system existed for the

184 On the mountainside above Cuzco, Tambomachay, known as the Bath of the Inca, is a place of worship dedicated to a hot spring. Our illustration shows the basins, carved out of the living rock, and the walls in receding terraces.

185 The stairs ascending to the upper level of the shrine at Tambomachay provides a good example of Inca polygonal masonry.

186 The retaining wall above the assembly at Tambomachay, with its large polygonal blocks, mortarless joints and trapezoidal niches, is characteristic of the sacred architecture of the Incas.

187 Pisac, an Inca site above the sacred valley of the Río Vilcanota, a tributary of the Urubamba. These superb *andenes* or man-made terraces, are still under cultivation today. The retaining walls, which follow the contour lines, testify to the enormous labours expended by the Incas on the reclamation of land.

188 The ceremonial centre of Pisac, situated at an altitude of 3,300 metres consists of various edifices with typically trapezoidal doors and niches. Intact, save for their thatched roofs, they are built of superbly dressed masonry and may be accounted one of the triumphs of Inca architecture. On the right is a rounded wall enclosing the sacred rock known as the Intihuatana.

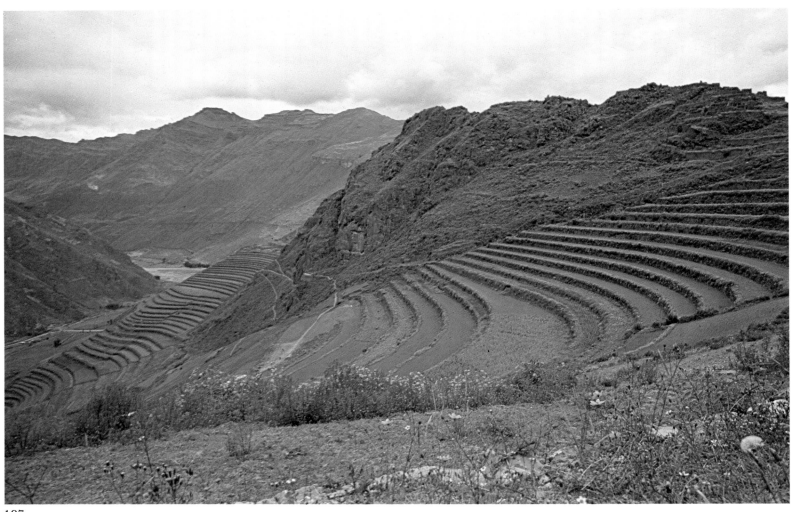

187

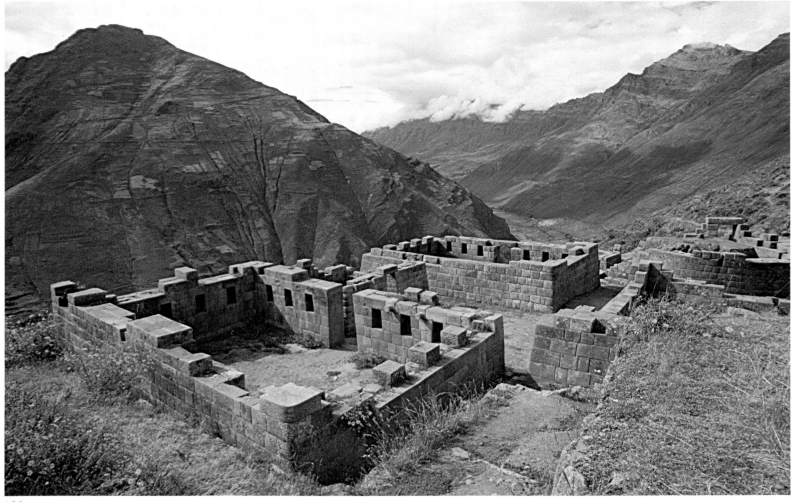

188

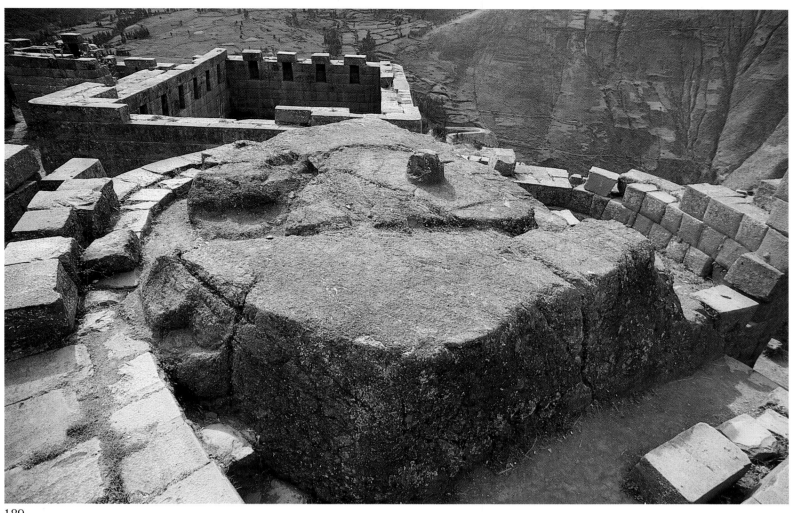

189

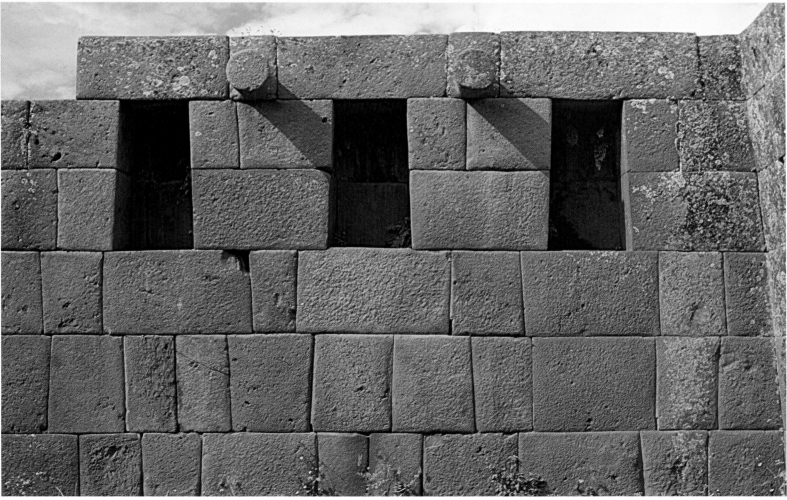

190

distribution of stocks built up from the surplus produced by each region. The Incas therefore constructed massive silos, granaries and warehouses in which to store those surpluses for distribution as need arose. But if it were to operate efficiently, this system postulated an exchange of complementary produce between various regions, hence the network of roads connecting every part of the country.

That network was but another part of the state-controlled infrastructure essential to the smooth functioning of an agricultural economy. It was a gigantic undertaking comparable to the achievements of the Roman road builders, and was based primarily on two systems, one running up the Pacific coast, the other following a parallel course through the highlands at altitudes of between 3,000 and 4,300 metres. The Andean highway alone was 5,200 kilometres long and the coastal highway some 4,000 kilometres, both being crossed at intervals by lateral roads linking mountains and coast. Taken as a whole, the system incorporated nearly 12,000 kilometres of road.

Wherever possible, the highway took a straight course and might be anything up to 8 metres wide. Severe gradients presented few problems since there were no vehicles. In fact the only road-users were the *chasquis* or runners, the litter-bearers who transported the nobility, the long trains of llamas each loaded to capacity with some 20 or 25 kilograms of produce and, of course, the military, for these roads were also of strategic importance and were, indeed, crucial to the safety of the empire.

Their building entailed a number of other works including bridges. These sometimes took the form of large cantilevered slabs (the arch not being known to the Incas) and sometimes of suspension bridges carried by thick cables made of cactus fibre. They were built at a safe height above the tumultuous rivers that flowed through the steep-sided valleys. A famous example of such a bridge (in this case over the Río Apurimac) was still in existence in the mid-nineteenth century.

Causeways, too, had to be constructed where roads ran through marshy ground, as also low adobe walls to check drifting sand where they crossed a desert. Post-houses or *tambos*, sited at intervals corresponding to a day's march, provided travellers and porters with rest, food and shelter for the night. It was even possible to visit public baths at various points along these highways which might be described as the lifelines of the empire.

They also permitted the dissemination of news at quite astonishing speed, given the absence of mounts or vehicles. The *chasquis* were organized on a military basis, being posted at intervals of some 3 kilometres in small huts or shelters made of branches, where they waited until another runner arrived with a message. This relay system enabled the *chasquis* to keep up a very fast pace, so that information could be conveyed at great speed over considerable distances in a very short time. Cieza de León relates that a message took only five days to reach Cuzco from Quito, 2,000 kilometres away. Thus some 650 to 700 *chasquis*, running day and night, must have averaged 16 kilometres an hour.

The Intellectual Aspect

Here the question arises as to the actual content of the messages thus carried. Writing as such would seem to have remained foreign to the Andean pre-Columbians, though various attempts have been made to

189 Pisac. The Intihuatana seen from above. Little modification was needed to turn this rock into a sacrificial altar, around which a semicircular wall was built.

190 Detail of an Inca wall at Pisac. The tenons jutting out of the surface between the niches acted as supports for the thatched roof. The masonry, laid in regular courses, is of admirable quality.

191 Terracotta receptacle for votive offerings, Inca Imperial style. Parrots, flowers and priestesses of the sun, or Mamaconas, form the decoration of this very elegant, long-necked vessel. Height 34 cm. Museo Regional de Cuzco.

192 Small aryballos from the Cuzco region. Inca Imperial style, with geometric decoration. The neck is adorned with a stylized human face. Its somewhat dry quality is typical of Inca art. Height 14 cm. Museo Regional de Cuzco.

193 This aryballos, with geometric decoration typical of the Inca style, is an exact replica, if on a reduced scale, of the large jars used for transporting water. These were carried on the back by means of a strap which passed through the handles on either side, over a nubbin by the base of the vessel's neck, and across the bearer's forehead. Height 27 cm. Museo Arqueológico, Lima.

194 Small Inca aryballos. The relief decoration simulates the shape of certain kinds of squash. Height 16 cm. Museo del Banco Central de Reserva, Lima.

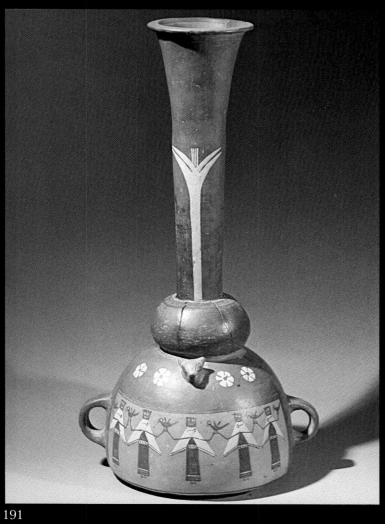

191

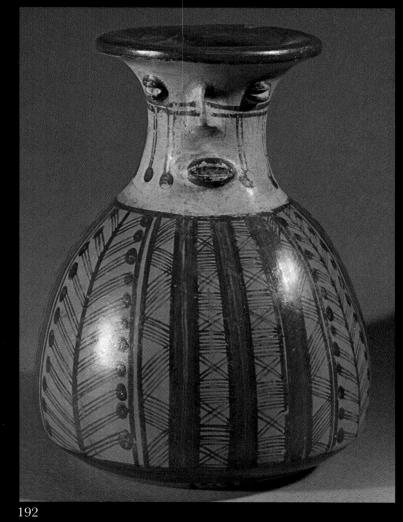

192

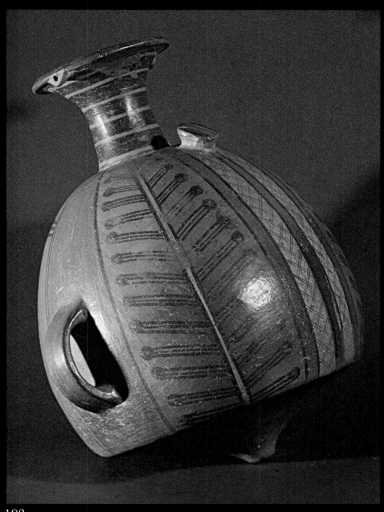

193

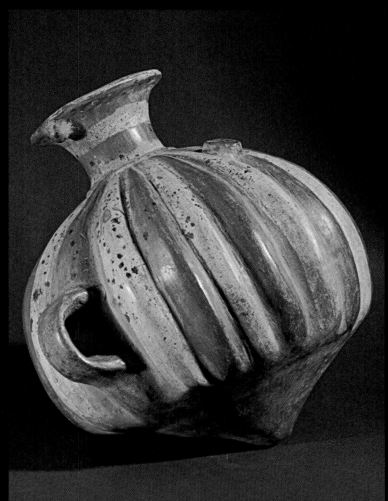

194

discover a sign-language in, say, Mochica 'beans' (Rafael Larco Hoyle), Paracas textile motifs (Victoria de la Jara), or the geometric designs of Inca cloths and *keros* (Thomas Barthel). Nor, despite periodic and sensational announcements to the contrary, would we seem to be on the verge of discovering any form of writing invented by the prehistoric peoples of South America that might compare with the glyphs of the Mayas, Mixtecs or Aztecs.

Nevertheless, the *chasquis* must sometimes have been entrusted with information that could not be memorized and thus transmitted by word of mouth—always a hazardous procedure, and especially so when, as in the case cited above, it had to be carried by numerous relays over very long distances. The Incas ingeniously solved the problem by perfecting a mnemonic device known as a *quipu* in which strings of various lengths and colours were attached to a larger piece of cord, each string being so knotted as to express numbers, after the manner of an abacus. By this means the consignor was able to send the consignee a whole range of signals based on an agreed code in which the various colours might signify categories of produce, goods or persons, while the knots conveyed information of a quantitative nature, either relating to the above categories, or, say, to production statistics.

Needless to say, the device, unlike writing, did not conform to a uniform code since it called for conventions that could be changed as and when need arose. It was, then, a mnemonic system, the chief value of which lay in the transmission of figures. The interpretation of the latter necessitated a verbal commentary on the part of the messenger or, more probably, of one of the government officials known as *quipu camayos*, who held the key and perpetuated the tradition. There is every likelihood that the numerical information conveyed was based on the decimal system.

However, as a highly mobile means of communication, the *quipu* could serve a double function: in the first place it enabled quantitative information to be conveyed by *chasquis* without its becoming distorted *en route*, and in the second it provided a means of storing particulars of the country's resources in what can only be described as data processing centres. Thus records could be kept showing, for example, the number of inhabitants and warriors in a given village, town or region, its output and reserves of goods and produce.

The *quipu*, in short, admirable though it was for book-keeping purposes and for the transmission of concrete, quantitative information, could not be used to convey ideas or abstract philosophical and historical concepts. Its interpretation depended on an oral code which has failed to survive, and no matter how many *quipus* may be found in coastal cemeteries, the information they were intended to convey will never be revealed to us. In the circumstances, these devices, however ingenious, cannot be said to have helped the Inca world to emerge from prehistory.

A Socialist Culture

There is a marked lack of consensus in regard to the Inca's social system. Some authors, among them Louis Baudin, see it as socialism before its time, citing social security and the redistribution of wealth, while others incline in favour of a slave theocracy not unlike the great absolutist

195 Stirrup-spout vessel from the north coast of Peru. Inca period. The vessel assumes the shape of a highly schematized penguin. Its forms, like its black, burnished surface, are derived from the Chimú potters. Height 19 cm. Museo Banco Central de Reserva, Lima.

196 The persistence of the Chimú forms and style under the Incas is attested by this vessel, also from the north coast of Peru, in the form of a pelican. Height 24.5 cm. Museo del Banco Central de Reserva, Lima.

197 Anthropomorphic vessel, Inca style, showing a lobster being caught in a lobster-pot. This piece testifies to the consummate skill of the north coast Inca potters. Length 29.5 cm. Museo Arqueológico, Lima.

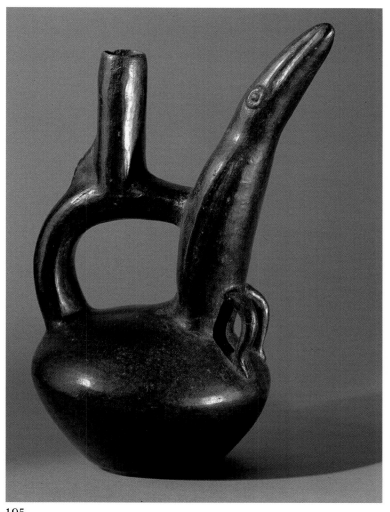

195

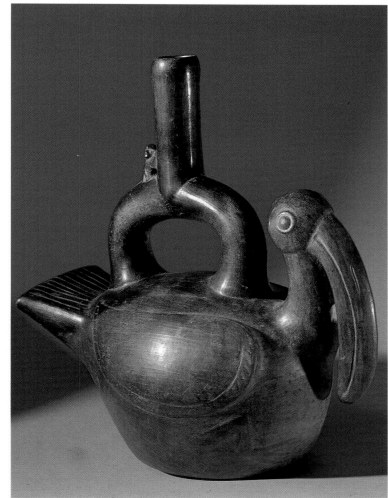

196

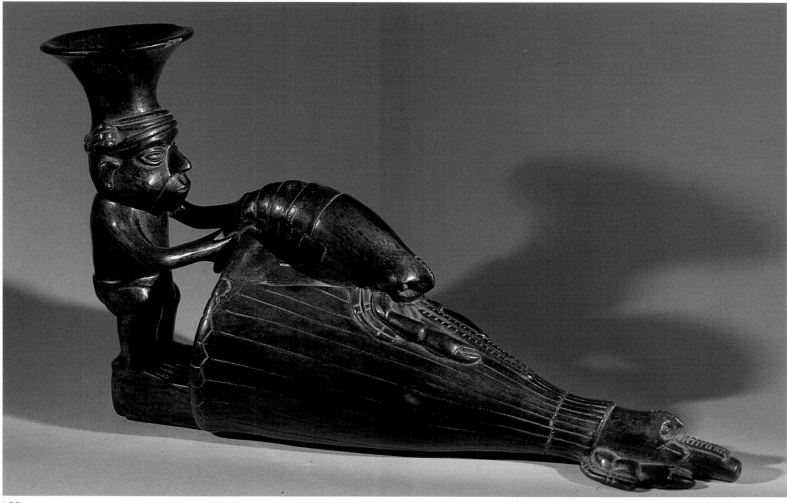

197

monarchies of antiquity, but organized along far more rigorous and inhuman lines.

Thus, depending on our point of view, we may regard it either as the perfect model of an idyllic world in which everyone is assured of a secure existence in his own appointed place in society, or as a kind of 'Gulag' in which all individuality has been lost by beings who have become slaves to the Inca. In short, either as heaven or hell.

As we have already mentioned, the social system of the Incas has been subjected by John V. Murra to a reinterpretation which may enable us to gain a better idea of the advantages and disadvantages inherent in such a régime. Unlike most authors, who follow the custom of drawing the bulk of their information from chronicles written immediately after the Conquest, Murra has recourse to the reports or *visitas* drawn up by the colonial officials. By adopting an ecological approach he has come to understand how the men of the Andes succeeded in perfecting what was a novel system of production. He points out that human energy was the chief convertible resource of Inca society and that the functioning of the state machine was based on tribute. For the excess production indispensable to the redistribution of wealth by the state and to its policy of social security would not have been attainable in the absence of *mita* labour.

Murra also underlines the constant endeavour to spread production over as many ecological levels as possible. The output of regions lying at different altitudes was redistributed and co-ordinated in such a way as to make a wider range of commodities available to the population. He calls this 'vertical control', the aim of which was to pool the complementary products of the high plateaux (meat, milk, leather), of less elevated zones (maize, quinoa, potatoes), of the temperate zones (fruit and vegetables), of the tropical, coastal zones (cotton, pimentos, fish and shell-fish) and finally, of the *montaña* and *selva* east of the altiplano (wood, coca, exotic produce, feathers, medicinal plants).

Murra goes on to suggest that social groups entered into association in order to form what he calls 'archipelagos of production' comprising centres at various altitudes to ensure the redistribution of resources. The archipelagos were based on a system of inter-regional exchange between zones producing different commodities. This system contributed to the wealth of each community subjected to 'vertical control' by ensuring the absolute complementarity of goods available to society at large. It was a solution that freed the population from the monotony of the limited diet which was commonly the lot of prehistoric peoples and often entailed gross nutritional deficiencies.

Thus, by amalgamating the high plateaux, valleys, plains and coast to form a single productive system, the administration was able to effect a substantial rise in the general standard of living. That the principle of complementarity was nothing new in Peru is evident from the examples of very early textiles cited above in which cotton was blended with wool. Here as elsewhere the Incas merely adopted such pre-existent solutions as they thought beneficial, took them to their logical conclusion and raised them to a principle of government.

Murra also discussed the colonists, known as *mitimaes* or *mitimacs*, who had been transferred by the Incas to specific localities, many of them far from their original homes. The intention was to further the unification of the peoples and achieve a uniformity in their customs and speech— perhaps, by introducing *Quechua* or *Runa Simi* as the standard language.

The *mitimaes,* regarded by many as belonging exclusively to oppressed peoples, call to mind the displaced persons, if not the deportees, of World War II. While it is true that entire tribes or villages might be moved to a new habitat, Murra has demonstrated that such transfers were aimed precisely at ensuring vertical control, while at the same time facilitating the interchange of knowledge and techniques. In other instances people might be transplanted to meet the demands of seasonal work or, again, to introduce into an ecological niche a type of farming hitherto unknown there, for instance the breeding of llamas at altitudes lower than those to which they had been accustomed.

In short, such mobility of labour was conducive, not only to the intermingling of different peoples from very diverse regions, but also to the realization of new potentialities. While, generally speaking, these shifts took place from the highlands around the capital to the coast, they might, in certain circumstances, be effected in the reverse direction. For instance, it was a regular practice to import members of a particular calling to Cuzco, as happened after the annexation of the Chimor empire when that country's metal- and gold-workers were tranferred *en bloc* to the capital. There were two reasons for this move: first, it deprived the Chimús of armourers who might otherwise provide material support for an insurrection; secondly, it brought the Incas an advanced technology indispensable to the maintenance of law and order and to the prosecution of war.

As we have already mentioned, weaving was included among the obligations represented by the *mita.* Murra has shown that the textile *corvée* was second only in economic importance to the agricultural *corvée.* Indeed, the cloth manufactured in the empire was superior to that made in Europe at the time, for the Incas were the legatees of Paracas, Nazca, Chincha, Chancay and Chanchán, which had produced the most remarkable weavers in prehistory.

The pre-Columbian Indians are known to have manufactured an enormous quantity of extraordinarily fine textiles. Until the Conquest the Incas' warehouses were packed with cloth and garments intended, not only for the people, but also for the aristocracy and the army. A mere eighteen years after the Spaniards' arrival, however, this magnificent industry lay in ruins, forgotten and abandoned.

To sum up, the Incas established an economic system based on vast reserves which filled the government warehouses and silos and were used to combat shortages and famine in lean years, as well as to facilitate a more equitable distribution of commodities to those parts of the country which might otherwise go short. In this way they also avoided private hoarding and speculation on a rise in 'prices'—the latter a manifestation of an imbalance in exchangeable commodities. It was a system conducive not only to a greater diversity of available goods but also to an existence free from all care for the morrow. A bad year for maize might well be a good one for potatoes.

Some people are repelled by what seems to them a rigorously organized authoritarian society in which everything was planned and freedom was unknown. Amazed that the inhabitants should have lived in windowless huts without seats or beds, they jump to the conclusion that these were prohibited, and are horrified to learn that men were forbidden to become intoxicated on maize beer *(chicha)* except on feast days and similar occasions. What they fail to remember is that in mediaeval Europe the serfs

led very similar lives and that they, too, a millennium ago, had no more hope of bettering themselves.

On the other hand, the social structure perfected by the Incas had many advantages, one such being a form of social security which provided for the sick and for widows and orphans. And even though elderly people over sixty were still required to work, if not very hard, this did at least mean that they remained full members of society—evidence of a saner outlook than that of today when retirement may spell total idleness and a consequent feeling of being unwanted.

It should not be forgotten that the original motive for Inca expansionism was over-population in the fertile valleys around Cuzco where all easily available land was quickly brought under cultivation. Again, it was in response to this demographic pressure that the Incas introduced the system of intensive production which they were ultimately to impose on all the developed societies of the Andes. What led them to bend all their efforts towards eliminating famine—and to such remarkably good purpose—was the spectre of poverty, and to this, too, must be attributed their preference for heavy labour and collective discipline as opposed to liberty—a concept in any case quite foreign to the prehistoric mind.

IX. The Incas and Art

In almost every field the Incas were the beneficiaries of the cultures that had preceded them, as indicated by the title of this book, *Art of the Incas and its Origins*. Indeed, their civilization and the power they wielded might almost be said to represent the most advanced stage reached by each of the peoples that went to make up their empire.

Whether we are concerned with institutions and beliefs, or with techniques and customs, the Incas were primarily the repositories of a common legacy—that of the Andean societies which had evolved during the 5,000 years before their advent. By the end of those five millennia there already existed a very complex infrastructure—later to be enlarged and exploited by the Incas—embracing both economic and agrarian aspects such as irrigation, stock-piling, barter and redistribution. In all cases, collective discipline and centralized organization would seem to have played an essential part in the survival of societies living in a desert or highland environment where nature could only be tamed by a concerted effort.

With a first-class army at their disposal and with the courage born of their determination to surmount the difficult problem presented by over-population—Toynbee's 'challenge'—the Incas embarked upon a series of victorious campaigns which enabled them to draw on the skills of each of the conquered territories in turn. They thus became the beneficiaries of the Nazca weavers, the altiplano builders, the Chimú goldsmiths and, again via Chanchán, of the Mochica hydraulic engineers. It was also, no doubt, to the Chimús that they owed a large part of their attainments: in branches of technology such as town planning, highway construction, metallurgy and ceramics, as well as in the socio-political field where the kingdom of Chimor served as a model for the organization and administration of the empire and also, perhaps, for some of the rites attending the monarchy. For it was not until after the fall of Chanchán that the 'genius' of the Incas was really to assert itself, a genius that combined powers of assimilation and adaptation with a profoundly syncretic vision. However they were not wanting in creativity, for the work of the Incas is usually recognizable at first glance. A new idiom is discernible both in their textiles, which are quite distinct from those of Paracas or Tiahuanaco, and in their pottery, which, far from adhering slavishly to Chimú models, engendered original forms such as the aryballos.

It was the astonishing mastery attained by the Incas in the fields of organization and collective discipline that enabled them to acquire a dominant position among their Andean contemporaries while taking full

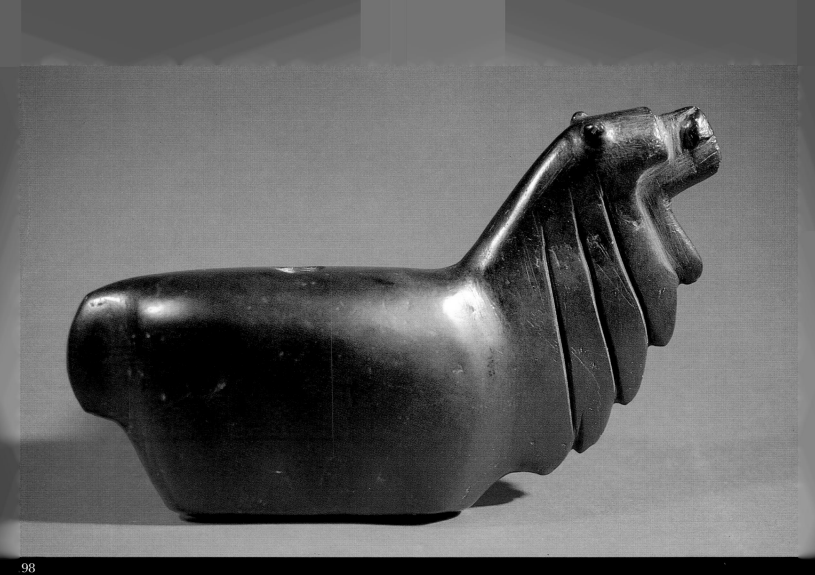

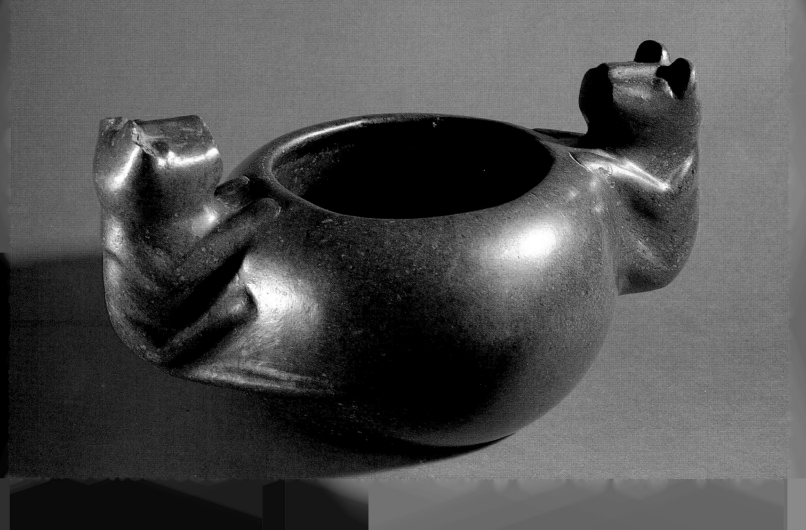

advantage of the techniques they had inherited. These the Incas incorporated into a well-defined political structure, into a productive and distributive system on the one hand and an administrative and military machine on the other, thereby achieving a quite remarkable measure of cultural homogeneity.

What role, then, was played by creative art in a political system in which centralization had been taken to extremes? We shall first consider architecture, the field in which the genius of the Incas is at its most apparent. Here, the adaptation of earlier idioms engendered an original style which manifests itself both in the forms and in the methods of construction. One cannot but be struck by this revival which infused new blood into architectural expression, not only in masonry at which the Incas excelled, but also in their use of adobes and *tapias*.

The Legacy of the Builders

We shall now turn to the legacy of which the Inca builders were the beneficiaries. The originality of their architecture may be attributed to the confluence of two neighbouring streams, one represented by the peoples of the altiplano, in particular the Collas, themselves heirs to Tiahuanaco, the other by the Chimús, and this especially in the field of town planning.

The most important bequest, namely the use of stone, came from Tiahuanaco–Huari, for Pachacuti soon followed up his victories over the Chancas and Collas by taking possession of the altiplano. We should not forget, however, that, by that time, Tiahuanaco's master masons had been dead and buried for some 400 years. Hence their skills must be assumed to have been passed on to the Incas through the agency of the Collas, always allowing for the fact that like materials are apt to evoke like methods.

While Pachacuti may well have been impressed by the ruins of Tiahuanaco, it seems improbable that Cuzco was a pastiche of Puma Puncu or Huari. Rather, it was something entirely new, based on architectural principles and masonry techniques of quite a different kind. Instead of plane joints, the Inca builders ground their blocks so that the slightly convex surface of one stone fitted exactly into a depression made in the stone below it. The Collas knew nothing of this method which they had to learn when brought in to build the great Cuzqueño monuments. It would therefore appear to be an original technique invented by the Incas.

On the altiplano round Titicaca the Collas constituted a culture characterized mainly by its remarkable funerary towers or *chullpas,* the repositories of mummies, wrapped in rich *fardos.* The architecture of the towers, whether on a square or a circular plan, reveals a high degree of technical expertise. Indeed, the construction of a curvilinear wall of dressed stone calls for a perfect command of stereotomy. We should not, however, exaggerate the influence allegedly exerted by the Collas upon the Incas, for although there are *chullpas* anterior to the Inca conquest, the best examples would seem to date from the time of the empire. Some of these are located at Sillustani, about 20 kilometres from Titicaca, at an altitude of some 4,000 metres. The setting, on the shores of Lake Umayo, is a magnificent one. In the interior of these towers, which served as tombs for the chiefs and their families, is a vaulted space, or rather a space covered by a false or corbelled arch. Here, in superimposed individual

198 Black basalt statuette of an alpaca from the Cuzco region. Inca Imperial style. The piece symbolizes the sacrifice performed to ensure the fertility of the land. Length 17 cm. Museo Regional de Cuzco.

199 Basalt mortar. Inca Imperial style. With its handles in the form of stylized pumas, this vessel must have served as a receptacle for votive offerings. Length 22 cm. Museo Regional de Cuzco.

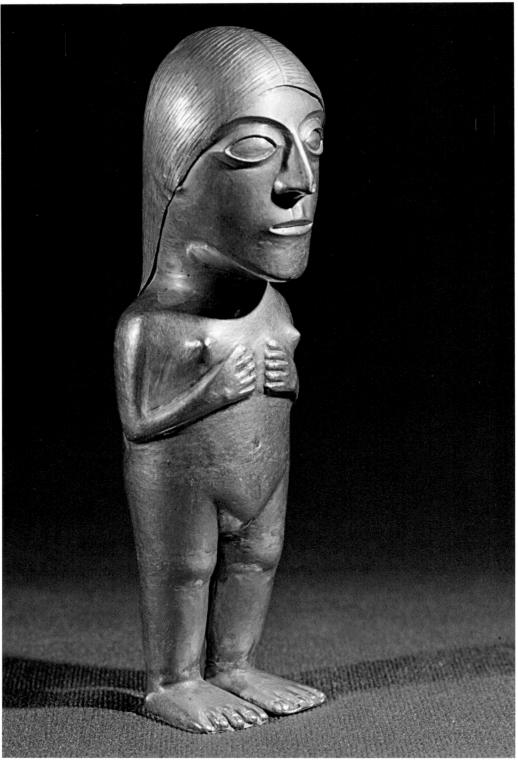

200

201

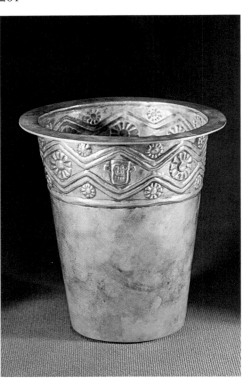

202

niches, the deceased were placed in a flexed position. The *chullpas* were built of fine blocks of volcanic stone whose outer faces were perfectly dressed, while their inner faces were left uncut and projected into a wall of rubble roughly mixed with beaten earth. Some of the towers are as much as 12 metres high and are crowned by a dome which, accentuated by a projecting band, gives the building a somewhat phallic appearance (Pl. 203).

Access to the tower was by way of a small opening, reminiscent of a cat-hole, which faced the sunrise. Elsewhere on the site, circles of standing stones with a similarly oriented opening were undoubtedly places of outdoor worship (Pl. 204). Round or square towers akin to those at Sillustani occur at other locations on the altiplano, among them Cutimpu, Acora, Mollocahua and Paucar Tambo.

As we have already noted, the second stream, which acted as a source of inspiration to Inca architects, was that represented by the Chimús. While their rectangular compounds comprising storehouses, plazas and orthogonal complexes undoubtedly influenced the planning of similar Inca cities, we should not underestimate the role played in urban development by Huari with its walled towns built of stone, as opposed to the *adobe* used at Chanchán. A case in point is Pikillaqta near Cuzco, built by the Huari people, which must have inspired Inca towns such as Racchi (or San Pedro de Cacha) and the lowland complex of Ollantaytambo.

Generally speaking, where architecture and town planning are concerned, inherited forms would seem to have played a subordinate role by comparison with the Inca genius and to be less in evidence here than in the other arts. Hence it would seem pertinent to draw attention to the contributions made in this field by the Inca builders whose work is of considerable interest. The remains—in many cases little more than 500 years old—are both numerous and impressive. On some sites all the basic structures—enclosures, walls, doorways, niches, shrines and storehouses—have survived, though they no longer possess their thatched roofs whose frames have either rotted away or been consumed by fire.

In view of the great abundance of such remains which are found, not only in the highlands and in the neighbourhood of Cuzco but also in the coastal plains from Ecuador to the Chilean frontier, we have felt impelled to confine our discussion to the better preserved and more spectacular examples, which of themselves constitute an important assemblage.

Planning and the Monuments of Cuzco

It is fortunate for the historian that Cuzco, the capital of the Inca empire, should have possessed buildings so strongly constructed and so resistant to the frequent earthquakes that, wherever possible, the Conquistadors decided to preserve them. In the main, these are edifices which survived the Indians' civil wars, the conflagration of 1535 when the Incas attempted to recapture the city and, finally, the internecine strife among factions of the Spanish army during the first years of the occupation. Damage was mainly confined to roofs and coverings made of thatch. The survival of most of the walls has preserved the original plan despite modifications resulting from the parcelling out of land amongst the conquerors, or from changes of use or ownership. As examples we might cite

200 Gold figurine from Cuzco province. This superb piece, found in a tomb at Paucar Tambo in 1934, is one of a pair of identical female deities, one in gold, the other in silver. Height 24 cm. Museo Regional de Cuzco.

201 Silver goblet. Inca period. This large piece, a product of the Chimú craftsmen, is a good example of embossed portraiture. Height about 20 cm. Museo Oro del Peru.

202 A fine silver vase from the neighbourhood of Quito, Ecuador. Inca style. Within the meanders, heads alternate with flowers. The latter, known as *cantu*, are similar to those on the vessel in Plate 191. Height 18.5 cm. Museo del Banco Central, Quito.

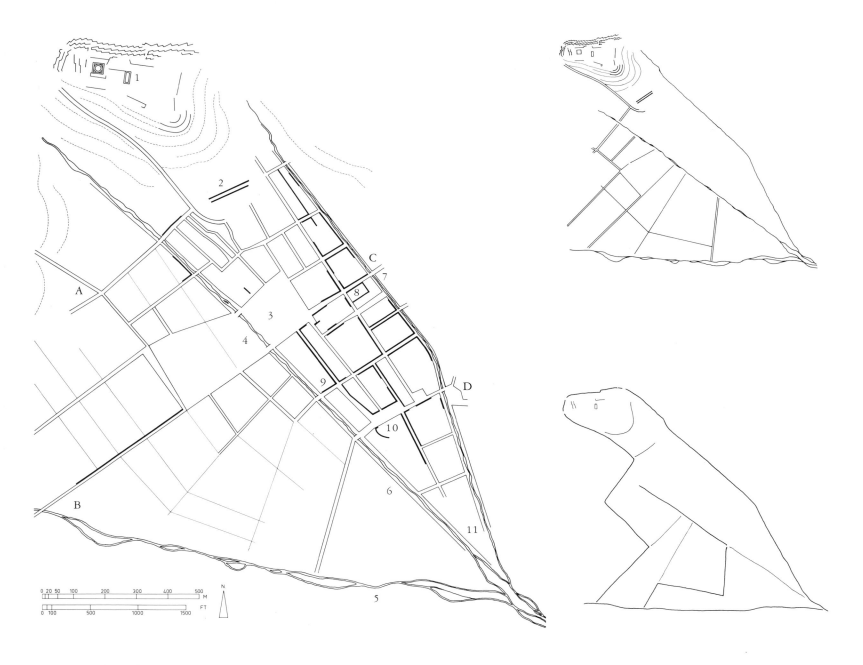

the insertion of Renaissance style doorways into an Inca structure, the
heightening of palaces and similar alterations.

While the secular buildings are largely unchanged, the same cannot,
alas, be said of the temples which have been drastically remodelled. In the
case of the Coricancha, dedicated to the cult of the Inca, and the great
sanctuary of the established religion, its conversion into a church and
convent called for a demolition programme which wrought havoc with
the site. Similarly, the material for the cathedral and many of the large
colonial churches was obtained from the buildings surmounting the great
fortress of Sacsahuamán, which were thus almost entirely destroyed.

Despite all this, enough has survived to allow us to reconstitute the
plan of the ancient city which was, after all, only sixty or seventy years
old at the time of the Conquest. For, on his return from his victorious
campagins in the mid-fifteenth century, Pachacuti embarked on a
thoroughgoing reconstruction of his capital. However his plan bears little
relation to that of the new towns erected on virgin ground in the con-
quered provinces. In the first place, Cuzco had been built on a relatively
irregular site encircled, in the north, by steep slopes and trisected by the
Huatanay (at the centre), the Tullumayo in the north-east and the Chun-
chul in the south, all of which converged in the Lower Town. In the

Plan of Cuzco
 1 Sacsahuamán
 2 Collcampata
 3 Haucaypata Plaza
 4 Cusipata Plaza
 5 Río Chunchul
 6 Río Huatanay
 7 Río Tullumayo
 8 Palace of the Inca Rocca
 9 Callejón de Loreto
10 Coricancha
11 Pumac Chupan (Puma's Tail)
The four roads leading to the four quar-
ters of the empire:
A Chinchasuyu road
B Contisuyu road
C Antisuyu road
D Collasuyu road
On the right, two sketches of the plan
of Cuzco, seen as the outline of a puma.

second place, it already contained a number of consecrated buildings whose sites had to be retained for religious reasons, so dictating the location of the larger sanctuaries.

Despite these reservations, it is apparent that Cuzco was built in accordance with a specific plan, for the town was divided into four quarters by two diagonals intersecting at the central plaza. One diagonal, on a north-west/south-east axis, followed the course of the Huatanay which had been straightened and embanked, while the other, on a south-west/north-east axis, corresponded to the thoroughfare that led respectively to Contisuyu and Antisuyu, two of the four imperial regions. The other two regions, Chinchasuyu and Collasuyu, were served by highways that started from the western and eastern fringes of the city. The great central plaza, divided into two parts by the Huatanay, consisted of the Haucaypata and the Cusipata. Today colonial buildings stand between them, surmounting the river now conducted underground. The four quarters of the town were precisely oriented and laid out roughly on a grid pattern. The most important were the Upper Town, Henan Cuzco, in the north and the Lower Town, Hurin Cuzco, in the east. The homes of the nobility, the palaces and principal sanctuaries were concentrated in these two areas.

The northern quarter terminated in the fortress of Sacsahuamán which dominated the whole town, a site no doubt selected by the Inca for his politico-military centre on account of its natural defences. Hence the layout of the complex, determined by the terrain, does not conform to the city's otherwise orthogonal plan to which, according to the Indian chroniclers and, more latterly, to John H. Rowe, it gave a strange configuration, namely that of a puma. Indeed, on careful scrutiny, the plan is found to resemble the general contours of the animal seen in profile, with Sacsahuamán for its head—a somewhat obvious symbol, since the fortress was itself the 'head' of the empire. The city's three rivers define the puma which is sitting on its haunches like the sculpted beasts of prey which keep watch outside some of the buildings at Huari.

The evident intention to assimilate the town with a totemic, tutelary animal inevitably calls to mind the Olmec city of San Lorenzo whose plan, as we pointed out in our book *Art of the Maya* (p. 29), resembles a jaguar's mask. We would add that at Cuzco this symbolism still survives in the name of one of its quarters, Pumac Chupan (puma's tail). On plan, this part of the town does in fact constitute the lower extremity of the animal, in that it occupies a narrow strip of ground bounded by the Tullumayo and Huatanay rivers, the former defining its back, the latter its belly, and both converging at the tip of the tail. Finally it will be seen that the Haucaypata plaza is situated at the very centre not only of the town but also of the animal. Hence its importance as a place of assembly on the occasion of feasts and rites—the throbbing heart, as it were, of the Inca nation.

The architectural style of the Incas took shape when Pachacuti, after a series of victorious campaigns against his neighbours, decided to rebuild the entire capital and thus make it a centre worthy of the empire he had created. The forms characteristic of Inca building would, it is true, already have been in existence. But since the conquering emperor demolished most of the earlier structures to replace them with others that still stand today, the whole conveys an impression of spontaneous generation. His action, however, has deprived us of the town's initial stage and hence of much that would have been of archaeological interest.

The main feature of the official architecture as represented by the Inca's palace, the temple and the accommodation for his administrators and guards is the fine masonry consisting of painstakingly dressed blocks laid without mortar. Most of the walls were given a pronounced batter. Openings such as doors and niches are trapezoidal and characterized by extreme sobriety, being innocent of mouldings or decoration save for a few relief designs—usually serpents or pumas—the purpose of which would seem to have been prophylactic rather than ornamental.

The Inca period, though of short duration, saw considerable advances in masonry. Initially this would seem to have consisted of large irregular polygonal blocks—a form of construction which, in fact, was never abandoned, as may be seen at Sacsahuamán where they are noteworthy on account of their careful fit and bold rustication. As time went on the blocks became progressively smaller and were laid in horizontal courses with rectangular joints. The masonry thus acquired a more regular appearance, retaining at most a low, rounded profile which in turn gave way to the smooth, uniform surface exemplified by the curved wall of the Coricancha, the great temple dedicated to the deified Inca.

It is surprising that, in an empire so vast, the main temple should be wanting in the monumental aspect presented by the Mochica pyramids or by huge structures such as Huaca Maranga near Lima, which covers an area of about 1,000 by 500 metres and rises to a height of some 50 metres. In Cuzco, if we except the Sacsahuamán fortress, there are no buildings of any great size, even the Coricancha being of modest proportions.

We are indebted for much of the following information to Graziano Gasparini and Luise Margolies, whose remarkable work on Inca architecture (*Inca Architecture,* Indiana University Press, Bloomington, 1980) considers the remains of the Coricancha in the light of excavations that were initiated six years after the severe earthquake of 1950. Restoration work and the use of probes have enabled us to gain a better idea of the organization of this assembly, many aspects of which, however, still remain obscure and have thus given rise to much conjecture as to its original state.

The sacred precinct was surrounded by a wall, part of which, curving towards the west, resembles on plan the bow of a ship (Pl. 176) and is said to have enclosed an *usnu* or sacrificial altar. Such *usnus,* also known as *subarauras* after the name given to them by Polo de Ondegardo, have often been mistaken for thrones or gnomons. To the Incas it was the holy of holies—the place, according to certain chroniclers, 'where the Sun is tied' *(Intihuatana).* As we shall see, no astronomical significance attaches to this connection with the sun as has sometimes been supposed. Rather it had magico-religious connotations related to sacrifice, which is known to establish a sort of bond between the deity and his worshippers. After the Conquest the Spaniards thought fit to put the stamp of Christianity upon this very holy place. Hence, the altar of the church of Santo Domingo, dedicated to Our Lady of the Rosary, was built directly above it, thus betokening the defeat of idolatry.

Most of the components of the Coricancha are still in existence today, having been preserved during the building of the cloister in the sixteenth century. They comprise four rectangular structures, two of which stand on the west side and two on the east side of a quadrangle 35 metres square. With their doors, sloping walls, trapezoidal Inca-style niches and

203 On the high plateaux of the Titicaca basin, the *chullpas* of Sillustani stand beside a magnificent lake. These funerary towers are faced with fine masonry consisting of large, perfectly squared off blocks laid without mortar. *Fardos* were housed in chambers within the buildings. While *chullpas* were probably in existence prior to the Inca conquest in the thirteenth century, the techniques used in their construction were not perfected until the imperial era.

204 On a promontory close to the *chullpas* at Sillustani are circles of standing stones, probably associated with funerary rites and with the rising of the sun on particular dates, as, presumably, were the *chullpas* themselves, since they possess small 'cat-doors' facing east.

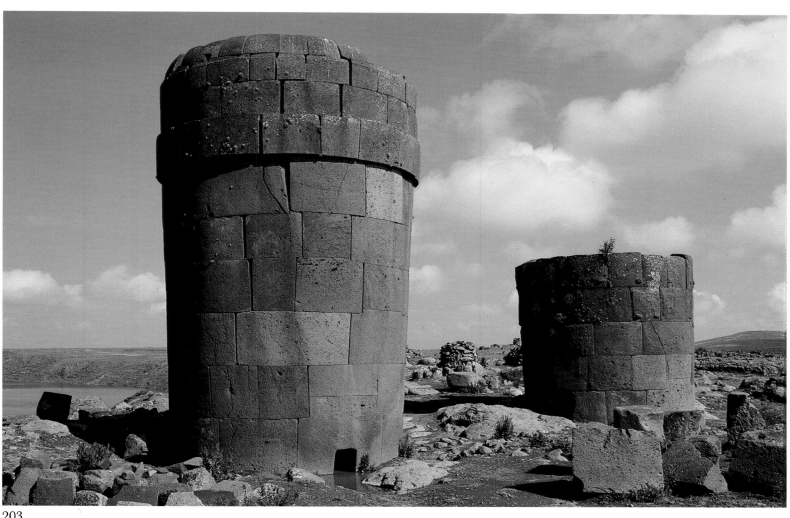

203

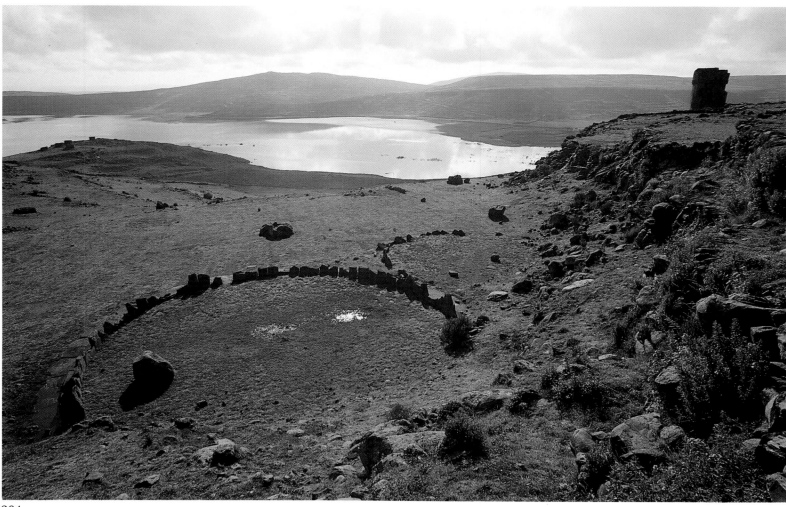

204

fine masonry laid in regular courses, these four halls combine to produce an effect of perfect symmetry. Between the entrance doors of the largest and best-preserved building, which has a floor area of 13 by 8 metres, there is a niche believed to have been the tabernacle of the temple. Its walls, according to the chroniclers, were adorned with gold plates and precious stones, as would seem to be borne out by the holes which could have served to secure these embellishments (Pl. 177). The similar building on the opposite side of the quadrangle may also have possessed such a niche and if, as has been suggested, the two tabernacles were dedicated to the Sun *(Inti)* and Moon *(Quilla)*, the second niche would have been decorated with silver plates.

In addition, the Corincancha served as a pantheon and mausoleum for the Inca emperors. Their enthroned mummies, wrapped in rich *fardos*, doubtless occupied the above-mentioned halls in accordance with an imperial cult which, though deriving directly from Chanchán, must have had very much earlier roots.

Carved out of the rock at the foot of the curved wall is a cistern with a series of basins (Pl. 178) dedicated to the deity of spring water, a place of ritual purification that might well have formed part of the Golden Enclosure, the description of which by Garcilaso faintly echoes a similar passage in Bernal Diaz's account of Tenochtitlán.

As a result of the drastic alterations carried out in Cuzco after the Conquest, it is virtually impossible to determine what were the internal arrangements and spatial organization of such of the Inca's many palaces and administrative buildings as still survive. The ancient palace of the Inca Rocca, possibly dating from the late fourteenth or early fifteenth century and not, apparently tampered with by Pachacuti, is noteworthy on account of its fine polygonal masonry (Pls. 171, 172). Tradition has it that the Inca Rocca was the founder of the dynastic branch which sprang from the Upper Town, Henan Cuzco, as opposed to the branch from the Lower Town, Hurin Cuzco.

The wall of the Collcampata, another pre-Pachacuti structure, is situated further up the slope, half-way between the town and Sacsahuamán. If, as supposed, this formed part of the palace of the mythological Manco Capac, it would have been built at the beginning of the thirteenth century (Pl. 175). The wall, 90 metres long and 4 metres high, supports a terrace and is reinforced by eight blind doors with double jambs. Its eroded condition bears out the view that it is an archaic structure of much earlier date than the buildings on the platform where the last Inca, Manco II, is believed to have lived before he rebelled against Spanish colonial rule. It was a case of history repeating itself—the return of the last of the Incas to the palace built by the founder of his line.

We must now turn to the puma's head, that is to say Sacsahuamán whose triple wall forms the northern boundary of the city above which the fortress rises. This impenetrable barrier, 410 metres long, is preceded by a huge expanse not unlike a glacis. The other three sides of the great esplanade of 2.5 hectares are flanked by natural ravines whose defensive qualities were enhanced by walls. Nothing is left of the buildings which once stood here—the palaces, their administrative and military dependencies and, perhaps, a small temple—save for the foundations. Of especial interest are those of a structure known as Muyumarca, a tower or keep, some 30 metres in diameter with three concentric walls, which may have been the residence of the Inca.

Aerial view of Sacsahuamán. On the left, the three zigzag walls, on the right, remains of the buildings, notably the tower with concentric walls.

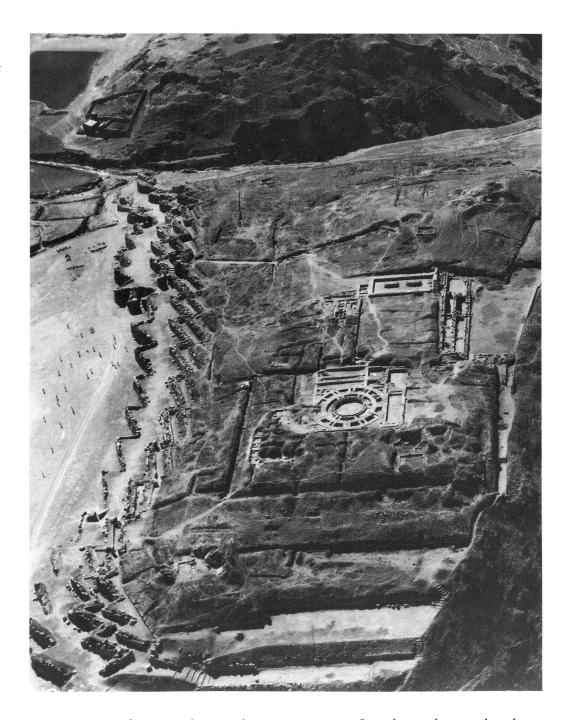

However, the most impressive structures at Sacsahuamán are the three walls, on plan like rows of saw-teeth, which rise in receding stages so ingeniously designed that each terrace covers the one below to constitute a redoubtable defensive work. The asymmetrical 'teeth' slant in a west-east direction and are superimposed in strict order. The first wall, which is constructed of the largest blocks and supports the widest terrace, has twenty-one salients as against nineteen and eighteen respectively in the case of the other two. The latter run roughly parallel and are separated by no more than a narrow ledge. Seen from the front the three serrated tiers of this formidable structure, which rises at an angle of 45°, recall the scales in a suit of armour (Pl. 181).

According to the chroniclers, the work was begun by Pachacuti in the fifteenth century, but that great captain never lived to see its completion some fifty years later. It is said to have required the labours of 20,000 men, while the stone, obtained from near by quarries, was worked on the site. The final stages were directed by Huayna Capac (1493-1525), only a few decades before the arrival of the Conquistadors.

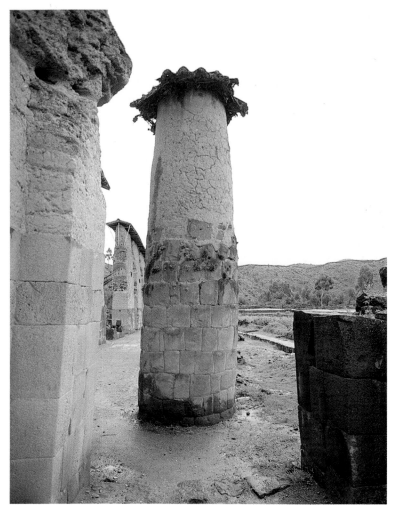

205

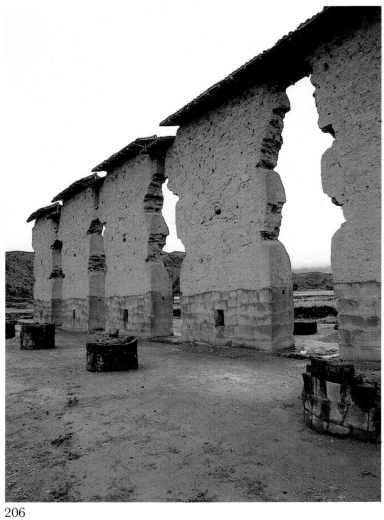

206

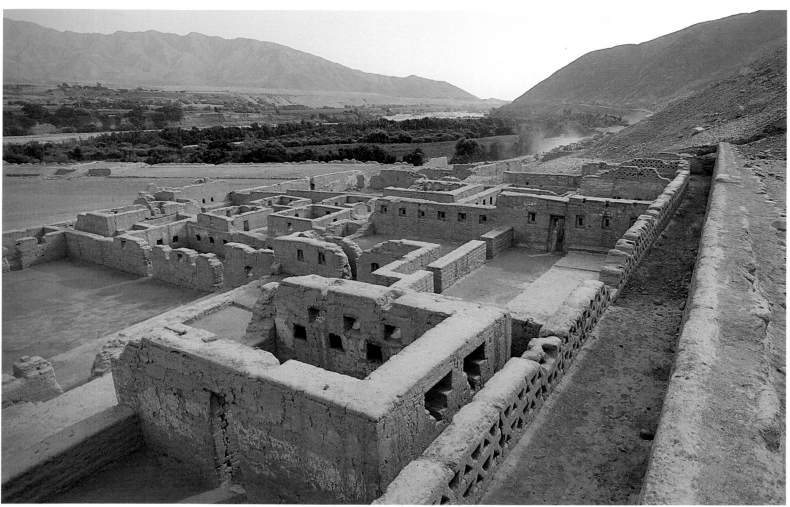

207

Nothing remains of the superstructure save a few ruinous foundations, for the dressed stone was removed by the Spaniards who used it to build their churches and, in particular, Cuzco cathedral. But the complex on the rocky backbone of Sacsahuamán undoubtedly harboured the 'brains' of the empire. Nor was it a fortress so much as a centre of government, an administrative hub. Its powerful fortifications were perhaps more symbolical than functional, for it was necessary that the place from which the Inca issued orders to all his subject peoples should be invested with a majesty commensurate with its importance. Had defence been the main object, then surely the south face of the assembly, precipitous though it was, would also have received zigzag walls, if only to prevent its being scaled by rebels in the event of an uprising in Cuzco.

When Cieza de León speaks of the House of the Sun, he simply means the residence of the Inca, Son of the Sun. He goes on to say that Sacsahuamán served the combined function of palace, storehouse, temple and fortress, which implies a variety of other uses. Nevertheless, the zigzag wall is a military structure, another example of which may be seen above the Puma Marca assembly overlooking Ollantaytambo, where the walls encircle a natural eminence. Only one ring, however, is given salients, these being restricted to the northern side as at Sacsahuamán.

Though performing a religious function in that it served the cult of the Inca, Sacsahuamán was not for all that a temple. To reach the sacrificial altar or *usnu,* the visitor must first cross the open space or glacis which abuts the walls, and then climb up amongst the rocks. Here he will find an eminence so carved as to form a double range of receding stages, one lower than, but parallel to, the other. At right angles to these, and giving a access to them, is a small and much eroded stairway. Known as the Throne of the Inca (Pl. 180), this *usnu* was the outdoor shrine where, by tradition, the priests sacrificed the white llama to the tutelary gods of the empire and its master.

As we shall see, *usnus* are invariably located on sites that have a commanding position or possess a cave, a spring or a geological or other natural feature of unusual shape. In the case of the Throne of the Inca, the priests were doubtless attracted by the pleasing undulations of volcanic rock known as El Rodadero and by the view that was afforded of Sacsahuamán below. Elsewhere, as at Sayhuite, the rocks are strongly eroded or, as in the Pachamama Temple at Machu Picchu, piled in chaotic heaps. Thus nature was the decisive factor in establishing the position of a place of worship. Many of them must have disappeared, especially those associated with vegetation, sacred trees or springs.

Kenco, near Sacsahuamán, is a magnificent example of a natural sanctuary. Here, amongst a group of fissured rocks a cave was converted into a place of sacrifice by the Inca architects and sculptors who kept their alterations as unobtrusive as possible. The cave, a shrine of the chthonic type, is complemented by an open-air temple, probably dedicated to the sun, and known as the amphitheatre. At its centre stands an object of worship in the shape of a rock (Pls. 182, 183).

In all cases human intervention was kept to a minimum and consisted at most in carving a rudimentary altar, making gutters to carry away the blood of sacrificial victims and fashioning steps or stairways which conformed as closely as possible to the natural rock formations. Too little attention has hitherto been paid to this aspect of the religious sculpture of the Incas. Yet it is of fundamental importance, for it constitutes the

205, 206 Ruins of the great temple of Viracocha at San Pedro de Cacha near Racchi on the Cuzco–Puno road. Lying at an altitude of 3,500 metres, this vast assembly, once an important religious military and economic centre, is disposed about a massive party wall 12.5 m high. The base which rises to a height of 2.5 m is built of fine masonry; the upper portion is an *adobe* construction. On either side of the wall is a row of eleven cylindrical columns, also with a stone base. Once 6.5 m high, they probably supported a ridged roof. The temple was 91 m long and 25 m wide.

207 The ruins of Tambo Colorado lie 60 km up the valley from Pisco, in the coastal plains of south Peru. This fortified Inca city contained not only courts surrounded by houses and barracks built of adobe, but also a post-house and storehouses. The whole was enclosed within a wall and acted as a blockhouse on the road along the Río Pisco. Said to have been founded by the Inca Pachacuti, its name derives from a few remaining traces of red and ochre colouring.

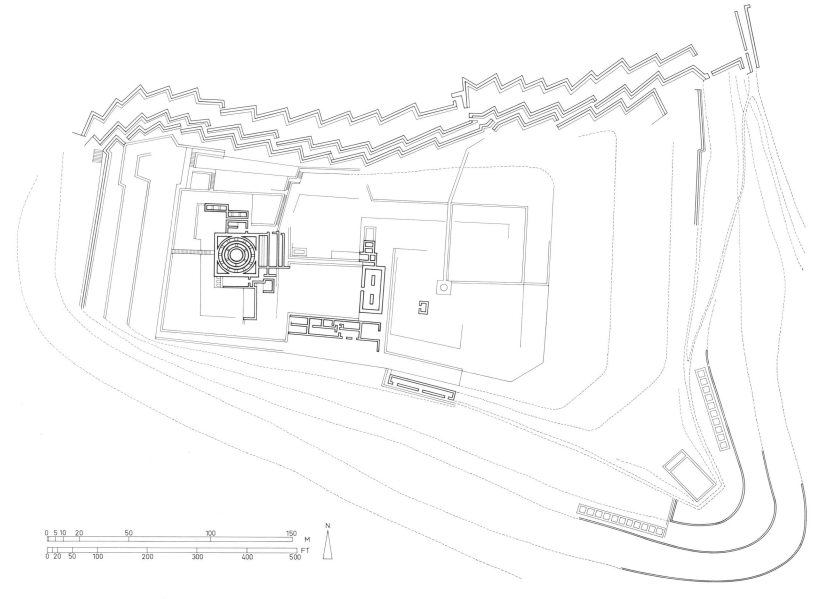

essence of that people's religious art, of which the most striking character-
istic is the endeavour to approximate the work of man as closely as
possible to the work of nature. The underlying concept is one which
today would be described as ecological, and is common to the religions
of many other civilizations, among them those of the Celts, the Gauls,
the ancient Greeks, the Hittites and even the Shintoists of Japan.

Natural springs, such as the one already cited in the case of the Cori-
cancha, played a major role in the 'pantheism' of the Incas. Not far from
Cuzco was another such shrine, the Tambomachay or Bath of the Inca,
used for ritual ablutions. The waters of this particular spring are hot,
owing to the volcanic activity that prevails in the region. The organiz-
ation of the site with its low, stepped retaining walls and its cisterns and
basins carved out of the living rock, reveals the skill of the Inca builders
in blending architecture with its surroundings (Pls. 184-6).

The City of Pisac: Eagle's Nest

The Pisac of today is a settlement lying at an altitude of 2,970 metres on
the floor of the fertile Vilcanota valley—the Sacred Valley of the Incas.
Above it, on a rocky spur jutting out across the valley, stands the ancient
city of that name. It is built on mountain ledges, interspersed with dizzy

General plan of the fortress of Sacsahua-
mán, which commanded the city of
Cuzco.

precipices, some as much as 3,300 metres high, and commands the surrounding country-side like an eagle's eyrie. At the foot of the eastern escarpment runs the Río Riachuelo Chongo, while the western side is flanked by the Quebrada del Kitamayu. Thus on three of its sides the spur possesses natural defences in the shape of precipices, while at strategic points, where mountain paths enter the inhabited areas, the defences are backed up by walls, outposts and fortified gates. Cultivated terraces supported by retaining walls alternate over a distance of several kilometres with habitations built on the saddle or on one of the few pieces of relatively level ground.

The *andenes* or terraces which follow the contours of the mountain slopes present an impressive spectacle. Many of them retain their old names—for example, Acchapata, Pacchayoc, Huanuhuanupata, Huinin, and Amaru Punku (Pl. 187). Each of the scattered compounds—for instance Pisaqa, Henan Pisac or Quanchisraqay, would seem to have had a specific function. They are linked by narrow tracks and, in one case, by a tunnel where the gradient is too steep to be climbed. Besides the Corihuairachina, a group of storehouses near the southernmost *andenes,* we might also cite the burial-ground known as the Antachaka and Tanta Marka necropolises. These were relegated to the far bank of the Quebrada del Kitamayu where the whole cliff is honeycombed with cells which must have once contained mummy bundles.

At Pisac, then, we encounter the remains of an entire city—dwellings, storehouses, fortifications, tombs and, last but not least, the superb temple complex known as the *Intihuatana* (Pl. 188). The doors and niches of these rectangular buildings are of the classic trapezoidal type like those of the Coricancha at Cuzco, though here built in beautiful rose-coloured stone (Pl. 190). At the centre of the assembly is the *Intihuatana* proper, a sacrificial rock, or *usnu* enclosed by a semicircular wall. Often described as a gnomon, the *usnu* was in fact no more than an altar upon which llamas were offered up in sacrifice to the sun (Pl. 189).

The spectacular nature of Pisac—abandoned immediately after the Conquest—lies, not only in its buildings which are remarkably well preserved, but also in its panoramic views. Save for Machu Picchu, there is probably no more beautiful Inca site.

The Lost City: Machu Picchu

The first reference to the magnificent assembly of Inca remains known as Machu Picchu was made in 1848 by a monk who had got wind of the place in the course of his peregrinations; we next hear of it in 1879, when a French explorer, Charles Wiener, attempted but failed to get there. In 1911, however, the town was opened up for archaeologists by an American, Hiram Bingham, at the head of a full-scale expedition.

After the execution in 1572 of Tupac Amaru, the last great Inca leader, and the suppression of his following, Machu Picchu was almost certainly abandoned as a ceremonial centre, just as Ollantaytambo had been thirty-three years previously, after the retreat of the Manco Inca. The reduced and demoralized population, having been witness to the greed of the Spaniards, would then have proceeded to strip the place of valuables such as gold sheathing, and at the same time, to abstract the more important *fardos.*

Huayna Picchu is a rocky eminence on which Machu Picchu is perched at an altitude of 2,430 metres. Its sugar-loaf summit soars, like a formidable watch-tower, above the north side of the town, while its foot, 200 metres below, is encircled on both east and west by the tumultuous Río Urubamba. The impenetrable jungle, through which the river has carved a gorge, like the precipitous cliffs that rise from its banks, have helped to isolate the town which could only be reached by the ancient Inca Trail. Starting at Ollantaytambo, 55 kilometres away, this ran through the mountains, punctuated at intervals by villages and post-houses, to end—within view of Machu Picchu—at a fortified gate guarding the last *col.* The town is entered through a group of seven dwellings beyond which are some magnificent *andenes,* whose once rich soil must have yielded two or three crops a year. The construction of the retaining walls represents a fantastic feat of land reclamation which testifies to the extraordinary tenacity of the Inca people, and to their determination to survive in what was a hostile and previously barren environment.

Behind the terraces, on a slope of nearly 45°, the densely packed houses descend in stages from the saddle to the very edge of the precipice. A stairway runs straight upwards alongside the stone edifices which are built without mortar and are intact save for their hipped or saddle-backed thatched roofs. At the centre of the first enclosure stands a curious structure known as the Torreón, built over a natural cave. This low semi-circular tower, constructed of fine masonry, rises above a fault in the rock and was dubbed by Bingham Royal Tomb (Pls. 215, 217). We need hardly add that names such as Royal Tomb, Jail Compound and Solar Calendar are figment rather than fact. Here we find the same dual symbolism as at Kenco, for the Torreón, itself an *usnu,* is built above a chthonic shrine. The cavern has been left in its natural state save for the modification of the rock to form a sacrificial altar akin to the 'gnomon' in the *Intihuatana* above it. The similarity of form clearly demonstrates that these supposed 'gnomons' had nothing whatever to do with astronomy. Rather, the upright portion would seem to have been fashioned in such a way as to support the neck of the llama offered up in sacrifice to the sun.

It is interesting to note that, here, as at Kenco, an open-air shrine is superimposed over a cave serving a chthonic cult, thus symbolizing in tangible form the marriage of sky, earth and underworld. All three share the same axis and are bound together by the serpent Amaru, the quintessential earth deity. It is here that the diurnal and the nocturnal suns of Indian mythology meet, hence the analogy between the two *Intihuatanas,* one subterranean, the other above ground and pointing towards the sky.

Through the Torreón runs the Stairway of the Fountains, a series of basins carved out of the rock and so positioned as to break the force of the water that flows down the slope after the almost daily tropical rainstorms. Each basin produces a different musical splashing—working with nature to create something beautifully mystical. Below that compound lies another complex known as the Jail. Here we again encounter a cave, barely touched by the hand of man and giving on to a plaza used, no doubt, on ritual occasions.

Above this assembly, and slightly to the north of it, is a small, square court surrounded on three sides by the great temples which stand out by reason of their impeccably dressed and fitted polygonal masonry. The three windows of the central edifice on the cliff edge to the east of the court give on to a grandiose landscape with the steep-sided gorge of the

In the cave beneath the Torreón at Machu Picchu is a rock carved in a manner similar to the Intihuatana (Pl. 219), to serve as a sacrificial altar.

208, 209 Oracular centre, Pachacámac, probably dating from the reign of the Inca Tupac Yupanqui (1471-93). The complex, which lies on a coastal promontory some 30 miles from Lima, experienced its apogee during the Inca period. As restored by Julio Tello, it comprises not only the Temple of the Moon, but also the House of the Virgins of the Sun, or Mamaconas. Classic features typical of Inca architecture are the trapezoidal niches with double jambs and walls with a dressed stone base and adobe superstructure.

210 Reputed to be the second most important Inca sanctuary, the ruins of the great Temple of Pachacámac crown a vast adobe pyramid which towers above the Pacific and its many offshore islands. According to the chroniclers, the temple, dedicated to the sun, once contained a chamber walled with gold in which the idol was kept.

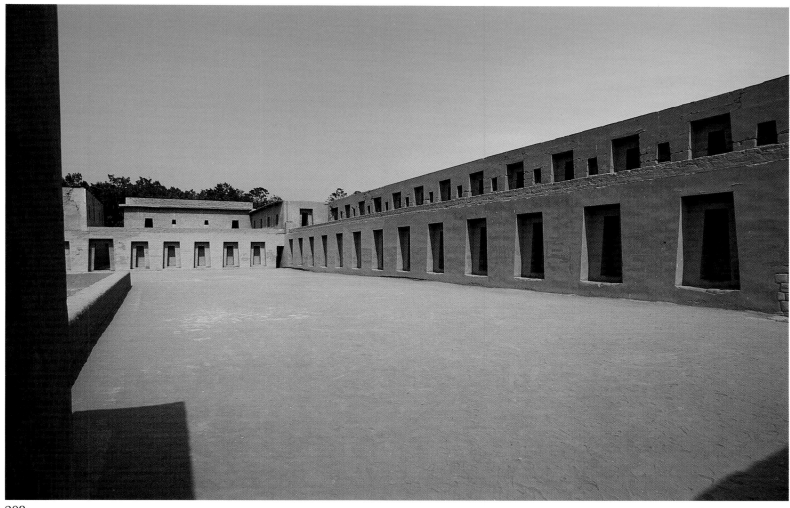

208

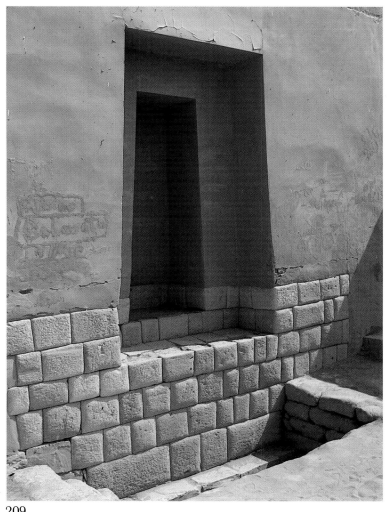

209

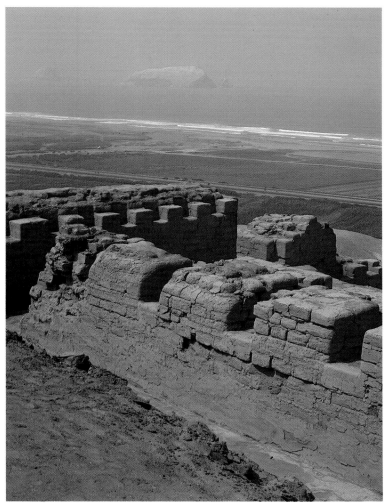

210

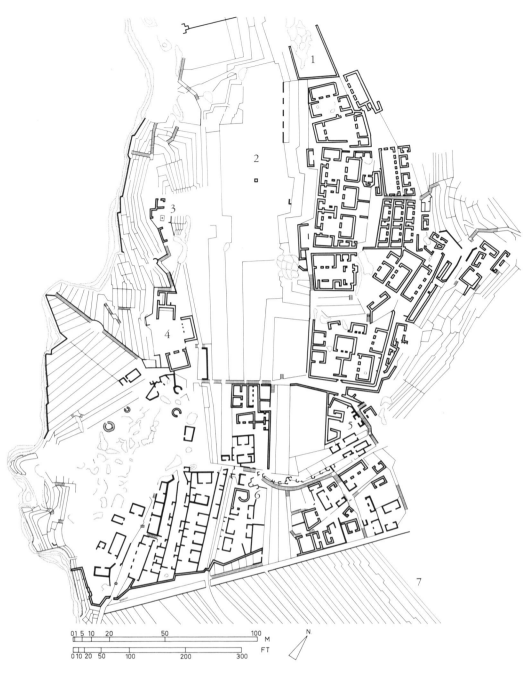

General plan of Machu Picchu:
1 Temple of Pachamama
2 Great Plaza
3 Intihuatana
4 Temple Compound
5 Jail Compound
6 Torreón and the so-called
 Cave of the Royal Tomb
7 *Andenes*

Urubamba below and, beyond, the great amphitheatre of mountains. In place of a front wall, this building has a pier which originally supported one section of the no longer extant roof. Part of one of the other walls consists of the natural granite, another instance of the Inca architects' recourse to nature as a medium.

If we continue up the saddle in a north-westerly direction, we reach the crowning feature of the city, the *Intihuatana* with its carved rock rising out of the ground. In modifying the natural forms of this finger of rock—some of whose planes have been left untouched—so as to give it the aspect of a sacrificial altar, the Incas have produced a magnificent piece of abstract sculpture. That this was no solar calendar is evident if only from its size, for it is much too low to cast a shadow that could be read with any accuracy, and not nearly wide enough to provide a sighting-line along one of its faces. Whatever the case, the fact that such a place was chosen for this shrine, dedicated to the pantheistic Inca religion, demonstrates yet again that people's feeling for the beauties of nature (Pl. 219).

On the far side of the plaza, which divides the north part of the city into two, is a complex of houses above which is a curious platform

enclosed by a wall of polygonal masonry. No buildings are to be seen within the wall but merely a heap of granite blocks above which rises a tall standing stone, again as at Kenco. This enclosure, known as the Pachamama Temple, is a typical Inca shrine dedicated to the forces of nature.

Thus, the tendency of the Incas to consecrate natural sites is evident throughout the town—in the cave known as the Moon Temple at the foot of the Huayna Picchu, in the altar above the Mirador, commanding the whole assembly, and, in fact, wherever the natural rock has been modified and summarily carved in such a way as to evoke a pantheist cult. This trait emerges with exceptional clarity at Machu Picchu, for elsewhere it has often been obscured by the construction of chapels which, it was hoped, would exorcize the cosmic powers and turn a pagan shrine into a Christian place of worship.

From the above brief reappraisal of the evidence it is apparent that the Inca religion was a good deal less alien and barbaric than the chroniclers would have us believe. Ignorant as they were of ethnography and mythology, the Spaniards were incapable of drawing a parallel between the religious practices of the Incas and the cults of Gaul and ancient Greece, and hence failed to see any connection between these various forms of pantheism. Our own analysis suggests a people close to nature who venerated the cosmic forces and whose idols, so abhorrent to the missionaries, seem to us not so much cruel and inhuman as comparable to, say,

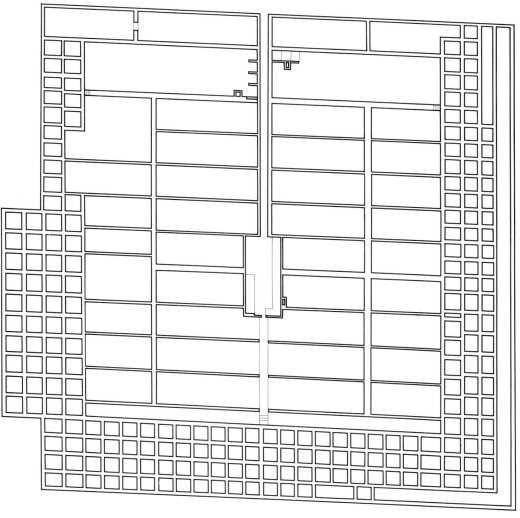

Plan of storehouses and silos at Inca-huasi. The latter were used for storing grain.

213

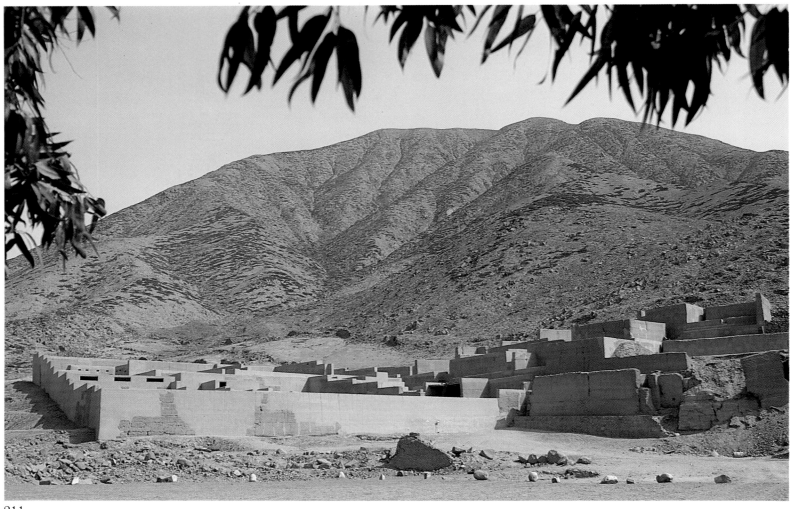

211

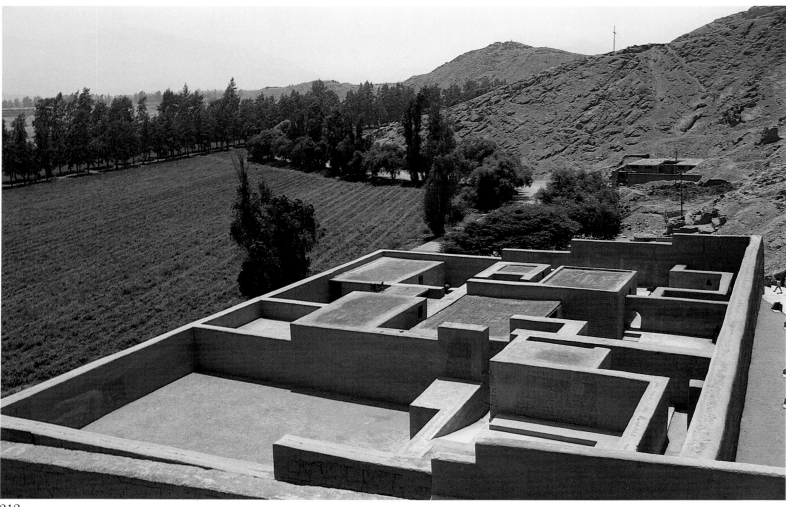

212

Plan and reconstruction of transverse section of the Temple of Viracocha at Racchi, after Gasperini and Margolies.

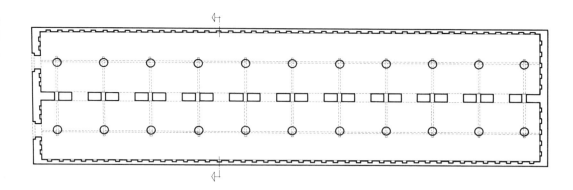

the Roman and Etruscan Lares. Moeover, as we have already seen, ancestor worship also played a most important role.

In fact, in the Inca world, almost any object or place might be consecrated and partake of divinity, whereupon it became a *huaca*, an object of profound pantheistic veneration.

Machu Picchu also enables us to gain a better idea of the domestic architecture of the time. Its building was begun by Pachacuti (1438-71) and probably completed by his son Tupac Yupanqui (1471-93). Round the shrines is a large variety of stone edifices built, as we have seen, without mortar. The no longer extant roofs would have been either hipped, in houses on a square plan, or saddle-backed in those on a rectangular plan. In some cases a party wall runs the length of the building, dividing it in two and acting as a support for the ridge beam. Houses are also disposed in terraces, or in groups of four round a court. They may be open at the front.

Another type, encountered for instance at Huánuco Pampa or Inkallakta, is the large communal building known as a *kallanka* with wooden posts which once supported a saddleback roof. At Inkallakta, the edifice is 78 metres long by 25 metres wide, and is divided into four aisles by three rows of posts.

Other Types of Building

Near the village of San Pedro de Cacha, 120 kilometres from Cuzco on the Puno road, lie the ruins of the great temple of Viracocha, an edifice of a most unusual kind, surrounded by a wall nearly 6 kilometres long, most of which is still standing. The temple is flanked by rows of habitations and by huge store-rooms in the form of silos. Of this gigantic, four-aisled edifice, whose hall 91 metres long and 25 metres wide has a floor area of 2,300 square metres, nothing now remains but the 12-metre high party walls on the long axis, and the two rows of cylindrical columns 6.5 metres high.

A peculiarity of this highland architecture is the use of dressed stone in conjunction with adobe, the latter forming the upper part of the wall (Pls. 205, 206). The same type of construction is found on the coast in the oracular sanctuary of Pachacámac with its huge pyramid rising up

211 Huaycan Tambo near Lima, recently restored, was an Inca posting-station similar to Tambo Colorado and must once have contained the palace of a senior government official, or *curaca,* a number of storehouses and a fortress guarded by a powerful enclosure wall built of adobe. It lies at the foot of a rocky hill-side on the edge of a fertile plain.

212 Inca palace at Puruchuco, in the Rimac valley near Lima. Restored some thirty years ago, the complex is very sober and modern-looking, with flat-roofed houses and halls, neatly disposed round courts and connected by a complex system of ramps and passage-ways. The whole is surrounded by a wall some 5 or 7 metres high and stands at the foot of a hill, well clear of cultivated ground.

215

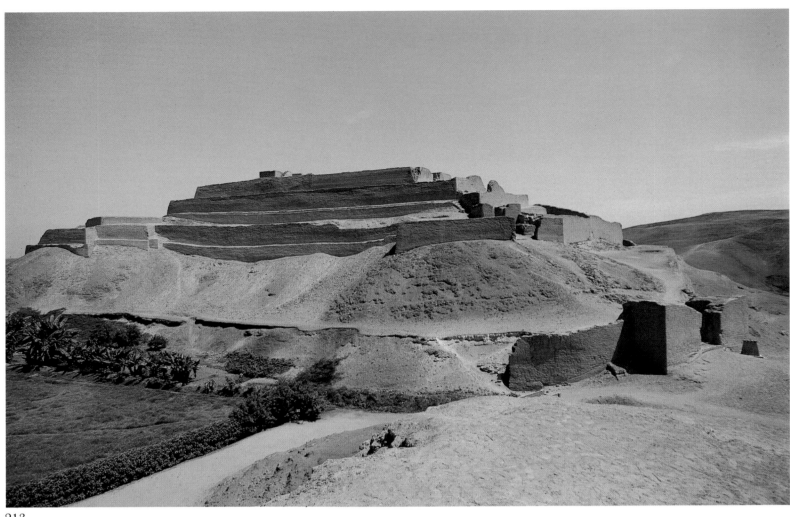

213

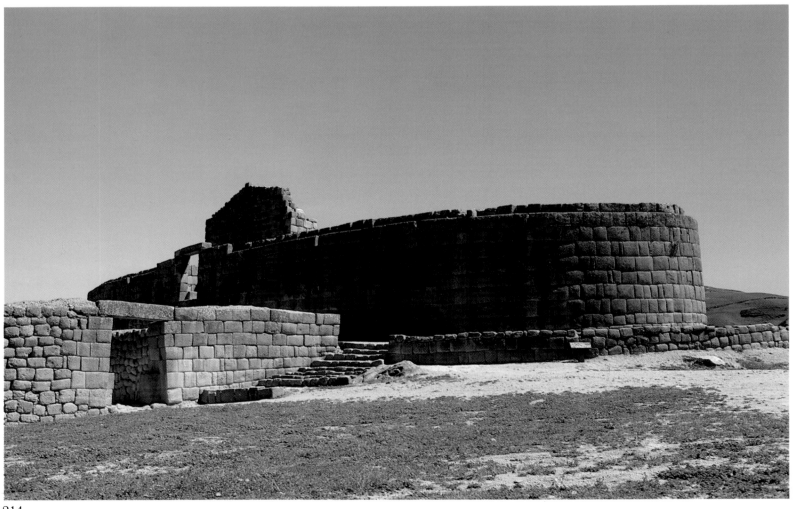

214

Plan of Tambo Colorado. On the slope north of the city is the post-house proper, within a square enclosure.

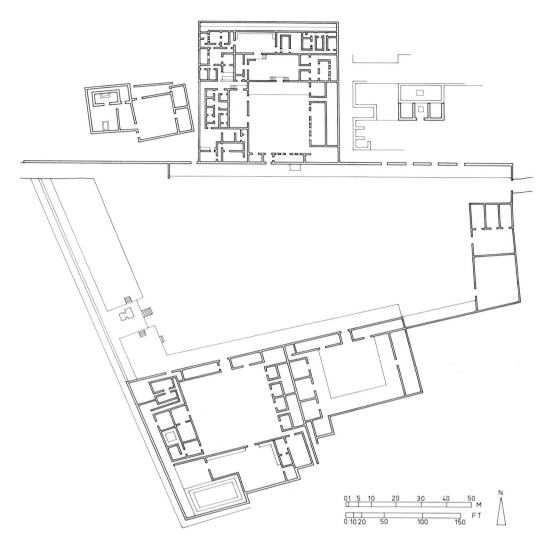

213 The formidable complex of Paramonga, which commands the Río Pativilca on the southern border of the Chimú empire. Opinion is divided as to whether it was a fortress or a temple. Both schools are doubtless right for, during the Chimú period, the edifice with its rows of walls and single access gate was probably intended to bar the coast road to an invading army. After the Inca conquest, however, the complex on its elevated site was given a sanctuary.

214 The Inca complex at Ingapirca, which lies at an altitude of 3,200 metres at the heart of the Cañari country in Ecuador, would also seem to have fulfilled a dual purpose. Here, in hostile territory, in the far north of the Inca empire near the second capital founded either at Cuenca or at Quito—the sources are contradictory—by Huayna Capac, it doubtless combined the functions of fortress and temple. The central structure, oval on plan, which overlooks the houses and ancillary sanctuaries, is an unusual example of Inca architecture. Measuring 35 metres by about 12 metres, it is surrounded by a wall of fine masonry. On the south side a single door gives access to two stairs serving two sanctuaries built back to back.

from the Pacific shore. Though this building dates from well before the Inca period, it received some important additions after incorporation into the empire, notably the House of the Virgins, of which the walls are built of small stone blocks with an adobe superstructure and typical trapezoidal doors and niches (Pls. 208-10).

The astonishing Inca road network would not have been feasible without the post-house, or *tambo,* system. As often as not the *tambo* also served as a residence for the *curaca,* an official whose duties comprised the administration of conquered territory and the organization of the *mita.* As an example we might cite the Tambo Colorado, a large assembly in the Pisco valley. Though wholly built of adobe, it remains in a remarkably good state of preservation (Pl. 207). The architect of the Huaycan Tambo, which lies at the foot of a hill near Lima, judiciously exploited the sloping site by terracing his buildings so as not to encroach on the adjoining agricultural land. The complex is surrounded by a high defensive wall, from which it may be inferred that a garrison was also stationed there (Pl. 211).

Also near Lima, at Puruchuco in the Rimac valley, is a remarkably well-restored villa (in the Roman sense of the term) which enables us to picture the life of a *curaca.* Here, fine halls are disposed about open spaces in the form of courts linked by level or inclined passage-ways. Much of the activity evidently took place outdoors under cloth canopies affording protection against the sun. The heavily fortified entrance in the enclosure wall leaves the visitor in no doubt as to the importance of the personage who lived in this superb dwelling (Pl. 212).

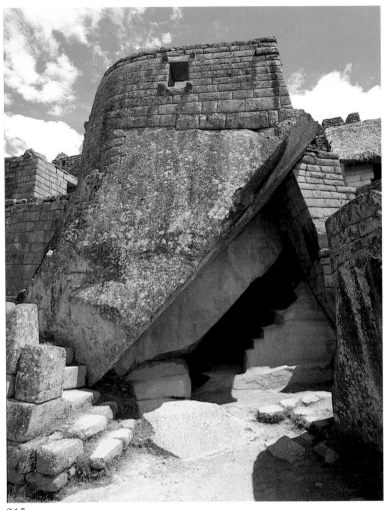

215

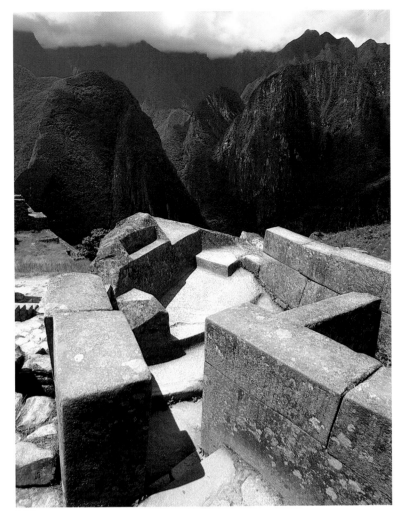

216

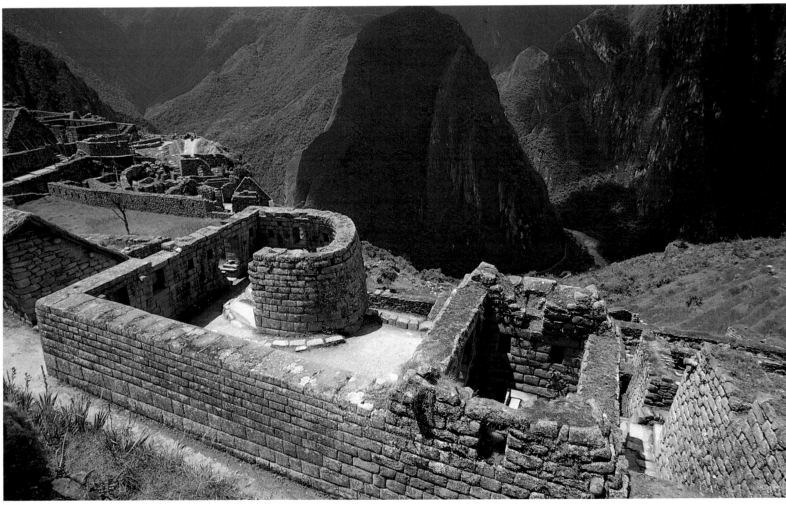

217

Plan of the palace at Puruchuco in the Rimac Valley near Lima.

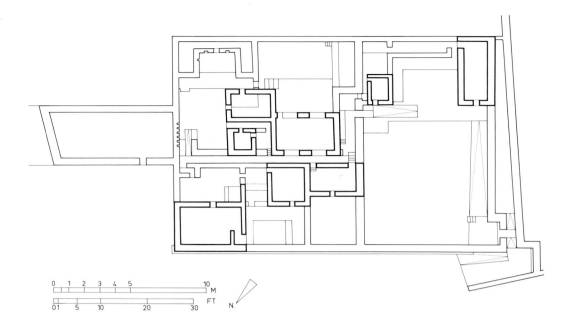

Below: Plan of the temple-fortress Ingapirca (Ecuador) with its twin sanctuaries dominating the oval esplanade.

215 At the centre of Machu Picchu the tower or Torreón stands above a natural rock cave, parts of which have been modified by carving. Dubbed, for reasons unknown, the 'Royal Tomb', it reflects the Incas' interest in the curiously shaped natural features they selected for their places of worship and sacrifice. Inside the cave a rock has been transformed into a sacrificial stone similar to the Intihuatana shown in Plate 219.

216 View from above of the valley of the Urubamba. The river flows round the foot of the saddle on which the remains of Machu Picchu stand. In the foreground, blocks of carved stone form an *usnu* akin to the 'Throne of the Incas'.

217 The Torreón at Machu Picchu, a horse-shoe shaped wall with trapezoidal niches, encloses another group of carved rocks constituting an *usnu*. Here again the Inca builders have joined forces with nature to produce a shrine. The building of the city is said to have been begun by the Inca Pachacuti in the mid-fifteenth century and to have been completed by his son, Tupac Yupanqui.

We shall conclude our discussion of Inca architecture with a few, all too brief, remarks on two structures of complementary type, namely the temple-fortresses of Paramonga and Ingapirca. The first, by the Río Pativilca, on the southern border of the kingdom of Chimor, may have served as a blockhouse on the coastal highway. We known that after the defeat of the Chimús, this strategic site was converted into a sanctuary and given a crowning pyramid with a superstructure of unbaked brick. Entrance could only be effected by posterns on the south side of the complex—a somewhat curious arrangement in a fortification intended to withstand attack from that direction. The posterns and the adobe construction of Paramonga are only two of several aspects in which it bears a resemblance to Pachacámac (Pl. 213).

Ingapirca is in Ecuador, north of Cuenca. Once known as Tumibamba, it is said by some to have been a second imperial capital founded by the Inca Huayna Capac (1493–1525). The complex is even more remarkable than Paramonga for here, 1,600 kilometres from Cuzco, the builders resorted to classic Inca masonry, with slightly rusticated blocks laid in

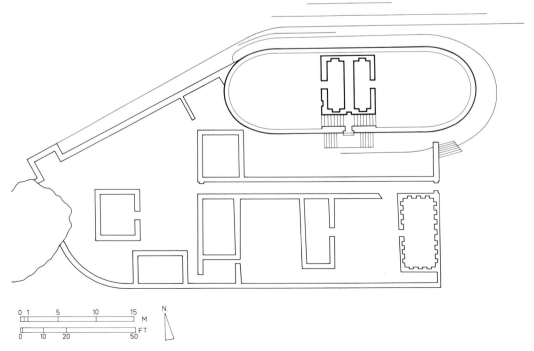

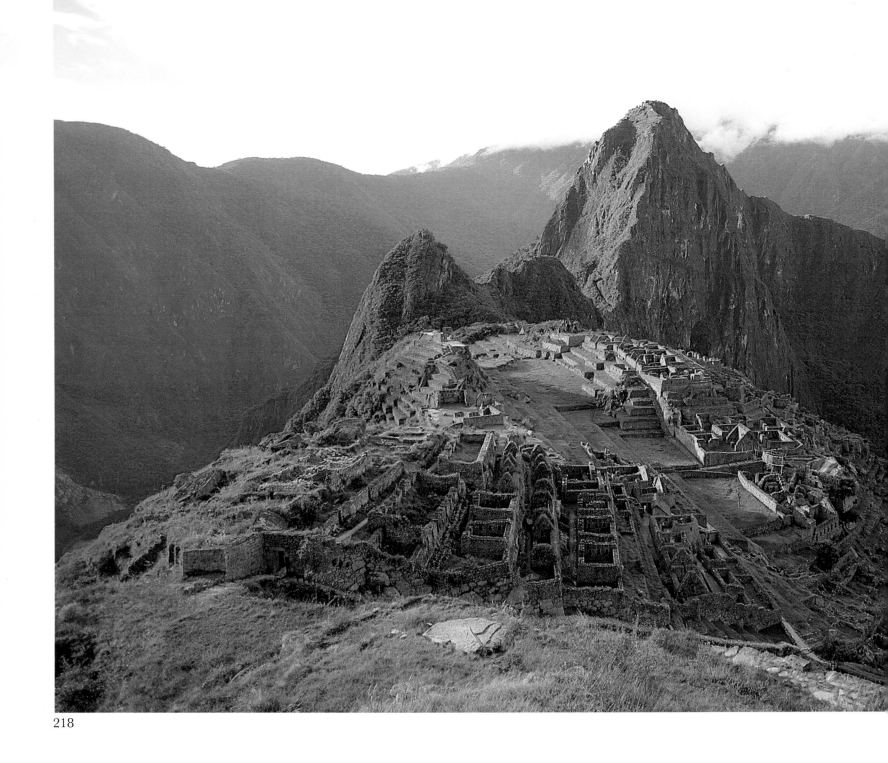

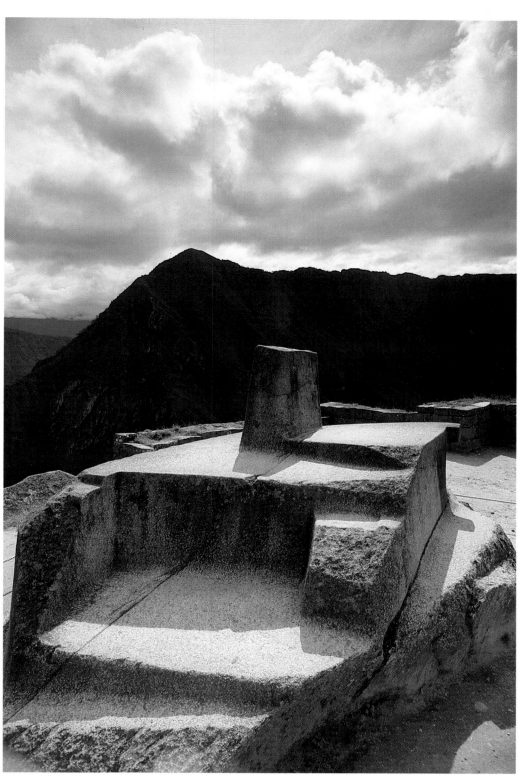

219

horizontal courses. This stone architecture in the heart of the Cañari country must have been the work of *mitimaes*—colonists, that is, who had been compulsorily relocated in the interests of imperial cohesion (Pl. 214).

Though, like Paramonga, it has often been dubbed a fortress, the main building would appear rather to be a sanctuary. This splendid, finely masoned platform is built on an oval plan formed around a line of three contiguous circles of equal diameter. Its only entry, on the south side, gives on to a landing from which two stairways rise in opposite directions, leading to twin temples on the summit, built back to back. The existence of twin temples on some of the earliest Andean sites such as Chavín and Moxeque would seem to justify the assumption that the traditions informing the religious thought of the pre-Columbians had survived the passage of several millennia. Hence the Incas may be regarded as the heirs to a past whose traditions they succeeded in synthesizing on the eve of the collapse brought about by the Conquest.

Inca Arts and Crafts

We have already drawn attention to the technological skills which accrued to the Incas. In Cuzco they brought together the cream of the empire's potters, weavers and goldsmiths with a view to discovering their trade secrets and expanding production. In the case of metallurgy and, notably, of gold-work, they were unquestionably indebted to the Chimús. Here we find little or no evidence of an Inca style as such, for the forms evolved by Chimor would appear to have remained largely unchanged. However, too few examples have survived to enable us to form any real idea of Inca work, the bulk of which was melted down to satisfy the Conquistadors' lust for gold.

For when the Inca sovereign Atahualpa was captured at Cajamarca by Pizarro in 1533, he attempted to buy his freedom by offering as much gold and silver as would fill a room as high as his arm could stretch. So rich were the Incas that the ransom, which was duly paid—but not honoured—brought in a haul of idols and gold plate weighing no less than eight tons. Much of this precious metal, otherwise obtainable only with some difficulty from the rivers of the Tumbes region, had been looted by the Incas from Mochica and Chimú cemeteries and had gone to the making of, amongst other things, the statues of Viracocha and Mama Ocllo which, so the chroniclers tell us, were as large as a man.

The all too rare gold and silver objects that have come down to us are funerary offerings found in tombs—for instance, little gold llamas which were to take the place of the real animal in the next world, or again, gold and silver effigies which served as surrogates for the young people who would otherwise have accompanied the deceased on his last journey. The latter, hollow statuettes with disproportionately large heads and bodies in a strictly frontal pose, strive after a realism more emphatic than that found in Chimú work, as do certain of the silver portrait vessels (Pls. 200, 201).

In the field of textiles the Incas were clearly indebted to Chancay and Nazca, large numbers of whose craftsmen they transported to the highlands. Their borrowings, however, were of a technical nature, for they succeeded in evolving an original style of their own, in which geometricity goes hand in hand with what is, perhaps, an unduly rigorous

218 After a long search, the American Hiram Bingham eventually discovered the site of Machu Picchu in 1911. It is the Incas' most spectacular architectural achievement, for it lies high up on a saddle whose vertiginous flanks are partially encircled by the Río Urubamba, a tributary of the Apurimac. Above the town the saddle rises to a peak known as Huayna Picchu (2,900 m.) The principal quarters lie on either side of a vast plaza which rises in stages between two mounds. Most of the buildings are intact save for their thatched roofs, enabling us to reconstruct the appearance of this settlement, perched on the heights like an eagle's eyrie. Its position made of it a natural fortress against incursions by the Amazonian tribes.

219 At the top of the temple complex in the western part of the town stands the Intihuatana or sacrificial stone, the formal vigour of which was achieved by giving an arrogant profile to the natural contours of the rock. Frequently described as an observatory or solar calendar, it seems far more likely that the Intihuatana was the town's principal *usnu* and, as such, had little or no astronomical significance.

organization. So varied and systematically disposed are the typically Inca figural motifs occupying the squares, that some authors have come to regard them as a form of writing, and have actually counted up to 400 different 'glyphs', to which they have attempted to provide a key. Whatever the case, these textiles, made on the tapestry principle, are the descendants of the fine stuffs produced in Paracas, Nazca and Tiahuanaco, to which they cede nothing in regularity and delicacy.

Inca pottery was also the product of a synthesis, which is not to suggest that it lacks originality. Here we may detect the presence of two major streams. The first derives from Chimú techniques with Mochica reminiscences, notably in the lustrous black ware made by the north-coast potters of Chanchán and Lambayeque. The stirrup spout persists alongside the single spout vessel, both of which display fine and very varied anthropomorphic and zoomorphic motifs. Other, mass-produced wares, however, are of lower quality (Pls. 195–7).

A greater degree of originality is discernible in the second of the two streams in which the forms and motifs are typically Inca and the style totally distinct from any other. The palette used by these potters suggests that they were of Nazca origin and had been 'imported' into the highlands. The pottery is characterized by the introduction of a new form, the so-called aryballos, namely a large globular jar with a conical base that could be implanted in the ground like the amphora of antiquity. Used for transporting water, it was carried on the back (Pls. 193, 194).

While the aryballos proper might be of considerable size, say 60 or 80 centimetres high, we also encounter miniature versions with anthropomorphic decoration (Pl. 192), and others intended for ritual use which are tall, slender and extremely elegant. Both these latter forms still retain the small lateral handles and the nubbin over which, in the larger pieces, the carrying strap is passed (Pl. 191).

The themes on the Inca vessels are noteworthy for the dryness and severity of their style. Besides the flowers and dancers represented on the last-named example, we frequently encounter designs suggestive of fine veins, probably symbolizing the trees and other vegetation whose growth depended on the water from the aryballos. This peculiarly Inca form of decoration is unlikely to have derived from earlier models.

While the Incas did not produce any outstanding sculpture—as we have seen, few carvings occur in their architecture—they developed an art that was entirely their own, namely objects made of hard stone such as small mortars and zoomorphic votive statuettes. Innumerable little llamas and alpacas in basalt or diorite have come to light in fields where they had doubtless been buried in the course of fertility rites. The treatment is sober, economical and highly stylized (Pl. 198).

Sometimes, too, we encounter beautifully polished mortars of great formal purity, in which the handles assume the shape of zoomorphic figures remarkable for their quality and understatement (Pl. 199).

In addition to the above-mentioned objects, all of which played a ritual role in the pantheistic religion of the Incas, we would cite the *kero,* a vessel distinguished not only by its materials, but also by the use to which it was put. Carved from a tree-trunk, it served as a 'communion' cup from which members of a clan would drink *chicha,* a mildly alcoholic beverage made from fermented maize. As in all pre-Columbian cultures the use of drugs, alcohol and hallucinogens had religious connotations. Coca was conducive to divination, as were certain species of mushroom to ecstasy,

while *chicha* provided a means of entering into communication with the divine. For this reason it was subject to a strict ritual which, indeed, persisted until long after the arrival of the Spaniards. Because they are made of perishable material, virtually all of the many surviving vessels of this kind date from after the Conquest. The *kero's* sober and gently flaring form was probably derived from the beautiful ceramic beakers of Tiahuanaco. Before long, however, it also assumed the aspect of a human face or a puma's mask, a genre in which the carving displays features of great originality. Once again, we find the schematism and rejection of naturalism which we have already come to recognize as typical characteristics of Inca art (Pl. 220).

In early pieces, painted with polychrome lacquer, the palette, though brilliant, is limited and the geometric designs are simple. However, contact with colonial art led, in the later vessels, to a kind of baroque profusion which tended to obliterate earlier Inca characteristics.

The Decline of the Pre-Columbians

Tahuantinsuyu, the Incas' Land of the Four Quarters, was a very real political and cultural entity, bound together by a common language, *Quechua*. Thus, it was a highly structured, monolithic empire that confronted Francisco Pizarro when he arrived in Peru at the head of 164 horsemen and foot-soldiers intent on carving out a 'kingdom' for himself as his fellow countryman, Hernando Cortès, had done twelve years earlier in Mexico.

For the Incas, 1533 was to be no less ominous a year than 1521 had been for the Aztecs. If the aggressor was similar in both cases so, strangely enough, were the circumstances which had caused the Aztec and Inca civilizations to assume analogous forms and succumb to a similar fate. For both the cultures which confronted the Conquistadors were characterized by a militaristic imperialism which had secured their hegemony over virtually all the neighbouring, highly developed regions. In one case, the empire extended from the Gulf to the Pacific and from Sonora to the Isthmus of Tehuantepec; in the other from the Colombian border to the middle of Chile.

These two pre-Columbian civilizations, which owed their existence to the centralized political macrostructure each had succeeded in creating, were the product of a long period of development. Both had expanded to their utmost extent when the Conquest brought their existence to a violent end. Both had exalted to the highest degree a military-economic organization cloaked by a centralized religious authority—a process in which individual values had gone by the board. Both had subdued their neighbours in order to enrich a restricted caste, an oppressive oligarchy that was the chief beneficiary of the system. In neither case was the political structure in any way egalitarian, nor does the concept of the 'socialist empire of the Incas' stand up to close examination, although the particular topographical conditions with which the latter had to cope necessitated a system of production and distribution that was better planned than that of the Aztecs. In the face of absolute despotism—and this applies to both civilizations—our notions of liberty lose all relevance.

In such circumstances, the collapse, before a handful of adventurers, of a nation several millions strong and boasting warriors renowned for their

220 Among the ritual objects which continued in use after the Conquest were the Inca *keros* or painted wooden beakers. Indeed most of the pieces that have survived date from the early colonial period. They were used by members of a kinship group for the drinking of a mildly alcoholic maize beer known as *chicha*. This beautiful anthropomorphic *kero* exemplifies the high degree of stylization attained by Inca art. Height 19.5 cm. Museo Regional de Cuzco.

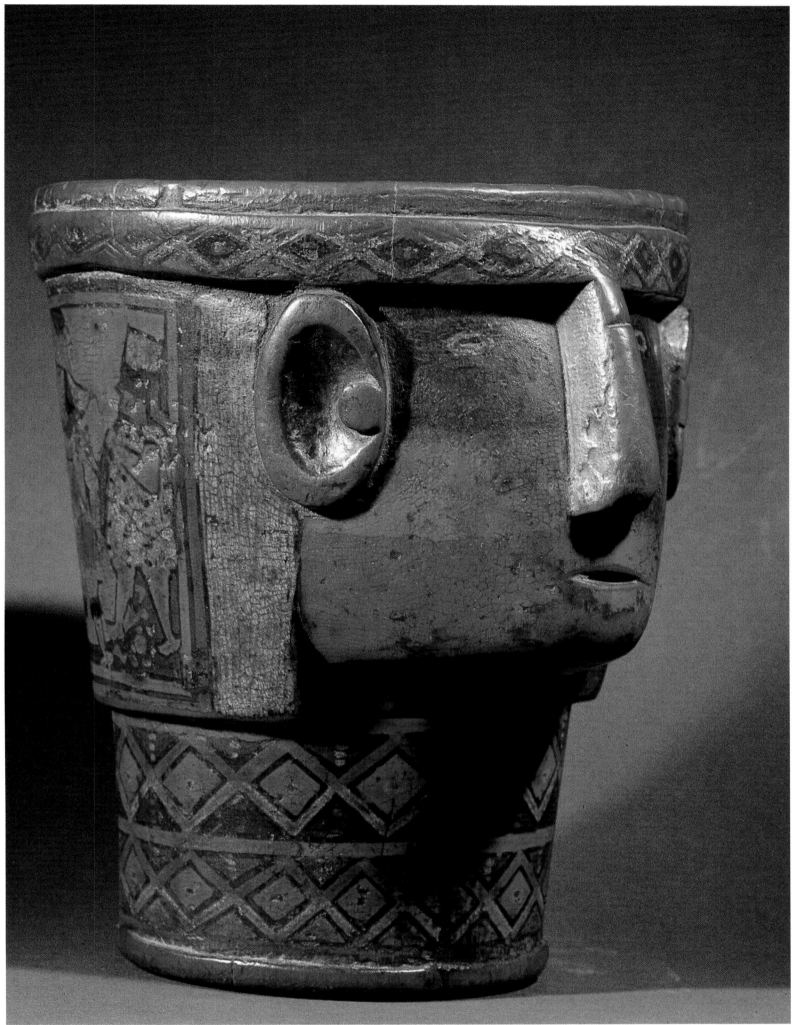

220

ferocity, might seem inexplicable, even having regard to their technological handicap in the matter of weaponry. To the Indians armed with javelins and bronze and stone maces, and having, for all protection, shields and padded cotton tunics, the Spaniards with their horses, helmets and breast-plates, steel swords and fire-arms such as blunderbusses, culverins and arquebuses, must have seemed well-nigh invincible.

There was another factor, however, that contributed towards this lightning victory, namely the civil war that for years had been ravaging the Inca nation. For the empire had grown too large to be ruled by a single master and, on the death at Tumibamba of Huayna Capac in 1525, seven years before the Conquistadors landed at Tumbes, the question of his successor had led to a disastrous schism. According to one account, Huayna Capac had decided to split the empire and appoint his son Huascar ruler of Cuzco, the original Inca capital, while bestowing his northern possessions on Atahualpa who lived with him at Tumibamba. The consequent division of power was to prove incompatible with the symbolic and religious organization of the Inca kingdom, which became engulfed in the struggle between the ancient and prestigious capital held by Huascar and the new capital at Tumibamba, now furnished with replicas of the Cuzqueño shrines. It would seem that, on the eve of the Spanish landing, Atahualpa had succeeded in crushing Huascar in the course of the internecine strife which had upset the delicate mechanism of the Inca empire.

Flushed with victory, Atahualpa could see no reason to mistrust the little band of Spaniards. As a result he fell into the trap Pizarro had set him at Cajamarca, was treacherously taken prisoner and, in 1533, was put to death after a mock trial which does little credit to the Conquistadors. His disappearance marked the end of the pre-Columbian world, although some of his less illustrious successors proceeded to open a glorious page in Indian history by leading insurrections against the Spaniards and laying siege to Cuzco, now occupied by the enemy, before withdrawing to Vilcabamba from which they continued to harass him until 1572. That was the end. Death and oblivion overtook the Inca civilization and all those which had preceded it.

The decline, which was a horrifyingly rapid one, was largely due to mortality and the dereliction of the land. The empire's vast Indian population had been drastically reduced and was now on the point of total collapse. This may be attributed to a number of factors, which both compounded and exacerbated each other. The first chronologically, but by no means the most important, was death in battle. Far more catastrophic than this, however, was slavery and the exactions of the colonists. But the greatest toll of all was taken by disease—infections imported by the Spaniards which, innocuous enough perhaps in the Old World, proved fatal to the Indians who did not possess the necessary antibodies.

In the course of the sixteenth century the population of Peru is said to have fallen by as much as 70 per cent and, in certain areas, by more than 90 per cent. From Spanish sources we learn that, fifty years after the arrival of the Conquistadors, only 600 persons remained in the Nazca town of Chincha as compared with 30,000 before the Conquest, in other words, no more than two per cent of the population.

However, the viceroy's policy, aimed at preventing further uprisings, was to bring about another catastrophe, this time of an ecological nature. For under a system known as reduction, the Indians were forced to leave their upland fastnesses and settle in 'new towns', thus forsaking not only

their traditional habitat, but also the *andenes* on which they depended for their subsistence. This led to the immediate collapse of agriculture, which in turn was followed by indigence and famine as the birth-rate again began to rise.

With the establishment of the colony, pre-Columbian traditions and techniques fell into desuetude while the system of food reserves and their distribution by the state was swept away. The substitution of a money for a barter economy and the consequent disappearance of the *mita* completed the country's ruin and wiped out its cultural and artistic heritage.

The effects of the ecological and social disaster, combined with the economic bankruptcy which resulted from the Conquest, are still apparent today. Despite the efforts made by a number of Andean countries in the sphere of irrigation and land improvement, there can be no denying that, 500 years after the collapse, the scars have not yet disappeared. Today Peru's cultivated area is between 40 and 45 per cent less than it was at the time of the pre-Columbians, evidence enough of the extraordinarily high density of the population comprised within the boundaries of the Inca empire.

Given such conditions, it would be otiose to enlarge on the still more drastic fate that befell the arts, peremptorily cut off from their cultural and religious roots. The disaster was complete.

Conclusion

In retrospect it may be seen that the course taken by Andean art over five millennia was one of steady development, beginning at Real Alto and terminating at Cuzco. The various centres gradually combined to form ever larger entities until, for a brief and final spell, all of them, from Ecuador to Chile, were united within the Inca empire. As we have seen, the tendency towards political centralization went hand in hand with uniformity in the sphere of architecture and the arts, and was thus conducive to a coherent, homogenous style which acted as a bond between the different parts of the country.

Born of the desire to worship the forces of nature and to raise them to the status of gods, art was entrusted with the task of investing everyday objects with propitiatory and prophylactic powers, thereby consecrating them both for ritual use and as viatica for the dead. Increasingly, then it came to be an instrument of government.

Just as at Tenochtitlán, where art was translated into a language of religious terrorism in the service of the imperialist Aztec rulers, so, at Cuzco, it became the expression of a cultural and religious unity based on the cult of the Inca and on the performance of pantheistic rites. The fact that these took precedence over local religious beliefs betrays the intention to impose common forms throughout Tahuantinsuyu.

It was a development which became increasingly manifest with each successive phase in the political and religious unification of the Andean world: first Chavín, then Tiahuanaco–Huari, followed by the kingdom of Chimor and, finally, by the Incas, in whom it experienced its apogee. The whole intent of the state machine was to exalt the splendour of a court in which the temporal and spiritual powers were vested in one and the same individual, just as the whole aim of the system was to obtain the means to sustain that cosmic vision. For only collective labour could provide the untold wealth required for the glorification of the Inca as god incarnate. Here a tribal chief had been transmogrified into a supreme ruler, and a small highland community's tribal forms of expression had succeeded in supplanting those of its neighbours. The same principle may be observed at work in the case of most great empires with hegemonic aspirations.

And while the aesthetic outlook of less dictatorial, more humanistic societies such as those of Mochica, Nazca and Chorrera, may seem more attractive, the fact remains that the language of forms was hammered out in the course of the phases alluded to above, phases which are alternately 'introvert' and 'extravert'. For that language was directed, now towards

228

the individual and the exploration of his particular characteristics, now towards the promotion of unity and cohesion—at the cost, be it said, of a measure of monotonous repetition. Diversity or uniformity—such was the dilemma of art. And it was the task of the various styles to strike a balance between those two extremes.

What we are witnessing, beyond all doubt, among these Andean civilizations, is the birth of a sequence of styles, each distinct from and unlike any other. We can follow them all, through their infancy, prime and decline, assess the value of their legacies, discover reminiscences—in short, observe the growth of a long line resonant with the voices of distant forbears. For between the dawn of Valdivia and the brutal twilight of the Incas there was no real hiatus.

To a greater extent, perhaps, than anywhere else, this country of topographical extremes, of valleys separated by vast deserts, gave birth to distinct entities which man sought to bring together by disrupting the solitude of isolated societies and forming them into polities of sufficient size to permit that mutual complementarity which alone might enable them to withstand the hazards presented by, for instance, the climate, or hostile incursions. And art, in its turn, provides a true reflection of those repeated attempts at unity followed by disintegration, of those phases of expansion and retraction, of diastole and systole, whose rhythm characterizes the onward progress of the peoples and their self-affirmation.

Because of its autonomous development, uncontaminated by the cultures of the West, the art of the Andean pre-Columbians gives magnificent scope for the study not only of forms, but also of modes of thought and of man himself. Moreover, it testifies to the aspirations to beauty shared by all human societies. The decoration of the earliest and most humble pots and fabrics invests their functionalism with an aesthetic dimension, as do frescoes, sculptures and imposing proportions that of the earliest sanctuaries. It is touching to observe these tentative beginnings in societies whose course ran parallel with our own, For as we now know, the cultivators of the Pacific coast embarked on their first artistic ventures at the same time as their counterparts in the Near East. Valdivia was contemporaneous with Sumer.

But while we are now aware that the continuous chain linking Real Alto to Cuzco is a matter of historical fact, there is no denying the yawning gaps that still bedevil this particular sphere of art. Indeed, our conspectus, which began with the Mayas and the Aztecs and now also embraces the Andean countries, will long remain subject to drastic revision in the light of discoveries that have yet to be made.

Chronological Table I

Ecuador	North Peru	Central and South Peru
22000 First wave of immigrants from Asia reaches the American continent 15000 First arrivals in South America 13000 Second wave of immigrants reaches the American continent 10000 Third and final wave of immigrants from Asia 9400 Fragments of cut stone near mastodon in Chile 7000 First attempts to domesticate food plants 5500 American horse becomes extinct 4300 Cold dry phase favours emergence of agriculture in Amazonia 4000 Evidence of maize in layers in Ecuador 　　　Evidence of cotton in textiles		
3500 Real Alto, first Valdivia city 3100 Loma Alta: First occupation of site 2600 Valdivia: Phase I 2400 Valdivia: Phase II 2300 Valdivia: Phase III 2100 Valdivia: Phase IV 2000 Valdivia: Phase V 1800 Valdivia: Phase VI 1700 Valdivia: Phase VII 1600 Valdivia: Phase VIII 1500 Machalilla: arrival of a new people	2125 Huaca Prieta: occupation of site 2000 El Paraiso: village of bean cultivators 1950 Huaca Prieta: decorated gourds 1850 Kotosh: Temple of the Crossed Hands 　　　Appearance of pottery 1800 Sechín Alto: sanctuary in use until 500 B.C. 1500 Cerro Sechín: Temple of sculptured monoliths 1350 Pampa Gramalote: textiles of *Camelidae* wool 1300 Caballo Muerto: Huaca de los Reyes	3000 Domestication of the llama and alpaca on the altiplano 　　　Paracas: villages of fishermen and shell-gatherers
1200 Chorrera: new ceramic style 800–500 Heyday of pottery 600 First gold-work in North Ecuador 500 Chorrera: decline 　　　Appearance of La Tolita and Jama Coaque cultures which survived until A.D. 500	1200 Kotosh/Kotosh: evidence of maize cultivation in highlands 1190 Sechín Alto: circular plaza 1000 Tembladera, Cupinisque: pottery 850 Chavín: building of temple commences 　　　Lanzón: 850–800 　　　Urabarriu pottery: 850–460 　　　Tello Obelisk: 800–650 　　　Jaguar lintel: 700–460 　　　Portal: 550–460 　　　Chakinani pottery: 460–390 　　　Raimondi monolith: 460–300 　　　Janabarriu pottery: 390–200 500 First gold-work in Peru 460 Vicús Chavinoid pottery 400 Vicús Salinar pottery 300 Loma Negra: copper-work 250 Vicús Virú pottery 200 Gallinazo pottery 　　　Proto–Mochica culture 100 Vicús Mochica pottery	1200 Appearance of pottery on south coast 1000 Early Paracas 500 Paracas Cavernas or Middle Paracas 300 Paracas Necropolis or Late Paracas 100 Proto- or Early Nazca, until A.D. 200 　　　First drawings on Nazca and Palpa pampa

Chronological Table II

North Peru	Central and South Peru	Altiplano Peru/Bolivia
Moche I: 100 B.C.–A.D. 100		Marcavelle: appearance of pottery 1000–650 B.C. Pucára style: 100 B.C.-A.D. 350
100 Mochica culture Moche II: A.D.100–200 150 Occupation of Santa Valley by Mochicas 200 Moche III: A.D. 300–600 Heyday of Mochica Classicism 500 (End of La Tolita and Jama Coaque cultures in Ecuador)	A.D. 100–500 Recuay pottery 200 Middle Nazca Phase III: A.D. 200–300 300 Late Nazca: until A.D. 600 Phase IV: A.D. 300–400 Phase V: A.D. 400–500	100 Ascendancy of Tiahuanaco in Titicaca Basin Tiahuanaco Phase III: Acapana and Semi–subterranean Temple: A.D. 100–350 250 Huari founded (?) 350 Tiahuanaco Phase IV: Kalasasaya until A.D. 500
600 Mochica regression A.D. 600–700 Moche V: A.D. 600–700 Pampa Grande founded; Mochica decline 700 Huari–Tiahuanaco influence	550 Last drawings Nazca–Palpa (?) pampa Phase VI: until end of Nazca, A.D. 650–700 650 Influence of Huari–Tiahuanaco on coast Influence of Huari on Huaraz and Wilcawaín until 1100	500 Huari pottery 550 Influence of Tiahuanaco on Huari 600 Classic Tiahuanaco pottery, until A.D. 800 A.D. 650–1000: Tiahuanaco proseletizes Paracas, Nazca and north coast 700 Pacheco style kraters 800 Tiahuanaco–Huari 'expansivo' style
900 Cajamarca and Lambayeque 1000 Appearance of Chimú culture 1100 Middle Chimú 1150 Building of Chanchán begins 1250 Huaca el Dragón near Chanchán 1370 Chimús control territory of Mochica Confederation 1420 Tschudi Compound, Chanchán 1465 Ancocoyuch defeated by Inca Pachacuti Incas dominate north coast up to Ecuador 1500 Incas build Ingapirca (Ecuador)	1100 Ica culture 1200 Chancay culture 1300 Ica–Chincha culture 1460 Inca domination of south coast 1500 Incas build Tambo Colorado	1200 Arrival of Incas on the altiplano Manco Capac, first Inca king 1350 Inca Rocca, 6th king, founds Henan Cuzco dynasty 1438 Pachacuti: Inca imperialism Sacsahuamán founded Machu Picchú and replanning of Cuzco 1471 Tupac Yupanqui, son of Pachacuti 1493 Huayna Capac Work begun on shrine at Kenco 1525 Huascar 1532 Atahualpa defeats Huascar and is captured by Pizarro 1533 Death of Atahualpa at Cajamarca; succeeded by Topa Hualpa 1535 Burning of Cuzco 1536 Rebellion led by Manco II 1572 End of Inca resistance at Vilcabamba

Acknowledgements

The author and photographer would like to thank the following individuals and institutions for their assistance:

The Swiss Ambassador to Peru, M. Luciano Mordasini.

The Swiss Ambassador to Colombia and Ecuador, M. Charles Steinhäuslin.

The Swiss Chargé d'affaires in Quito, M. Théodore Portier.

The Swiss Chargé d'affaires in La Paz, M. Edwin Trinkler.

The Swiss Consul in Guayaquil, M. Emilio Mettler.

Dr. Luis Enrique Tord, Director General of the Instituto Nacional de la Cultura, Lima.

Sr. Victor Pimental Gurmendi, Director of the Museo Nacional de Antropología y Arqueología, Lima.

Sr. Yoshitaro Amano, Director of the Museo Amano, Lima.

Sr. Alvaro Roca-Rey, Technical Director of the Museo Oro del Perú, Lima.

Sra. Iñes Maria Flores, Director of the Museo del Banco del Pacifico, Guayaquil.

Sr. Olaf Holm, Director of the Museo Antropológico del Banco Central del Ecuador, Guayaquil.

Sr. Hernan Crespo Torral, Director of the Museo del Banco Central del Ecuador, Quito.

The Director of the Museo del Banco Central de Reserva, Lima.

The Directors of the Regional Museums at Cuzco and Ica, and of the Casa de Cultura, Guayaquil.

Professor Federico Kauffmann-Doig, Lima.

M. Louis Necker, Director of the Musée d'Ethnographie, Geneva.

The Société Suisse des Américanistes, Geneva, and its Librarian, Mlle Bernadette Chevalier.

The Abegg Foundation, Riggisberg, Berne.

Lastly, we would like to express our thanks to Iberia Spanish Airlines and, in particular, M. Werner Gerig, Regional Manager at Geneva, for the facilities accorded on the Company's Latin American routes.

Select Bibliography

Alcina José, *L'art précolombien,* Mazenod, Paris, 1978.

Baumann, Peter, *Valdivia, la découverte de la plus ancienne civilisation d'Amérique,* Robert Laffont, Paris, 1982.

Benson, Elizabeth P., *A Man and a Feline in Mochica Art,* Dumbarton Oaks, Trustees for Harvard University, Washington D.C., 1974.

Bird, Junius B., *Paracas Fabrics and Nazca Needlework,* The Textile Museum, Washington D.C., 1954.

—, 'Pre-Ceramic Art from Huaca Prieta, Chicama Valley', in *Pre-Columbian Art History, Selected Reading,* Peek Publications, Palo Alto, 1977.

Browman, David I., 'Demographic Correlation of the Wari Conquest of Junin', in *American Antiquity,* vol. 41, No. 4, Salt Lake City, 1976.

Burger, Richard L., 'The Moche Sources of Archaism in Chimú Ceramics', in *Ñawpa Pacha,* No. 14, Institute of Andean Studies, Berkeley, 1976.

—, 'The Radiocarbon Evidence for the Temporal Priority of Chavín de Huántar', in *American Antiquity,* Vol. 46, No. 3, Salt Lake City, 1981.

Chavez, Sergio J., 'The Arapa and Thunderbolt Stelae', in *Ñawpa Pacha,* No. 13, Institute of Andean Studies, Berkeley, 1975.

Chavez, Sergio J., and Mohr-Chavez, Karen L., 'A Carved Stela from Taraco, Puno, Peru', in: *Ñawpa Pacha,* No. 13, Institute of Andean Studies, Berkeley, 1975.

Conrad, Geoffrey W., 'Cultural Materialism, Split Inheritance, and the Expansion of Ancient Peruvian Empires', in *American Antiquity,* Vol. 46, No. 1, Salt Lake City, 1981.

—, 'The Burial Platforms of Chan Chan: Some Social and Political Implications', in *Chan Chan: Andean Desert City,* School of American Research, Advanced Seminar Series, University of New Mexico Press, Albuquerque, 1982.

Cordy-Collins, Alana, 'Chavín Art: Its Shamanic/Hallucinogenic Origins', in *Pre-Columbian Art History,* Peek Publications, Palo Alto, 1977.

Disselhoff, Hans D., 'Seis Fechas Radiocarbónicas de Vicús', in *38th International Congress of Americanists,* Vol. 1. Stuttgart-Munich, 1969.

Donnan, Christopher B., 'Moche Art and Iconography', in UCLA, *Latin American Center Publications,* Vol. 33, Los Angeles, 1976.

—, *Moche Occupation of the Santa Valley, Peru,* University of California Press, Berkeley, Los Angeles-London, 1973.

Donnan, Christopher B., and McClelland Donna *The Burial Theme in Moche Iconography,* Dumbarton Oaks, Trustees for Harvard University, Washington, D.C., 1979.

Eisleb, Dieter, *Altperuanische Kulturen,* Museum für Völkerkunde, Berlin, 1975.

—, *Altperuanische Kulturen II, Nazca,* Museum für Völkerkunde, Berlin, 1976.

Eisleb, Dieter, and Strelow, Renate, *Altperuanische Kulturen III, Tiahuanaco,* Museum für Völkerkunde, Berlin, 1980.

Eubanks Dunn, Mary, 'Ceramic Depictions of Maize' in *American Antiquity,* Vol. 44, No. 4, Salt Lake City, 1979.

Engel, Frédéric A., 'Le Complexe précéramique d'El Paraiso (Pérou)', in *Journal de la Société des Américanistes,* Vol. 55, No. 1, Paris 1966.

—, *Le Monde précolombien des Andes,* Hachette, Paris, 1972.

—, 'Sites et établissements sans céramique de la côte péruvienne', in *Journal de la Société des Américanistes,* Vol. 46, Paris 1957.

—, 'Un groupe humain datant de 5000 ans à Paracas, Pérou', in *Journal de la Société des Américanistes,* Vol. 49, Paris, 1960.

Estrada, Emilio V., *Las Culturas Pre-Clásicas, Formativas o Arcaicas del Ecuador,* Publicación del Museo Estrada, Guayaquil, 1st ed. 1958, 1975.

—, *Valdivia, un sitio arqueologico formativo en la costa de la provincia de Guayas, Ecuador,* Guayaquil, 1956.

Evans, Clifford, and Meggers, Betty, 'Formative Period Cultures in the Guayas Basin, Coastal Ecuador', in *American Antiquity,* Vol. 22, Salt Lake City, 1957.

—, 'Relationships between Mesoamerica and Ecuador', in *Handbook of Middle American Indians,* Vol. 4, University of Texas, Austin, 1966.

Flornoy, Bertrand, *L'Aventure Inca,* rev. ed., Librairie Académique Perrin, Paris, 1980.

Gasparini, Graziano, and Margolies, Luise, *Inca Architecture,* Indiana University Press, Bloomington-London, 1980.

Grieder, Terence, 'A Dated Sequence of Building and Pottery at Las Haldas', in *Ñawpa Pacha,* No. 13, Berkeley, 1975.

Hagen Victor von, *La Route royale des Incas,* Editions France-Empire, Paris, 1978.

—, *Le Pérou avant les Incas,* Editions France-Empire, Paris, 1979.

Harcourt, Raoul d', *Les Textiles anciens du Pérou et leurs techniques,* Paris, 1934.

Hawkins, Gerald S., *Ancient Lines in the Peruvian Desert,* Final Scientific Report for the National Geographic Society Expedition, Smithsonian Institution Astrophysical Observatory, Cambridge, Mass., 1969.

Hocquenghem, Anne-Marie, 'Une interprétation des (vases-portaits) mochicas', in *Ñawpa Pacha,* No. 15, Berkeley, 1977.

—, 'Un (vase-portrait) de femme Mochica', in *Ñapa Pacha,* No. 15, Berkeley, 1977.

Horkheimer, Hans, and Kauffmann-Doig, Federico, *La Cultura Inca,* Peruano Suiza S.A., Lima, 1965.

Isbell, William H., and Schreiber, Katharina, 'Was Huari a State?', in *American Antiquity,* Vol. 43, Salt Lake City, 1978.

Ishida, Eiichiro, *Andes I,* Kadokawa Publishing Co., Tokyo, 1960.

Izumi, Seiichi, and Sono, Toshihiko, *Andes II, Excavations at Kotosh, Peru 1960,* Kadokawa Publishing Co. Tokyo, 1963.

Jung, Carl G., *Les Racines de la Conscience, Etudes sur l'Archétype,* Editions Buchet/Chastel, Paris, 1971.

—, *Métamorphoses de l'âme et ses Symboles.* Editions Buchet-Chastel, Paris, 1953.

Kano, Chiaki, *The Origin of the Chavín Culture,* Studies in Pre-Columbian Art and Archaeology, No. 22, Dumbarton Oaks, Trustees for Harvard University, Washington, D.C., 1979.

Kauffmann-Doig, Federico, *La Cultura Chavin,* Peruano Suiza S.A., Lima, 1963.

—, *Manual de Arqueología Peruana,* Peiso, Lima, 1980.

Kelm, H., and Münzel M., *Herrscher und Untertanen, Indianer in Peru,* Museum für Völkerkunde, Frankfurt am Main, 1973-4.

Kern, Hermann, *Materialien zum Verständnis der peruanischen Erdzeichen,* Kunstraum München, Munich, 1975.

Knapp, Gregory, 'Prehistoric Flood Management on the Peruvian Coast: reinterpreting the "Sunk fields" of Chilca', in *American Antiquity,* Vol. 47, Salt Lake City, 1982.

Kosok, Paul, *Life and Water in Ancient Peru*, Long Island University, New York, 1965.

Kozlowski, Janusz K., and Bandi, Hans-Georg, *Le Problème des racines asiatiques du premier peuplement de l'Amérique*, Bulletin No. 45, Société Suisse des Américanistes, Geneva, 1981.

Kutscher, Gerdt, *Nordperuanische Keramik: Figürlich verzierte Gefässe der Früh-Chimu*, Verlag Gebr. Mann, Berlin, 1954.

—, *Chimu, Eine altindische Hochkultur,* Verlag Gebr. Mann, Berlin, 1950.

Lanning, E.P., 'Early Ceramic Chronologies of the Peruvian Coast of Peru', in *American Antiquity,* Vol. 28, No. 3, Salt Lake City, 1959.

Lapiner, Alan, *Pre-Columbian Art of South America,* Harry Abrams Inc. Publ., New York, 1976.

Larco Hoyle, Rafael, *Pérou,* Collection Archaeologia Mundi, Nagel, Geneva, 1966.

Lathrap, Donald W., *El Ecuador Antiguo, Cultura, Ceramica y Creatividad,* Museo del Banco del Pacifico, Guayaquil, 1980.

—, 'Gifts of Cayman: Some Thoughts on the Subsistance Basis of Chavin', in *Pre-Columbian Art History,* Palo Alto, 1977.

—, *The Moist Tropic, The Arid Lands, and the Appearance of Great Art Styles in the New World,* Special Publications, The Museum Texas Tech. University, 1974.

—, *The Upper Amazon,* Praeger, New York, 1970.

Lathrap, Donald W., Marcos, Jorge G., and Zeidler, James A., 'Real Alto: An Ancient Ceremonial Center', in *Archaeology,* Vol. 30, No. 1, New York, 1977.

Lechtman, , Heather, Antonieta Erlij, and Barry Jr., Edward J., 'New Perspectives on Moche Metallurgy: Techniques of Gilding Copper at Loma Negra, Northern Peru', in *American Antiquity,* Vol. 47, Salt Lake City, 1982.

Lévi-Strauss, Claude, 'Le Dédoublement de la représentation dans les arts de l'Asie et de l'Amérique', in *Anthropologie Structurale,* Plon, Paris, 1958.

Lothrop, Samuel K., *Amerikanische Kunst,* Walter Verlag, Olten, 1959.

—, *Les Trésors de l'Amérique précolombienne,* Skira, Geneva, 1964.

—, 'Metalworking Tools from the Central Coast of Peru', in *American Antiquity,* Vol. 16, Salt Lake City, 1950.

Lumbreras, Luis G., *El Arte y la Vida Vicus,* Banco Popular del Peru, Lima, 1978.

—, *Arqueología de la America Andina,* Editorial Milla Batres, Lima, 1981.

—, 'Excavaciones en el Templo antiguo de Chavin (Sector R), Informe de la sexta Campaña', in: *Ñaupa Pacha,* No. 15, Berkeley, 1977.

Matsuzawa, Tsugio, 'The Formative Site of Las Haldas, Peru, Architecture, Chronology and Economy', in *American Antiquity,* Vol. 43, No. 4, Salt Lake City, 1978.

Meggers, Betty, 'Climatic Oscillation as a Factor in the Prehistory of Amazonia', in *American Antiquity,* Vol. 44, No. 2, Salt Lake City, 1979.

—, *Ecuador,* Thames and Hudson, London, 1966.

Meggers, Betty, and Evans, Clifford, 'The Machalilla Culture', in *American Antiquity,* Vol. 28, No. 2, Salt Lake City, 1962.

Meggers, Betty, Evans, Clifford and Emilio Estrada, 'The Early Formative Period of Coastal Ecuador: the Valdivia and Machalilla Phases', in *Smithsonian Contributions to Anthropology,* Washington D.C., 1967.

Menzel, Dorothy, John H. Rowe, and Dawson, Laurence E., *The Paracas Pottery of Ica, A Study in Style and Time,* University of California Press, Berkeley and Los Angeles, 1964.

Mohr-Chavez, Karen L., 'Archaeology of Marcavelle, Valley of Cuzco', in *Baessler Archiv,* New Series, Vol. 28, Berlin, 1980.

Morrisson, Tony, *Pathways to the Gods. The Mystery of the Andes Lines.* Harper and Row, New York, 1978.

Moseley, Michael E. (ed.), and Day (ed.), Kent C., *Chan Chan: Andean desert City,* A School of American Research Book, University of New Mexico Press, Albuquerque, 1982.

Murra John V., *Formaciones economicas y politicas del Mundo Andino,* Instituto de Estudios Peruanos, Lima, 1975.

—, 'La Funcion del Tejido en varios contextos sociales en el Estado Inca', in *100 años de Arqueología en el Peru,* Instituto de Estudios Peruanos, Lima, 1970.

—, *La Organización economica del Estado Inca,* Siglo Veintiuno, Mexico City, 1978.

Myers, Thomas P., 'Formative Period Occupations in the Highlands of Northern Ecuador', in *American Antiquity,* Vol. 41, No. 3, Salt Lake City, 1976.

Oberem, Udo, *Estudios sobre la Arqueología del Equador,* BAS 3, Bonn, 1976.

O'Neale, Lila M., *Textile Periods in Ancient Peru,* 3 Vols.: I. in collaboration with Kroeber, A. L., University of California Press, Berkeley, Los Angeles, 1930; II. *Paracas Caverns and the Grand Necropolis,* University of California Press, Berkeley, Los An-

geles, 1942; III. in collaboration with Bonnie Jean Clark, *The Gauze Weaves,* University of California Press, Berkeley, Los Angeles, 1948.

Parsons, Jeffrey R., and Psuty, Norbert, 'Sunken Fields and Prehispanic Subsistance on the Peruvian Coast', in *American Antiquity,* Vol. 40, Salt Lake City, 1975.

Pease, Franklin, G. Y., *Les Derniers Incas de Cuzco,* Mame, Paris, 1974.

Ponce Sanginés, Carlos, *El Templete semisubterraneo de Tiwanaku,* Editorial Juventud, La Paz, 1981.

—, *Panoramas de la Arqueología Boliviana,* Editorial Juventud, La Paz, 1980.

Porras, Pedro I., and Piana Luis, *Ecuador Prehispanico,* Instituto Geografico Militar, Quito, 1976.

Pozorski, Thomas, 'The Early Horizon Site of Huaca de los Reyes: Societal Implications', in *American Antiquity,* Vol. 45, No. 1, Salt Lake City, 1980.

Reiche, Maria, *Geheimnis der Wüste,* Selbstverlag Hohenpeissenberg, 1968, 3rd, ed. 1980.

Reichlen, Henry, 'Découverte de tombes Tiahuanaco dans la région de Cuzco', in *Journal de la Société des Américanistes,* Vol. 47, Paris, 1954.

—, 'Notes sur l'Archéologie', in *Guide Bleu, Pérou—La Paz,* Hachette, Paris, 1980.

Rivet, Paul, and Arsandaux, Henri, *La Métallurgie en Amérique précolombienne,* thesis, Paris, 1946.

Rodriguez Suy Suy, Victor A., 'Chanchan: ciudad de Adobe, Observaciones sobre su base ecologica' in *Actas y memorias: 37º Congreso Internacional de Americanistas.* Buenos Aires 1966, Publ. 1968.

Roe, Peter G., 'A Further Exploration of the Rowe Chavín Seriation and its Implications for North Central Coast Chronology', in *Study in Pre-Columbian Art and Archaeology,* No. 13, Dumbarton Oaks, Trustees for Harvard University, Washington, D. C., 1974.

Rowe, A. P., Benson, Elizabeth, and Schaffer, A. L., *The Junius B. Bird Pre-Columbian Textile Conference,* The Textile Museum and Dumbarton Oaks, Trustees for Harvard University, Washington, D. C., 1979.

Rowe, John H., 'Archaeological Explorations in Southern Peru 1954–1955', in *American Antiquity,* Vol. 22, Salt Lake City, 1956.

—, *El Arte de Chavín: Estudio de su forma y su significado,* Historia y Cultura, Instituto Nacional de Cultura, Lima, 1972.

—, 'The Sunken Gardens of the Peruvian Coast' in, *American Antiquity,* Vol. 34, Salt Lake City, 1969.

234

Sawyer, Alan R., *Ancient Peruvian Ceramics, The Nathan Cummings Collection, Greenwich (Conn.) and Metropolitan Museum of Art,* New York Graphic Society, New York, 1966.

—, 'Paracas and Nazca Iconography', in *Pre-Columbian Art and Archaeology,* Harvard University Press, Cambridge, 1961.

Seiler-Baldinger, Annemarie, *Systematik der textilen Techniken,* Basler Beiträge zur Ethnologie, Vol. 14, Basle, 1973.

Shimada, Izumi, 'Economy of a Prehistoric Urban Context: Commodity and Labor flow at Moche V Pampa Grande, Peru', in *American Antiquity,* Vol. 43, No. 4, Salt Lake City, 1978.

Stierlin, Henri, *Art of the Maya—From the Olmecs to the Toltec—Maya,* transl. Peter Graham, Rizzoli, New York, 1981.

—, *Art of the Aztecs and its Origins,* transl. Betty and Peter Ross, Rizzoli, New York, 1982.

Thompson, Donald E., 'Una Evaluación arqueologica de las Evidencias ethno-historicas sobre la Cultura Incaica', in *100 Años de Archeología en el Perú,* Instituto de Estudios Peruanos, Lima, 1970.

Ubelaker, Douglas, H., 'The Ayalán Cemetery: A Late Integration Period of Burial Site on the South Coast of Ecuador', in *Smithsonian Contributions to Anthropology,* No. 29, Washington, D. C., 1981.

West, Michael, 'Early Watertable Farming on the North Coast of Peru', in *American Antiquity,* Vol. 44, Salt Lake City, 1979.

Whitten, Richard G., 'Comments on the Theory of Holocene Refugia in the Culture History of Amazonia', in *American Antiquity,* Vol. 44, No. 2, Salt Lake City, 1979.

Wilbert, Johannes, *The Thread of Life: Symbolism of Miniature Art from Ecuador,* Dumbarton Oaks, Trustees for Harvard University, Washington, D. C. 1974.

Willey, Gordon R., *An Introduction to American Archaeology,* Vol. 2, Prentice Hall, New Jersey, 1971.

Zevallos Menéndez, Carlos. *La Agricultura en el Formativo Temprano del Ecuador (Cultura Valdivia), Casa de la Cultura Ecuatoriana, Guayaquil,* 1971.

Index

The numbers in italics refer to the plates.

Abancay 177
Acchapata 209
Acora 199
Acosta, José de 173
Ai Apaec 169
Alaska 22
Allen, P. 135
Alto de las Guitarras 79
Amaru Punku 209
Amat, H. 81
Amazonia, Amazonian 3, 7, 11, 15, 19, 22, 24, 25, 31, 33, 34, 36, 40, 43, 48, 62, 71, 81, 89, 139, 170, 177; 41
Amazon river 18, 62, 82
America 7, 19, 24, 31
 Central 7, 8, 17, 30, 40
 North 22, 76
 South 7, 8, 10, 11, 14, 15, 16, 17, 18, 22, 24, 25, 27, 28, 30, 34, 50, 106, 157, 190
Ancón 177
Ancocoyuch 151
Andes 7, 10, 13, 16, 17-18, 30, 62, 73, 146, 157, 185, 192, 194; 33
Antachaka 209
Antisuyu 180, 201
Apurimac: see Río Apurimac
Apurlec 152
Arapa 131
Arequipa 114
Argentina 7, 17, 175, 177
Arica 18
Ascope aqueduct 90
Asia 19, 24
 South-East 24, 28; 19
Atacamá Desert 17
Atahualpa 222, 226
Ávila, Francisco de 173
Ayacucho 131, 141, 144
Aztecs 14, 175, 190, 224, 228-9
Azuay 49, 81-2, 89

Babylon 10, 30, 37
Bandi, H. G. 22
Barcelona (Ecuador) 11
Barthel, Thomas 190
Batán Grande 152; 160
Baudin, Louis 190
Baumann, Peter 22, 109
Bellamy, H. S. 135
Bennett, Wendell Clark 16, 137
Bergier, Jacques 135
Bering Strait 19, 22
Bingham, Hiram 11, 209; 218
Bird, Junius 22, 50, 51, 119
Bishof, Henning 31

Bolivia, Bolivian 7, 8, 11, 15, 17, 131, 133-4, 137, 154; 122
British Columbia 71, 76
Browman, David L. 141
Burger, Richard L. 60, 66, 79-81, 167
Bushnell, Geoffrey 31, 45, 86

Caballo Muerto 56, 79
Cahuachi 116, 129
Cajamarca 144, 152, 177, 180, 222, 226
Cajamarquilla 141, 169
Calderón 18
Callejón de Conchucos 62
Callejón de Huaylas 19, 62, 134, 146
Cañari 222; 214
Cañete 114, 177; see also Río Cañete
Casma 42, 55, 59; see also Río Casma
Cerro Blanco 66
Cerro Churú 159
Cerro Sechín 10, 42, 59-62, 68-70, 78, 90, 137; 33-5
Chancas 177, 197
Chancay 169, 177, 193, 222; 165-7; see also Río Chancay
Chanchán 11, 149, 152, 156, 159-66, 180, 193, 195, 199, 204, 223: 163
 Huaca el Dragón 166; 150, 151
 Huaca Esmeralda 166; 152, 153
 Tschudi 159, 164; 146-8, 152-3
Chanquillo 57-9
Charcas 17, 19, 22
Chavín de Huántar 10, 11, 19, 25, 28, 43, 49, 56, 60-2, 66-78, 79-84, 87-90, 102-4, 106, 109-10, 113, 114, 117-19, 131, 135, 137, 139, 144-6, 167, 172, 222, 228; 36, 38, 40, 43, 48-9, 101, 122, 125
 Lanzón 66-71, 78; 37, 41
 Lintel of the Jaguars 39
 Raimondi Stela 68, 71, 73, 76, 116, 141; 42, 109
 Tello Obelisk 68, 71, 73; 41
Chicama 12, 50, 79, 87, 90, 151; 98-100; see also Río Chicama
Chichén Itza 62
Chile, Chilean 7, 17, 18, 22, 50, 175, 177, 199, 224, 228
Chillón 52
Chimor kingdom 11, 43, 151, 167, 180, 193, 195, 219, 222, 228
Chimús 10, 11, 82, 90, 92, 99, 107, 109, 149-54, 156, 159-66, 167-70, 172, 177-80, 185, 193, 195, 197, 199, 219, 222-3; 146, 151, 154-9, 161-4, 195-6, 201, 213
China 10, 30, 109; 94
Chincha 177, 193, 226
Chinchasuyu 180, 201
Chongoyape 79-81
Chorrera 9, 10, 12, 43, 45-9, 78, 81-2, 86-9, 110, 117, 173, 228; 15-32, 51
Chuquimancu 177

Cieza de León, Pedro de 124, 134, 173, 188, 207
Clementina 7
Cochabamba 134
Coe, Michael 24
Cojimies 95
Colima 48
Collas 177, 197
Collasuyu 180, 201
Colombia, Colombian 7, 8, 10, 18, 24, 31, 33, 106, 107, 175, 224
Conchapata 144
Condorhuasi 79
Conquistadors 11, 14, 30, 36, 170, 172, 199, 205, 222, 224-6; 176
Conrad, Geoffrey W. 161, 166
Contisuyu 180, 201
Copacabana 131
Cordillera 7, 17, 18, 19, 25, 33, 30, 49, 52
 Blanca 17, 62
 Negra 17
 Occidental 17
 Oriental 17, 175
Corihuairachina 209
Cortès, Hernando 224
Costa Rica 8
Cuenca 11, 219
Cuismancu 177
Cupisnique 49, 78, 79-84, 87, 89, 131; 44
Cutimpu 199
Cuzco 9, 11, 12, 131, 167, 172, 175-7, 180, 182, 188, 193, 194, 197, 199-209, 215, 219-22, 226, 228-9; 192, 198, 200
 Amarucancha 173
 Callejón de Loreto 173, 174
 Collcampata 204; 175
 Coricancha 180, 200, 202, 204, 208, 209; 176-8
 Cusipata Plaza 201
 Haucaypata Plaza 201
 Henan 201
 Hurin 201
 Inca Rocca, palace 204; 171, 172
 Kenco 207, 210, 213; 182-3
 Pumac Chupan 201
 Sacsahuamán 200, 201, 202, 204, 205, 207; 179-81

Däniken, Erich von 135
Dawson, L. 13
Day, Kent C. 161
Diaz del Castillo, Bernal 204
Donnan, Christopher B. 99

Ecuador, Ecuadorean 7, 8, 9, 10, 11, 12, 14, 15, 17, 18, 25, 28, 31, 34, 40, 42, 43, 45-9, 50, 51, 62, 78, 87, 89, 106, 107-10, 151, 177, 180, 199, 219, 228; 1, 11, 15, 17, 22, 26, 51, 70, 95, 202, 214

Egypt 10, 30, 31, 107, 182 ; *9*
Eisleb, Dieter 113
El Aspero 52
El Paraiso 52
El Purgatorio 92
Engel, Frédéric 52, 84, 87, 99, 113, 134
Esmeraldas 107 ; *13, 14, 84*
Estrada, Emilio 31, 43
Europe 24, 154, 193
Evans, Arthur 15
Evans, Clifford 31

Feldmann, R. A. 52
Fester, R. 22
Flornoy, Bertrand 170
Fortaleza 151 ; *see also* Río Fortaleza
Frias 107 ; *83*

Gallinazo 89-90
Garcilaso de la Vega 173, 175, 204
Gasparini, Graziano 202
Gaul 213
Gayton, A. H. 113
Gê 42
Giza 94-5, 134
Gran Pajatén 170
Greece 30, 213
Greenland 22
Guangala 110
Guayaquil, Gulf of 12, 18, 33, 49, 78, 86

Harcourt, Raoul d' 122
Harris, D. H. 24
Hawkins, Gerald S. 127
Hill, Betsy 34
Hocquenghem, Anne-Marie 99
Holm, Olaf 31
Horkheimer, Hans 177
Hoz, Sancho de la 173
Huaca de las Avispas 161 ; *see also* Chanchán
Huaca de los Idolos : *see* El Aspero
Huaca de los Reyes 56 ; *see also* Caballo Muerto
Huaca Maranga 202
Huaca Prieta 50, 51, 117 ; *2*
Huancas 177
Huánuco 54
Huánuco Pampa 215
Huanuhuanupata 209
Huaraz 62, 148 ; *140, 142*
Huari 11, 90, 113, 119, 131, 133-4, 141-8, 197, 199, 201 ; *130-1, 134-6, 142*
Huascar 226
Huatanay 182 ; *see also* Río Huatanay
Huatun Huillay 141
Huaycan Tambo 217 ; *211*
Huayna Capac 175, 205, 219, 226 ; *173, 183*
Huayna Picchu 210, 213 ; *218*
Huilcahuain *140*
Huinin 209
Humboldt current 18, 111

Ica 10, 79, 113, 177 ; *169-70 ; see also* Río Ica

Incanato 12, 177
Incas 8, 9, 11, 14, 18, 28, 30, 119, 133, 138, 144-6, 151, 152, 154, 164, 167, 169, 170, 172-209, 212-15, 217-26, 228-9 ; *164, 170-1, 173-4, 176, 182-3, 185, 187-8, 190-5, 197-9, 201-2, 208-14, 217-18, 220*
India 30
Ingapirca 11, 219 ; *214*
Inkallakta 215
Isbell, William 134, 141
Izumi, Seichi 52-4

Jama Coaque 10, 109-10 ; *95-100*
Jara, Victoria de la 190
Jargampata 159
Jequetepeque : *see* Río Jequetepeque
Judge, James 109
Jung, Carl Gustav 106
Junín 141

Kalasasaya : *see* Tiahuanaco
Kantatayita : *see* Tiahuanaco
Kauffmann-Doig, Federico 70-6
Kiss, Edmond 135
Kola Peninsula 22
Kolata, Alan L. 161
Kosok, Paul 90, 124, 154
Kotosh 25, 49, 52, 55, 81-2
Kozlowski, J. 22
Kroeber, A. L. 113
Kutscher, Gerdt 149

La Balsita *15, 26*
La Cumbre 151
La Estaqueria 116
Laguna de Conococha 62
La Irene *21*
La Libertad 45
Lambayeque 79, 92, 97, 144, 149, 167, 169, 223 ; *158-60, 162 ; see also* Río Lambayeque
La Paz 15, 137
Lapiner, Alan 89
Larco Hoyle, Rafael 13, 84, 87, 134, 167, 190
Las Haldas 10, 55, 59, 66, 135
Lathrap, Donald W. 16, 24, 25, 31, 33, 40, 62, 71, 81 ; *41*
La Tolita 9, 10, 107, 109 ; *84-94*
Lévi-Strauss, Claude 76
Lima 15, 52, 84, 141, 149, 151, 169, 202, 217 ; *211-12*
Loma Alta 33, 34, 36
Loma Negra 107
Lothrop, Samuel K. 99, 107, 119
Lumbreras, Luis G. 66, 79-81 ; *43, 47*
Lupacas 177

Machalilla 9, 12, 42-3, 45-9, 82, 86, 89 ; *11-14*
Machu Picchu 7, 11, 207, 209-15 ; *216, 218*
 Intihuatana (Solar Calendar) 210 ; *215, 219*
 Jail Compound 210

Pachamama Temple 207, 213
 Torreón (Royal Tomb) 210 ; *215, 217*
Magellan, Strait of 22
Mama Ocllo 222
Manabí 89 ; *1, 12, 16-27, 29, 31*
Manco Capac 175-7, 204 ; *175*
Manco II 204
Mangelsdorf, P. 24
Mantaro 134
Maranga 151, 169
Marañón : *see* Río Marañón
Marcavelle 131
Marcos, Jorge G. 40
Margolies, Luise 202
Mayas 8, 14, 25, 30, 76, 185, 190, 229
Meggers, Betty 24, 31, 33
Mena, Cristóbal de 173
Menendez, Carlos Z. 31
Menzel, Dorothy 13, 113
Mexico, Mexican 28, 30, 34, 37, 48, 60, 79, 81, 94, 97, 106, 175, 224 : *22*
Mexico City 37
Middle East 154
Minchanzaman 151
Mixtecs 106, 190
Moche, Mochicas 8, 9, 10, 11, 12, 13, 14, 45, 59, 78, 81-2, 84, 86, 89, 90, 92-4, 97, 98-102, 104, 106-7, 110, 114-17, 133, 144, 146, 149, 151, 152, 154-6, 157, 167-9, 170, 173, 185, 190, 195, 202, 222, 223, 228 ; *51, 58-62, 64, 67-74, 76-7, 80-3, 137, 145, 157 ; see also* Río Moche
 Pyramid of the Moon 97 ; *66*
 Pyramid of the Sun 94-7 ; *65-6*
 Late Mochicas 149 ; *75, 78*
Mochica Alta, canal 151, 156
Mohenjo Daro 37
Mollocahua 199
Monte Albán 60
Mora Vieja, canal 156
Moro, canal 90, 151
Moseley, Michael E. 161
Moxeque 56, 59, 63, 141, 222 ; *see also* Río Moxeque
Muisne *13-14*
Murra, John Victor 175, 192-3

Ñaymlap 169 ; *154-5, 158, 163*
Nazca 9, 10, 11, 13, 71, 76, 82, 113, 114-16, 119-29, 133-5, 141, 144, 173, 177, 193, 195, 222, 223, 226, 228 ; *103-6, 107-12, 117, 120*
 Late Nazca 117 ; *113*
Nepeña 92, 97, 151 ; *67 ; see also* Río Nepeña
Nicaragua 8
Norton, Presley 31, 33

Ocucaje 13
Ollantaytambo 199, 207, 209, 210
Olmecs 10, 24, 81, 201
Otuma 111

Pacatnamú 11, 92, 152, 159
Pacchayoc 209
Pachacámac 11, 134, 141, 149, 151, 177-180, 215, 219 ; *208-10*
Pachacuti, Santacruz 173
Pachacuti Yupanqui 175-80, 197, 200, 201, 204, 205, 215 ; *176, 181, 207, 217*
Pacheco 144 ; *132*
Palpa 122, 127 ; *117, 120*
Pampa de San José 122
Pampa Gramalote 117
Pampa Grande 92, 97
Panama 8
 Isthmus of 25
Pañamarca 92, 97 ; *67-8*
Paracas 10, 14, 62, 71, 79, 111-13, 114-16, 117-22, 131, 190, 193, 223 ; *40, 101-2, 114-16, 167*
Paramonga 11, 151, 219-22 ; *213*
Parson, Jeffrey R. 139
Parsons, Lee A. 99
Paucar Tambo 199 ; *200*
Pauwels, Louis 135
Persia 37
Peru, Peruvian 7, 8, 10, 11, 12, 14, 15, 17, 18, 19, 24, 25, 28, 31, 33, 34, 42, 43, 45, 49, 50, 51, 52, 62, 78, 79, 81, 84, 86, 87-90, 97, 106-7, 111-13, 122, 131, 133-4, 146-8, 149, 151-2, 169, 180, 185, 192, 224, 226, 227 ; *2, 12, 33, 36, 45, 51, 70-1, 79, 83, 98-101, 115, 140, 168, 195-6, 207*
Petén 25
Pikillaqta 141, 159, 199
Pisac 208, 209 ; *187-90*
Pisaqa 209
Pisco 111, 177, 217 ; *see also* Río Pisco
Pisquillo Chico *166-7*
Piura 11, 12, 62 ; *see also* Río Piura
Pizarro, Francisco 172, 222, 224, 226
Pizzaro, Hernando 173
Pizzaro, Pedro 173
Poma de Ayala, Guaman 173
Pozorski, Thomas G. 56, 161
Puerto Hormiga 31
Puma Marca 207
Puno 131, 215
Puruchuco 217 ; *212*

Quito *188 ; 202*

Racchi 199 ; *205-6*
Real Alto 33, 34, 40-2, 60, 70, 228-9
Recuay 146
Reiche, Maria 124-7
Reichel-Dolmatoff, G. 16, 24, 31
Resbalon 27
Rimac 141, 169, 217 ; *212 ; see also* Río Rimac
Ríos
 Apurimac 19, 177, 188
 Babahoyo 45
 Cañete 19
 Casma 19, 57

Chancay 19, 169
Chicama 19, 90, 152, 156
Chira 19
Chunchul 200
Fortaleza 151
Grande de Nazca 116, 177
Higueras 54
Huatanay 185, 200-1
Ica 116
Jequetepeque 19, 79, 90, 92
Lambayeque 19, 90, 152
Leche 90, 92, 152
Lomas 116
Lurín 19
Marañón 18, 19, 62
Moche 19, 43, 56, 90, 92-4, 149, 156
Mosna 62, 66
Motupe 152
Moxeque 57-9
Nepeña 19, 90
Ocoña 116, 133
Orinoco 18
Pativilca 19, 146, 219 ; *213*
Pisco 19, 116, 133 ; *207*
Piura 19, 84
Reque 90
Rimac 19
Santa 18, 62, 90
Santiago 107
Sechín 57-9
Supe 19
Tullumayo 200, 201
Tumbes 151
Ucayali 82
Urubamba 210, 212 ; *218*
Verde 40
Vilcanota 182, 185, 208 ; *187*
Virú 19, 90, 146, 152
Zana 90
Rome 30, 215
Rowe, John H. 13, 71, 113, 146, 201 ; *41*

Sacsahuamán: *see* Cuzco
Salinar 89
Sanginés, Carlos Ponce 137-8 ; *123*
San Isidro *12, 16, 29*
San Lorenzo 201
San Pablo, lake 40
San Pedro de Cacha : *see* Racchi
Santa 19, 146-8, 152 ; *143 ; see also* Río Santa
Santa Catalina 87
Santa Elena, Peninsula 45
Santiago 18 ; *see also* Río Santiago
Santillán, Fernando de 173
Sarmiento de Gamboa, José de 173
Sauer, O. 24
Saville, Marshall H. 107
Sawyer, Alan R. 113
Sayhuite 207
Schaedel, Richard 166
Sechín Alto 10, 55, 56-9, 66, 135
Shimada, Izumi 97
Siberia 22
Sillustani 197, 199; *203-4*

Sono, Toshihiko 52-4
Sonora 224
Spain, Spaniards 134, 172, 173, 193, 202, 207, 213, 224-6
Spitsbergen 22
Strong, William D. 113
Sumer 31, 229
Supe 52; *see also* Río Supe

Tacaynamo 151
Tacna 149
Tahuantinsuyu 180, 224, 228
Talara 12
Tambo Colorado 217; *207, 211*
Tambomachay 208; *184-6*
Tantamyo 170
Taraco 131
Tarmas 177
Tehuantepec, Isthmus of 224
Tello, Julio 16, 54, 78, 81, 113, 114, 117-19, 169 ; *208-9*
Tembladera 49, 78, 79-84, 110 ; *98-100*
Tenochtitlán 204, 228
Teotihuacán 79, 94
Tiahuanaco 11, 19, 28, 78, 131, 133-48, 172, 197, 223-4; *122, 124, 128-9, 132-3, 137-9, 167*
 Acapana 135, 138, 139; *123*
 Bennett Stela 141
 El Fraele Stela 137, 141
 Gateway of the Moon 138, 139
 Gateway of the Sun 137, 139; *125, 132*
 Kalasasaya 137-8, 139 ; *122-3, 127*
 Kantatayita 138
 Kheri-Kala 138
 Ponce Stela 137, 141; *127*
 Puma Puncu 138, 139, 141, 197
 Putuni (Palace of the Sarcophagi) 137
 Semi-subterranean Temple 131, 137-8, 139; *122, 124*
Tierra del Fuego 17
Titicaca, lake 11, 19, 62, 131, 133, 134, 135, 139, 144, 148, 175, 177, 180, 197 ; *203*
Tlatilco 37
Tomabal (or Tomaval) 92
Toynbee, Arnold 195
Trujillo 12, 152; *151*
Tschudi, 159
Tucume 152
Tumbes 180, 222, 226; *see also* Río Tumbes
Tumibamba 219, 226
Tupac 175
Tupac Amaru 209
Tupac Yupanqui 180, 215; *208-9, 217*
Tutishcainyo 43, 81-2

Uhle, Max 16, 113
Umayo, lake 197
Urubamba 11, 19, 134, 185; *216; see also* Río Urubamba
Urrutia, Domingo Seminario 86

Valdivia 7, 8, 9, 12, 25, 31, 33-4, 36-7, 40-3, 45, 49, 50, 51-2, 81, 86-9, 173, 229; *1-10*, *15*, *30*
Velázquez de Espinoza 70
Venezuela 22
Vichansao, canal 151, 156
Vicús 9, 10, 12, 13, 14, 43, 49, 78, 81-2, 84-9, 98, 106-7, 114, 117, 144, 154, 169, 173; *45-7*, *50-64*, *79*, *137*

Vilcabamba 226
Vilcanota: *see* Río Vilcanota
Viracocha 131, 139-41, 144, 152, 169, 215, 222; *125-6*, *132*, *167*
Viracochapampa 141, 159
Virú 87, 89, 92; *see also* Río Virú

Wairajirca: *see* Kotosh
Wiener, Charles 209

Wilbert, Johannes 110
Wilcawaín 148; *141*
Willey, Gordon R. 8, 87, 89

Yapura 131
Yupanqui, Tito Cusi 173

Zeidler, James A. 40

List of Plates

Plate numbers

Valdivia pottery and sculpture	1–10
Machalilla pottery	11–14
Chorrera pottery and sculpture	15–32
Bas-reliefs at Cerro Sechín	33–5
Sculpture, bas-reliefs and stelae at Chavín	36–42
Chavín and Chavinoid pottery	43–50
Vicús pottery	51–64
Site and pyramids at Moche	65–6
Site at Pañamarca	67–8
Mochica pottery	69–78
Vicús gold-work	79
Mochica gold-work	80–2
Frias gold-work	83
La Tolita gold-work	84–91
La Tolita pottery	92–4
Jama Coaque pottery and seals	95–100
Paracas pottery	101–2
Nazca pottery	103–13
Paracas–Nazca textiles	114–16
Drawings and tracks at Nazca	117–21
Tiahuanaco monuments	122–7
Tiahuanaco–Huari pottery	128–39
Wilcawaín monuments	140–2
Recuay pottery	143–5
Tschudi compound at Chanchán	146–9
Huaca el Dragón at Chanchán	150–1
Huaca Esmeralda at Chanchán	152–3
Chimú–Lambayeque pottery and ceramics	154–64
Chancay textiles	165–7
Ica–Chincha feather mantle	168
Ica gold-work	169–70
Inca monuments at Cuzco	171–8
Fortress of Sacsahuamán	179–81
Kenco sanctuary	182–3
Tambomachay, Bath of the Inca	184–6
Andenes and monuments at Pisac	187–90
Inca pottery	191–7
Inca sculpture	198–9
Inca gold- and silver-work	200–2
Monuments at Sillustani	203–4
Temple of Viracocha at Racchi	205–6
Tambo Colorado, an Inca posting-station	207
Inca temple at Pachacámac	208–10
Huaycantambo, an Inca posting-station	211
Inca palace at Puruchuco	212
Temple-fortress at Paramonga	213
Temple-fortress at Ingapirca	214
Machu Picchu, an Inca city	215–19
Inca wooden *kero*	220

List of Figures, Maps and Plans

Pages

General map of pre-Columbian Peru, showing the principal sites mentioned in the text	20–21
Elevation and plan of hut at Real Alto	37
Relief of the Real Alto site and reconstruction of plan	40
Gourd from Huaca Prieta	51
Diagrammatic drawing of bichrome textile from Huaca Prieta	51
Plan of El Paraiso	54
Plan of Sechín Alto	54
Plan of Las Haldas	55
Plan of the Huaca de los Reyes	56
Aerial view of Chanquillo	57
Longitudinal section and plan of the pyramid at Moxeque	59
Axonometric drawing of the temple at Cerro Sechín	60
Diagrammatic plan of the sanctuary at Chavín de Huántar	63
Diagrammatic drawing of the Lanzón	68
Bas-relief at Chavín de Huántar	70
Diagrammatic drawing of motif on a column at Chavín	71
Siting, side elevation and plan of the Pyramid of the Sun	94
Mythical fishing scene, Mochica	97
Diagrammatic drawing of a gold ornament, Chavín	106
Motif from a terracotta seal, Jama Coaque	107
Impressions made by cylinder seals, Jama Coaque	109
Diagrammatic drawing of Paracas–Necropolis textile design	122
Drawings of a spider and a whale in the Nazca desert	124
Plan of tracks, lines and drawings in the desert between Pampa and Nazca	126
Drawings of a condor and a bird, Nazca desert	129
Plan of site at Tiahuanaco	135
General plan of Chanchán	157
Aerial view of the Labyrinth Compound, Chanchán	158
Plan of Labyrinth Compound, Chanchán	159
Plan of Rivero Compound, Chanchán	164
Axonometric drawing of the Huaca el Dragón	166
Plan of the city of Cuzco	200
Plan of Cuzco, seen as the outline of a puma	200
Aerial view of Sacsahuamán	205
Plan of the fortress of Sacsahuamán	208
Sacrificial altar in the cave at Machu Picchu	210
General plan of Machu Picchu	212
Plan of storehouses and silos at Incahuasi	213
Plan and transverse section of the temple of Viracocha at Racchi	215
Plan of Tambo Colorado	217
Plan of the palace at Puruchuco	219
Plan of the temple-fortress at Ingapirca	219

This book was printed in December 1983 by Arts Graphiques Héliographia S.A., Lausanne
Photolithographs: Cooperativa lavoratori grafici, Verona
Setting: Arts Graphiques Héliographia S.A., Lausanne

Binding: H. & J. Schumacher A.G., Schmitten
Layout: Henri Stierlin
Production: Emma Staffelbach